Big Art
Small Art

TRISTAN MANCO

Big Art
Small Art

✕

288 ILLUSTRATIONS, 257 IN COLOR

Thames & Hudson

Contents Big Art

Contents Small Art

A
Sense
of Scale

Art has the power to stimulate and present us with new ways of seeing, and fundamental to this is scale. In the words of the influential American land artist Robert Smithson, 'Size determines an object, but scale determines art. A crack in the wall if viewed in terms of scale, not size, could be called the Grand Canyon. A room could be made to take on the immensity of the solar system.' This notion of perception lies at the heart of our investigation into the creative use of scale in art. While the artists presented in the following pages create work at different sizes, it is the imaginative potential of scale that is an essential element of their work.

The impulse to create art at either end of the scale – works that are so complex or large that they barely seem possible – appears to be instinctive. Throughout history, we have marvelled at intricately crafted objects, whether it be fine carving, jewelry or sculpture. Likewise, grand projects that impact the wider environment and leave a lasting legacy have long instilled appreciation and wonder, from megalithic stone monuments to the Nazca lines of the Andes. Scale is an eternal fascination from which artists continue to draw inspiration as a means to explore and better understand our ever-changing world, and our place within it.

In this age of rapid change, the exploration of scale has become markedly more ambitious, fuelled by globalization and advances in technology. The internet in particular has made the world a smaller and more interconnected place, and enabled artists to reach a far wider audience. Whether working big or small, artists are embracing the futuristic tools at their disposal – technology they could only have dreamed of in the past – to create virtually any object imaginable. Tomás Saraceno is a striking example, combining artistic vision with engineering expertise to make floating, inflatable biospheres on an epic scale. At the same time, we still value and feel connected to work that is made by hand – a sentiment that is perhaps epitomized in the work of Joe Fig, whose miniature reproductions of artists in their studios pay homage to the act of creation with an awe-inspiring level of detail.

The sheer pace of transformation is affecting the way we use space, from

the public and cultural spheres to the digital realm. While artists take a more global approach, art institutions in cities around the world have been competing to put themselves on the map with large-scale commissions that make a bold statement. Works are taking on ever-greater dimensions in vast warehouse-sized museums and public spaces where huge teams of specialists are charged with translating grandiose ideas into a tangible reality. Among the many examples of this shift towards large-scale commissions are *Big Bambú* (2008–ongoing) by Doug and Mike Starn and *Dalston House* (2013) by Leandro Erlich. *Big Bambú* is a series of colossal bamboo structures, including one that was built in the roof garden of the Metropolitan Museum of Art, New York, in 2010. In *Dalston House*, which was commissioned by the Barbican in London, Erlich presented a familiar scene – the façade of a life-size house – in a disorientating way through the use of a large mirror; visitors could watch themselves acting out surreal scenarios as they moved around the work.

Like *Dalston House*, much of the big art in this book is designed to be interactive and throw us off guard. Nike Savvas, who explores colour and space through her installations, gives a fascinating insight into this approach. 'Large-scale works embody a number of different considerations,' she explains. 'They focus less on the production of objects and place more emphasis on the creation of immersive environments and sensorial experiences to transport the viewer to other realms. The scale of these works functions to immerse the viewer optically and physically, while colour activates and triggers the senses. While this may transport us to a temporary state of elation, it also invites the unwelcome prospect of bewilderment and crisis that may ensue from optical overload and spatial disorientation.'

This sense of disorientation can also be found in works at the opposite end of the scale. Thomas Doyle creates miniature snapshots of life with a post-apocalyptic feel: claustrophobically trapped under glass cases, his small-scale figures populate a world of immaculate gardens and white

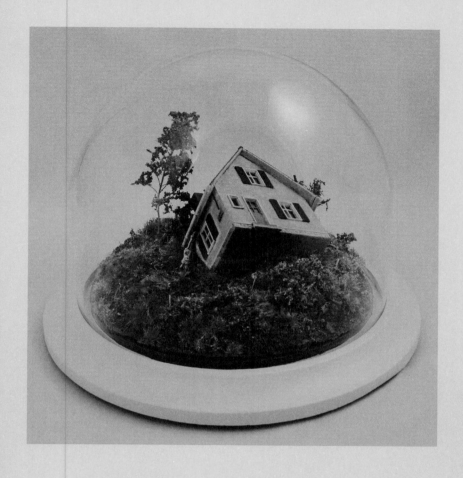

LEFT
Thomas Doyle
Failure to Extract
2013
Mixed media
×
22 × 24 cm (8 ¾ × 9 ½ in.)

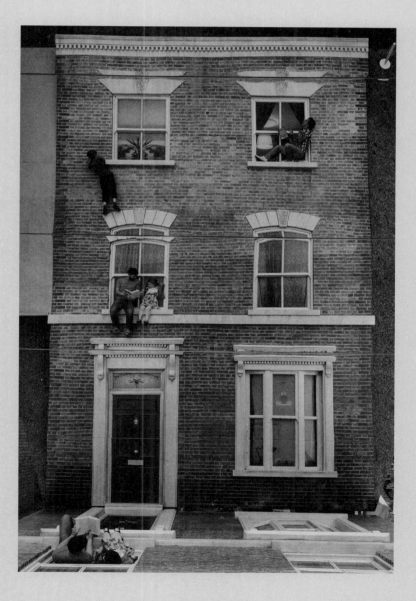

RIGHT
Leandro Erlich
Dalston House
2013
London, UK
Print, lights, mirror
×
8 × 6 × 12 m (26 × 20 × 39 ft)

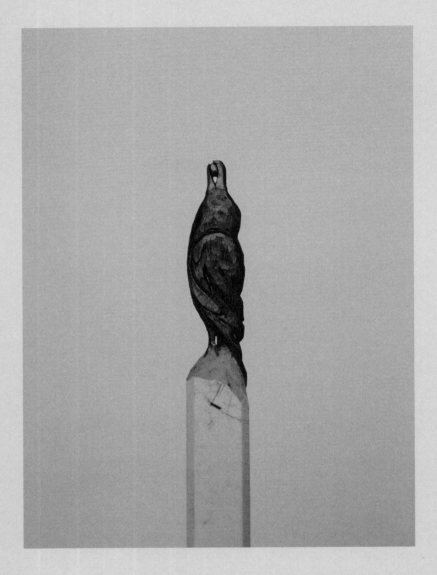

LEFT
Diem Chau
The Raven & The Sun
2012
Carved carpenter's pencil
×
14 × 1.6 × 0.6 cm (5 ½ × ⅝ × ¼ in.)

BELOW
Motoi Yamamoto
Labyrinth
2012
Bellevue Arts Museum, Bellevue,
Washington, USA
Salt
×
5 × 14 m (16 ½ × 46 ft)

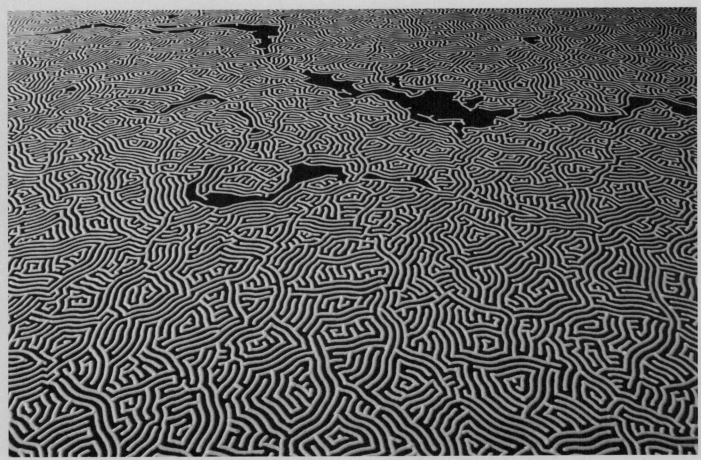

picket fences but are depicted in the midst of disaster. Nancy Fouts also draws on familiar associations but twists our expectations in works that are created in the tradition of surrealist sculpture, such as a cactus-like balloon with spines. Whereas these works are suited to a pristine gallery setting, Evol takes his art to the street, transforming everyday urban features such as electrical enclosures into mini concrete tower blocks through the medium of paint. The results are executed with such skill that passers-by often do a double take.

The unconventional media used by some of the artists can heighten the impact of the works. In viewing the leaf art of Lorenzo Manuel Durán or the miniature sculptures carved in crayons and pencil leads by Diem Chau, you cannot help but be impressed by the skill involved in transforming such small-scale, fragile materials into works of art. In some cases, the material suggests or even dictates the form a work should take, including its scale. This is the case with Iori Tomita, Fujiko Nakaya and Motoi Yamamoto, who use unusual media – animal specimens, fog and salt, respectively – to creative effect.

At the end of each installation, Yamamoto invites visitors to take a handful of salt – a substance we all need to survive – and return it to the sea, thus completing the natural cycle of life.

Many of the artists in these pages explore our role within the world, particularly our impact on the environment, but it is perhaps the large-scale works that pack the biggest punch. Pascale Marthine Tayou tackles environmental issues head-on with *Plastic Bags* (2001–11), a 10-m-high (33-ft) hanging net made from thousands of colourful plastic bags – one of the most common indicators of global waste – in a project that is both stunning and shocking. Other artists broach the subject in a more subtle way. Jason deCaires Taylor creates large clusters of underwater sculptures that are transformed into artificial reefs, increasing marine biomass and providing a habitat for fish species. In a comparable attempt to find alternative, utopian ways of living that address global issues such as climate change, Tomás Saraceno constructs large-scale habitable networks that combine engineering expertise with inspiration from science and nature.

Science and nature are themes that run throughout the book. Egied Simons, for example, harvests biological material such as larvae and projects microscopic images of his samples onto walls in both inside and outside spaces. The glass microbiology of Luke Jerram also focuses on magnifying natural forms – in this case, viruses such as HIV, smallpox and E. coli – to reveal the beauty but also the global impact of these tiny infective agents. With Klari Reis, it is her choice of a Petri dish as the support that provides a strong visual association with science. Meanwhile, Nicolás Labadia and Alberto Baraya mimic traditional collections of natural specimens in staged displays: the former by using found objects to create hybrid creatures, presented as if they were authentic finds; the latter by documenting artificial flora and fauna as if they were real plants.

The works in these pages reveal a rich variety of intentions and approaches, encompassing a wide aesthetic – from the natural to the synthetic, from the hyperreal to the otherworldly. Whether big or small, they provoke questions, arouse emotions and offer fresh perspectives. The creators of these works are not only generators of 'big ideas'; they are also great collaborators, working with engineers, scientists and other specialists. The thirst for fresh ideas and the challenge of working at extremes of scale have driven many of them to embrace new technology, materials and methods. A number of them have been recognized for their vision and inspiration, including Janet Echelman and Theo Jansen, who have both taken part in the highly regarded TED (Technology, Entertainment, Design) talk series, a non-profit venture that honours innovators around the globe. By daring to think big or small, these leading lights in contemporary art – game-changers in their fields – are opening our eyes to things we might previously have taken for granted and making us look at the world around us in new ways.

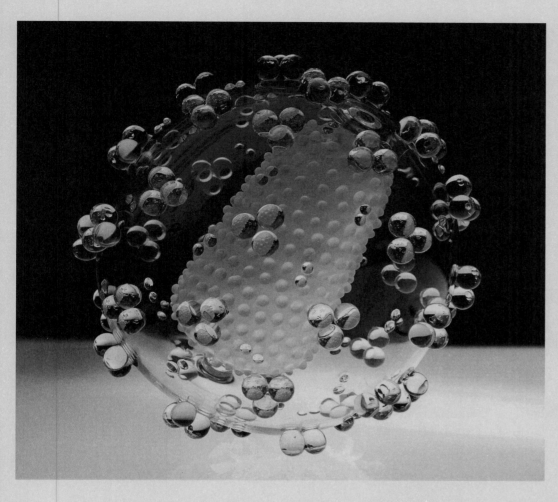

LEFT
Luke Jerram
HIV
2009
Flameworked glass
×
21 × 21 cm (8 ¼ × 8 ¼ in.)

BELOW
Janet Echelman
She Changes
2005
Oporto, Portugal
Painted galvanized steel,
Tenara architectural fibre
×
Net: 46 × 46 × 24 m (150 × 150 × 80 ft)

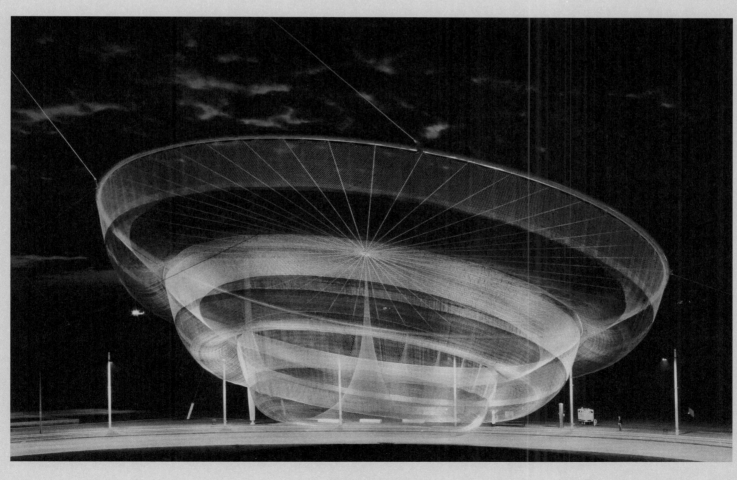

Big
Art

This is the age of big, bold and beautiful art — art that bursts out of buildings, floats in the sky like a giant Zeppelin or is etched into the landscape at such an epic scale that Google Earth can pick it up. The artists profiled here are pushing their work to new heights, creating thoughtful, unexpected, astonishing pieces. Seismic shifts in technology, science and the creative economy in recent years have made it possible for artists to produce works and installations with increasingly daring ambition. While many artists do not rely on technology or substantial resources to create large-scale art, the current climate is encouraging them to think big.

Our appetite for art worldwide is steadily growing, with museum visitor numbers hitting the roof, new art fairs being launched each year, and the rise of jumbo-sized art spaces such as Tate Modern in London, established in a former power station in 2000. In response to this momentum and growth in the art world, tastes seem to have shifted towards large-scale installations. The works commissioned for the great Turbine Hall at Tate Modern have been particularly influential in offering artists a vast arena in which to work freely and create something outside the normal scope of a gallery space. In *The Weather Project* (2003), Danish–Icelandic artist Olafur Eliasson filled the hall with a huge representation of the sun, using hundreds of lamps that radiated yellow light, and humidifiers that created a fine mist. Colombian sculptor Doris Salcedo's piece *Shibboleth* (2007), a 167-m-long (548-ft) crack in the hall's floor, was the first work to be integrated directly into the fabric of the space. Such installations have arguably become the new cathedrals of art, providing a place for contemplation and engagement in an increasingly secular and insular society.

Interaction has been a key consideration in many of the works in this book, which includes several high-profile commissions designed to encourage audience participation from artists such as Leandro Erlich (*Dalston House*, 2013; Barbican, London) and Jaume Plensa (*Crown Fountain*, 2004; installed in Millennium Park, Chicago). Another interactive work to have hit the headlines is *RedBall Project* by Kurt Perschke, who has integrated a giant inflatable red ball into architectural spaces around the world with the aim of engaging local people and offering a different view of the city. Janet Echelman turns our attention to the skies above, which she lights up with colourful, intricately woven net sculptures that transform public areas into mesmerizing, inspiring spaces.

In recent years, there has been a drive for large-scale art of this nature to create a more sensory and immersive experience for the viewer than it did in the past. Brent Christensen's immense ice wonderlands are vast labyrinthine spaces in which visitors can lose themselves in a maze of stairs, archways and tunnels. Tomás Saraceno's inflatable, transparent biospheres, which appear to float in cavernous spaces like something from a science-fiction film, invite us not only to explore these spaces, but also to interact socially with others within this environment. Installations such as these have been breaking down barriers between what we consider to be inside and outside spaces. Indeed, Saraceno's *On The Roof: Cloud City* (2012), exhibited at the Metropolitan Museum of Art in New York, featured habitable geometric structures perched on the roof garden of the building.

Colour often plays a crucial role in pushing the boundaries of immersive art. Katharina Grosse breaks down the linear structure of a gallery space by covering every surface and object in a burst of spray-painted colour. Barcelona-based collective Penique Productions choose a single colour for their ephemeral installations, essentially using air to vacuum-pack entire rooms in plastic. Nike Savvas's colour-infused environments, meanwhile, alter as visitors immerse themselves in the works. Her acclaimed *Atomic: Full of Love, Full of Wonder* (2005) — a sea of coloured balls suspended in a gallery — explored spatial relationships and could only be viewed fully from a distance. Using materials en masse or without limits allows these artists to review their physical properties and stretch their artistic potential.

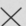

Some of these immersive works have benefited from extraordinary collaborations with scientists and other specialists. Collaborative creation enables artists to realize their ambitious visions by pooling the diverse skills of others. Doug and Mike Starn work with teams of climbers to create vast organic structures constructed with bamboo poles, while Adrián Villar Rojas describes his towering clay sculptures as 'collective efforts' that can involve ten to fifteen people and thousands of man hours. Jason Hackenwerth also has a team of assistants to blow up the thousands of latex balloons that make up his organic, biological forms. Other artists such as the Spanish art collective Boa Mistura include local communities in the creation of their immense murals, often to highlight social issues. The production of large-scale works can involve numerous unseen collaborators, too, such as curators, committees and city planners, who try to ensure that a piece of art is sympathetic to a specific location and engages local people.

There are many reasons why an artist may choose to make an outsized work. To some extent, the choice of media can dictate the scale of the work. For instance, artists such as Fujiko Nakaya and Motoi Yamamoto embrace elemental materials in their installations. Nakaya's magical fog sculptures, created with a specially designed fog system, envelop public spaces and adapt to changes in the wind, temperature and humidity. Yamamoto's huge installations are made from nothing but salt, which he then asks visitors to return to the sea to complete the natural cycle of life. In his *Terrestrial Series*, Jorge Rodríguez-Gerada depicts iconic figures at huge dimensions using materials such as sand and gravel at strategic locations. As the Cuban–American artist explains, 'Working at very large scales becomes a personal challenge, but it also allows me to bring attention to important social issues. The size of the piece is intrinsic to the value of its message.'

For many artists in this book, big art is about more than simply getting noticed. Installations are often staged in response to significant political, social or philosophical issues, where a bold artistic statement is necessary. José Lerma's giant portraits of obscure historical figures explore the nature of power and corruption, an issue that remains as pertinent today as it was in the past. Nikolay Polissky's monumental wooden construction *Large Hadron Collider* (2009) – a homage to the iconic particle collider of the same name – makes a statement about the semi-mystical status of modern science by transforming this scientific milestone into a ritualistic object. Others target consumerism and environmental issues by highlighting consumption and waste in society, including Pascale Marthine Tayou and Choi Jeong-Hwa, who used recycled materials in their respective works *Plastic Bags* (2001–11) and *1,000 Doors* (2009) to get the message across. Jason deCaires Taylor's underwater sculptures are a highly original approach to environmental issues, gradually turning into artificial reefs that provide a new habitat for fish species.

Put simply, big art can be an equivalent response to a big problem. But it can also be seen as a celebration of the human spirit and the natural urge to make a creative mark upon the earth. Lilian Bourgeat and Jean-François Fourtou play on our perceptions of scale with disproportionately large or small objects that transport us to a dreamy, fantastical world reminiscent of *Gulliver's Travels*. Theo Jansen creates stunning mechanical kinetic sculptures that move across the ground like living, breathing creatures, using the power of wind. Such works fill us with wonder, but they also have the potential to change the way we view the world around us. As New York art dealer Gavin Brown once said in a discussion about the rise of big art, 'When we are able to fly around the globe in twenty-four hours, and that kind of movement is a common, everyday occurrence, then we have lost our physical sense of awe. These large-scale works might be a conscious attempt to rediscover that awe.'

Boa Mistura

— PROFILE P. 122 —

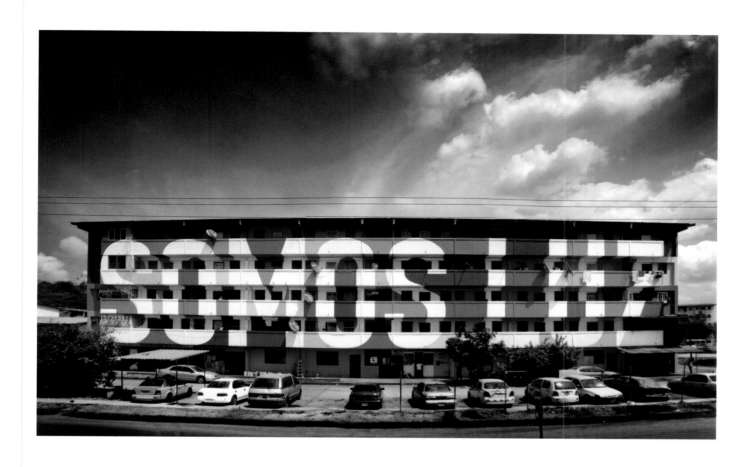

ABOVE
Somos Luz (*We Are Light*)
2013
Panama
×
16 × 70 m (52 ½ × 230 ft)

RIGHT
Somos Luz (before)

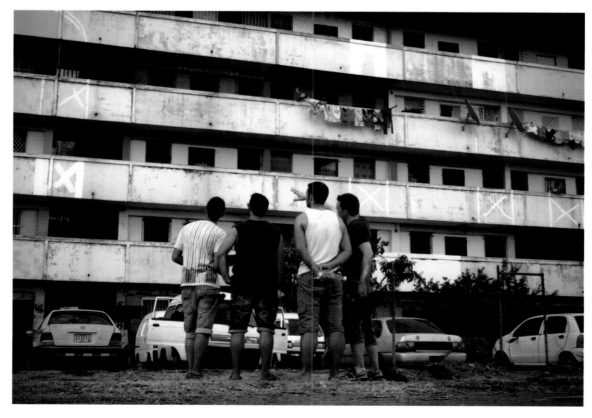

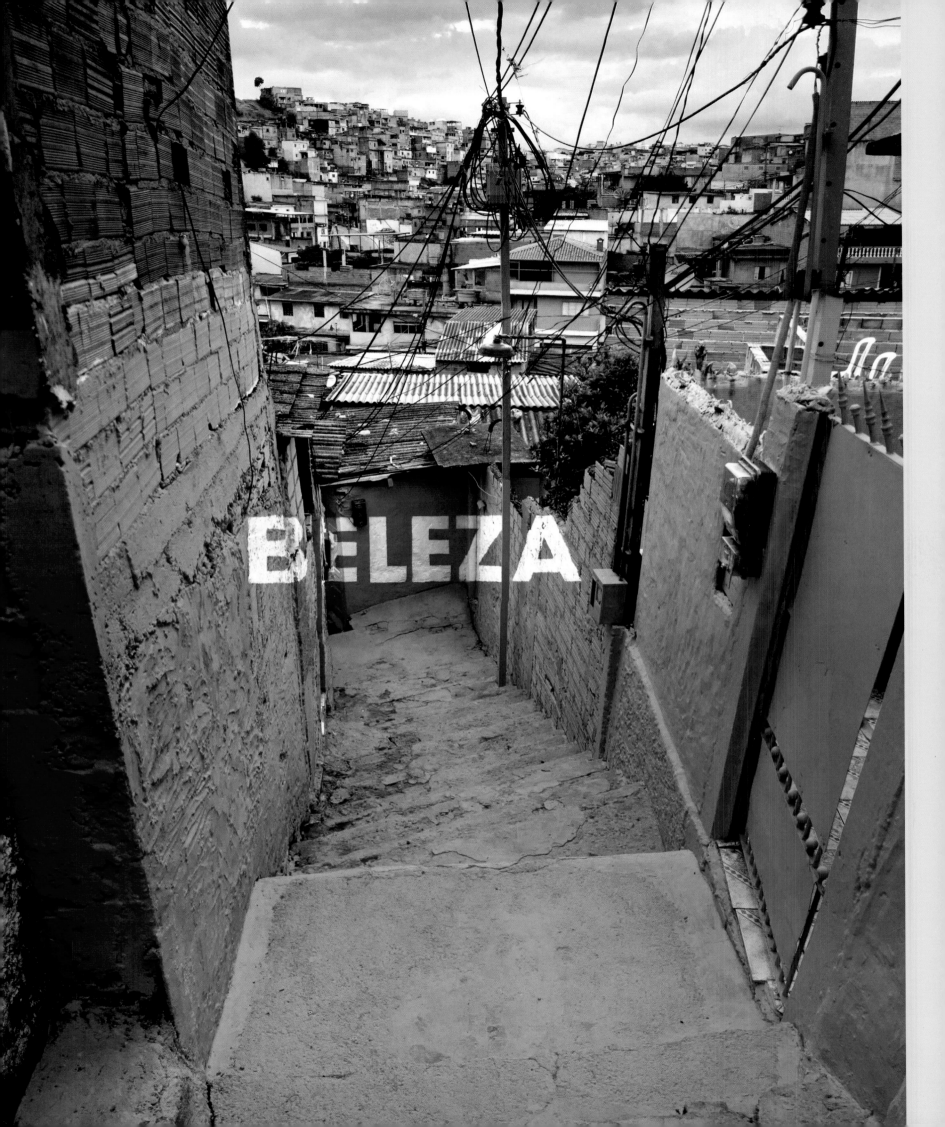

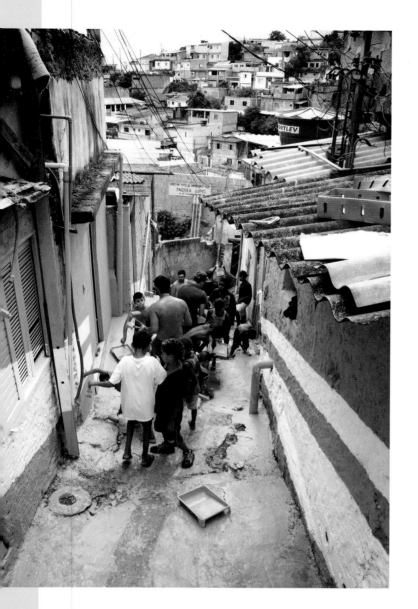

LEFT
Firmeza (*Strength*)
Work in progress
2012
São Paulo, Brazil
×
20 × 1.5 × 3 m (65 ½ × 5 × 10 ft)

BELOW
Amor (*Love*)
2012
São Paulo, Brazil
×
15 × 1.5 × 3 m (49 × 5 × 10 ft)

OPPOSITE
Beleza (*Beauty*)
2012
São Paulo, Brazil
×
30 × 3.5 × 3 m (98 ½ × 11 ½ × 10 ft)

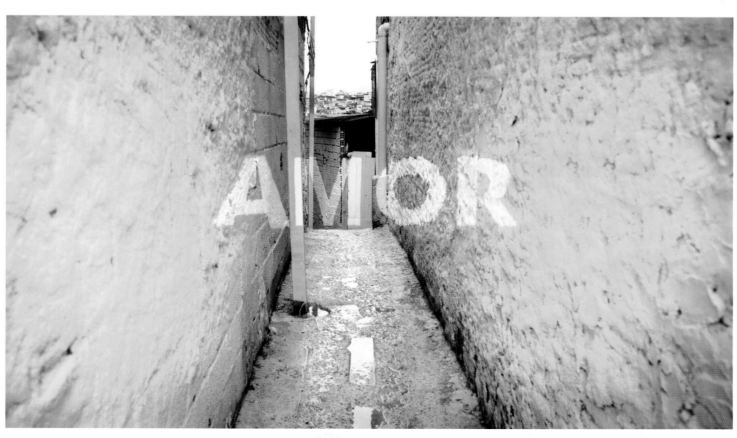

Lilian Bourgeat

— PROFILE P. 122 —

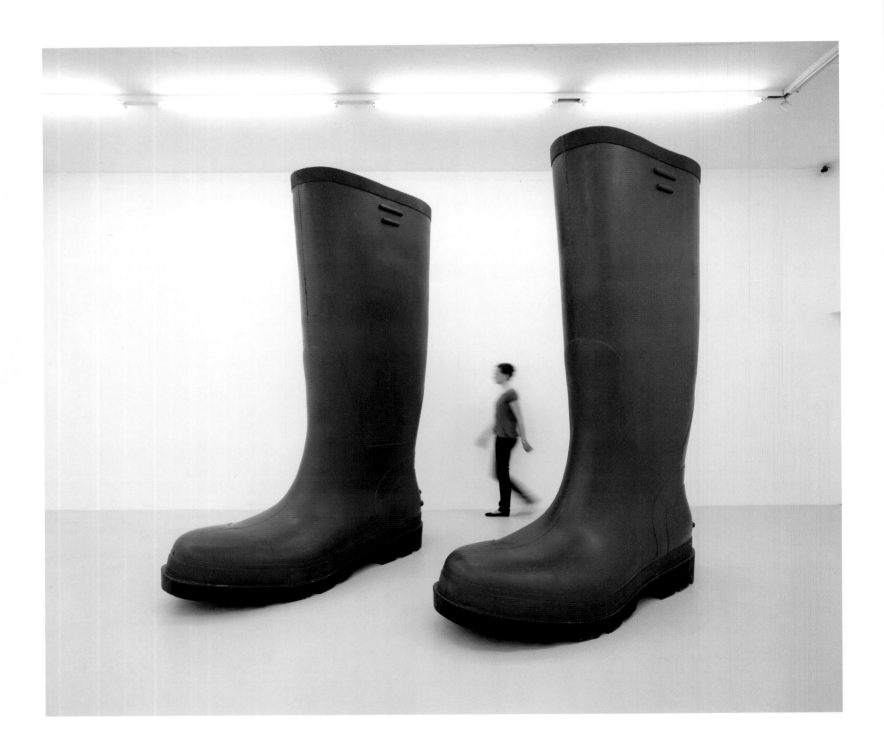

Invendu-bottes (Unsold Boots)
2009
Polyester resin in two parts
×
Each 300 × 200 × 80 cm (118 ⅛ × 78 ¾ × 31 ½ in.)

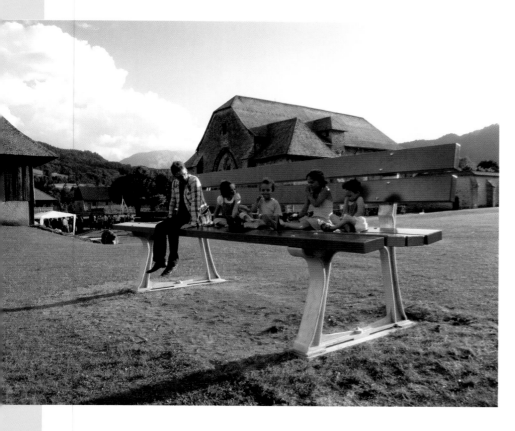

LEFT
Banc public (*Public Bench*)
2009
Aluminium, steel, wood
×
187.7 × 500 × 160 cm
(73 ⅞ × 196 ⅞ × 63 in.)

RIGHT
Le dîner de Gulliver (*Gulliver's Dinner*)
2008
Polyester resin, glass, stainless steel, porcelain
×
Dimensions variable

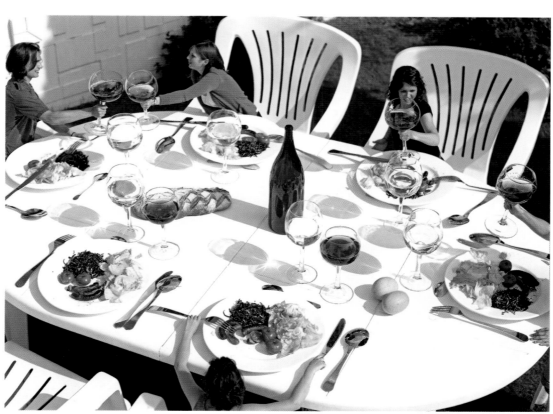

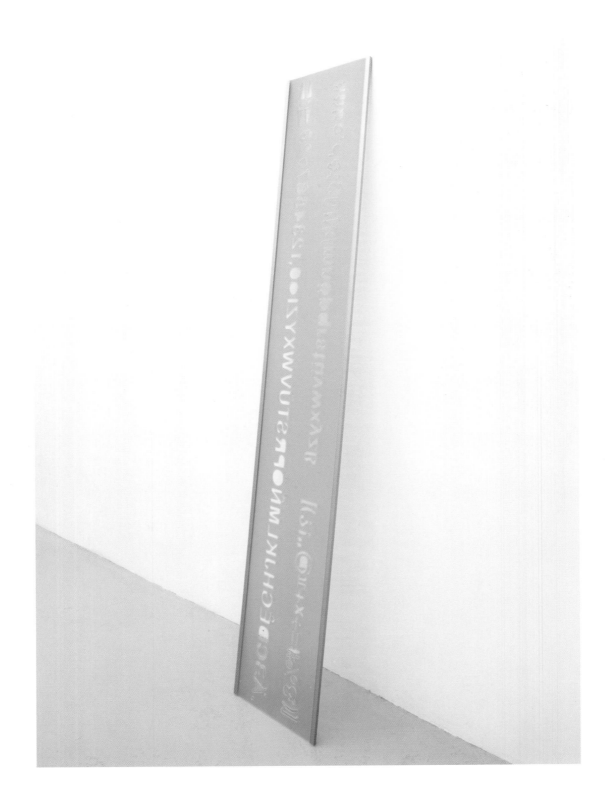

ABOVE *Trace-lettres* (*Alphabet Stencil*), 2008. Plexiglas.
200 × 70 cm (78 ¾ × 27 ⅝ in.).

OPPOSITE *Mètre* (*Tape Measure*), 2007. Metal, polyester resin.
Dimensions variable.

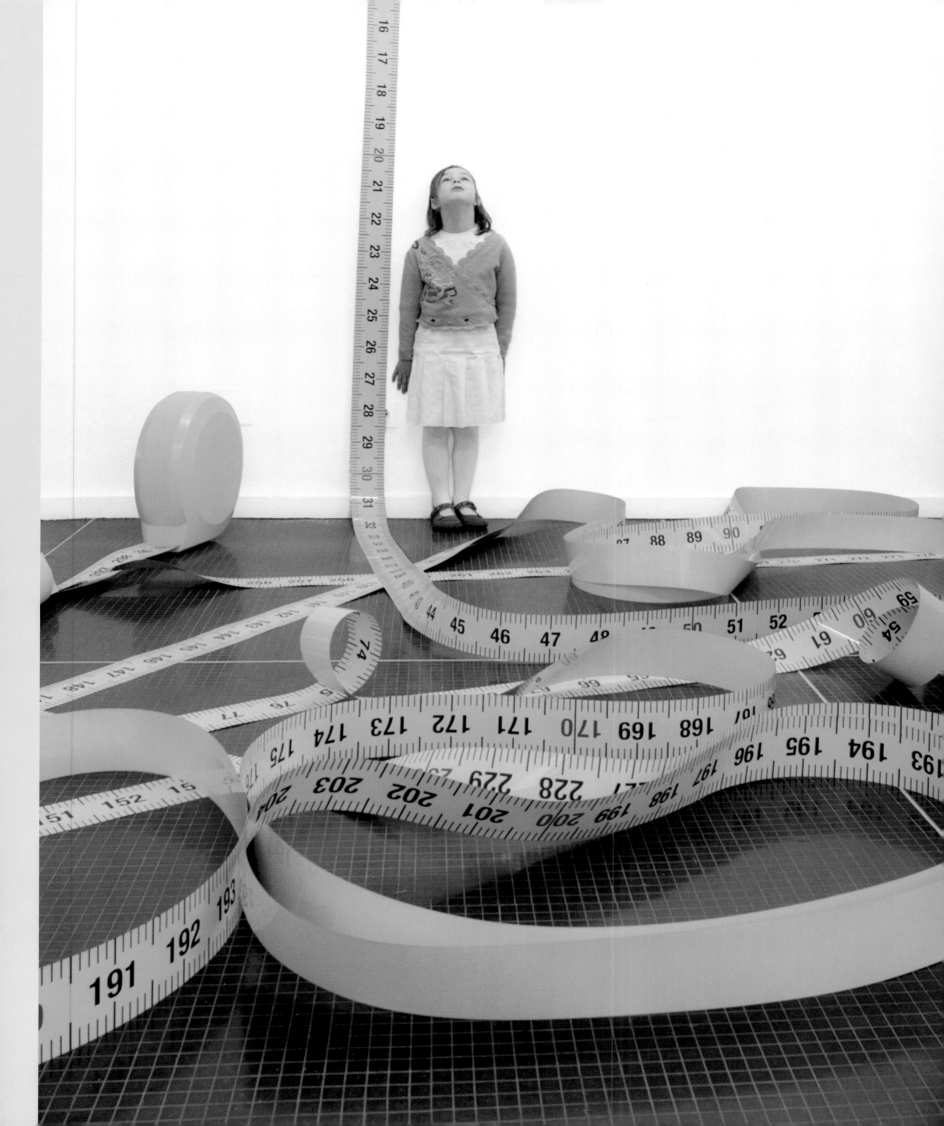

Brent Christensen

— PROFILE P. 124 —

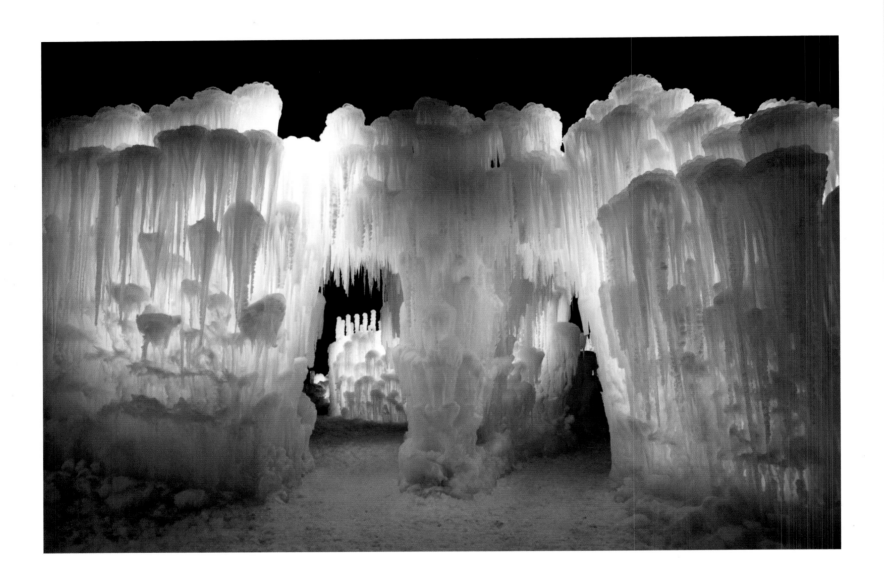

ABOVE AND OPPOSITE

Ice Castle

2011—12

Silverthorne, Colorado, USA

Ice, fluorescent lighting

×

Dimensions variable

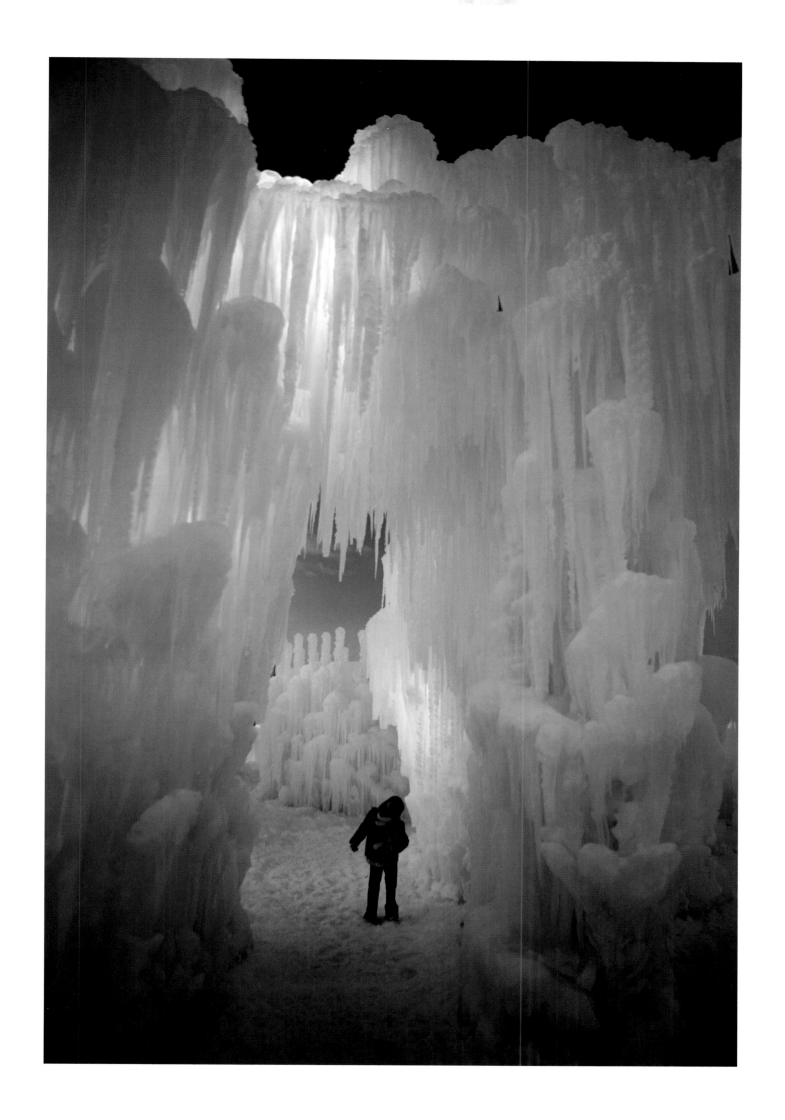

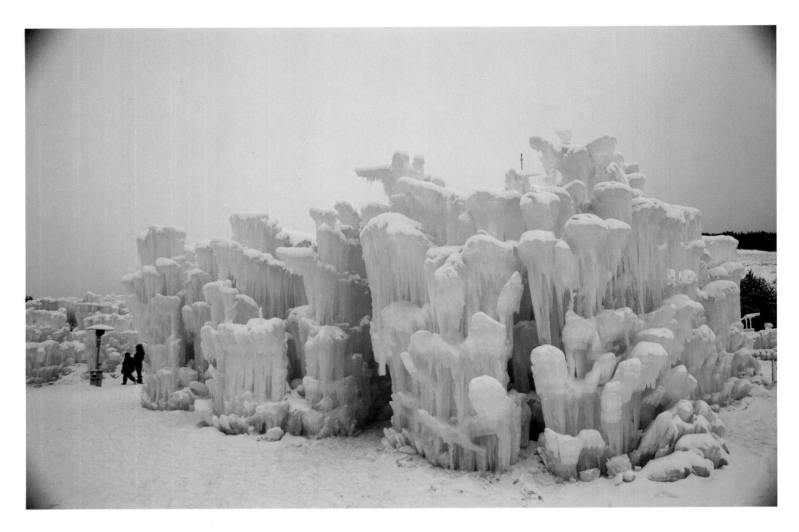

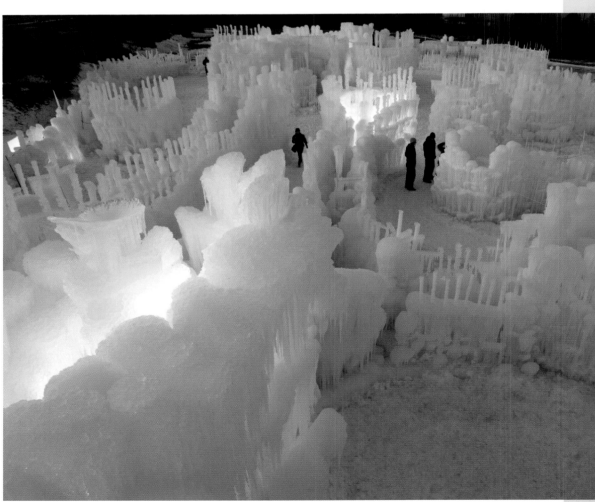

ABOVE
Ice Castle
2012—13
Bloomington, Minnesota, USA
Ice, fluorescent lighting
×
Dimensions variable

RIGHT
Ice Castle
2011—12
Silverthorne, Colorado, USA
Ice, fluorescent lighting
×
Dimensions variable

OPPOSITE
Ice Castle
2011—12
Silverthorne, Colorado, USA
Ice, fluorescent lighting
×
Dimensions variable

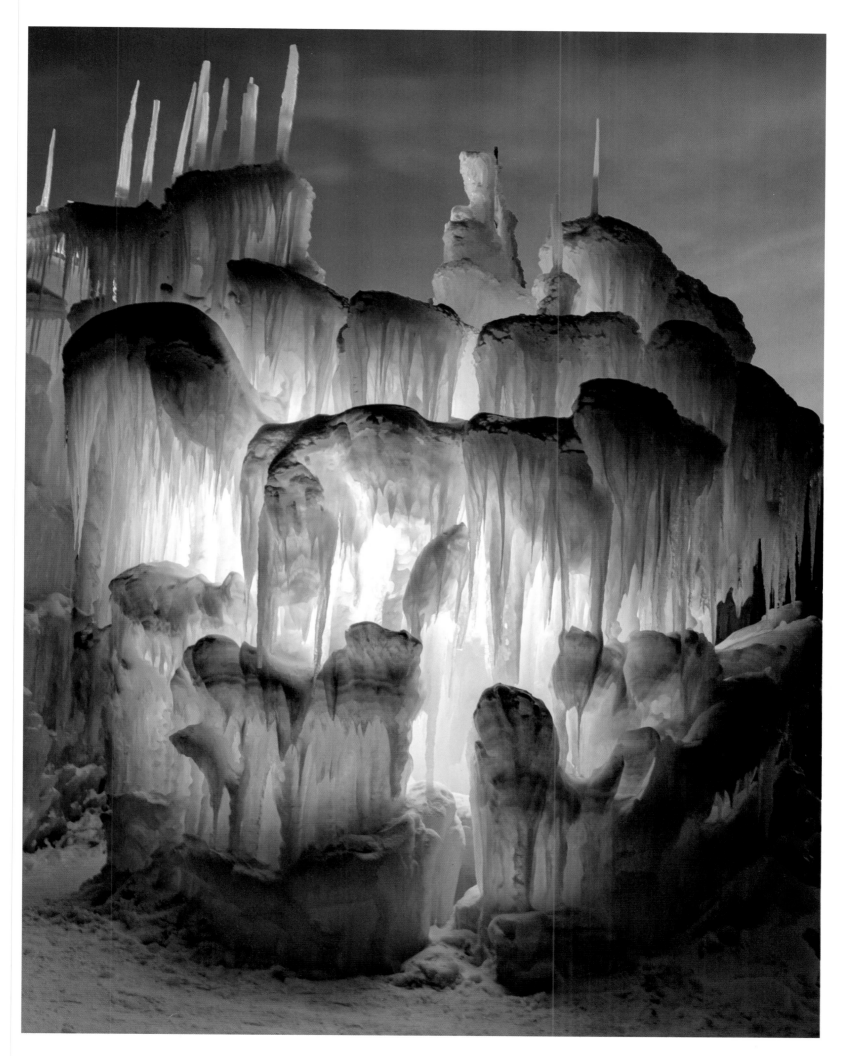

Janet Echelman

— PROFILE P. 125 —

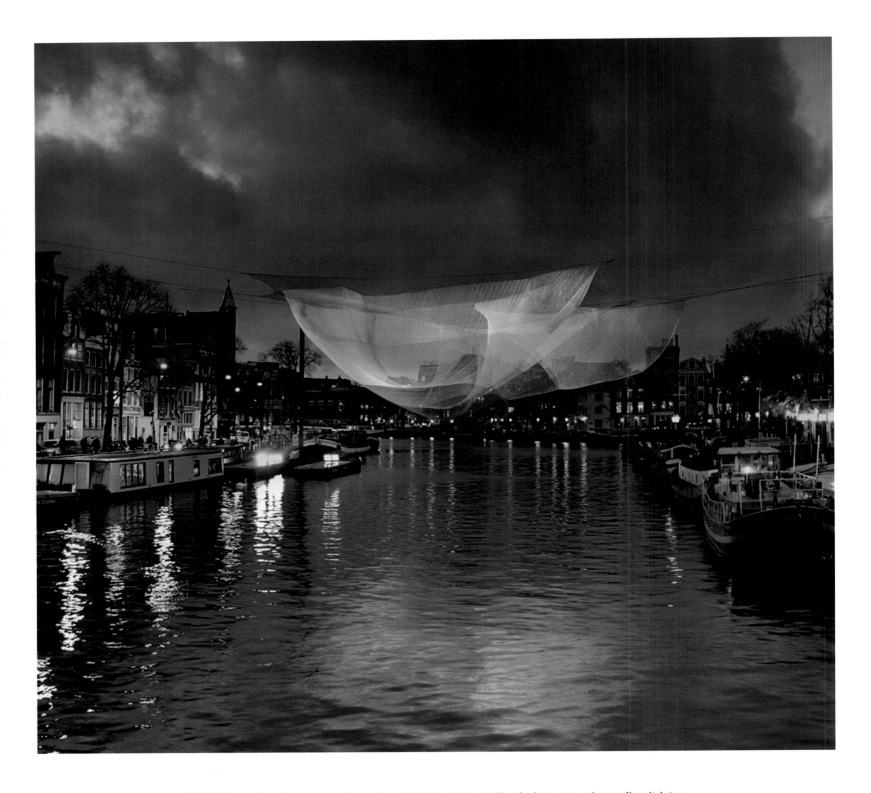

ABOVE *1.26 Amsterdam*, 2012–13. Amsterdam, Netherlands. Spectra fibre, high-tenacity polyester fibre, lighting.
Net: 24 × 18 × 9 m (80 × 60 × 30 ft).

OPPOSITE *1.26 Denver*, 2010. Denver, Colorado, USA. Spectra fibre, high-tenacity polyester fibre, lighting.
Net: 24 × 18 × 9 m (80 × 60 × 30 ft).

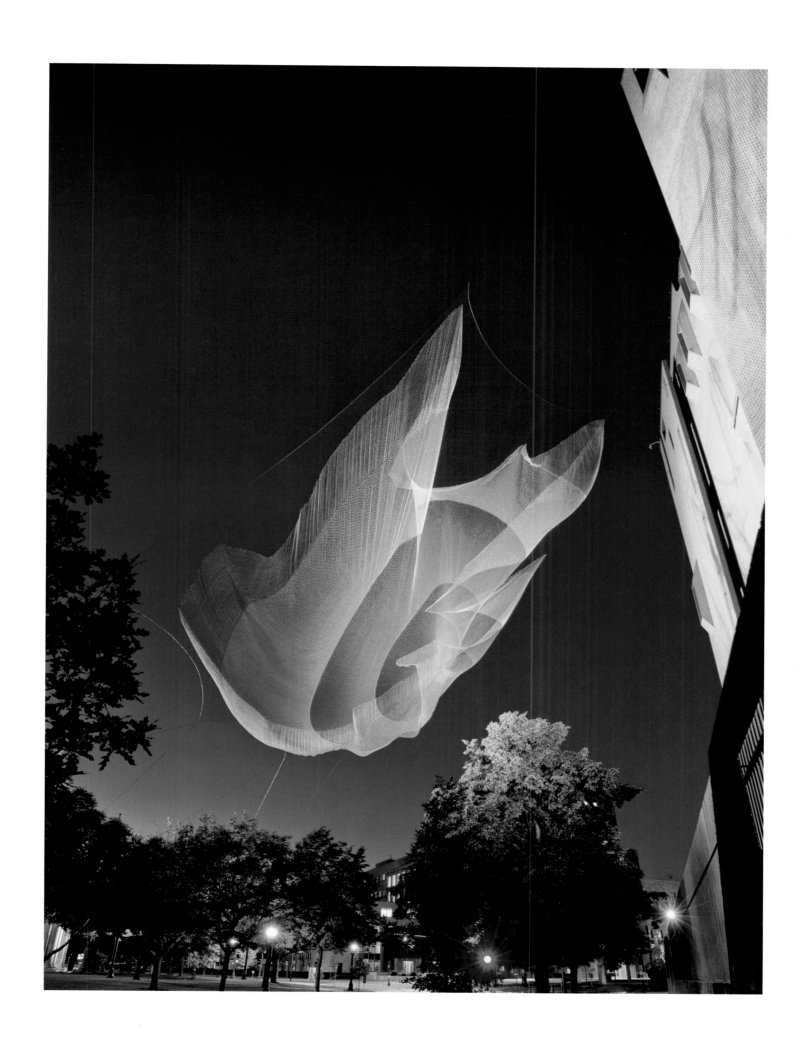

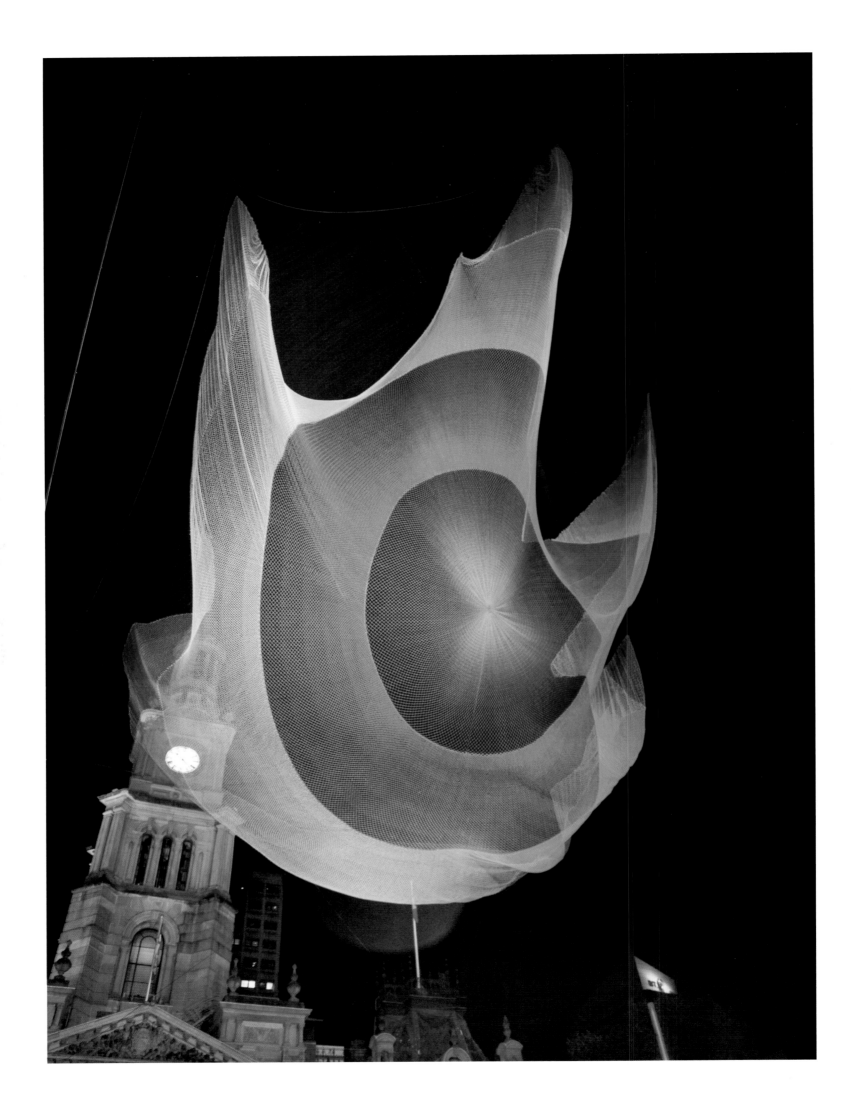

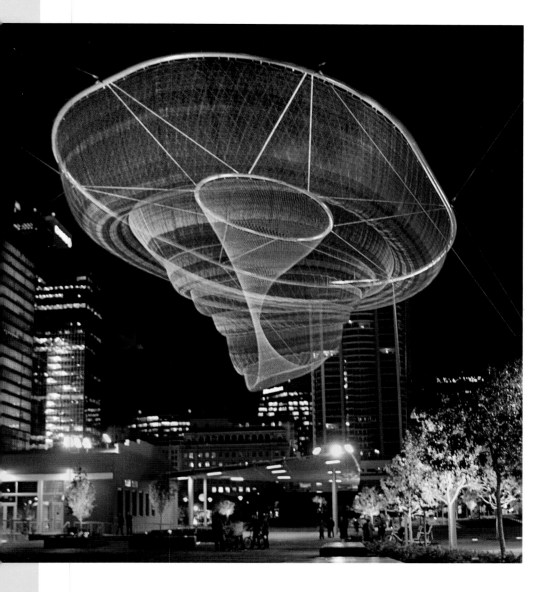

LEFT AND BELOW
Her Secret Is Patience
2009
Phoenix, Arizona, USA
Painted galvanized steel and cables, changing sets
of recyclable high-tenacity polyester fibre, lighting

×

Net: 30 × 30 × 19 m (100 × 100 × 62 ft)

OPPOSITE
1.26 Sydney
2011
Sydney, Australia
Spectra fibre, high-tenacity polyester fibre, lighting

×

Net: 24 × 18 × 9 m (80 × 60 × 30 ft)

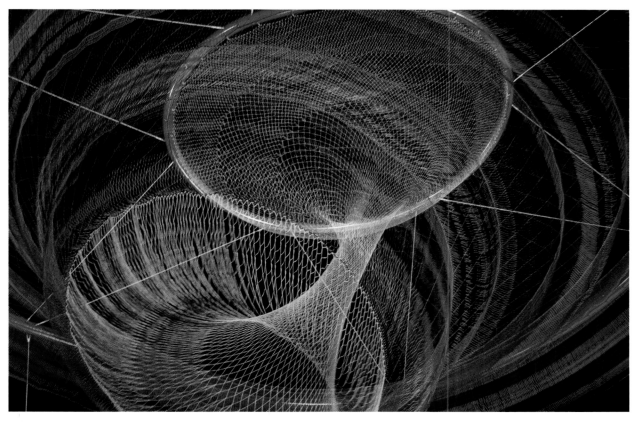

Leandro Erlich

— PROFILE P. 125 —

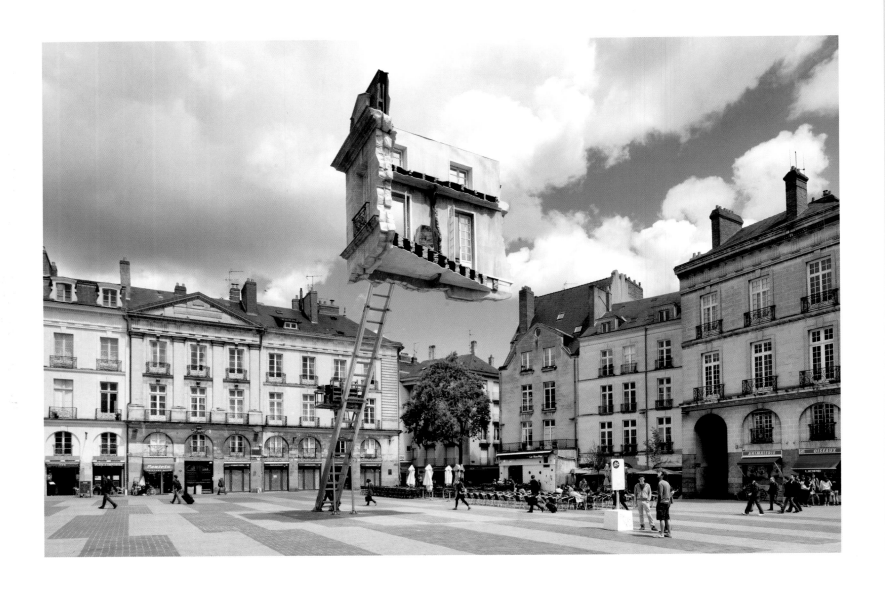

Monte-meubles: L'ultime déménagement
2012
Nantes, France
Metal structure, fibreglass resin,
set of furniture, wooden windows

×

14 × 6.5 × 10 m (46 × 21 × 33 ft)

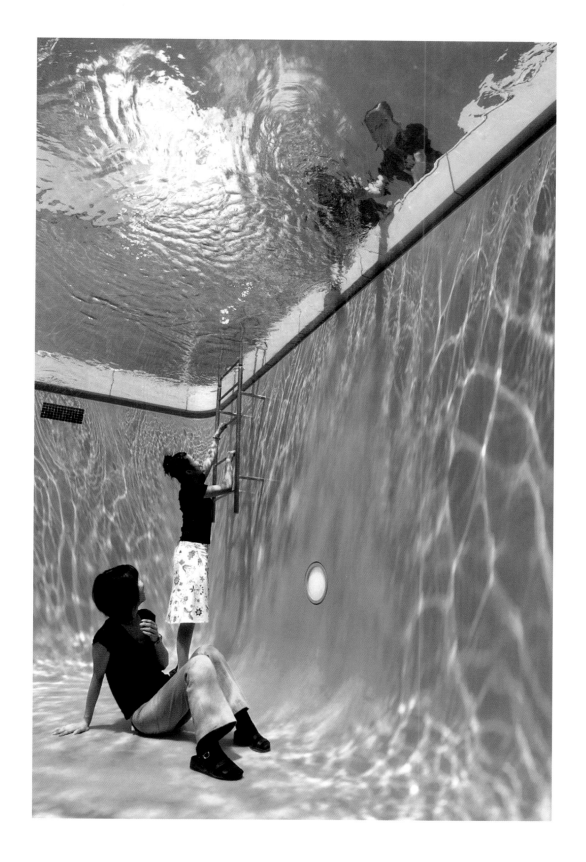

Swimming Pool
1999
21st Century Museum of Contemporary Art, Kanazawa, Japan
Mixed media

×

Dimensions variable

LEFT AND BELOW
Tsumari House
2006
Echigo-Tsumari Art Triennale,
Niigata Prefecture, Japan
Print, lights, mirror
×
8 × 6 × 12 m (26 × 20 × 39 ft)

BELOW
Dalston House
2013
London, UK
Print, lights, mirror
×
8 × 6 × 12 m (26 × 20 × 39 ft)

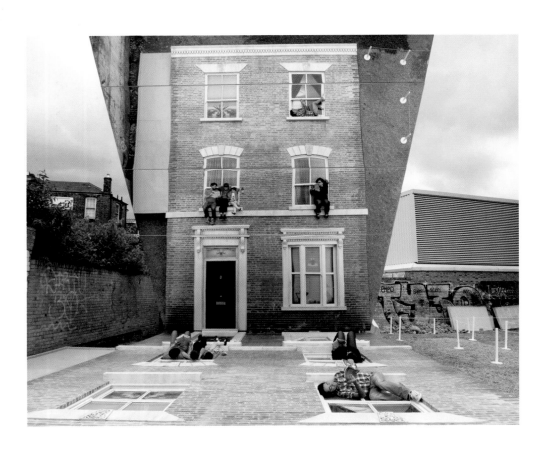

OPPOSITE
Bâtiment (Building)
2004
'Nuit Blanche', Paris, France
Print, lights, mirror
×
8 × 6 × 12 m (26 × 20 × 39 ft)

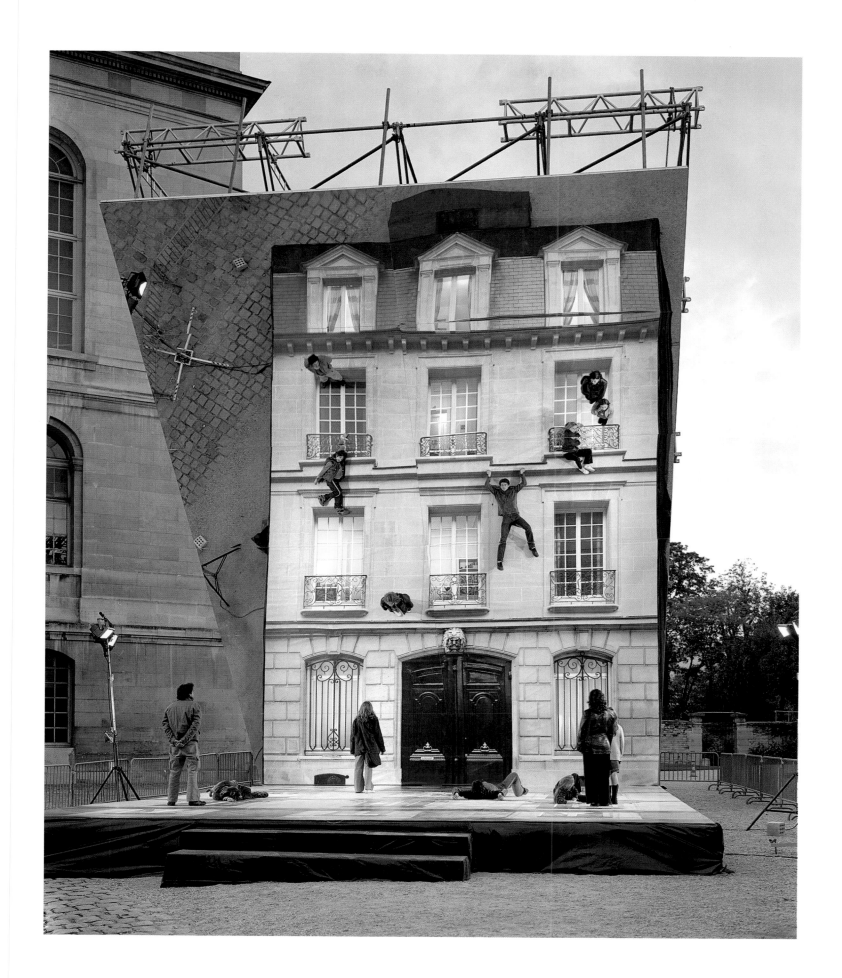

Jean-François Fourtou

— PROFILE P. 126 —

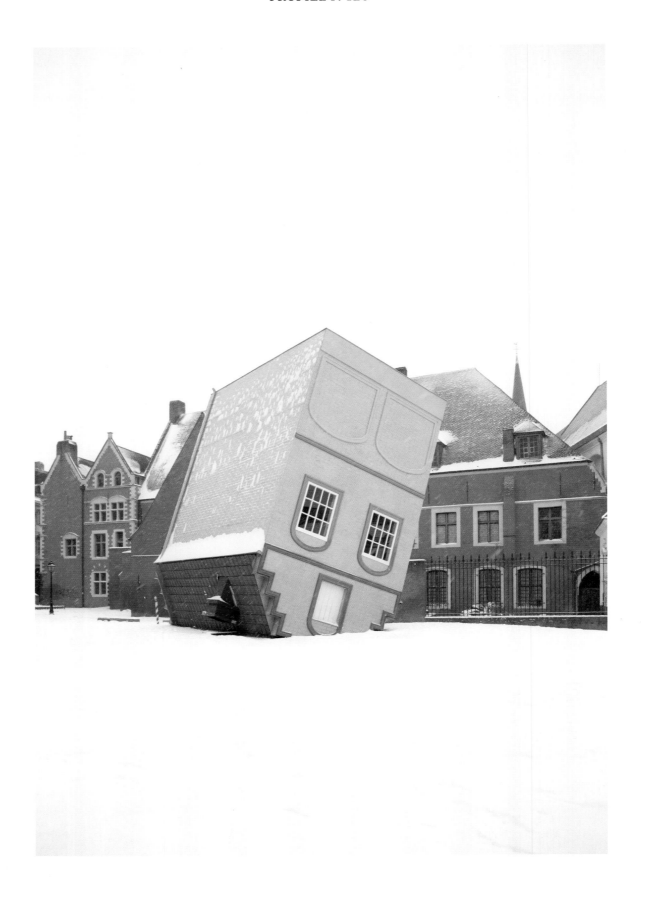

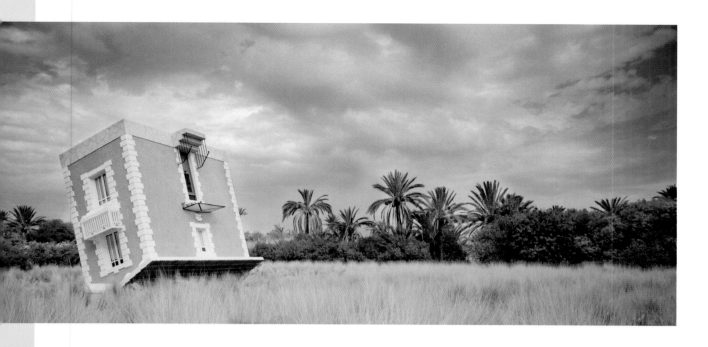

LEFT
Tombée du ciel
(*Fallen from the Sky*)
2010
Mixed media
×
Dimensions variable

OPPOSITE
Fantastic
2011
Lille, France
Mixed media
×
Dimensions variable

BELOW
Untitled (*Bathroom*)
2010
Mixed media
×
Dimensions variable

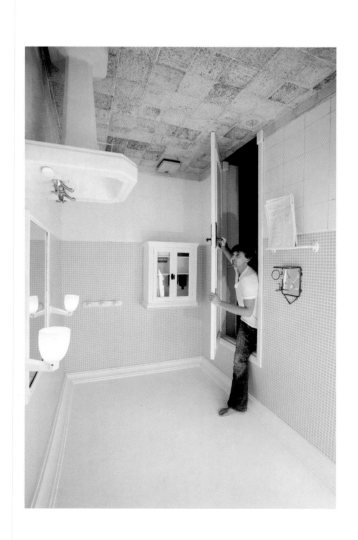

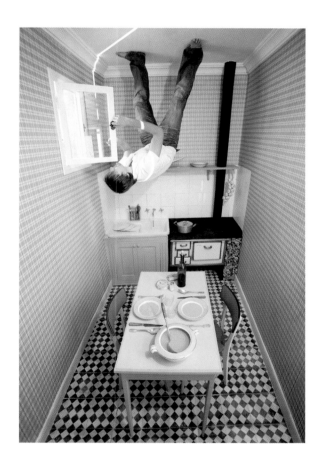

ABOVE
Untitled (*Kitchen*)
2010
Mixed media
×
Dimensions variable

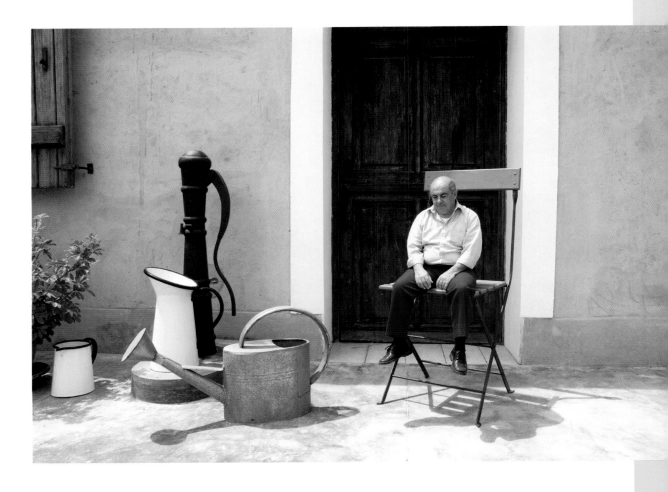

RIGHT
Untitled (JJ on Red Chair)
2007
Mixed media
×
Dimensions variable

BELOW
Untitled (JJ's Feet in Front of Bed)
2007
Mixed media
×
Dimensions variable

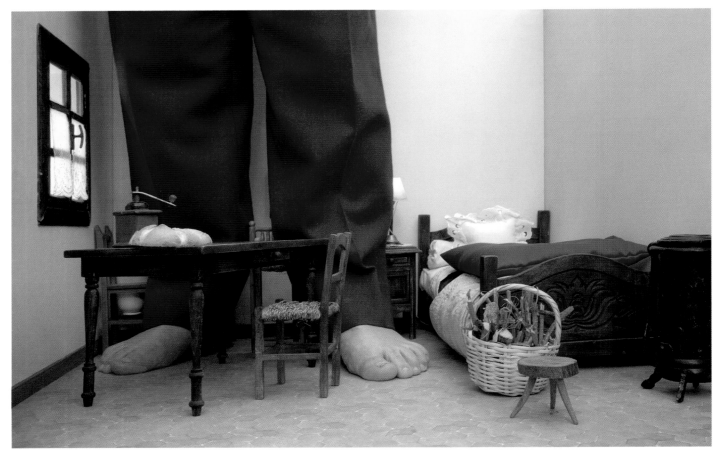

Untitled (JF Seen from Above)
2007
Mixed media
×
Dimensions variable

Katharina Grosse

— PROFILE P. 127 —

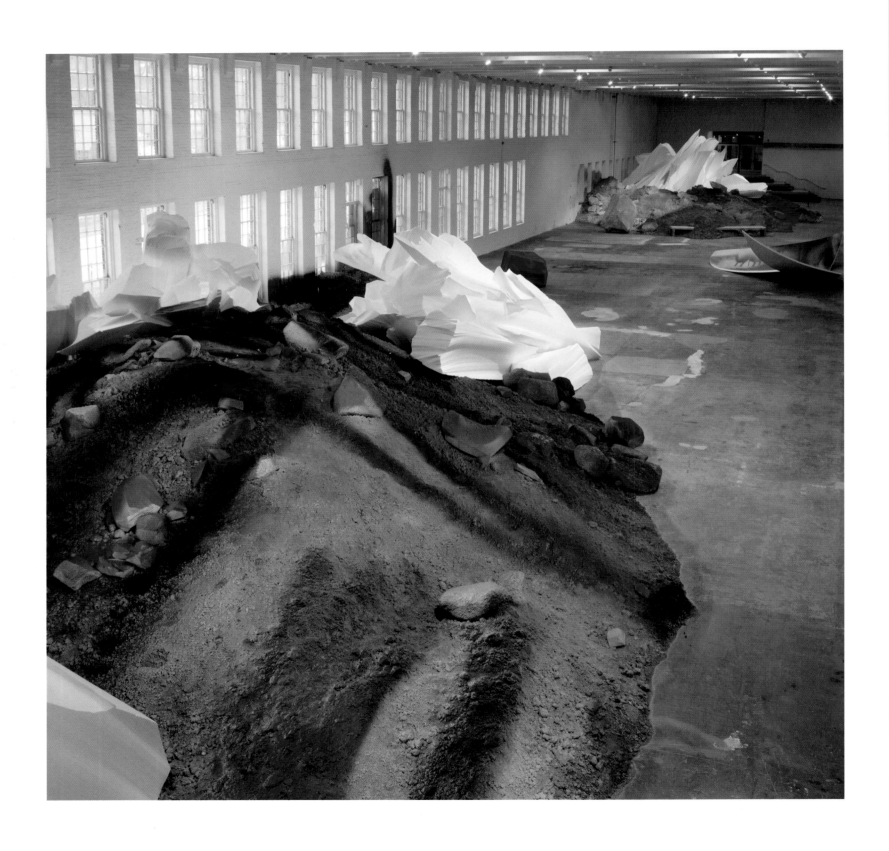

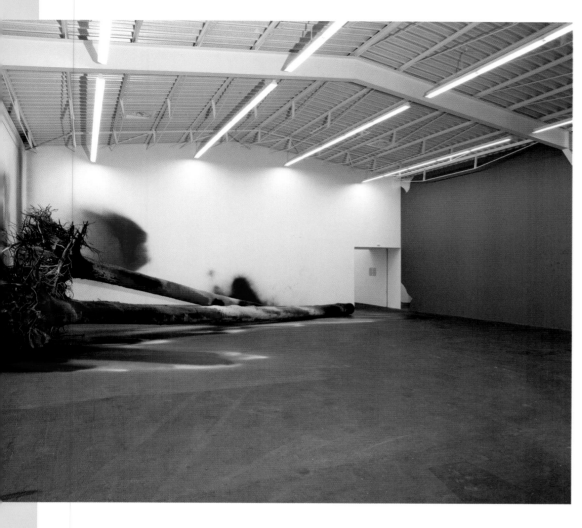

LEFT AND BELOW
I Think This Is a Pine Tree
2013
Hamburger Bahnhof, Staatliche
Museen zu Berlin, Berlin, Germany
Acrylic on wall, floor, tree trunks, roots

×

Dimensions variable

OPPOSITE
One Floor Up More Highly
2010
Massachusetts Museum of Contemporary Art,
North Adams, Massachusetts, USA
Acrylic on wall, floor, clothing,
Styrofoam, glass-fibre-reinforced plastic

×

Dimensions variable

OVERLEAF
*Two Younger Women Come In
and Pull Out a Table*
2013
De Pont Museum voor Hedendaagse Kunst,
Tilburg, Netherlands
Acrylic on wall, latex, PVC balloons

×

Dimensions variable

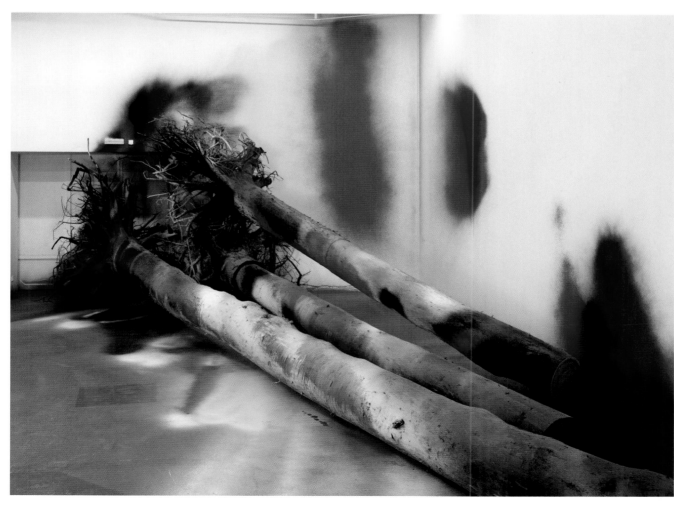

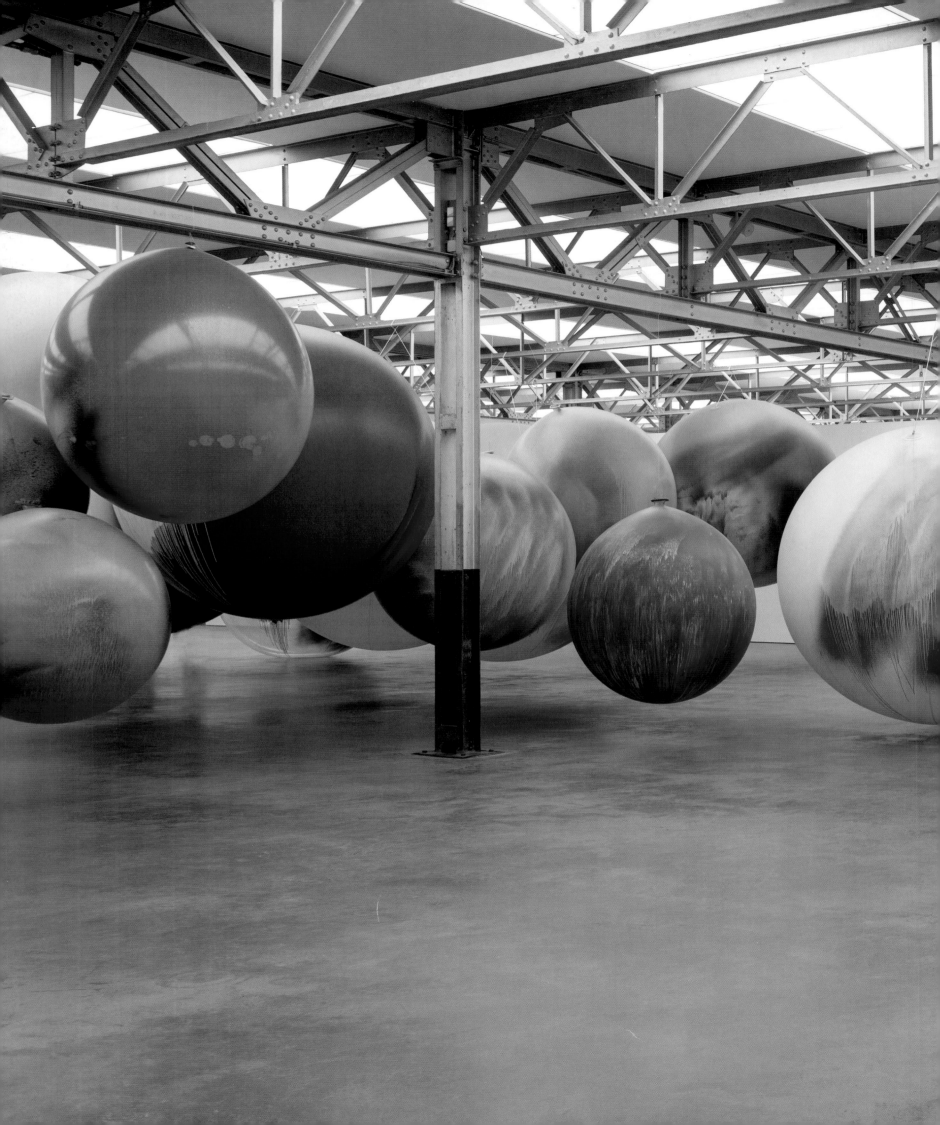

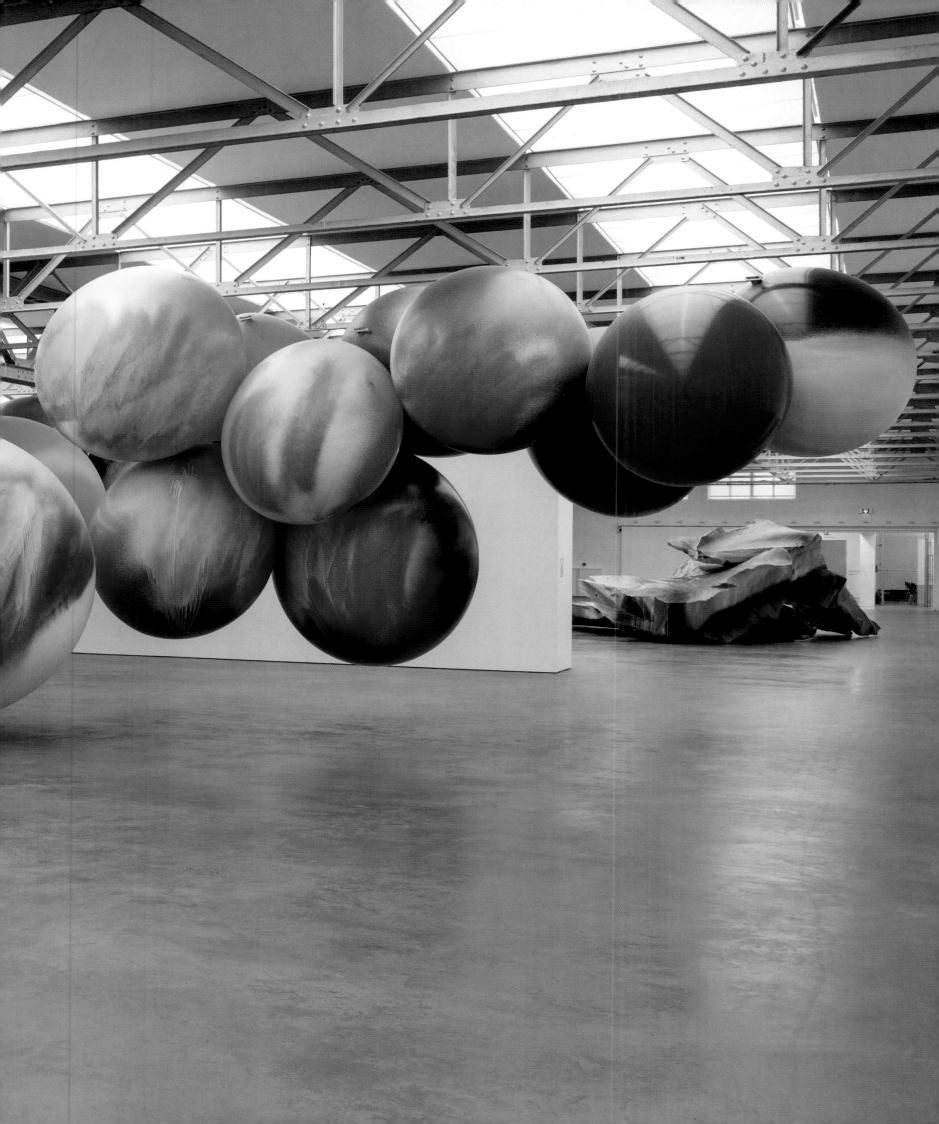

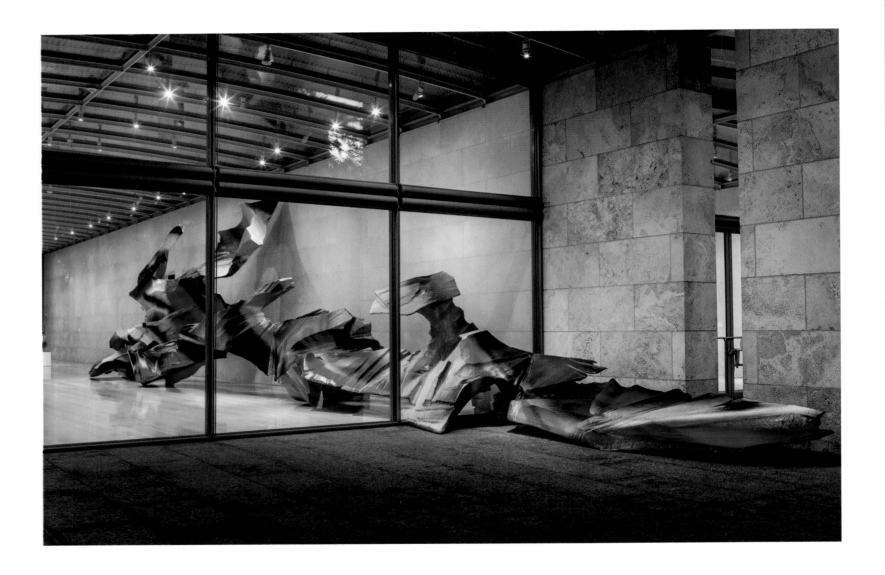

ABOVE *Wunderblock*, 2013.
Nasher Sculpture Center, Dallas, Texas, USA. Acrylic on glass-fibre-reinforced plastic.
Dimensions variable.

OPPOSITE *Pigmentos para plantas y globos* (*Pigments for Plants and Balloons*), 2008.
Artium, Vitoria-Gasteiz, Spain. Acrylic on wall, soil, floor, balloons.
Dimensions variable.

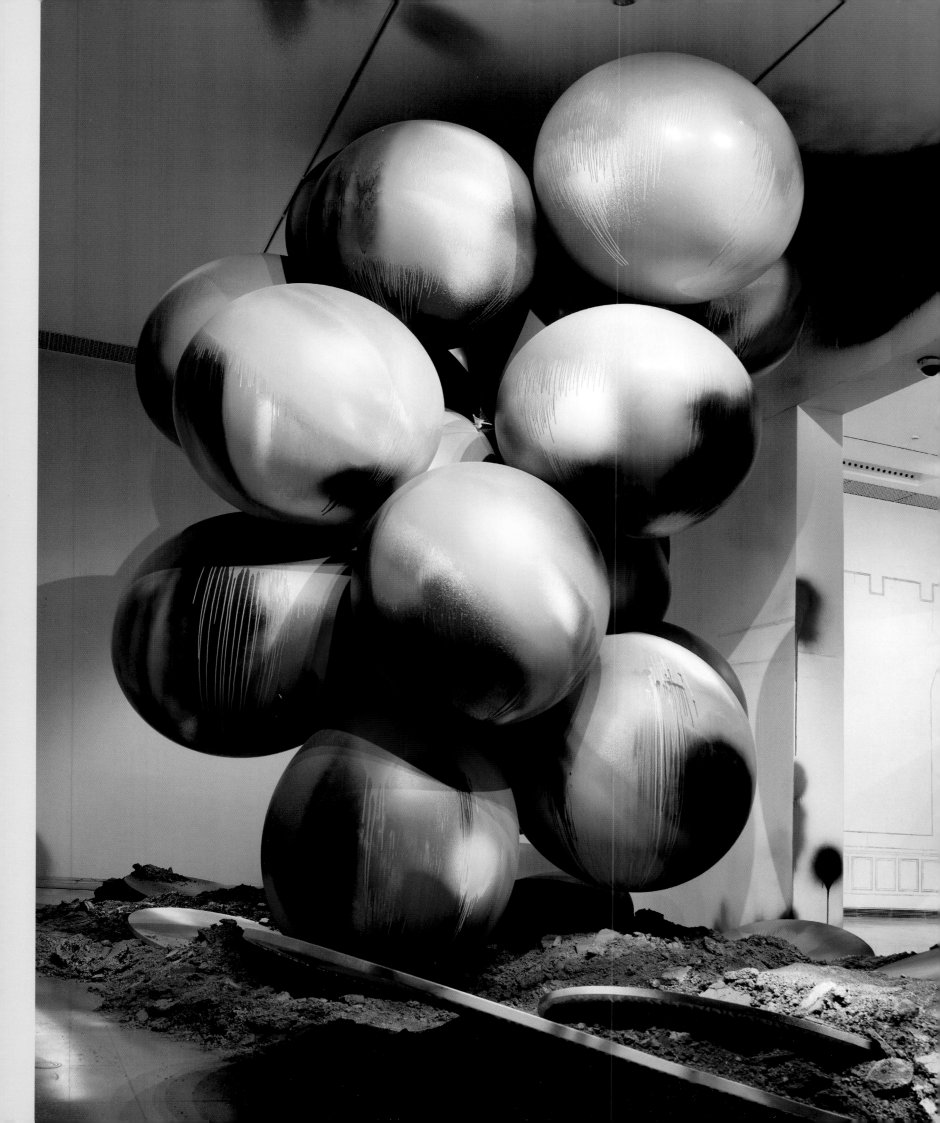

Jason Hackenwerth

— PROFILE P. 128 —

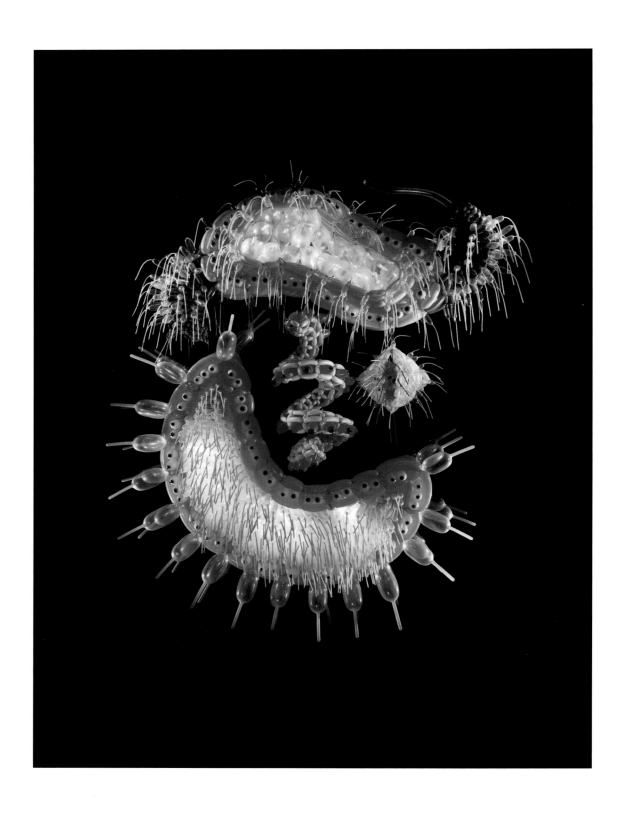

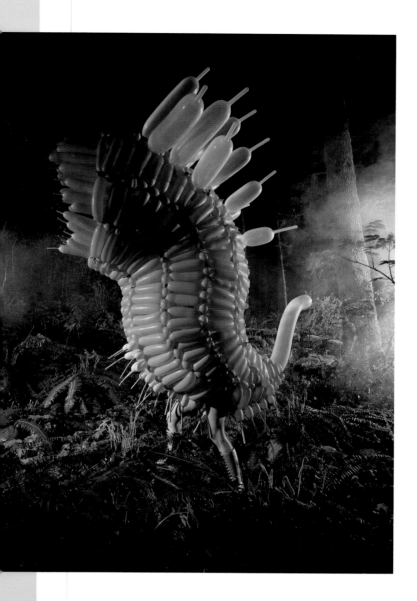

LEFT
Alien Rainforest
2007
Latex balloons
×
Dimensions variable

BELOW
Nucleotide
2010
Latex balloons
×
Dimensions variable

OPPOSITE
Peaches and Cream
2011
Created for *New York Times T Magazine*
Latex balloons
×
4 × 2.75 m (13 × 9 ft)

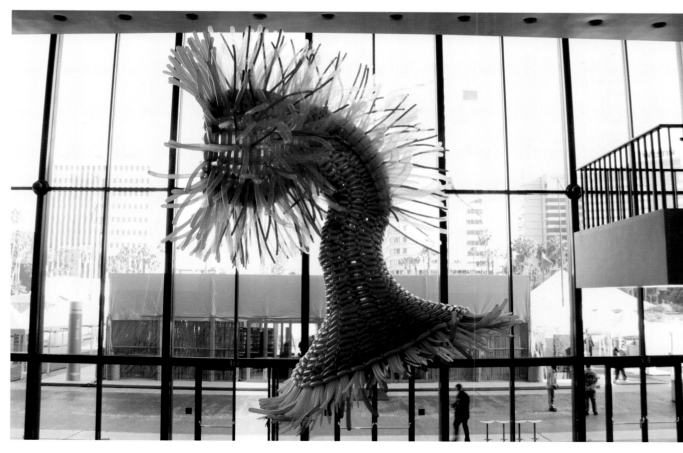

RIGHT AND BELOW
Bang Bang Boom
2011
Latex balloons
×
Dimensions variable

OPPOSITE
Pisces
2013
National Museum of Scotland, Edinburgh
Latex balloons
×
Dimensions variable

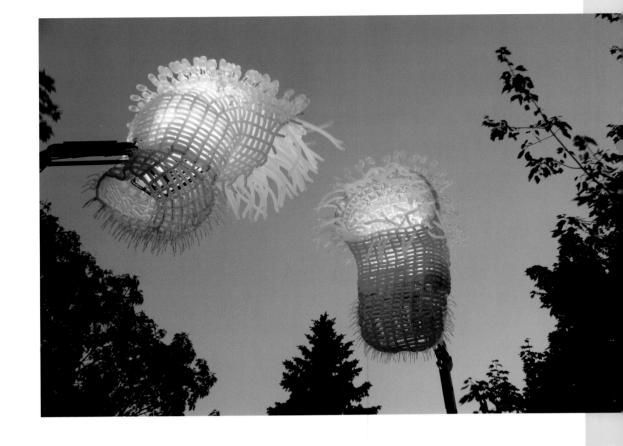

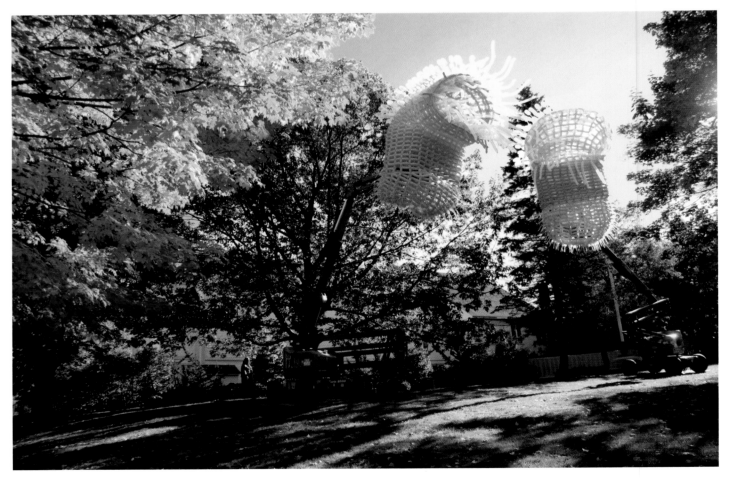

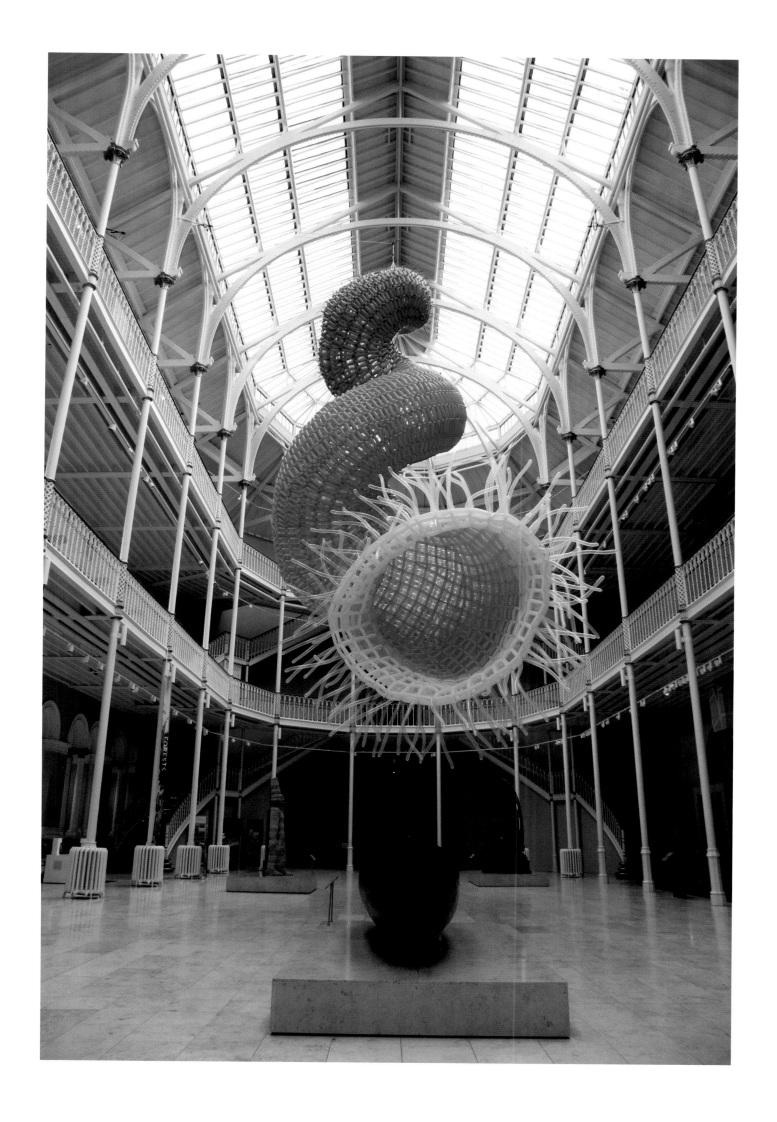

Theo Jansen

— PROFILE P. 129 —

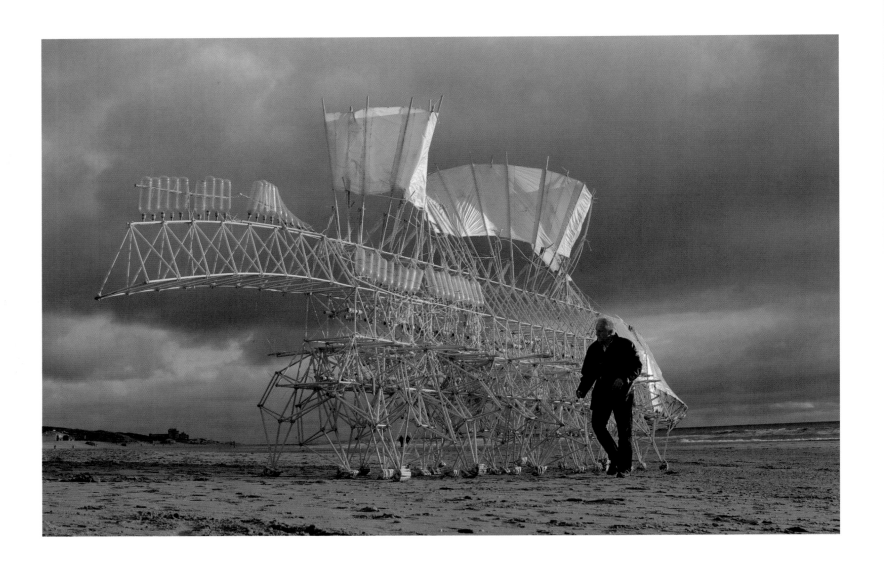

Animaris Umerus
2009
Scheveningen, Netherlands
PVC
×
c. 10 × 2 × 3 m (33 × 6 ½ × 10 ft)

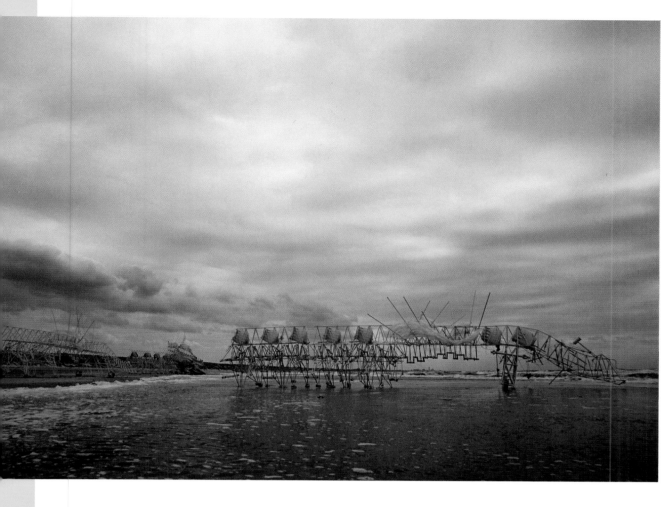

LEFT AND BELOW
Animaris Percipiere Rectus
2005
IJmuiden, Netherlands
PVC
×
c. 10 × 2 × 3 m
(33 × 6 ½ × 10 ft)

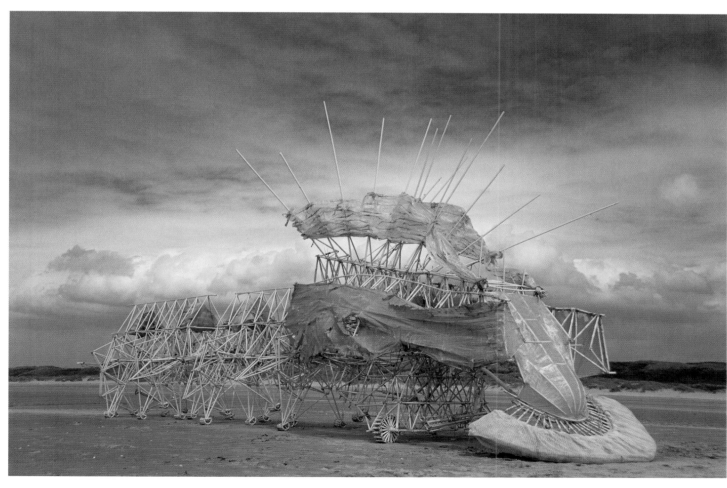

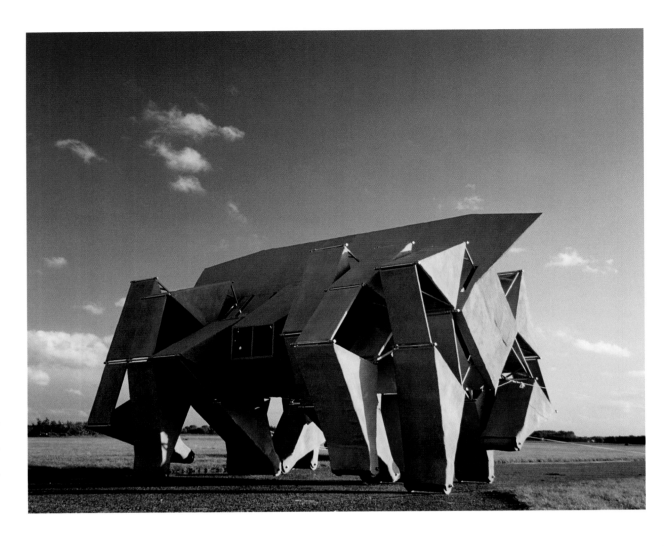

LEFT AND BELOW
Animaris Rhinoceros
2004
Valkenburg Naval Air Base,
Valkenburg, Netherlands
Metal, polyester
×
4.7 m (15 ½ ft) high

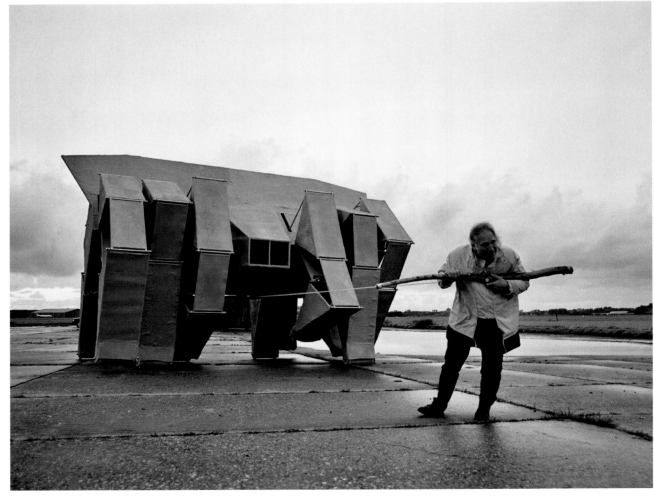

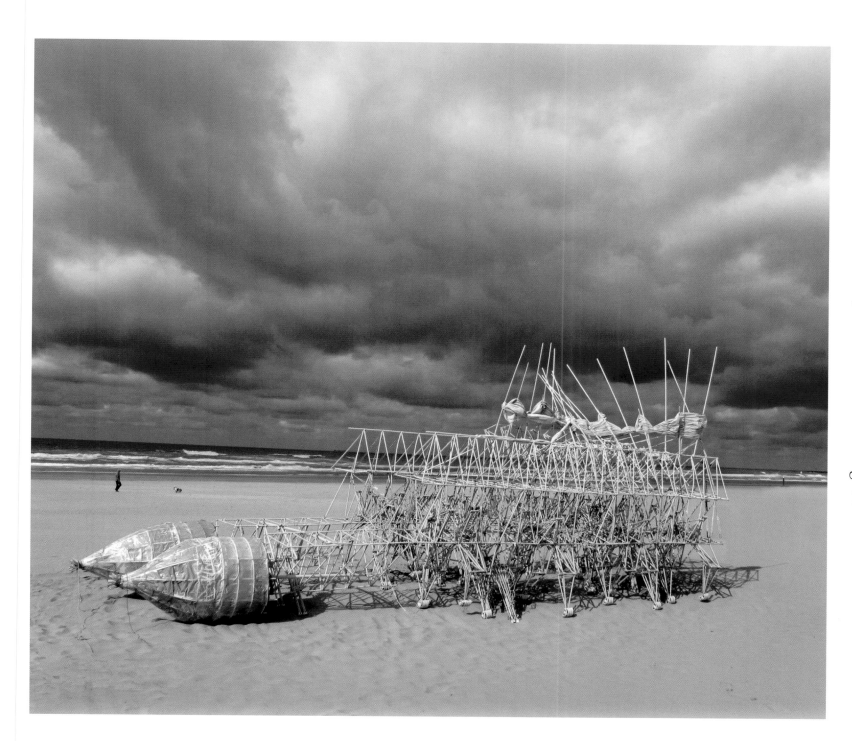

Animaris Gubernare
2011
Stille Strand, Netherlands
PVC
×
c. 10 × 2 × 3 m (33 × 6 ½ × 10 ft)

Choi Jeong-Hwa

— PROFILE P. 129 —

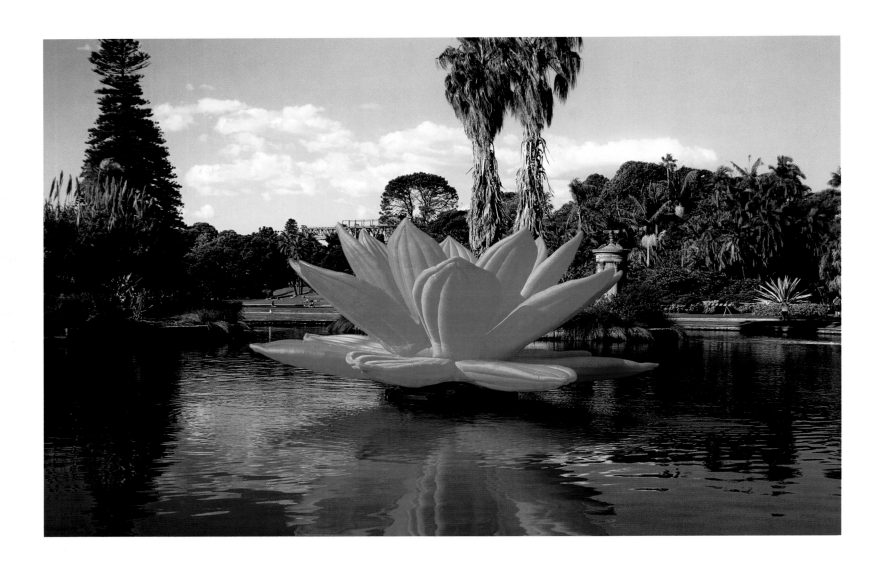

Breathing Flower
2010
Biennale of Sydney, Sydney, Australia
Fabric, air blower

×

12 m (39 ft) diam.

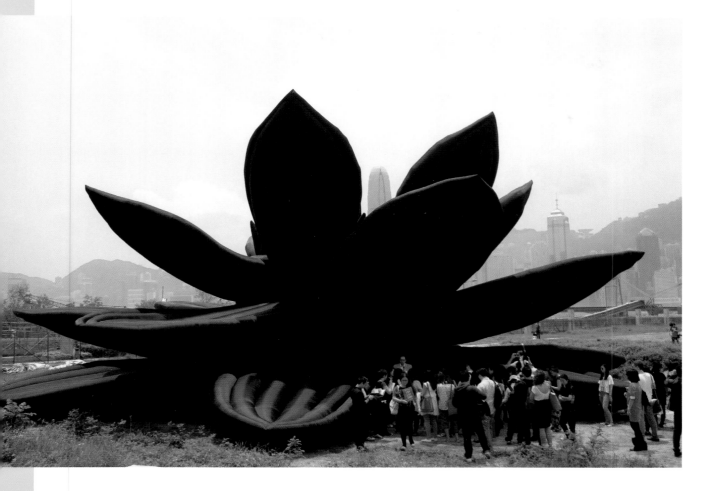

LEFT
Emptiness Is Form,
Form Is Emptiness
2013
M+ Museum, Hong Kong
Fabric, air blower
×
25 m (82 ft) diam.

BELOW
Golden Lotus
2012
Kiev, Ukraine
Fabric, air blower
×
10 m (33 ft) high

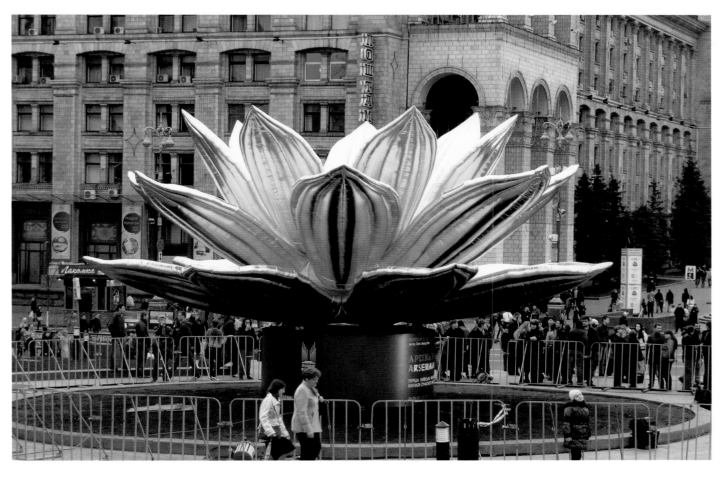

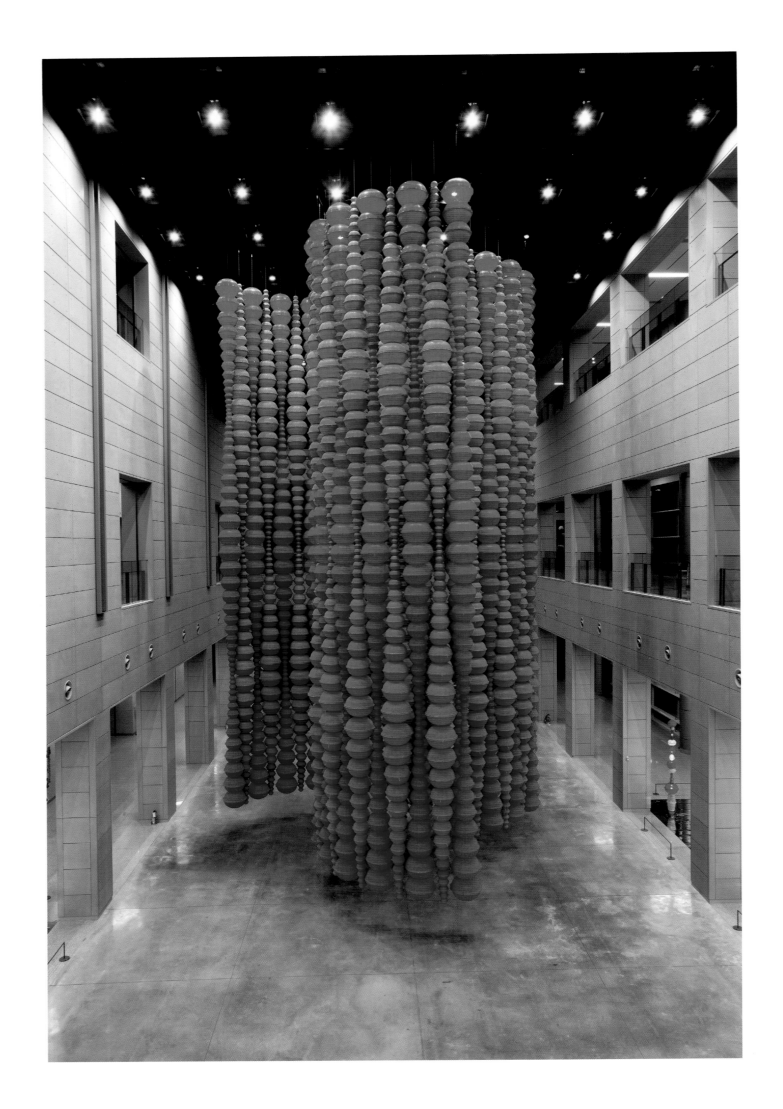

RIGHT
1,000 Doors
2009
Seoul, South Korea
Abandoned doors, steel scaffolding
×
25.5 × 30.5 × 8 m (84 × 100 ½ × 27 ft)

BELOW
Flower Horse
2008
Towada, Japan
FRP/steel frame
×
5.5 m (18 ft) high

OPPOSITE
Kabbala
2013
Daegu Art Museum, Daegu, South Korea
Plastic baskets
×
18 m (59 ft) high, 10 m (33 ft) diam.

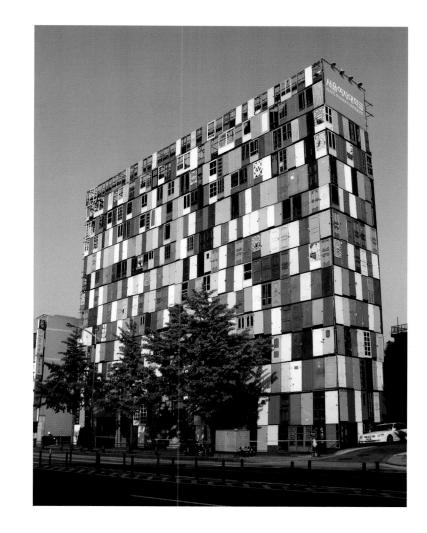

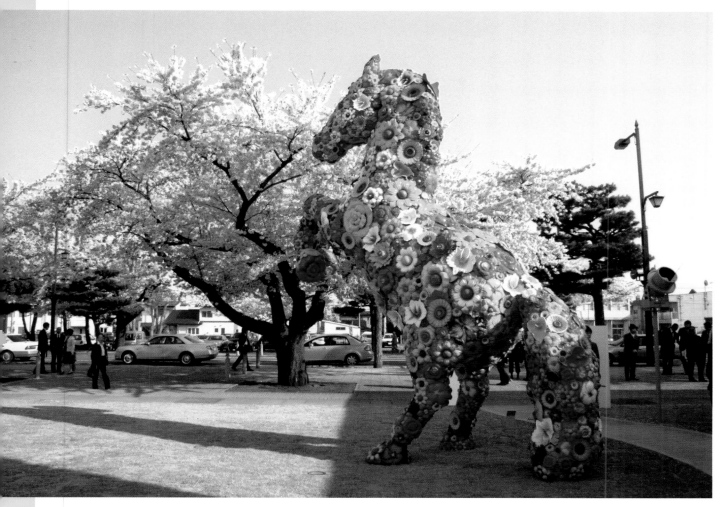

José Lerma

— PROFILE P. 130 —

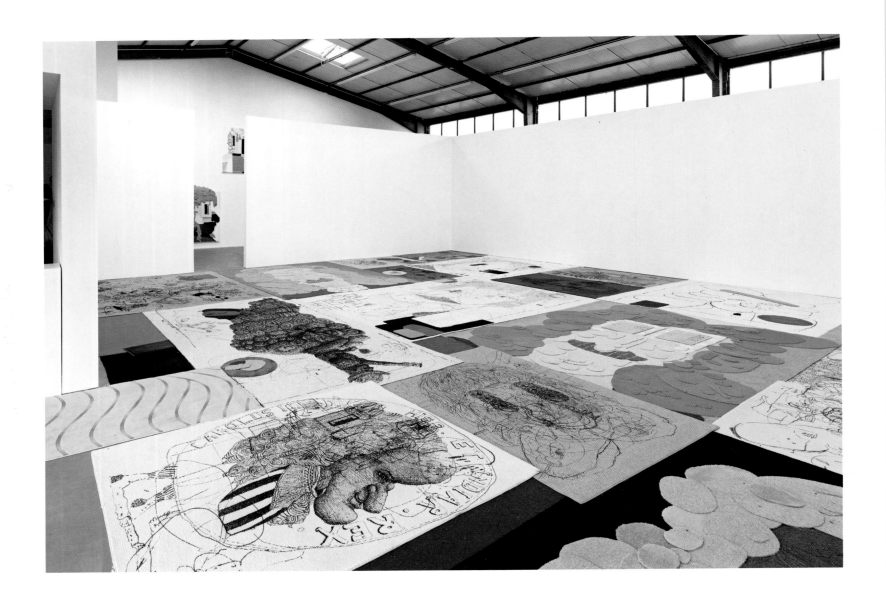

'El Pendejo'
2009
Loock Galerie, Berlin, Germany
Collage and ink on carpet

×

Dimensions variable

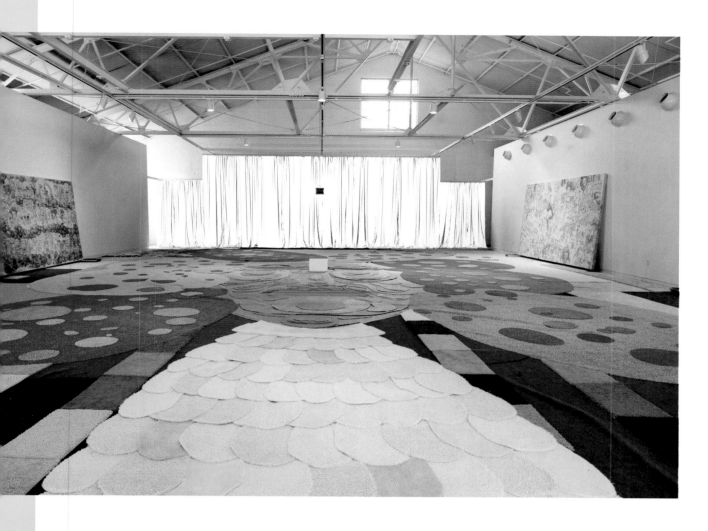

LEFT AND BELOW
'The Credentialist'
2012
CAM Raleigh, Raleigh,
North Carolina, USA
Mixed media
×
Dimensions variable

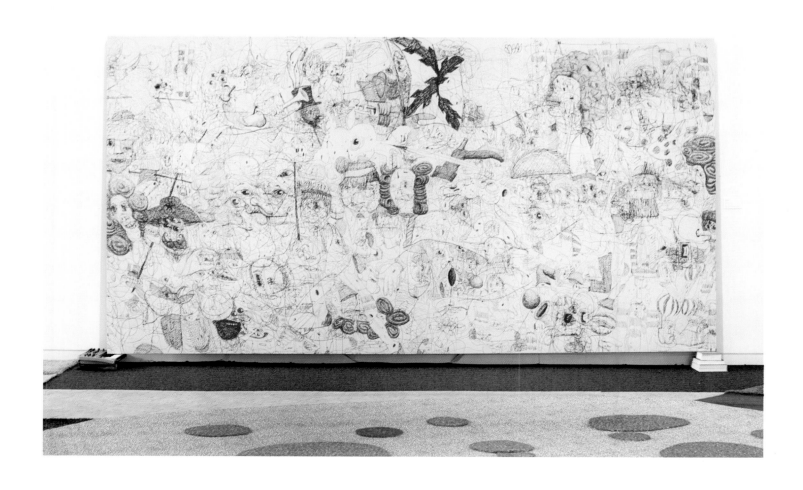

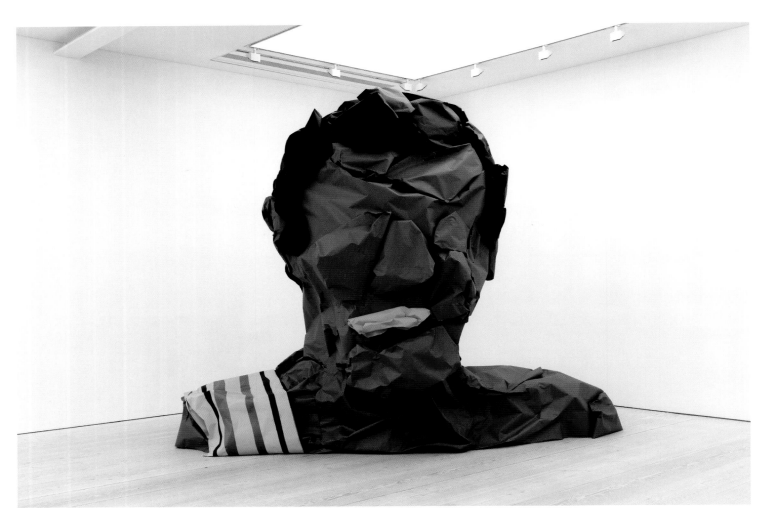

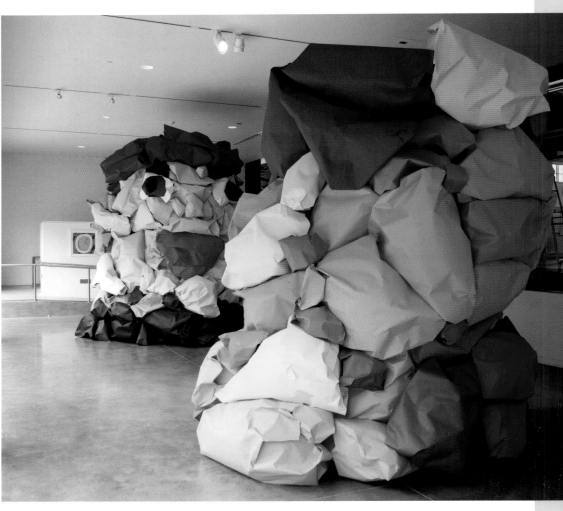

ABOVE

Bust of Emanuel Augustus
Collaboration with Héctor Madera
2012
Saatchi Gallery, London, UK
Paper

×

Dimensions variable

RIGHT AND OPPOSITE

The Countess and the Godmother
Collaboration with Héctor Madera
2012
Museum of Contemporary Art, Chicago, Illinois, USA
Paper

×

Dimensions variable

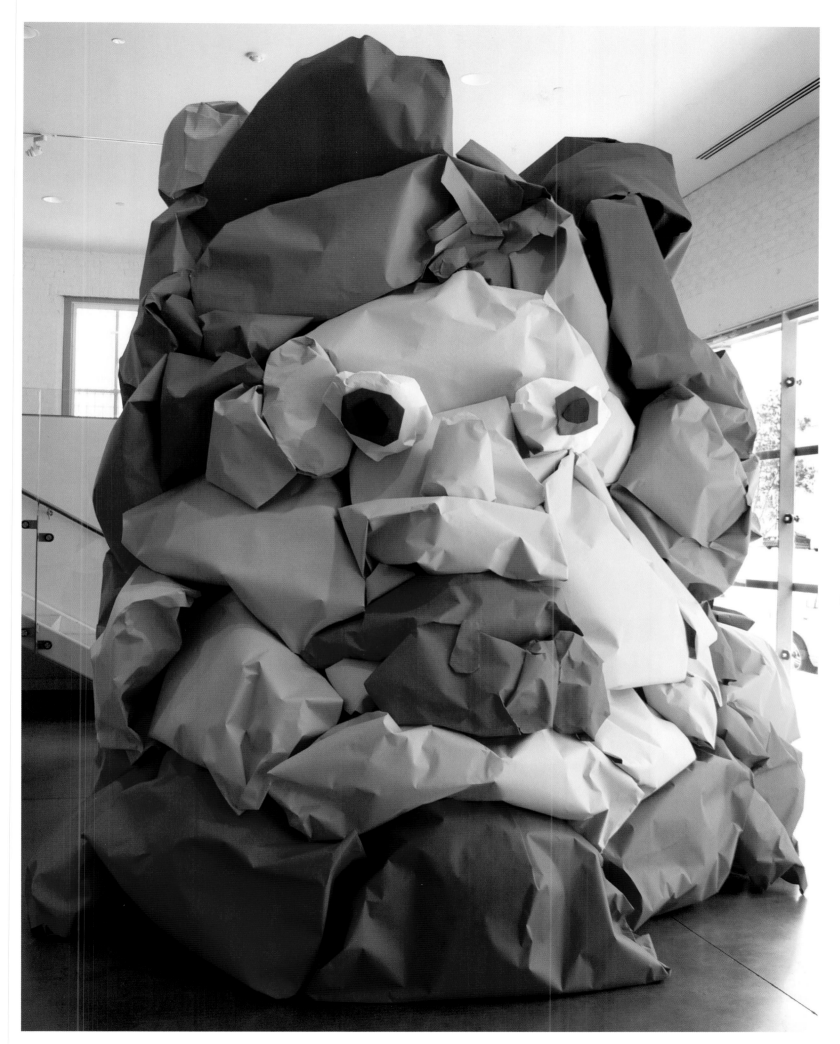

Fujiko Nakaya

— PROFILE P. 131 —

Tales of Ugetsu, Fogfalls #47670, 2008. Yokohama Triennale, Yokohama, Japan.
Water fog, 276 nozzles, 2 pumps, anemometer, control program.
Dimensions variable.

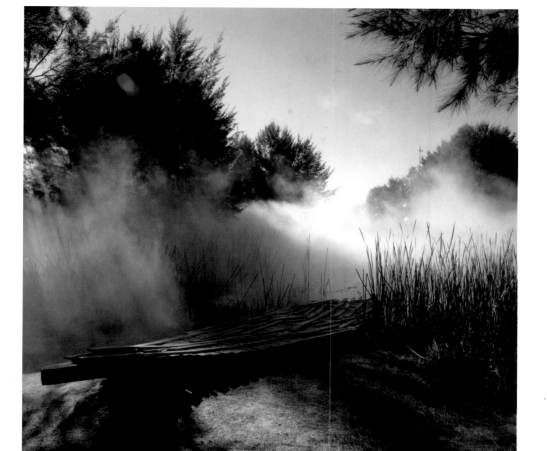

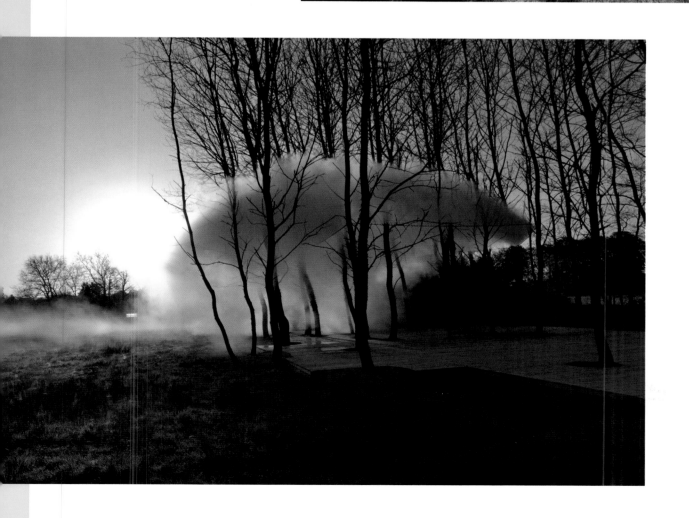

RIGHT
Foggy Wake in a Desert: An Ecosphere
Fog Sculpture #94925
1983
National Gallery of Australia, Canberra, Australia
Water fog, 900 nozzles, 1 pump, timer

×

Dimensions variable

BELOW
Standing Cloud
2013
Goualoup, Chaumont-sur-Loire, France
Water fog, 400 nozzles, 2 pumps, 1 timer

×

Dimensions variable

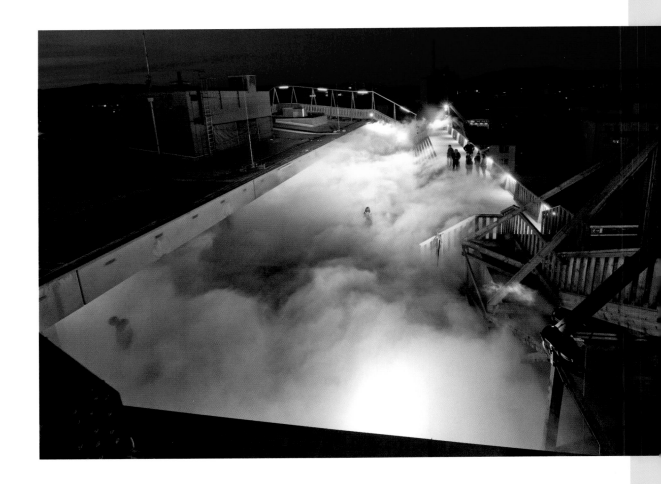

RIGHT
Cloud Parking in Linz
Cloud Installation #11060
2011
OK Offenes Kulturhaus, Linz, Austria
Water fog, 584 nozzles, 2 pumps, 6 valves, 1 DMX
×
Dimensions variable

BELOW
Freedom Fog – Place de la République
2013
'Nuit Blanche', Paris, France
Water fog, 2,000 nozzles, 6 pumps, timer
×
Dimensions variable

OPPOSITE
Fog Bridge
Fog Sculpture #72494
2013
Exploratorium, San Francisco, California, USA
Water fog, 832 nozzles, 6 pumps,
anemometer, Max program
×
50 m (164 ft) long

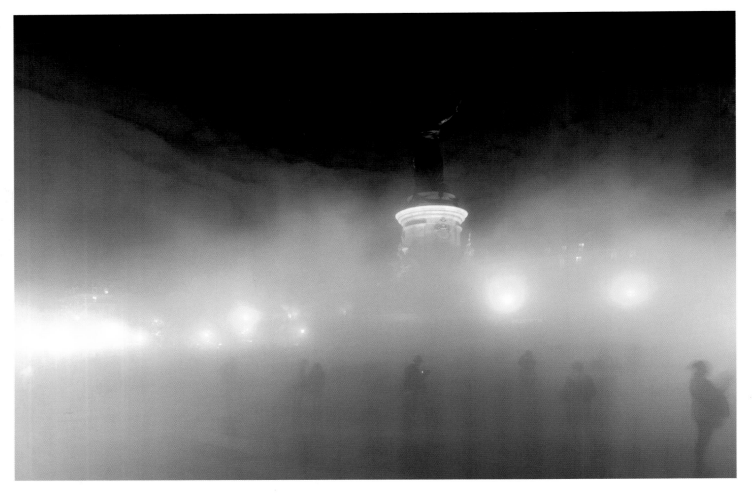

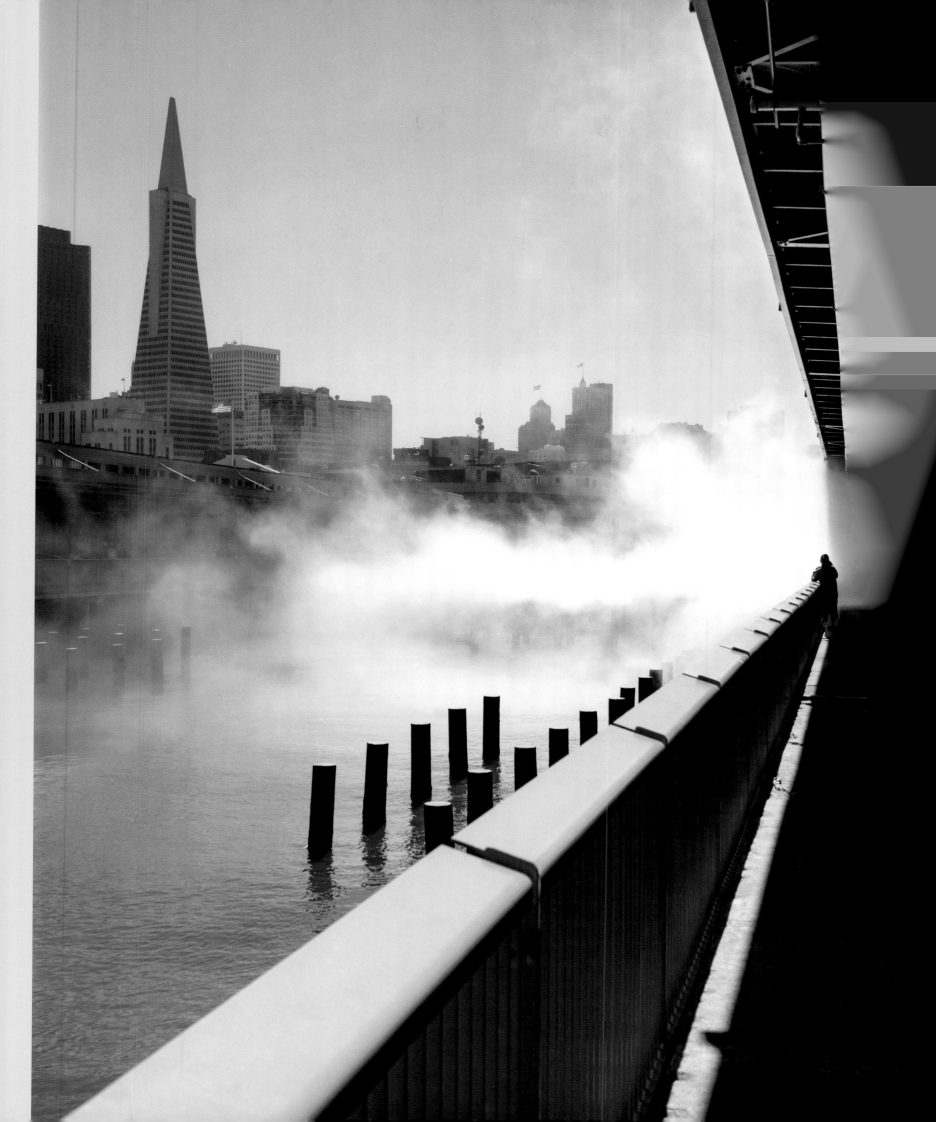

Penique Productions

— PROFILE P. 132 —

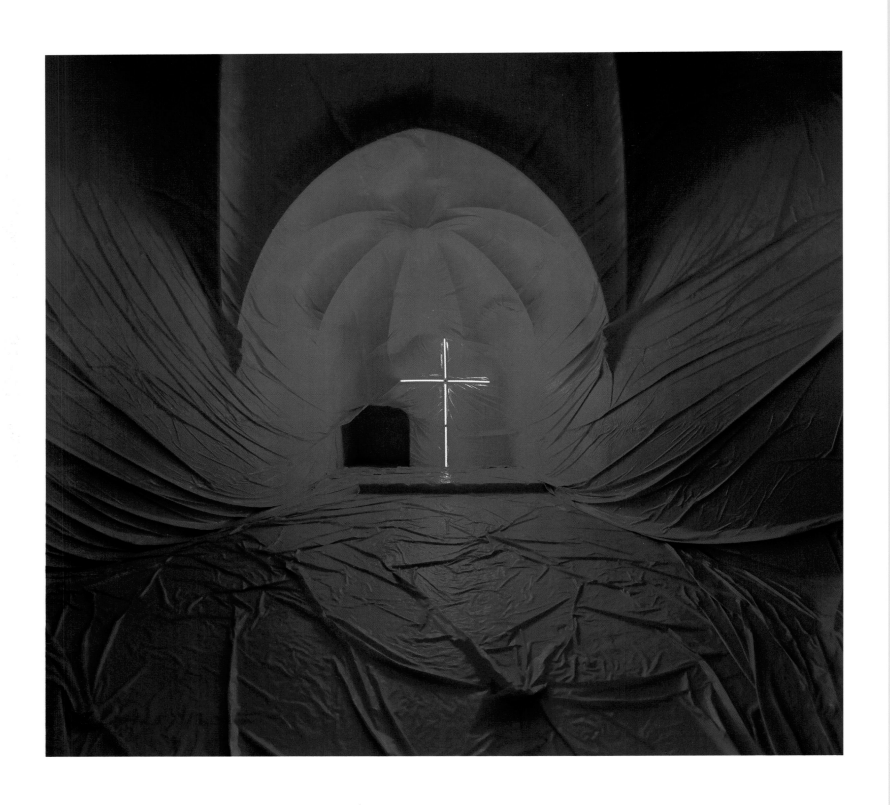

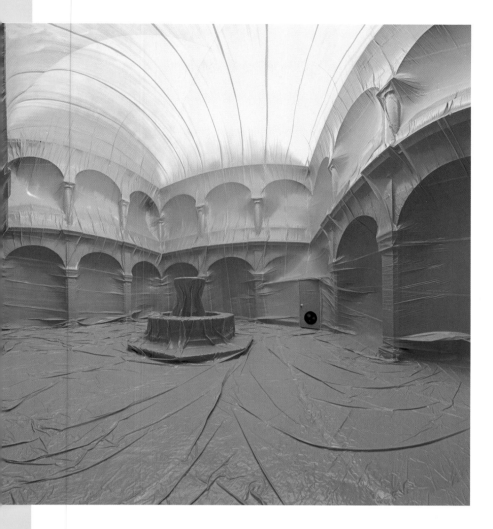

LEFT
El claustro (*The Cloister*)
2011
Querétaro, Mexico
Inflatable plastic
×
10 × 10 × 11 m
(33 × 33 × 36 ft)

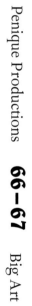

RIGHT
Bathroom
2009
Nottingham Trent University, Nottingham, UK
Inflatable plastic
×
2.5 × 2.5 × 2.5 m (8 × 8 × 8 ft)

OPPOSITE
La capella (*The Chapel*)
2009
Piera, Spain
Inflatable plastic, neon crucifix
×
5.5 × 6 × 15 m (18 × 20 × 49 ft)

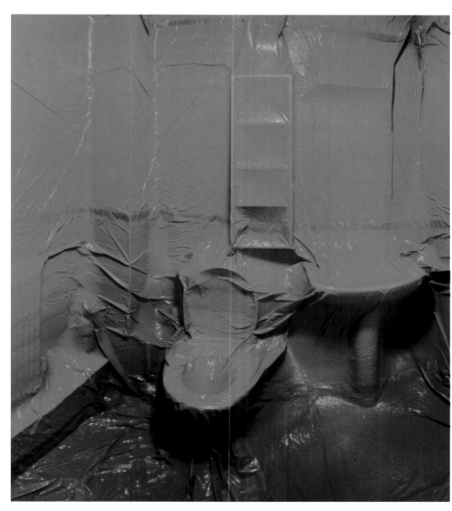

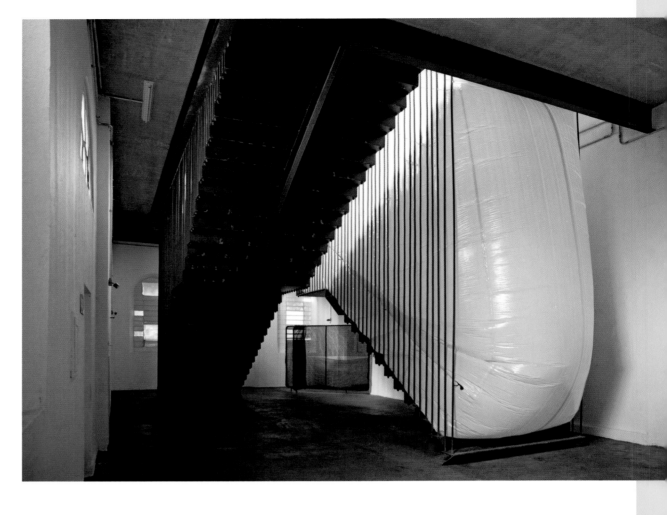

RIGHT AND BELOW

enNOVA

2012

Three installations at São Paulo, Brazil;
Belo Horizonte, Brazil; Barcelona, Spain

Inflatable plastic

×

Dimensions variable

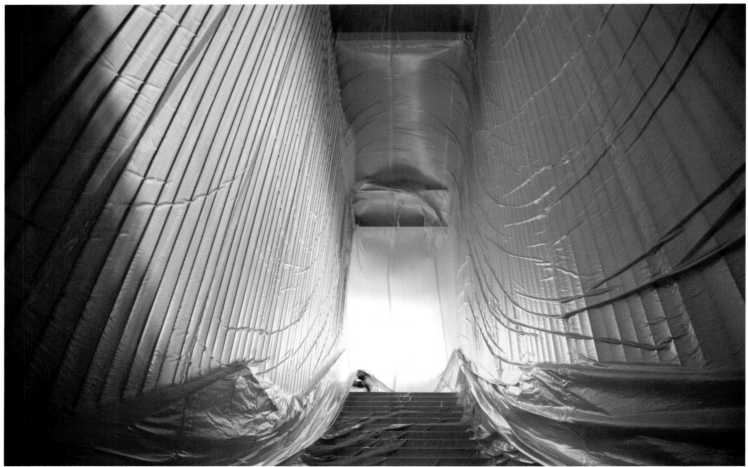

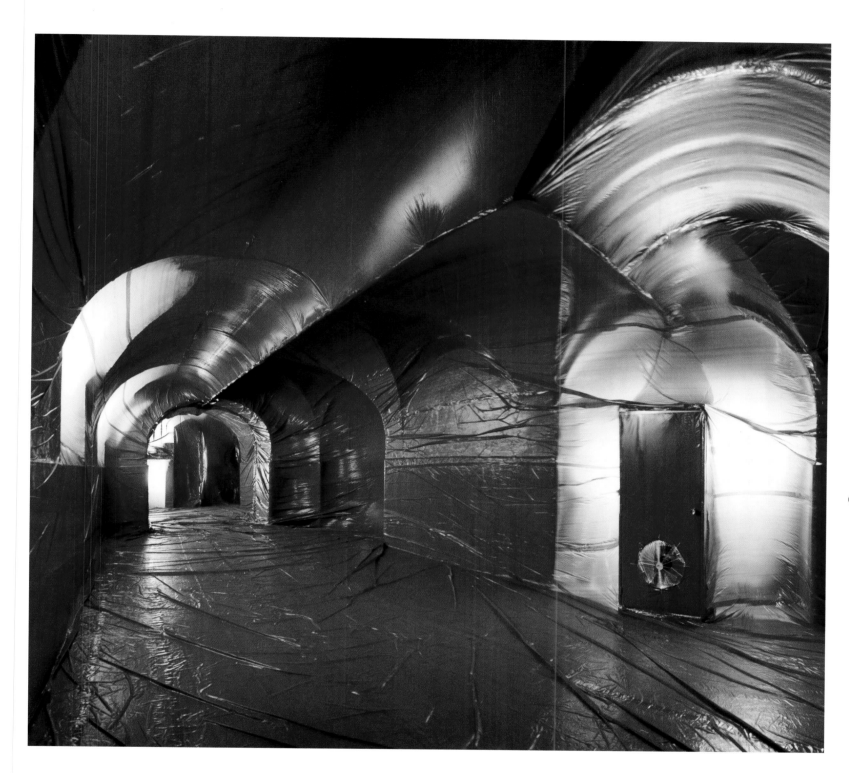

El sótano de la Tabacalera
(*The Basement of the Tabacalera*)
Madrid, Spain
2011
Inflatable plastic

×

13 × 15 × 7 m (43 × 49 × 23 ft)

Kurt Perschke

— PROFILE P. 133 —

ABOVE *RedBall Abu Dhabi*, 2011. Al Jahili Fort, Al Ain, Abu Dhabi, UAE. Plastic ball.

OPPOSITE *RedBall Perth*, 2012. Fremantle Town Hall, Fremantle, Australia. Plastic ball.

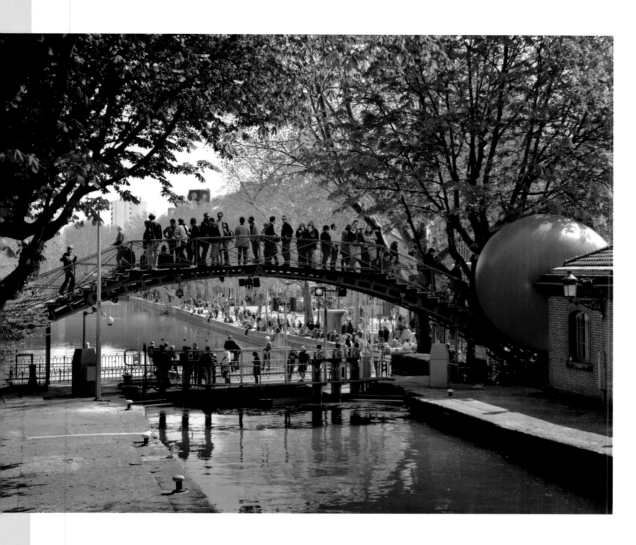

LEFT
RedBall Paris
2013
Plastic ball

BELOW
RedBall UK
2012
Golden Jubilee Bridge, London, UK
Plastic ball

OPPOSITE
RedBall Scottsdale
2007
Arabian Library, Scottsdale, Arizona, USA
Plastic ball

Jaume Plensa

— PROFILE P. 135 —

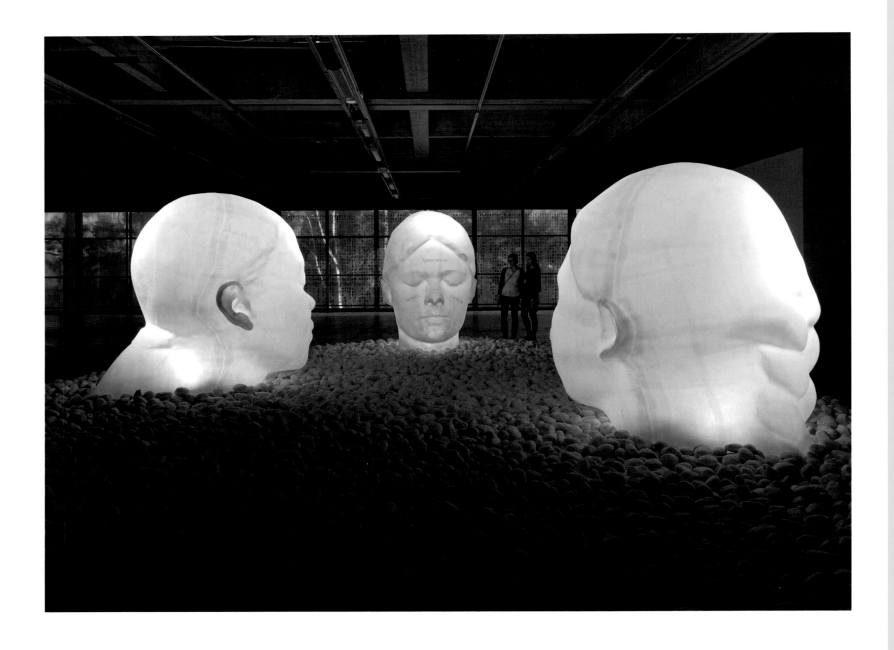

ABOVE *In the Midst of Dreams*, 2012.
EMMA – Espoo Museum of Modern Art, Helsinki, Finland.
Polyester resin, fibreglass, stainless steel, marble pebbles, light.
Dimensions variable.

OPPOSITE *Body of Knowledge*, 2010.
Goethe University, Frankfurt am Main, Germany. Painted stainless steel.
800 × 526 × 526 cm (315 × 207 × 207 in.).

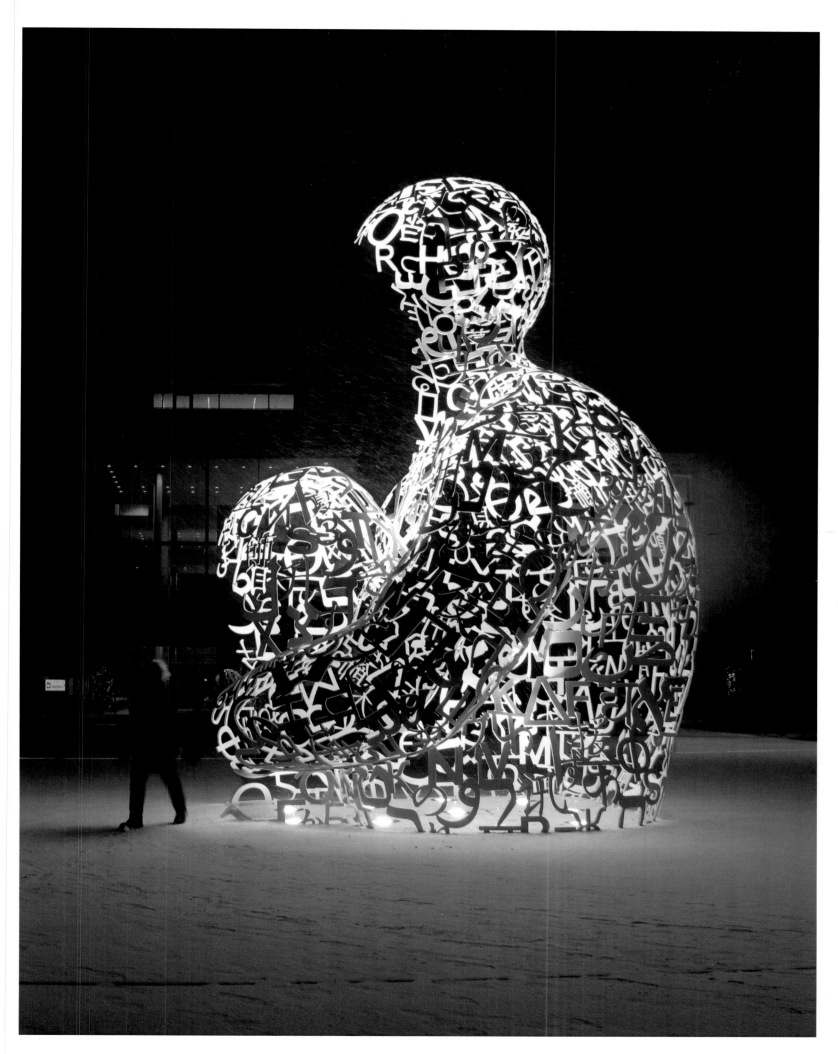

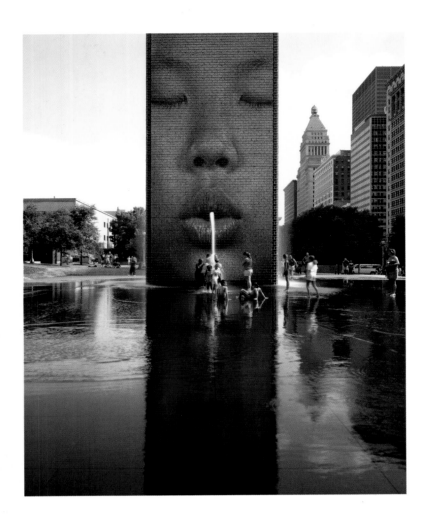

THIS PAGE AND OPPOSITE

Crown Fountain

2004

Millennium Park, Chicago, USA

Glass, stainless steel, LED screens, light, wood, black granite, water

×

Two towers, each 16 m (52 ½ ft) high

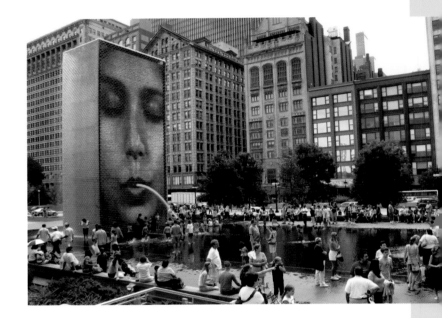

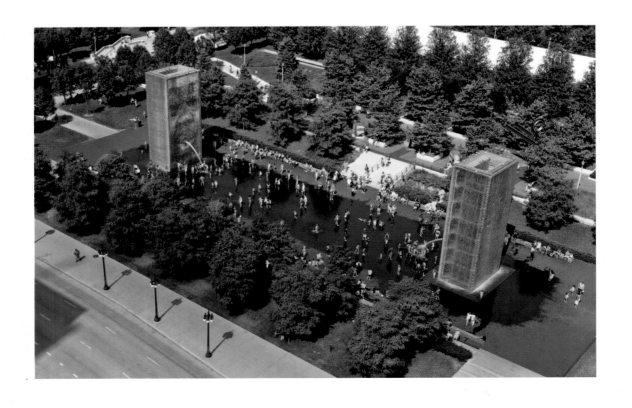

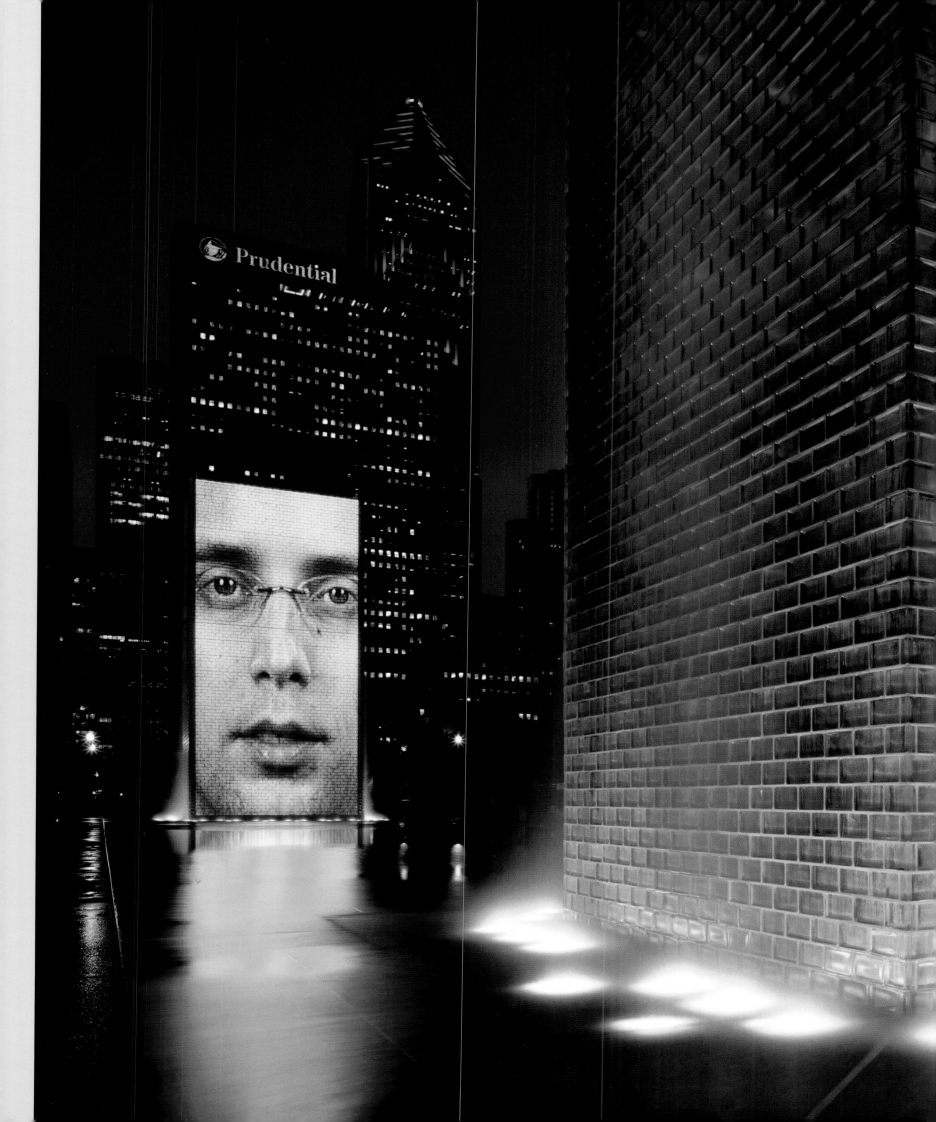

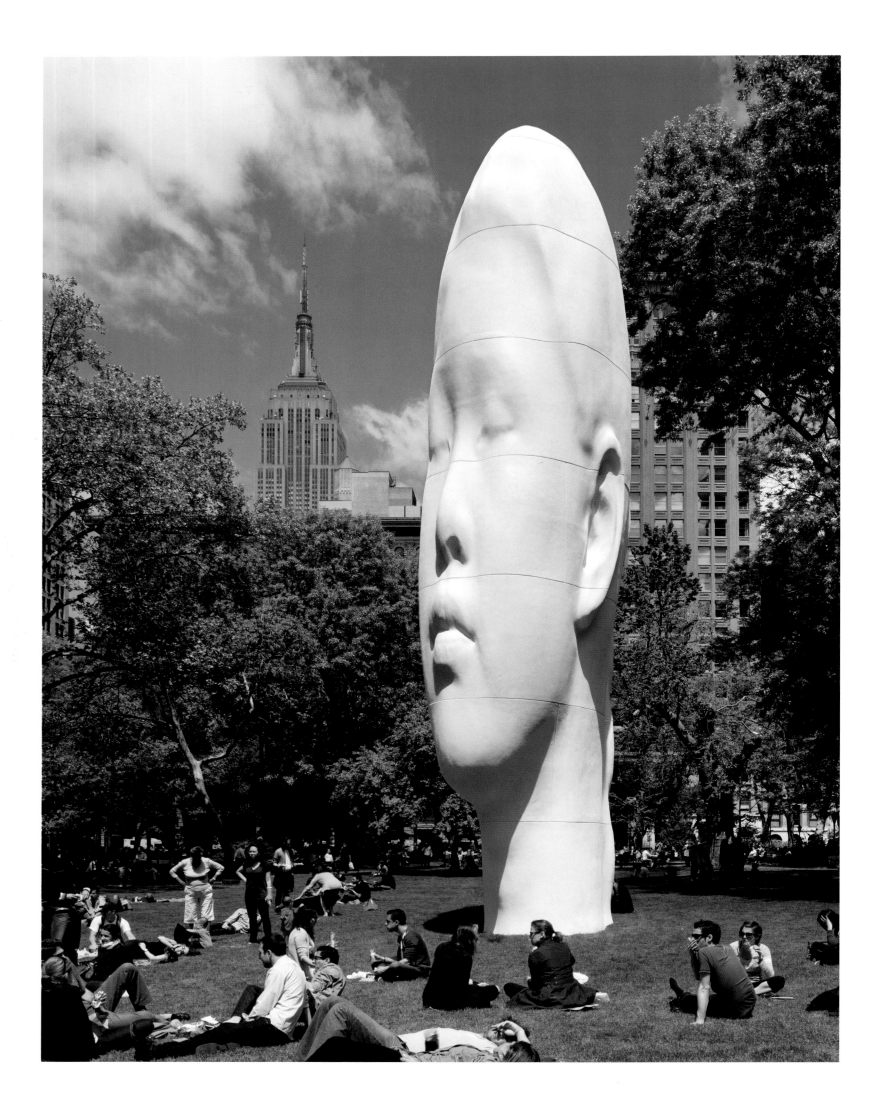

RIGHT
Olhar nos meus sonhos (Awilda)
(Listening to my Dreams, Awilda)
2012
Botafogo Beach, Rio de Janeiro, Brazil
Polyester resin, marble dust
×
12 m (39 ft) high

BELOW
Nuria and *Irma*
2007 and 2011 respectively
Yorkshire Sculpture Park, West Bretton, UK
Stainless steel
×
4 × 4 × 3 m (13 × 13 × 10 ft) each

OPPOSITE
Echo
2011
Madison Square Park, New York, USA
Polyester resin, fibreglass, marble dust
×
14 m (46 ft) high

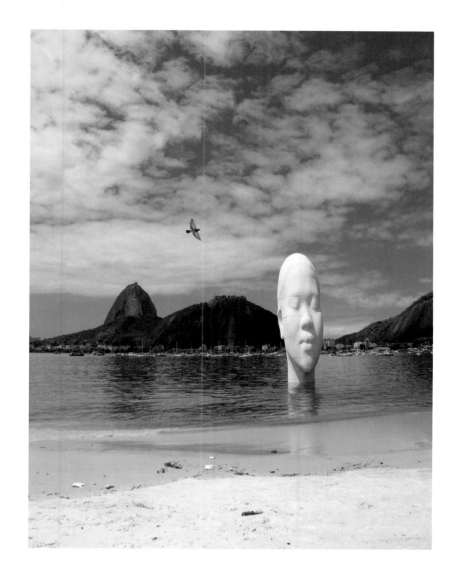

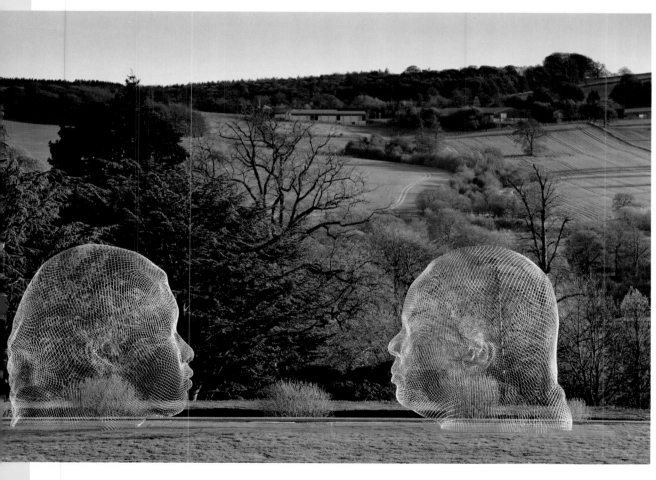

Nikolay Polissky

— PROFILE P. 135 —

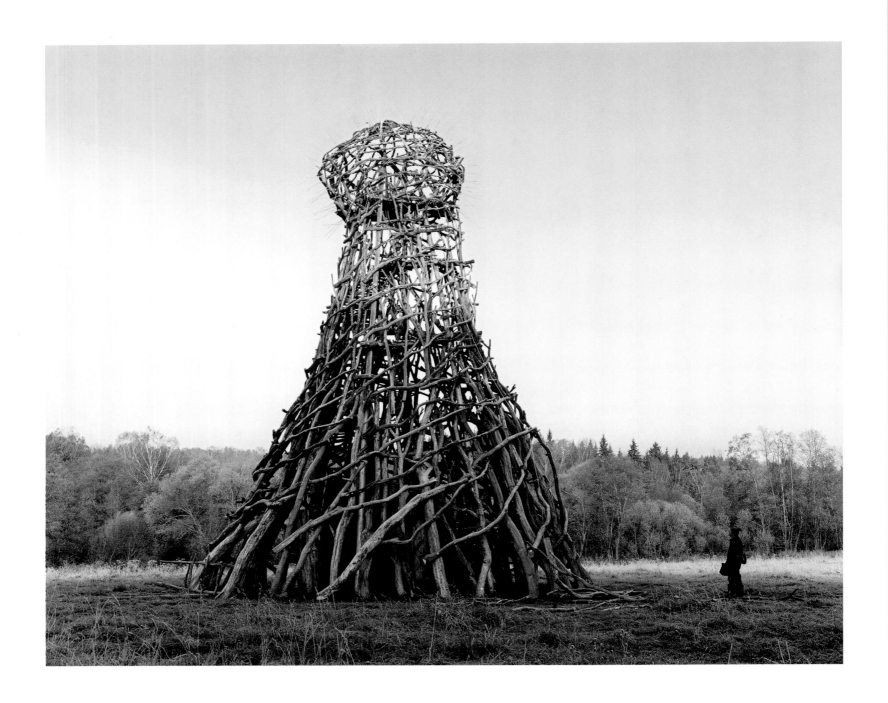

Lighthouse on Ugra
2004
Village of Nikola-Lenivets, Kaluga Region, Russia
Branches
×
16 m (52 ½ ft) high, base diam. 12 m (39 ft)

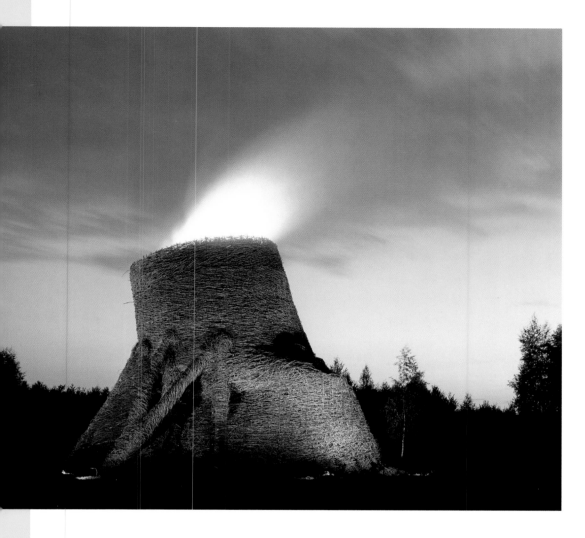

LEFT
Hyperboloid Cooling Tower
2009
Village of Nikola-Lenivets, Kaluga Region, Russia
Rods, branches
×
18 m (59 ft) high, base diam. 16 m (52 ½ ft)

BELOW
Media Tower
2002
Village of Nikola-Lenivets, Kaluga Region, Russia
Branches, bicycle wheels
×
26 m (85 ft) high, base diam. 13 m (43 ft), 6 levels

OVERLEAF
Beaubourg
2013
Village of Nikola-Lenivets, Kaluga Region, Russia
Metal structure, wood
×
22 m (72 ft) high, max. diam. 22 m (72 ft)

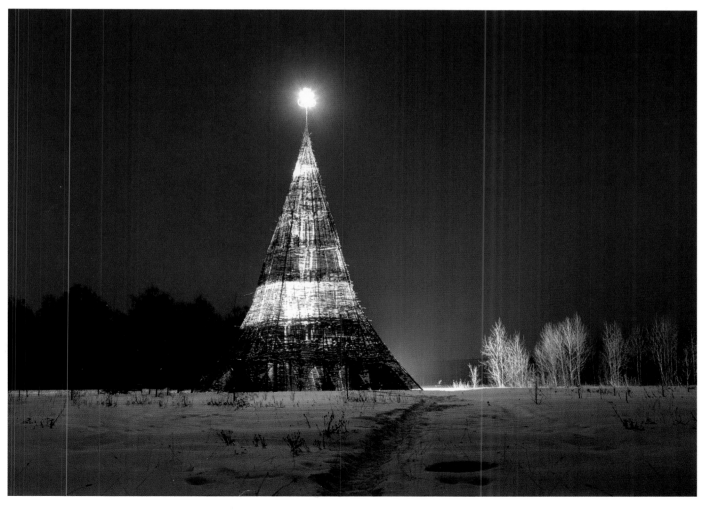

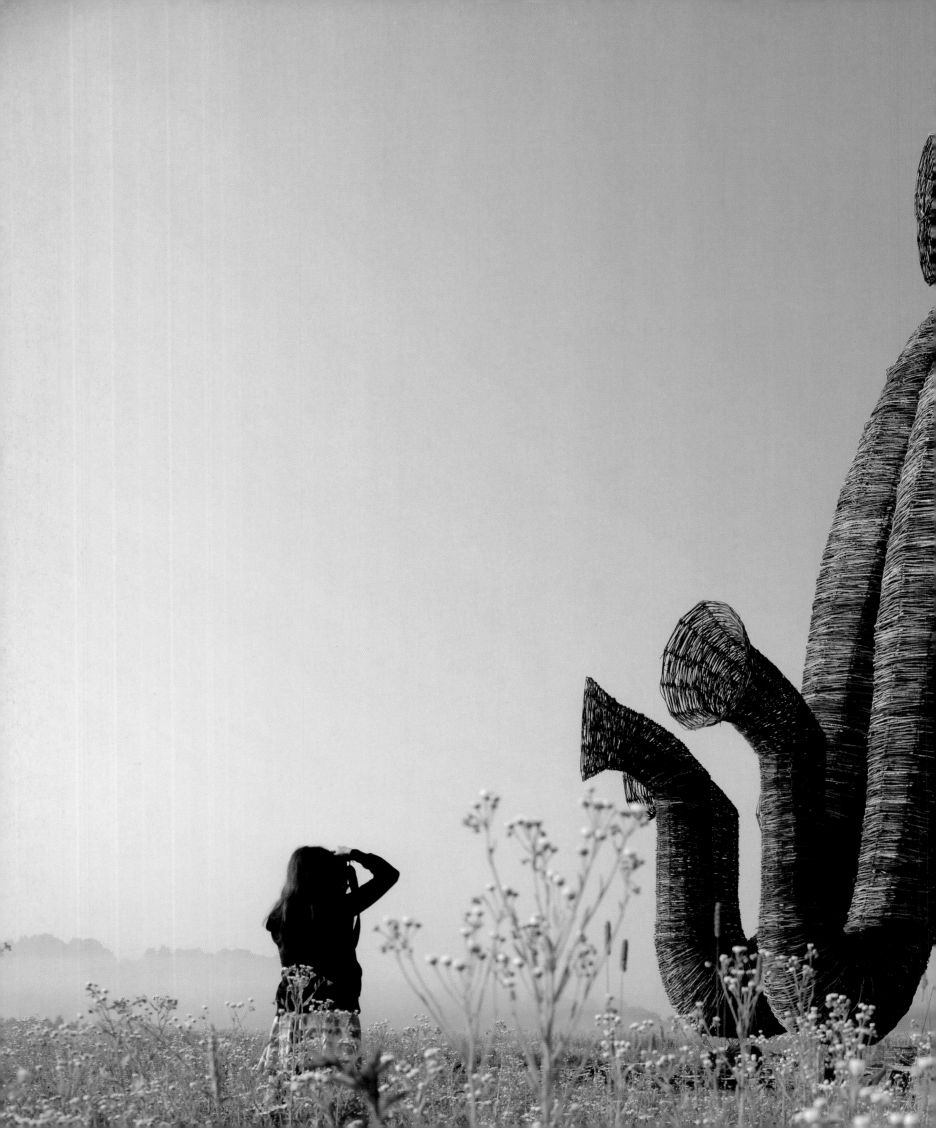

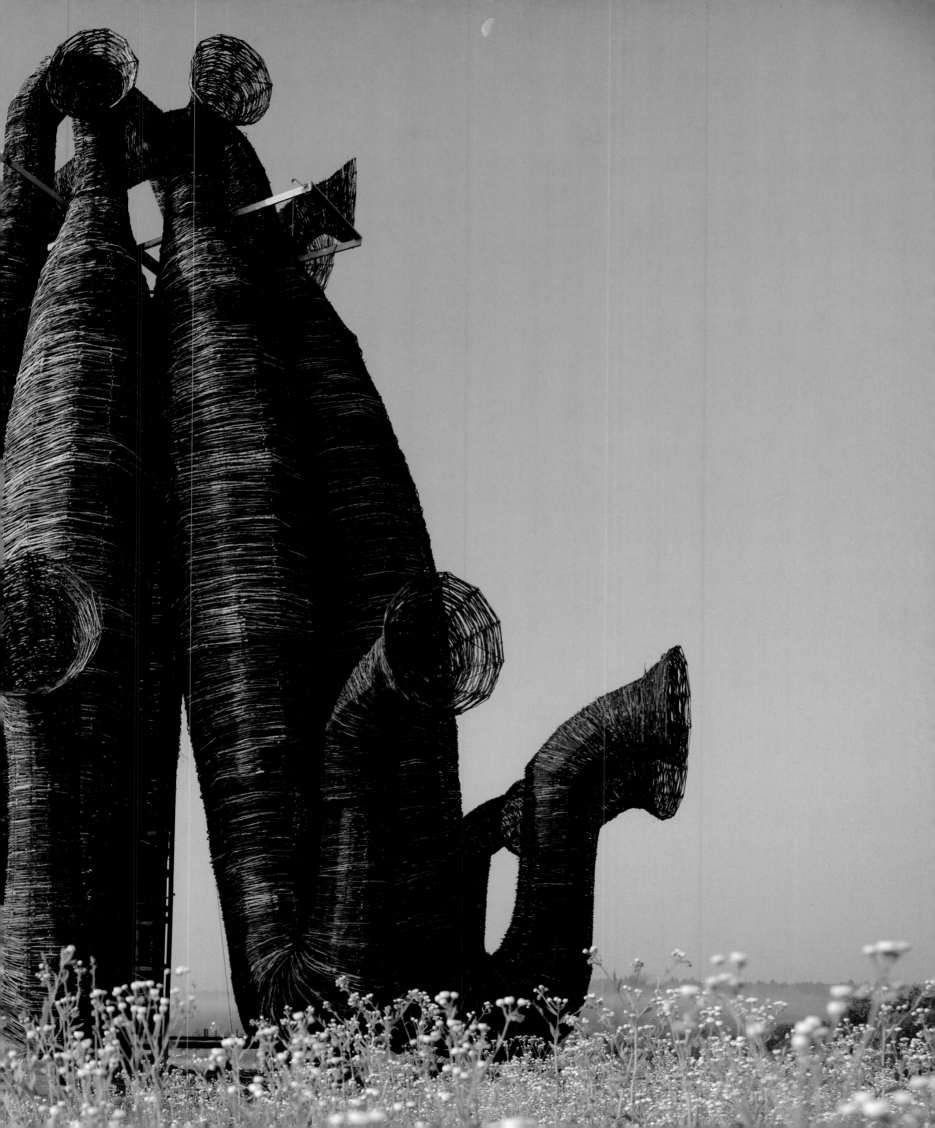

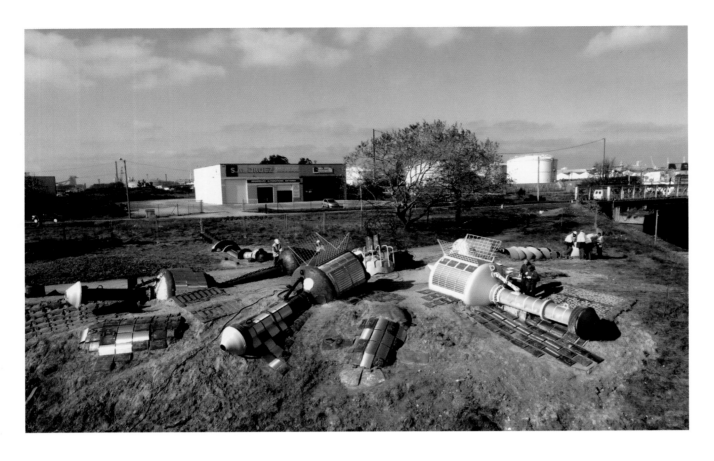

ABOVE AND RIGHT
Spoutnik
2010
Dunkerque, France
Mixed media including beacons, buoys, metal

×

Dimensions variable

OPPOSITE
Large Hadron Collider
2009
Musée d'Art Moderne Grand-Duc Jean,
Luxembourg City, Luxembourg
Wood

×

Dimensions variable

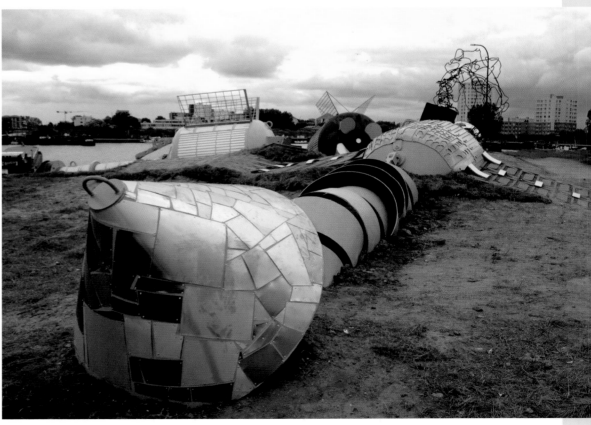

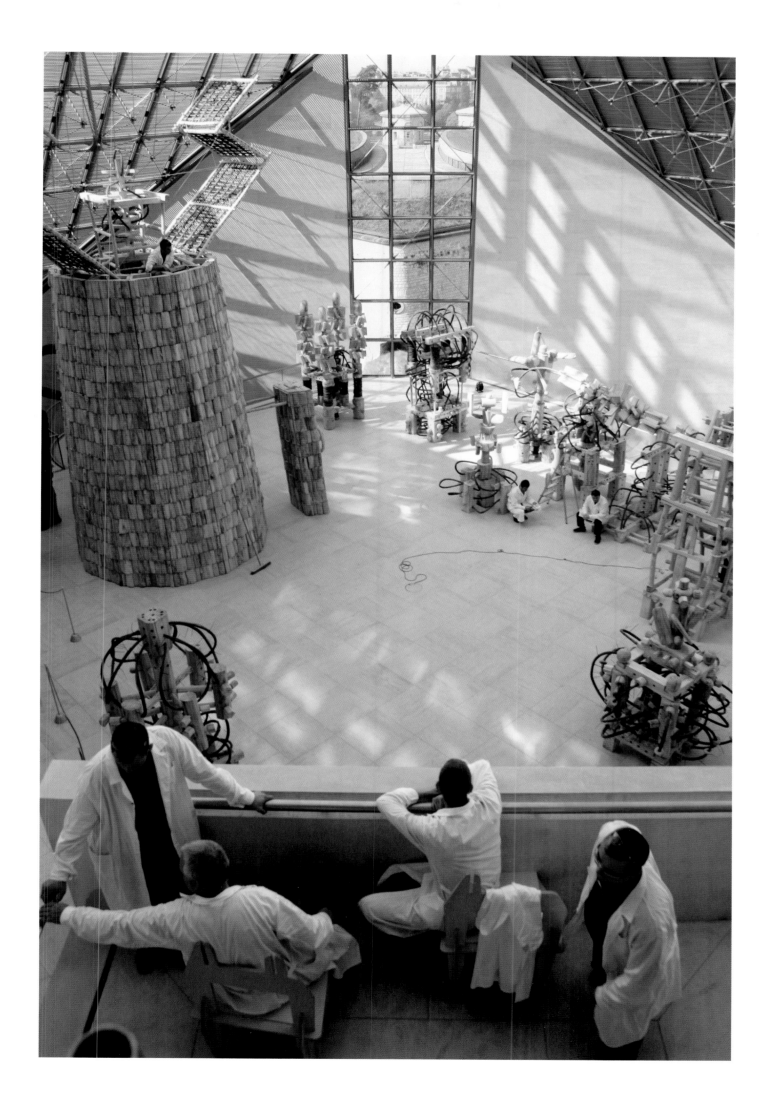

Jorge Rodríguez-Gerada

— PROFILE P. 136 —

ABOVE *Identity Series: Santos Valencia*, 2009.
Valencia, Spain. Mixed media.
Dimensions variable.

OPPOSITE *Terrestrial Series: Homage to Enric Miralles*, 2009.
Barcelona, Spain. Mixed media.
Dimensions variable.

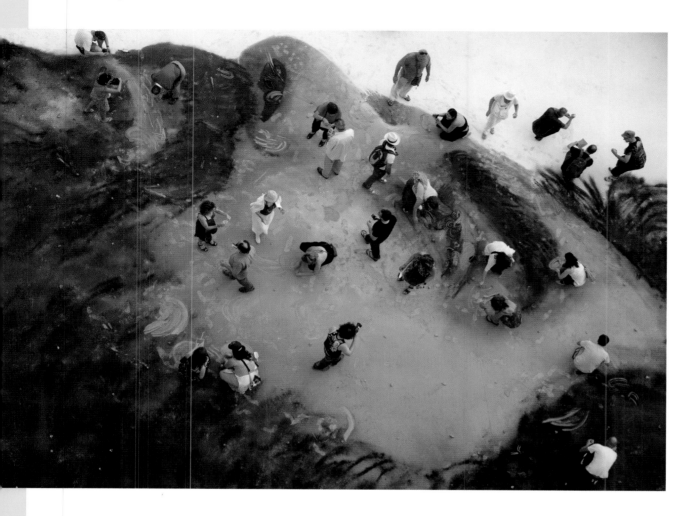

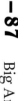

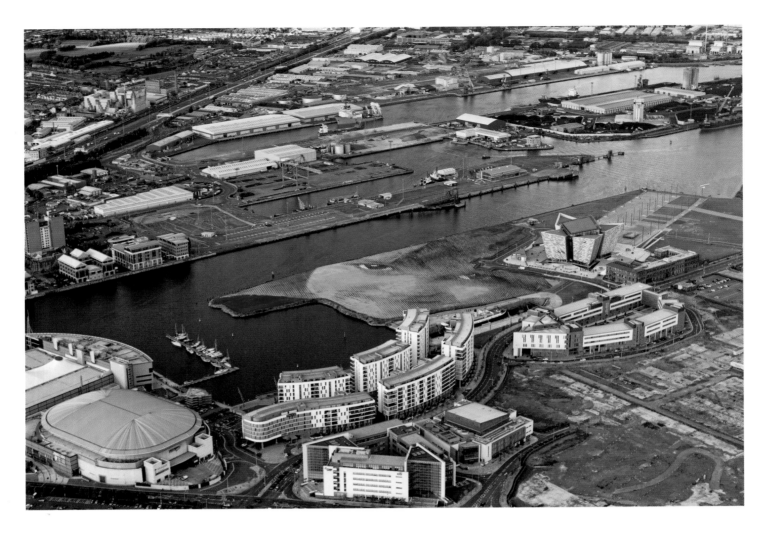

ABOVE AND RIGHT
Terrestrial Series: Wish
2013
Titanic Quarter, Belfast, Northern Ireland
Mixed media

×

Dimensions variable

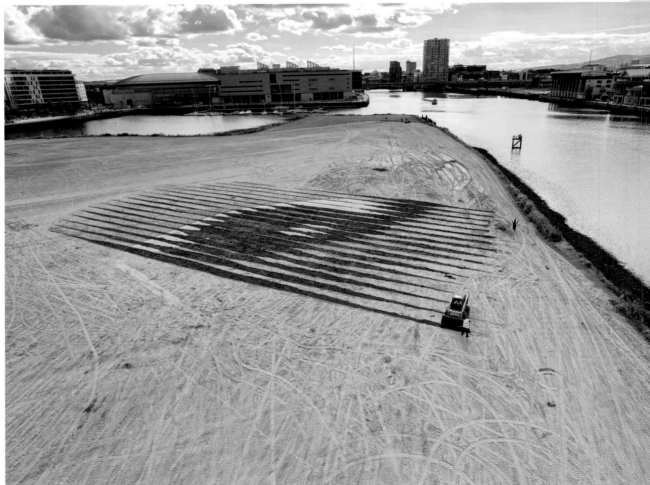

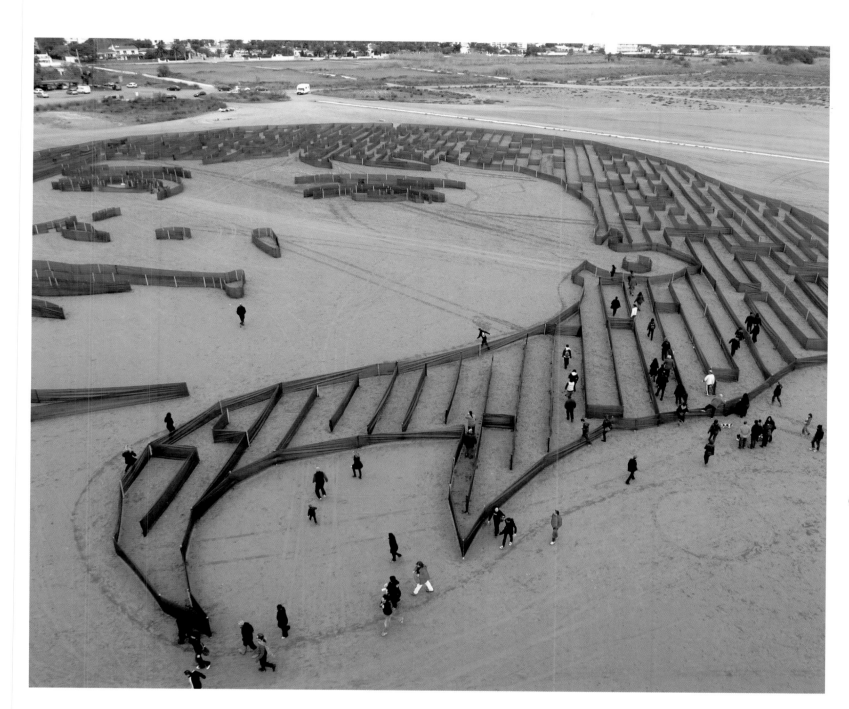

Terrestrial Series: Gal-la
2010
Ebro Delta, Spain
Mixed media

×

Dimensions variable

Adrián Villar Rojas

— PROFILE P. 137 —

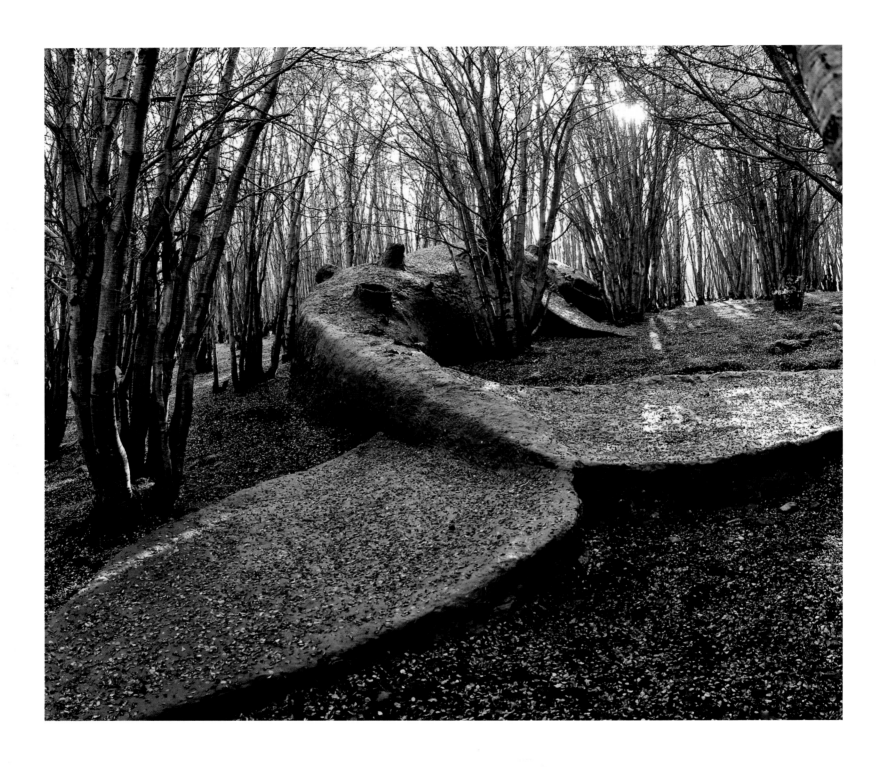

ABOVE *Mi familia muerta* (*My Dead Family*), 2009.
End of the World Biennale, 2nd Edition, Ushuaia, Argentina. Wood, rocks, clay.
3 × 27 × 4 m (10 × 88 ½ × 13 ft).

OPPOSITE *Una persona me amó* (*A Person Loved Me*), 2012.
New Museum, New York, USA. Clay (unfired), wood, cement, metal, Styrofoam.
7.5 × 5 × 5 m (24 ½ × 16 ½ × 16 ½ ft).

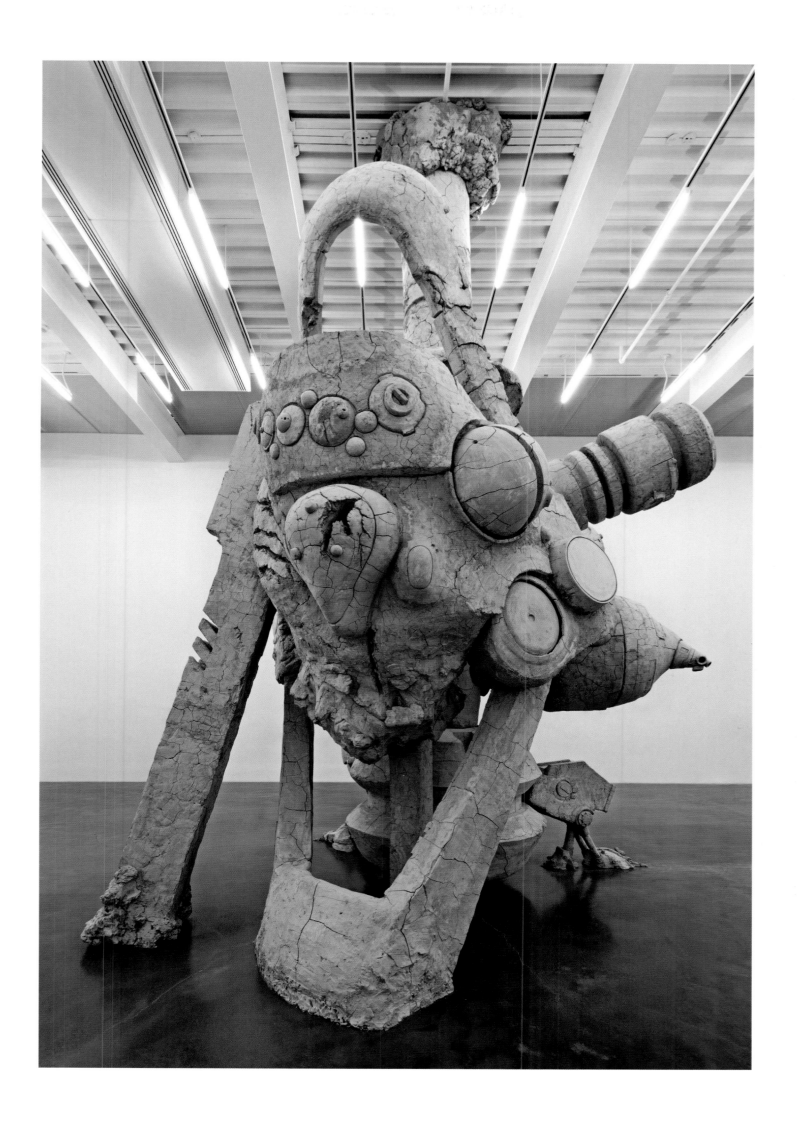

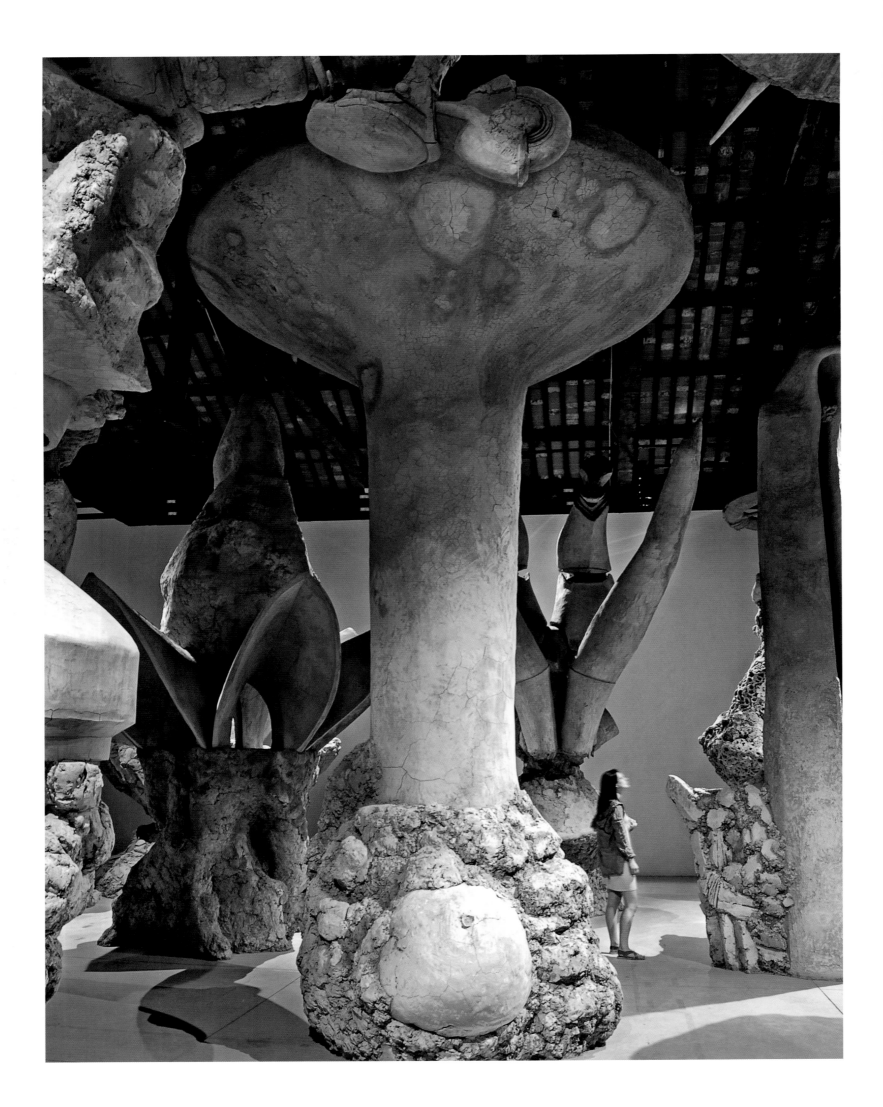

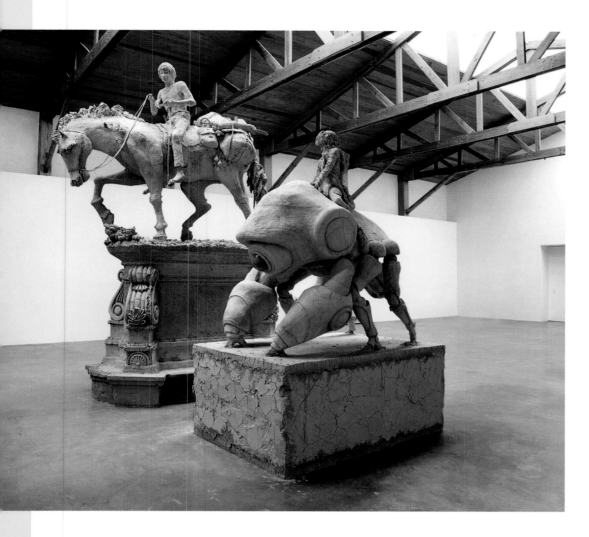

LEFT
Las mariposas eternas
(*The Eternal Butterflies*)
2010
kurimanzutto Gallery, Mexico City, Mexico
Clay (unfired), cement, burlap, wood, metal,
glass, fossils, plastic ice cream cups

×

4.5 × 5 × 4 m (15 × 16 ½ × 13 ft)

BELOW
Poemas para terrestres
(*Poems for Earthlings*)
2011
Jardin des Tuileries, Paris, France
Clay (unfired), cement, burlap, metal, wood

×

90 m (295 ft) long, 40–400 cm (15 ¾ × 157 ½ in.) diam.

OPPOSITE
Ahora estaré con hijo, el asesino de tu herencia
(*Now I Will Be With My Son, The Murderer
of Your Heritage*)
2011
Argentinian Pavilion, Venice Biennale, Venice, Italy
Clay (unfired), cement, burlap, wood

×

Dimensions variable

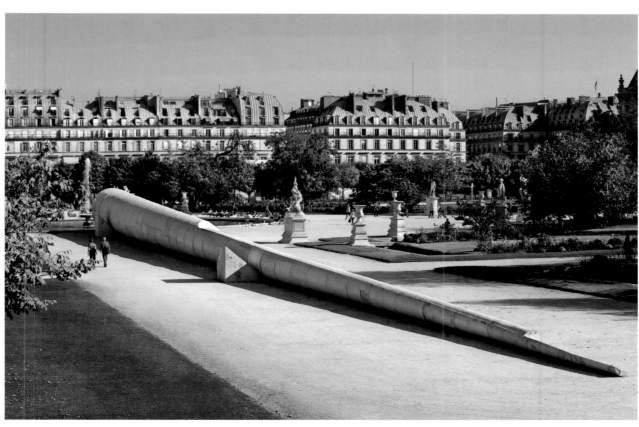

Tomás Saraceno

— PROFILE P. 138 —

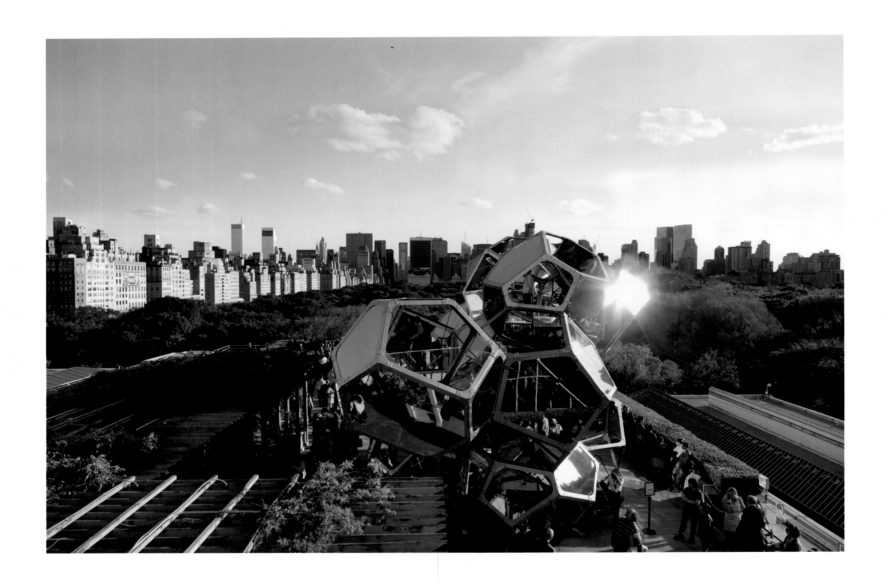

ABOVE AND OPPOSITE
On the Roof: Cloud City
2012
Metropolitan Museum of Art, New York, USA
Mixed media

×

Dimensions variable

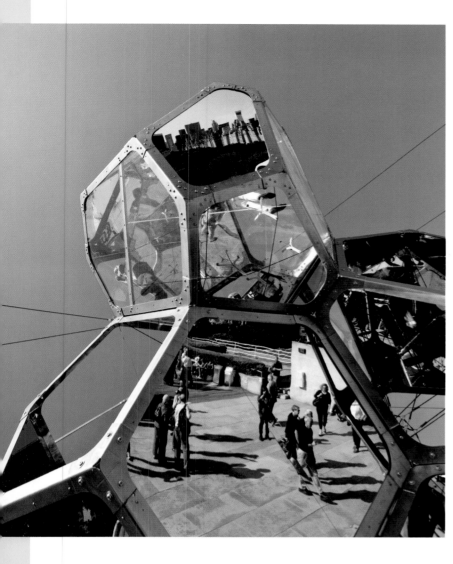

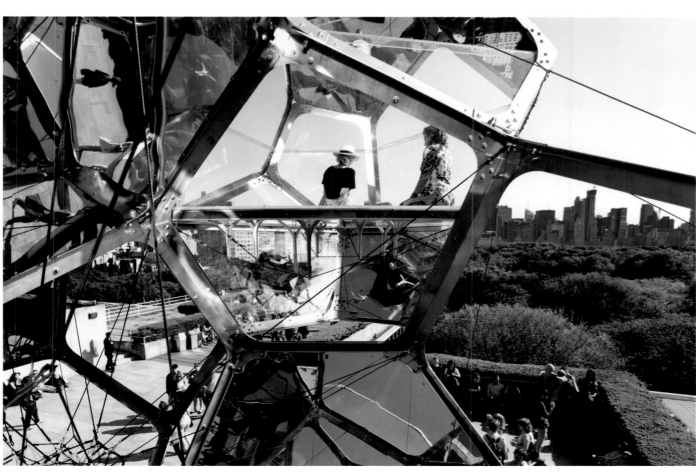

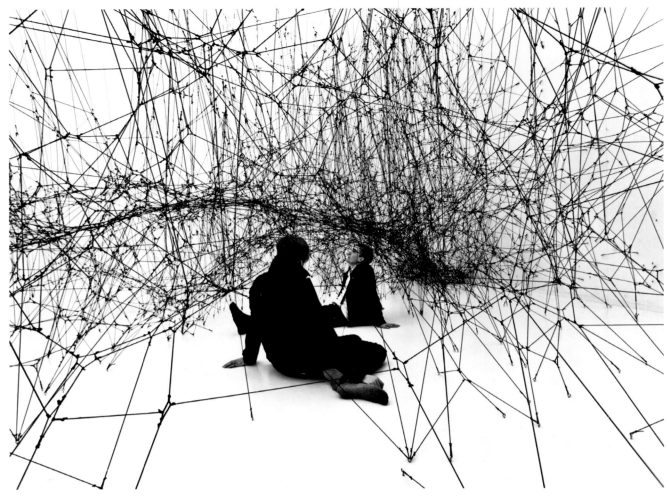

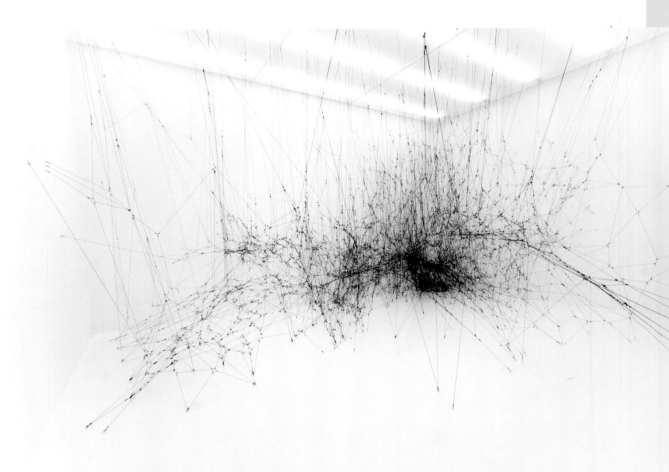

ABOVE AND RIGHT

14 Billion
2010
Bonniers Konsthall,
Stockholm, Sweden
Black cord, elastic rope, hooks

×

Dimensions variable

OPPOSITE

Flying Green House
2008
10th Sonsbeek International
Sculpture Exhibition,
Arnhem, Netherlands
Air pillows, rope, *Tillandsia* plants

×

c. 12.5 m (41 ft) diam.

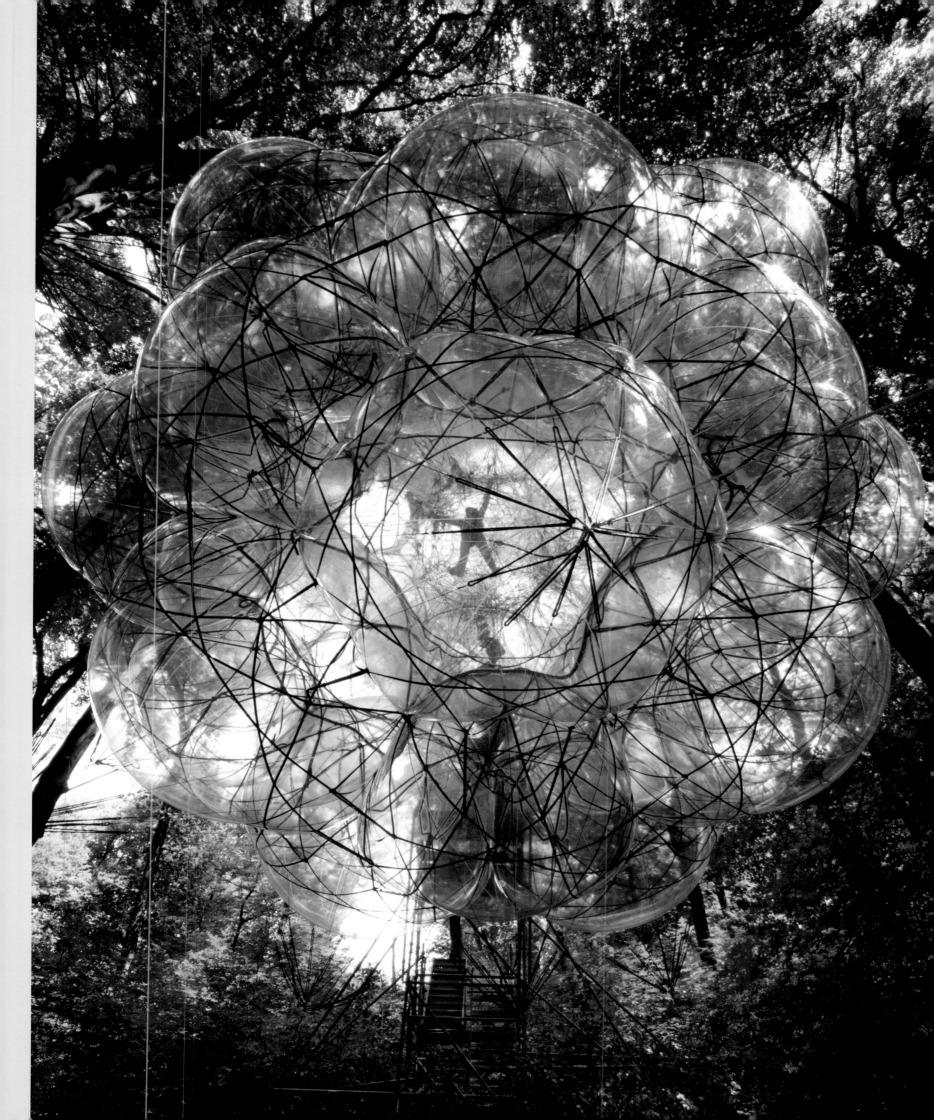

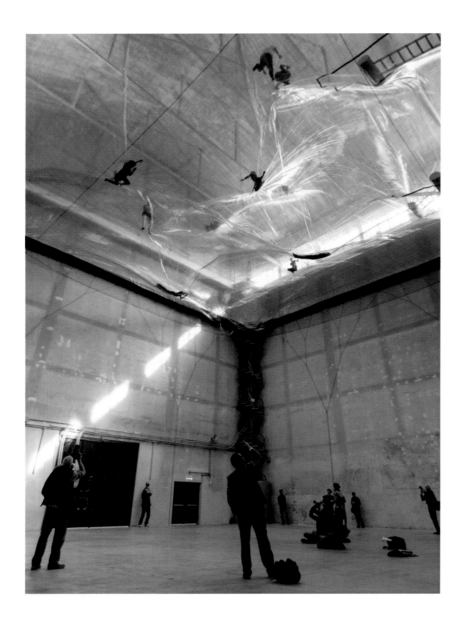

LEFT AND BELOW
On Space Time Foam
2012
HangarBicocca, Milan, Italy
Mixed media
×
24 m (79 ft) high

OPPOSITE
Cloud Cities
2011
Hamburger Bahnhof, Berlin, Germany
Mixed media
×
Dimensions variable

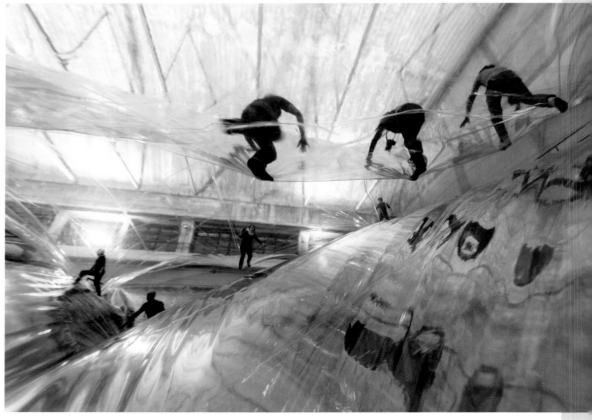

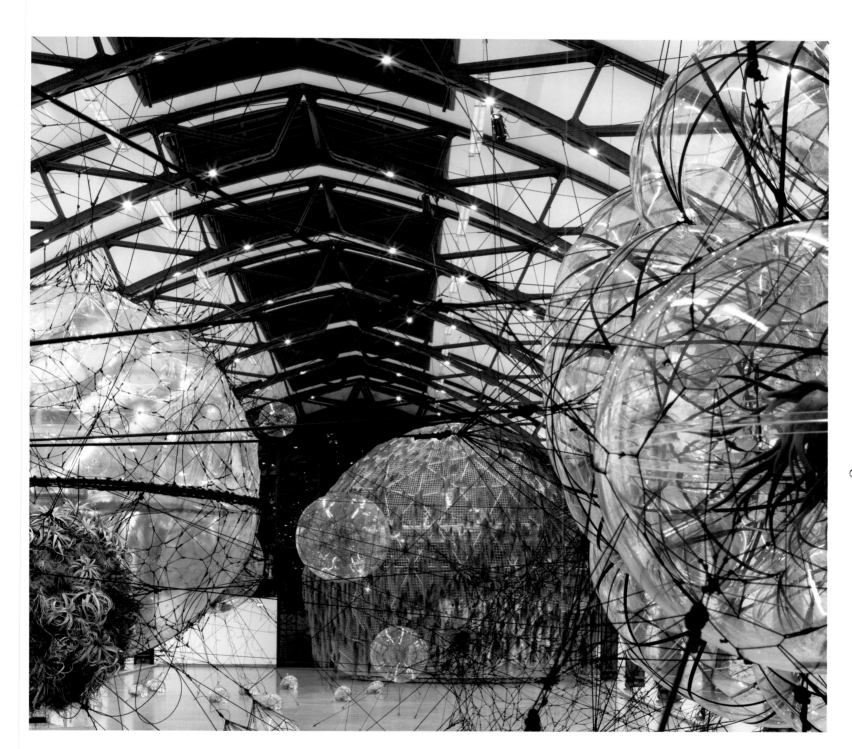

Nike Savvas

— PROFILE P. 139 —

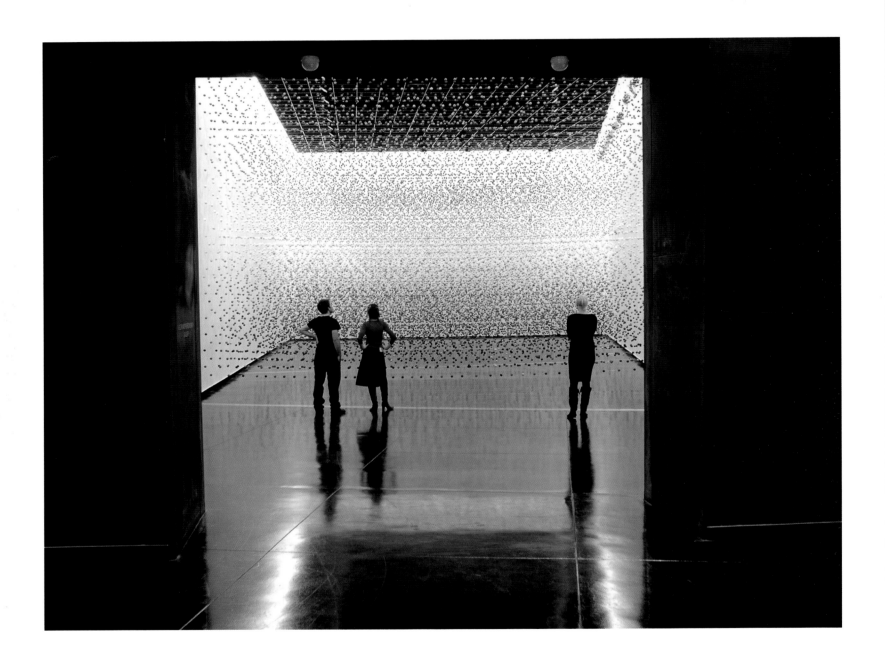

Atomic: Full of Love, Full of Wonder
2005
Australian Centre for Contemporary Art, Melbourne, Australia
Polystyrene, nylon wire, paint, electric fans

×

35 × 14 × 8 m (115 × 46 × 26 ft)

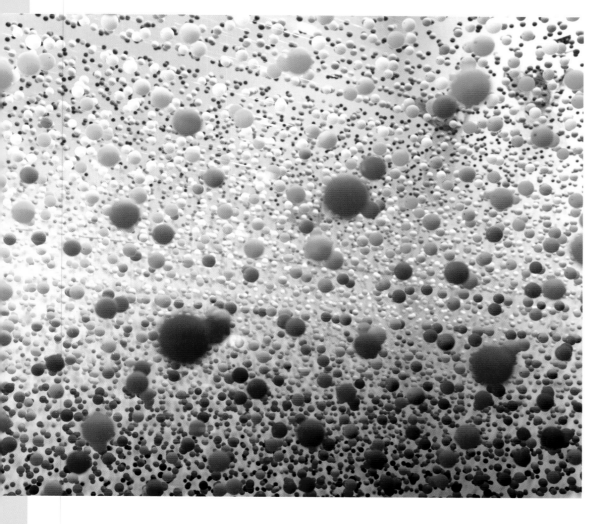

LEFT, BELOW AND OVERLEAF
Atomic: Full of Love, Full of Wonder
2005
Art Gallery of New South Wales, Sydney, Australia
Polystyrene, nylon wire, paint, electric fans

×

Dimensions variable

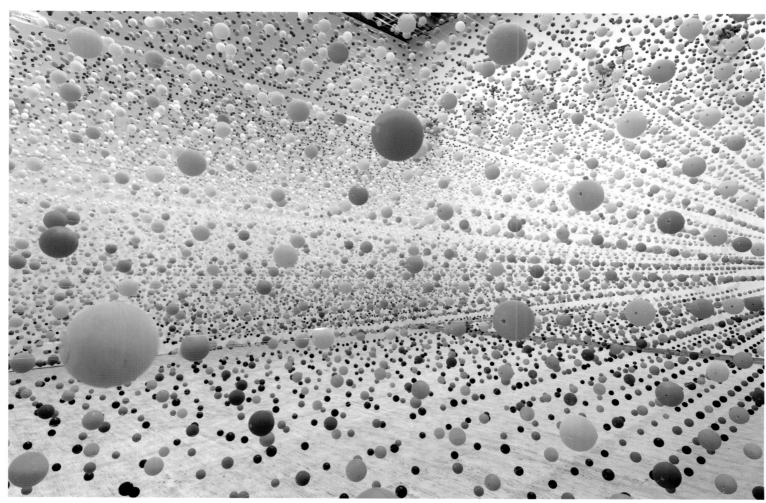

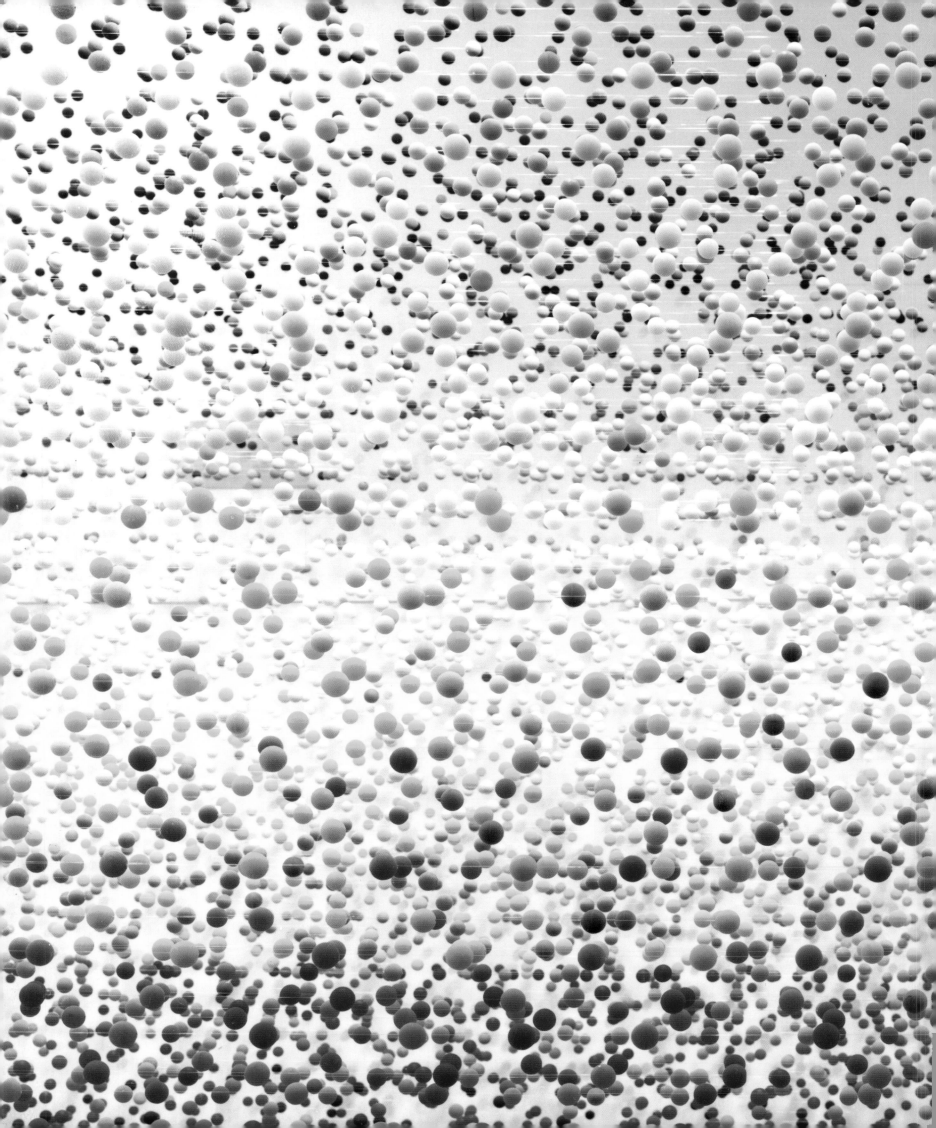

Doug and Mike Starn

— PROFILE P. 141 —

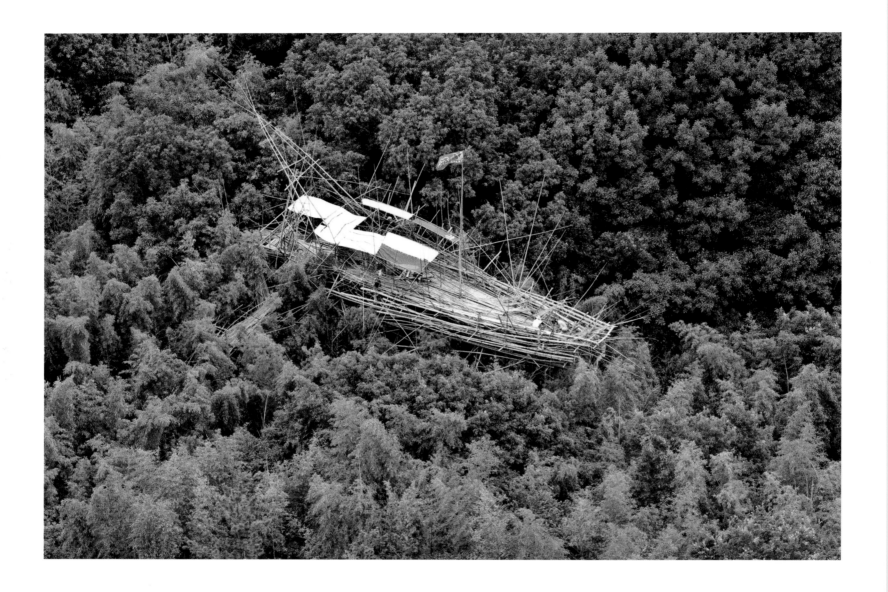

ABOVE AND OPPOSITE
Big Bambú #8
2013
Naoshima Museum, Setouchi Triennale, Teshima, Japan
Bamboo poles

×

Boat: 21 m (70 ft) long, 5.5 m (18 ft) wide

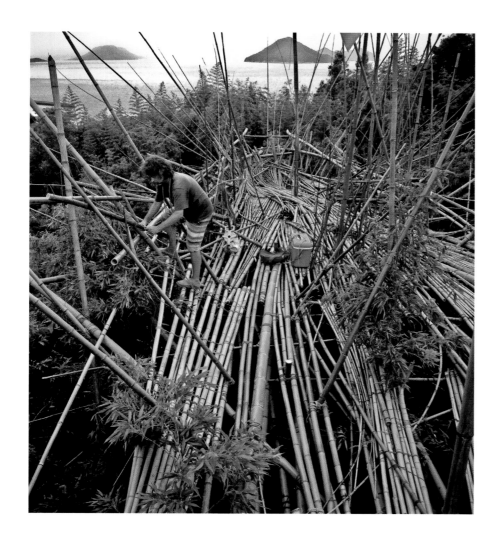

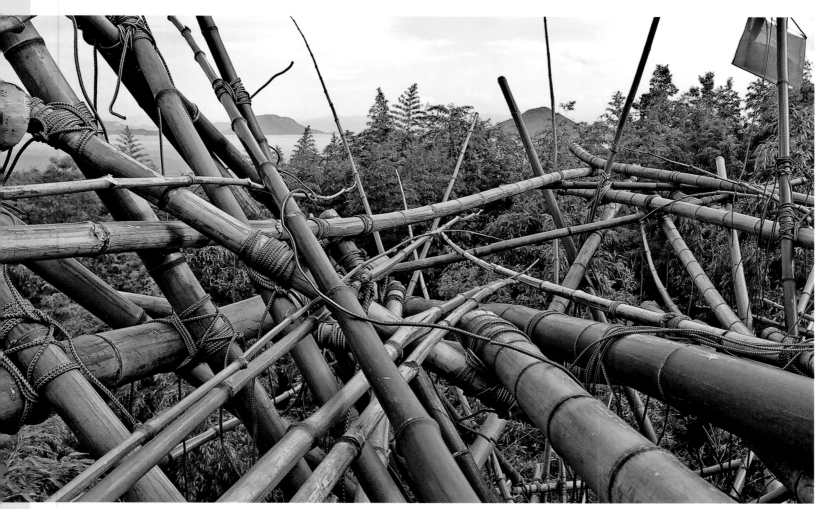

RIGHT AND OPPOSITE
Big Bambú
2011
54th Venice Biennale,
former United States Consulate, Venice, Italy
Bamboo poles
×
23 m (75 ft) high, 12 m (40 ft) diam.

BELOW
Big Bambú: Minotaur Horn Head
Work in progress
2012
Museo d'Arte Contemporanea Roma, Rome, Italy
×
43 × 15 × 23 m (140 × 50 × 75 ft)

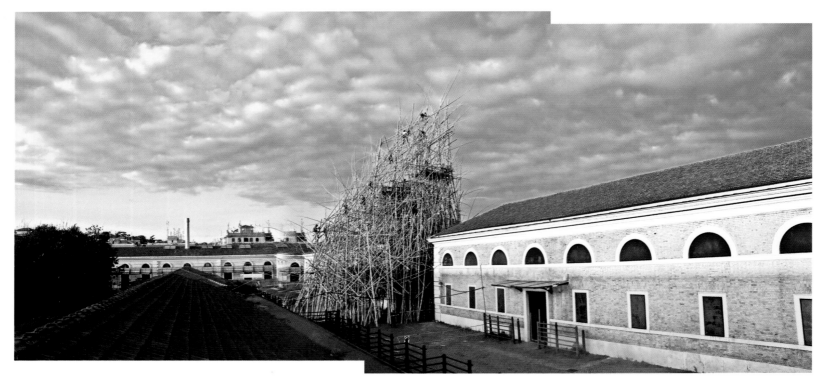

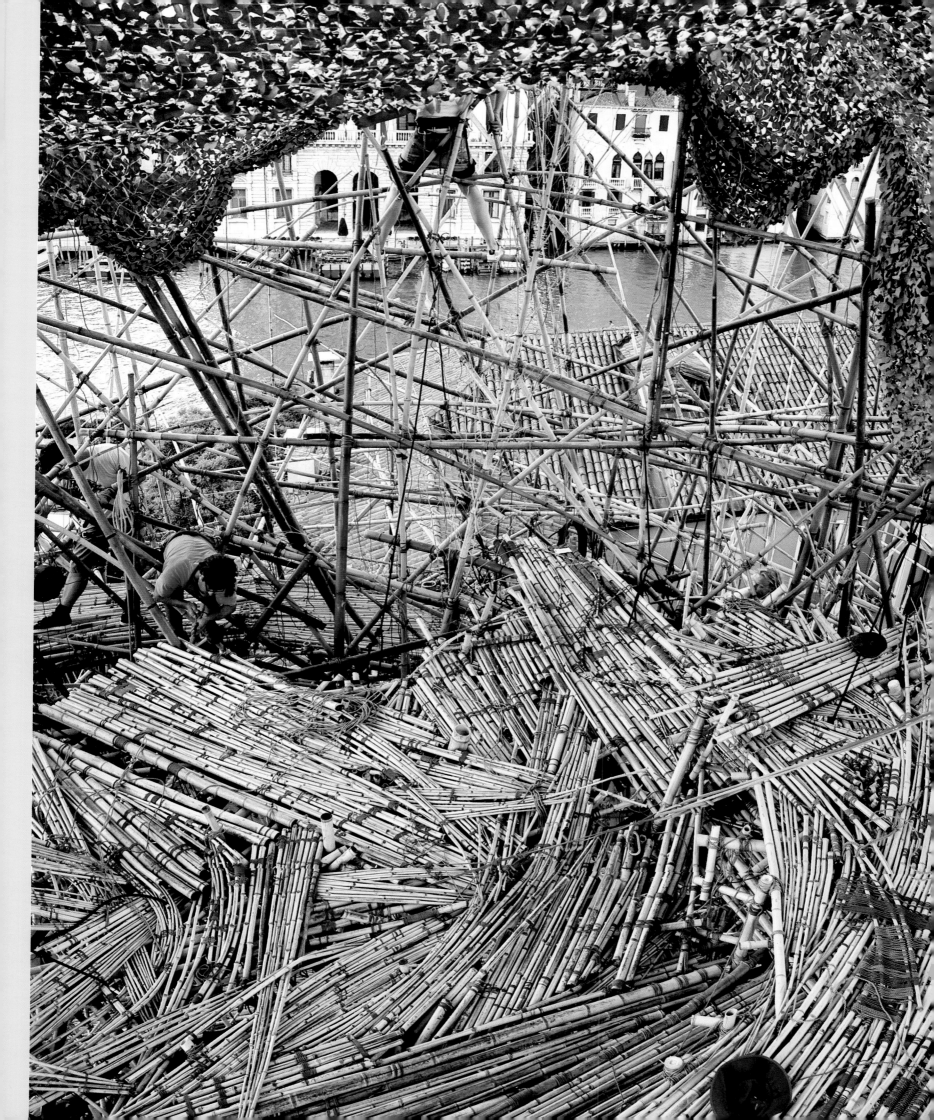

Jason deCaires Taylor

— PROFILE P. 142 —

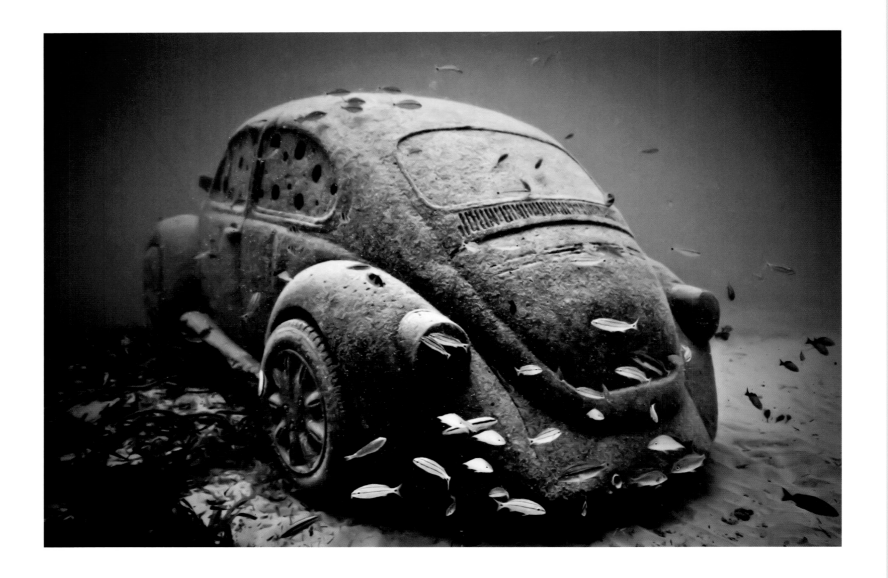

The Anthropocene
2011
Life-size replica of the classic VW beetle with internal living
spaces to support local crustacean populations
Cement, sand, microsilica, with fibreglass reinforcements

×

300 × 150 × 140 cm (118 ⅛ × 59 × 55 ⅛ in.)

RIGHT, BELOW AND OVERLEAF
The Silent Evolution
2010
Installation view (detail) in 2013, after three years' submersion,
Museo Subacuático de Arte, off the coast of Cancún/Isla Mujeres, Mexico
Cement, sand, microsilica, with fibreglass reinforcements
×
20 × 40 × 2 m (65 ½ × 131 × 6 ½ ft)

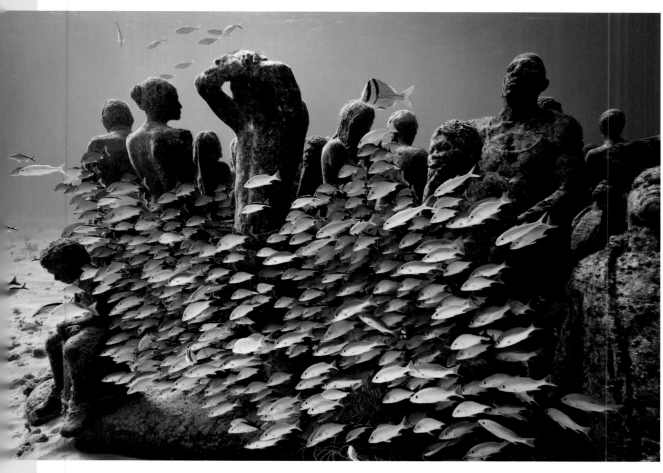

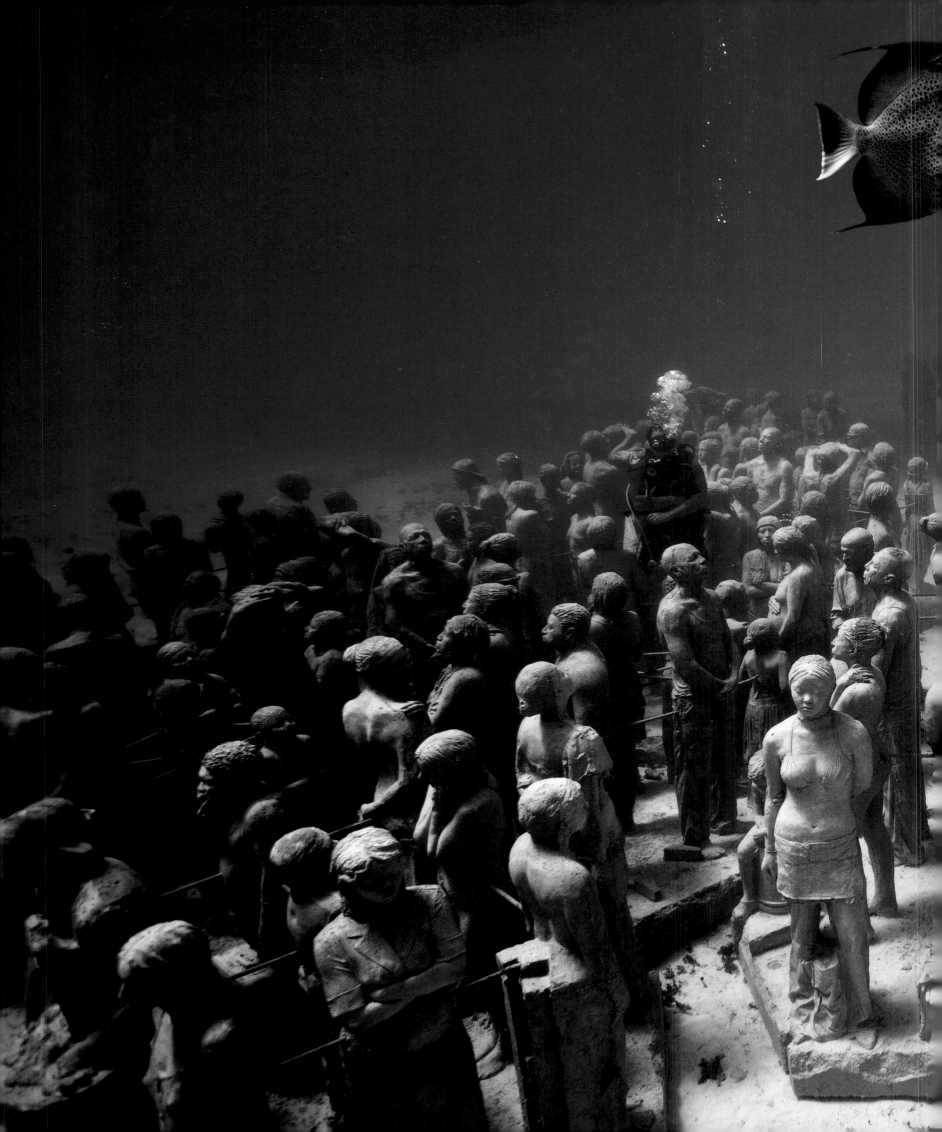

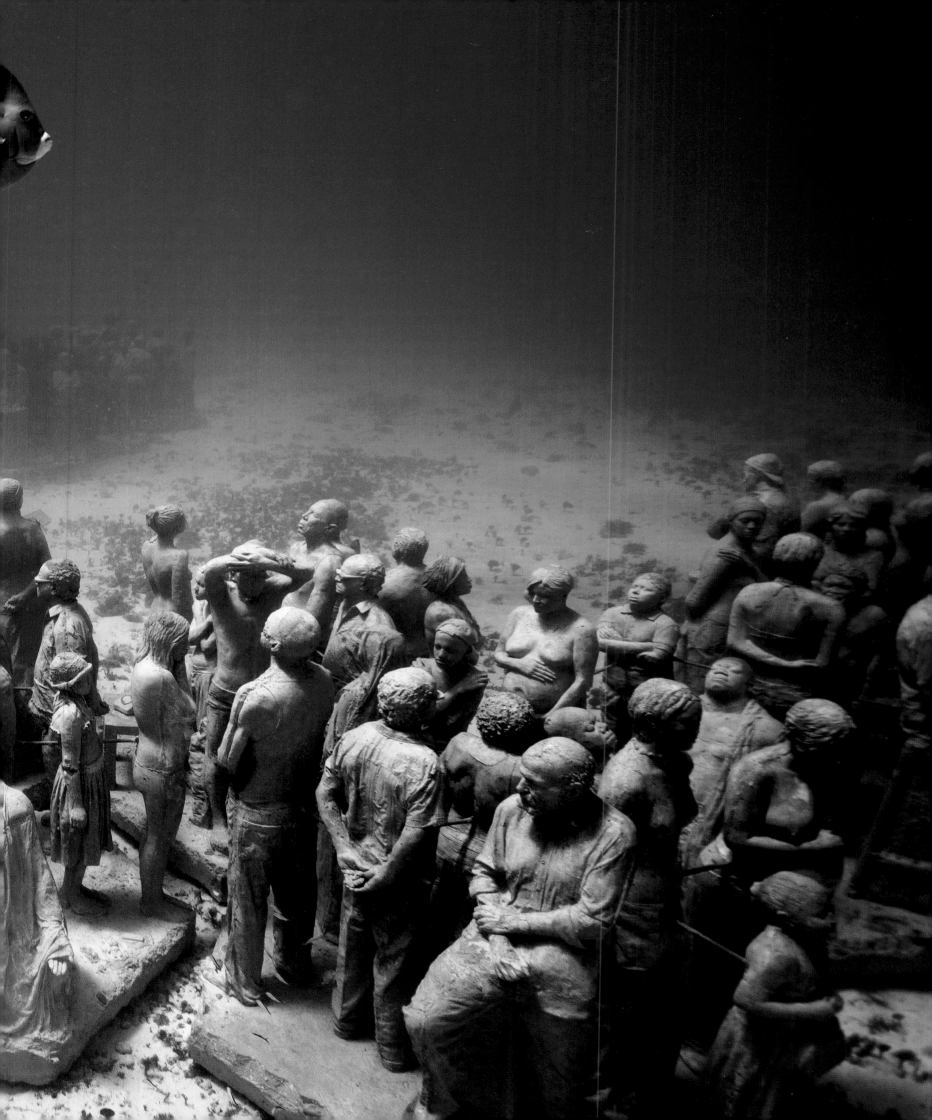

Pascale Marthine Tayou

— PROFILE P. 143 —

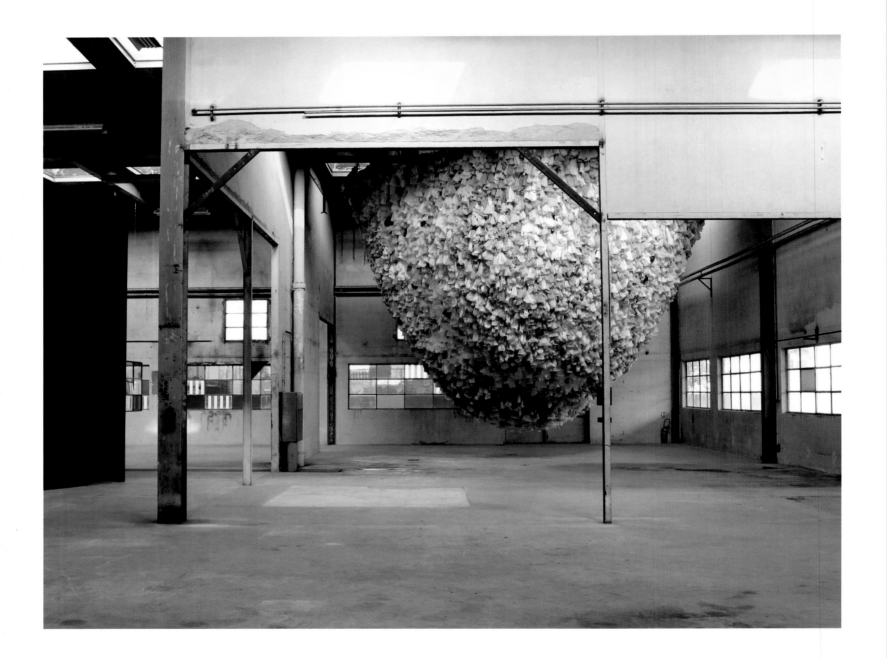

ABOVE *Plastic Bags*, 2001–11.
Galleria Continua, Le Moulin, Boissy-le-Châtel, France, 2011. Plastic bags.
Dimensions variable.

OPPOSITE *Plastic Bags*, 2001–11.
Museo d'Arte Contemporanea Roma, Rome, Italy, 2012. Plastic bags.
Dimensions variable.

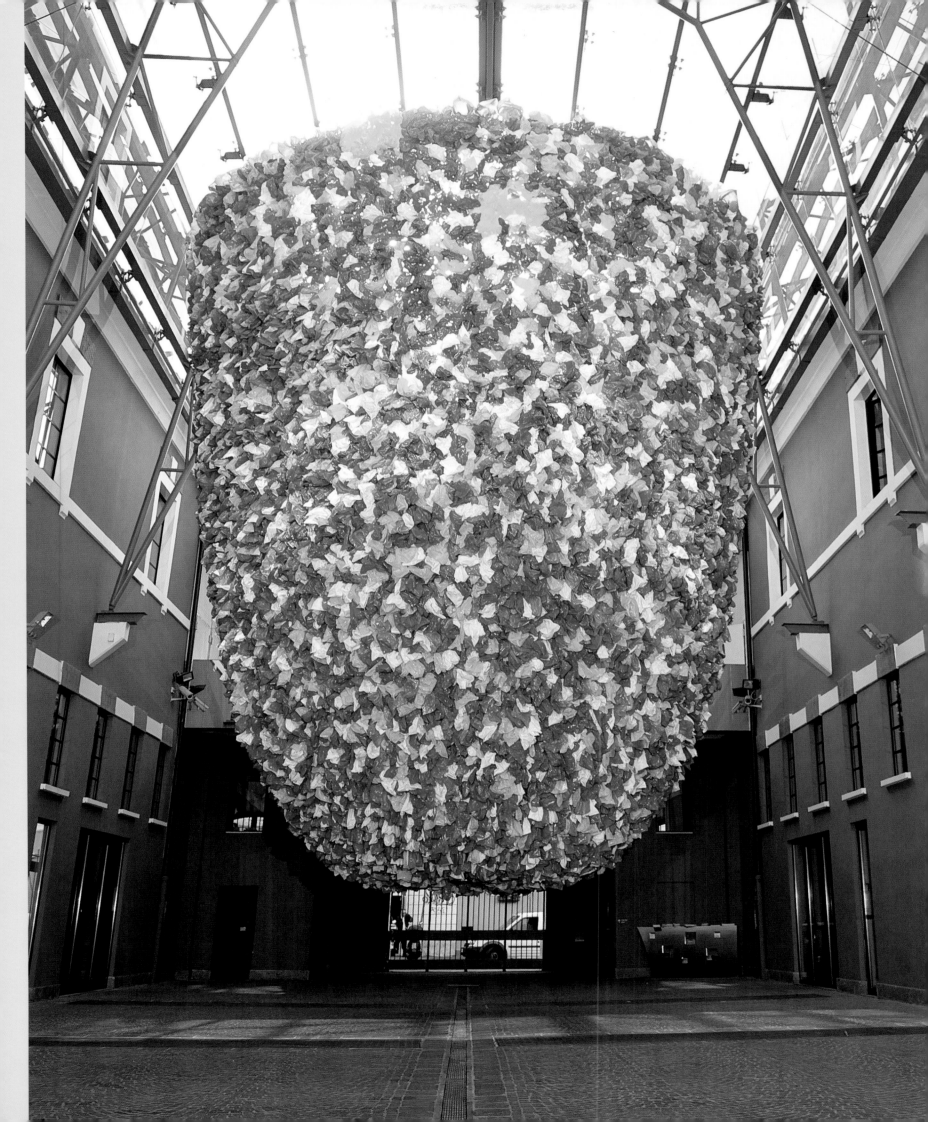

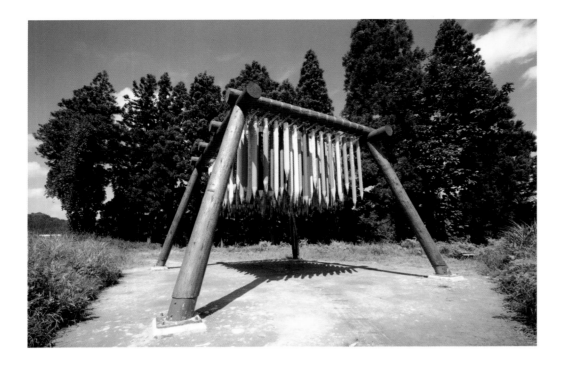

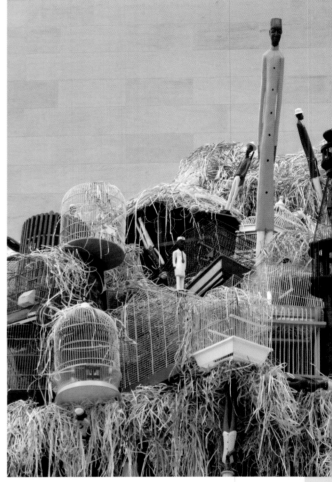

ABOVE
Reverse City
2009
Echigo-Tsumari Art Triennale, Niigata Prefecture, Japan
Wood, metal
×
50 × 75 × 85 m (164 × 245 × 278 ft)

RIGHT, BELOW AND OPPOSITE
Home Sweet Home
2011
Musée d'Art Moderne Grand-Duc Jean, Luxembourg City, Luxembourg
Wooden posts, birdcages, African statuettes, wires, headphones, speakers, hay
×
7 × 8 × 8 m (23 × 26 × 26 ft)

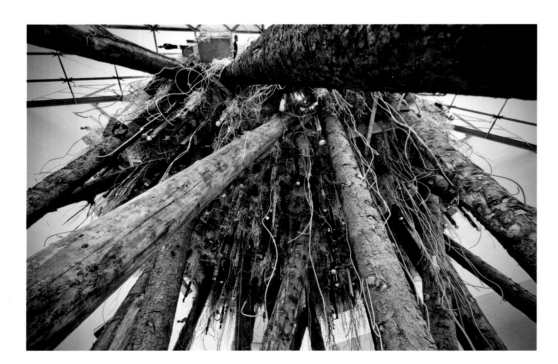

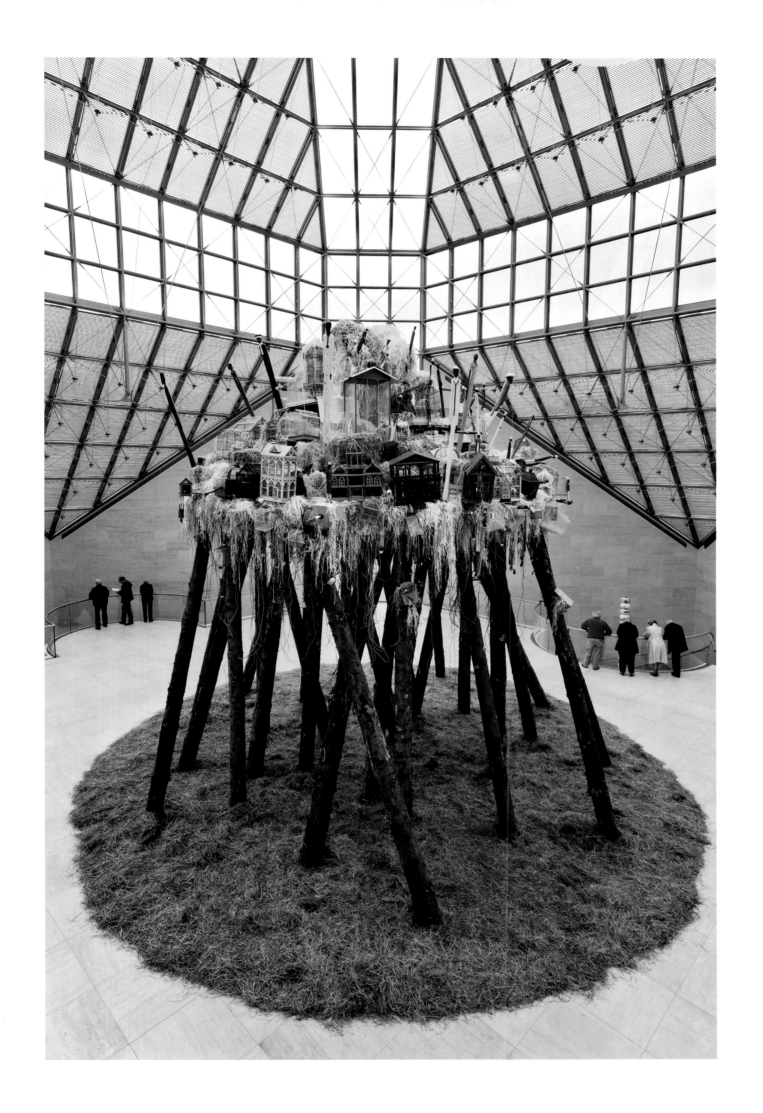

Motoi Yamamoto

— PROFILE P. 144 —

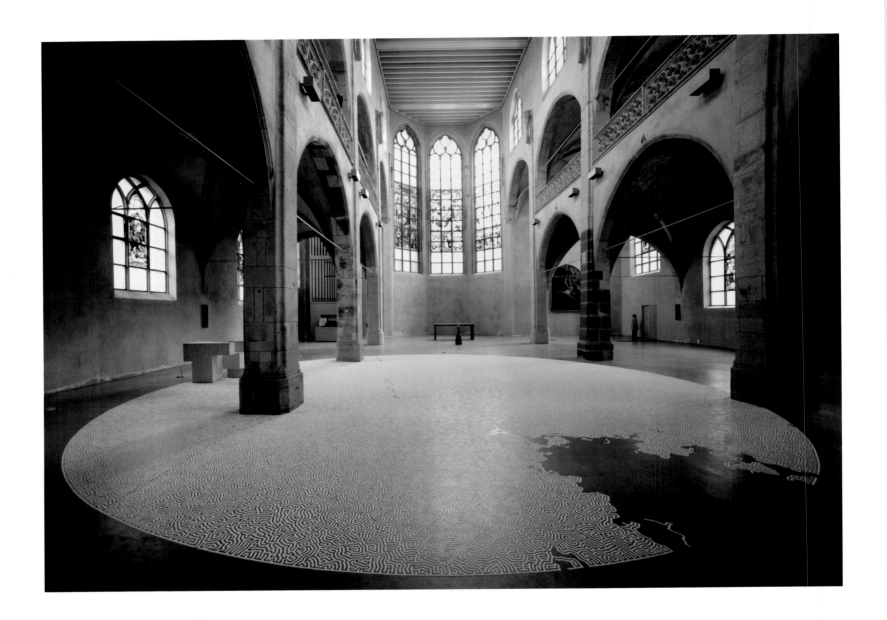

ABOVE *Labyrinth*, 2010. Kunst-Station Sankt Peter, Cologne, Germany. Salt.
12 m (39 ft) diam.

OPPOSITE *Labyrinth*, 2012. Bellevue Arts Museum, Bellevue, Washington, USA. Salt.
5 × 14 m (16 ½ × 46 ft).

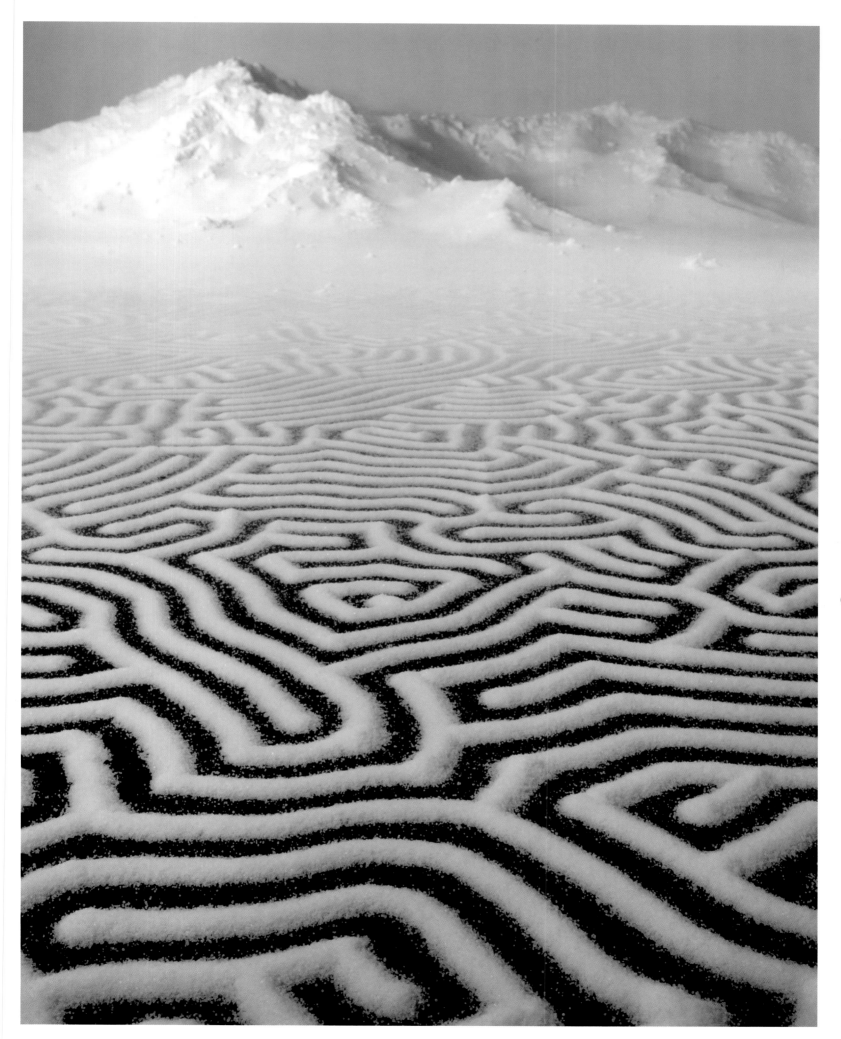

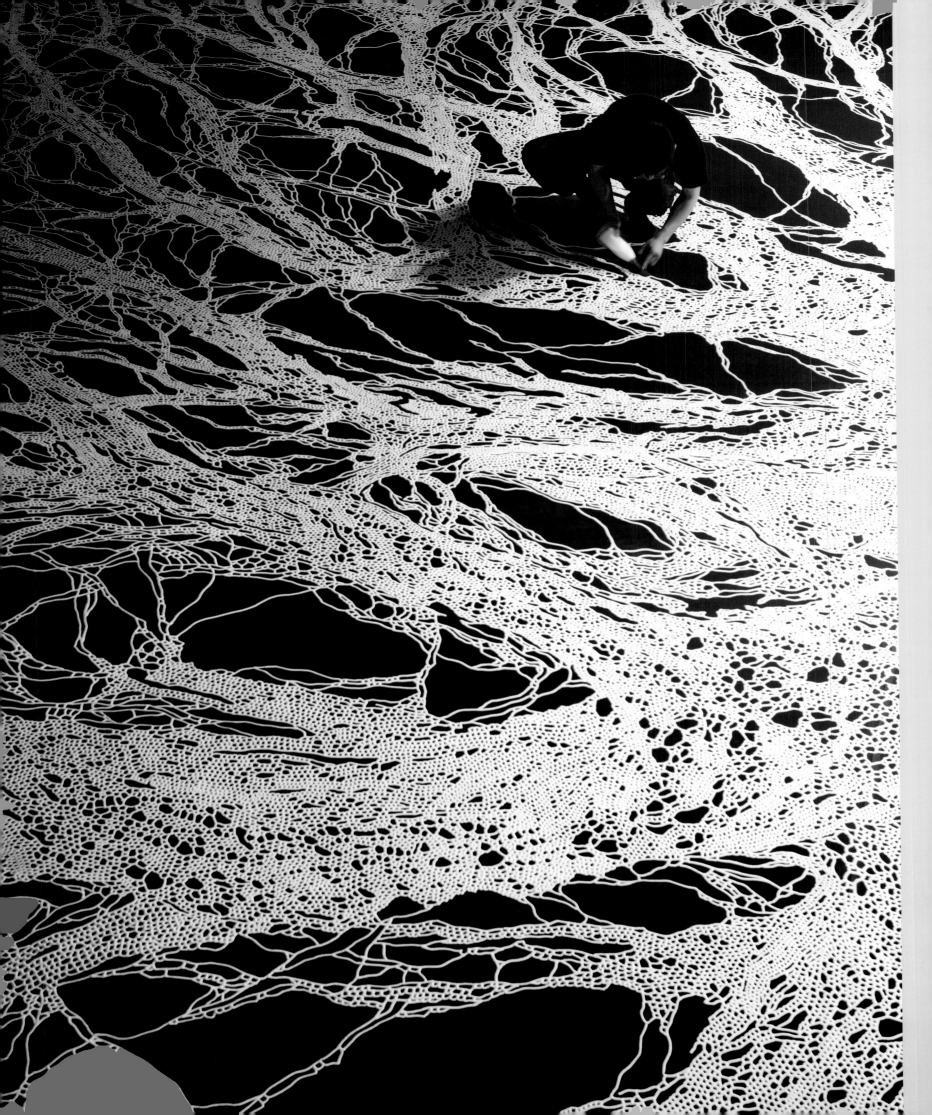

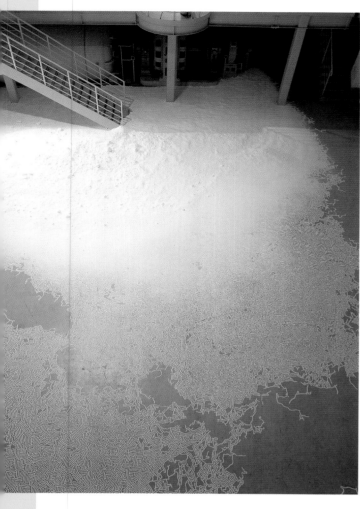

LEFT
Labyrinth
2005
Nizayama Forest Art Museum, Toyama, Japan
Salt
×
14.5 × 22.5 m (47 ½ × 74 ft)

BELOW
Floating Garden
2013
Mint Museum, Charlotte, North Carolina, USA
Salt
×
9 × 17 m (29 ½ × 56 ft)

OPPOSITE
Forest of Beyond
2011
Hakone Open-Air Museum, Kanagawa, Japan
Salt
×
16 × 16.5 m (52 ½ × 54 ft)

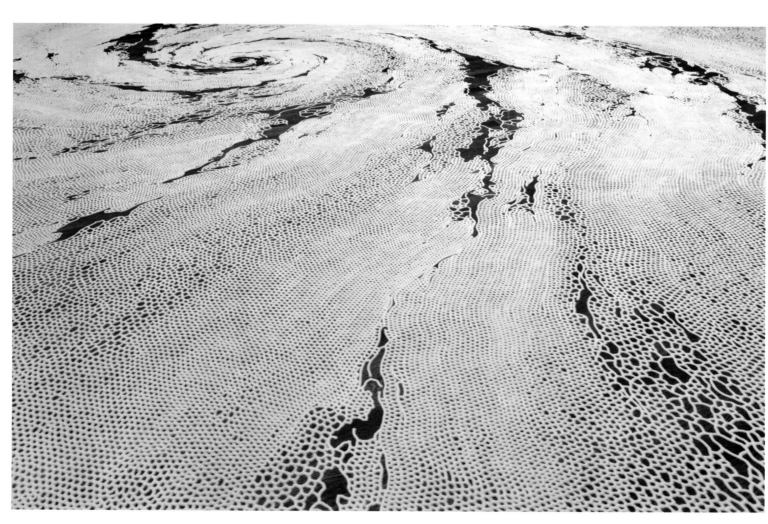

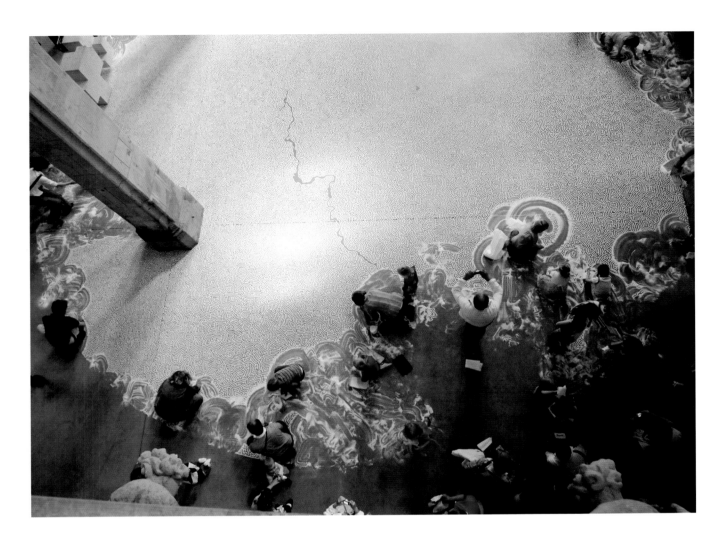

ABOVE
Return to the Sea
(*Labyrinth*)
2010
Kunst-Station Sankt Peter,
Cologne, Germany
Salt

×

12 m (39 ft) diam.

RIGHT
Return to the Sea
Salt from one of Yamamoto's
installations is returned to the sea.

Big

Art

Profiles

Boa Mistura

— IMAGES P. 17 —

This collective of urban artists, based in Madrid, takes its name from the Portuguese for 'good mixture', a reference to the diverse backgrounds and skills of its five members, who all influence and inform the group's practice. Formed in 2001 by architect Javier Serrano, civil engineer Rubén Martín, advertising and public relations graduate Pablo Purón and fine arts graduates Pablo Ferreiro and Juan Jaume, the collective is primarily known for the large-scale, vibrant murals that it has created across the globe, from South Africa and Brazil to Norway and Germany. Many of these public artworks also have a social element designed to involve the community in the creation and production of the pieces, while actively reflecting local concerns.

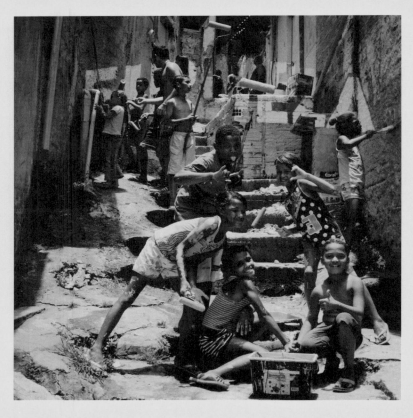

Boa Mistura, *Beleza* (*Beauty*), 2012. São Paulo, Brazil.
30 × 3.5 × 3 m (98 ½ × 11 ½ × 10 ft).

One of the works that best demonstrates this approach is *Luz nas vielas* (*Light in the Alleyways*) (2012). This project, which took place in Brasilândia, a district of São Paulo, formed part of the larger *Crossroads* series of participative urban interventions through which the collective used art as a tool to inspire and improve rundown communities. Hosted by a local family, so as to have direct contact with the community,

the group started by studying the social and geographic framework of the district. Brasilândia is a favela – a shanty town built in an environmentally fragile area by low-income, working-class people. Since residents occupy these sites illegally, they do not pay taxes and therefore lack even the most basic infrastructure; they are without access to sanitation, safe drinking water and electricity. In the favela model, low-quality houses are self-built out of necessity, either horizontally or vertically, resulting in a warren of paths and stairways that form the central network of the favela. The collective decided to focus on these narrow, winding streets for their interventions as they represented the inner life of the community.

As the artists spent time in the community, they began to learn about its social and economic development, as well as the hospitality and tolerance of the people. This inspired them to take a typographic approach: painting clear, uplifting words such as *amor* (love) and *firmeza* (strength) in white block letters against vivid backgrounds, they completely covered the selected paths and walls of the adjoining structures with colour. The results resonated with both the group and the local residents, many of whom had helped them to paint. The collective made clever use of perspective so that the words could only be read from a certain vantage point and appeared as if suspended against the background colour. This device was designed to make us look at the community and the environment more closely: on first impressions the favela landscape appears to be randomly abstract, but in a frozen moment – through the work – we see its coherence. By covering the whole street with the blocks of flat colour and statements, the collective presents an image of togetherness – an idea that is echoed in the experiences of inhabitants who cemented friendships and felt a stronger connection to their area by participating in the project. For Boa Mistura, the large scale of their work is vital, allowing it to be inhabited and change through interaction.

Lilian Bourgeat

— IMAGES P. 20 —

For many years, French artist Lilian Bourgeat has been creating installations of oversized everyday objects. The surprising scale of these pieces deprives them of their original function and transports the viewer into a fantastic theatrical world. The upscaling of day-to-day objects is by no means new: many artists have explored this concept, following in the footsteps of pop art pioneer Claes Oldenburg. However, Bourgeat takes the idea one step further by creating work

'With our work, we try to improve the areas of a city that, in our opinion, need it. The bigger the work, the more we improve the area. We feel that the street is the best place for art expression. It belongs to everybody and nobody at the same time. As urban artists, we feel the responsibility of doing something positive for the people; we have the tools to change the way they feel about their area. For us, it's important to involve the community in these projects. When people change their own community, they feel prouder of where they live and protect it.'

Boa Mistura

that can be viewed on many different levels: it charms us, confounds us and at the same time mocks the contemporary art world.

In a teasing way, Bourgeat breaks the conventions of presenting work in a space. In *Le dîner de Gulliver* (*Gulliver's Dinner*, 2008), a table and six chairs – complete with dinner service – are enlarged so that they fill the exhibition space, almost obstructing it, as if the piece were simply too big to be shown there. The spectator, who is usually the focus, is pushed aside, becoming subservient to the work. Bourgeat is fascinated by the ties between the art world and the real world, and the relationship between representation and perception. At the same time, he is not afraid of criticizing the art market with works such as *Piggy Bank* (1998), a giant piggy bank that highlights the often inflated valuation of art.

Part of the enjoyment of the work for the artist is the challenges he faces in the construction and manufacture of the objects at such a large size. In order for them to work, they need to be fully functional and authentic. As a result, he has created many extraordinary objects: a giant tape measure on which each millimetre equals one centimetre; PVC cups that are 40 cm (15 ¾ in.) in height but are fully usable; push-pins that are 36 cm (14 ⅛ in.) in diameter, displayed on cork panels; and 3-m-high (10-ft) boots. All these gigantic items are perfectly finished, giving the illusion of being mass-produced.

It is in part the authentic nature of these hyperreal objects that draws the audience to them, as well as their intriguing placement. For Bourgeat, participation in the works is key to their success, since without people, the scale would not be appreciated. Seemingly innocent and beguiling, his installations appeal to people of all ages, who are lured into a theatrical interaction with the work. While no doubt enchanting, Bourgeat's work questions our comprehension of reality and disturbs our everyday understanding of the world. With some similarities to *Gulliver's Travels*, Jonathan Swift's masterpiece, in Bourgeat's domain commonplace items and habitual customs have been metaphorically turned upside down in order to re-examine human nature and society. His supersized objects consequently explore the way that humans manipulate their environment to satisfy their own vanities through objects and social conventions.

American artist builds these structures in situ, on a foundation of naturally frozen water on grass. The artist grows between 3,000 and 5,000 icicles per day – a process that requires access to millions of gallons of water – and then fuses them to the structure by hand until it reaches some 6–7.5 m (20–25 ft) in height. When completed, these ice castles are a delight to explore, with a maze of stairs, archways and tunnels to get lost in. They become even more atmospheric at night, when hundreds of compact fluorescent bulbs embedded in the walls light them up with radiant colour. Ephemeral by nature, they can only survive in cold conditions and last the winter months before eventually melting away.

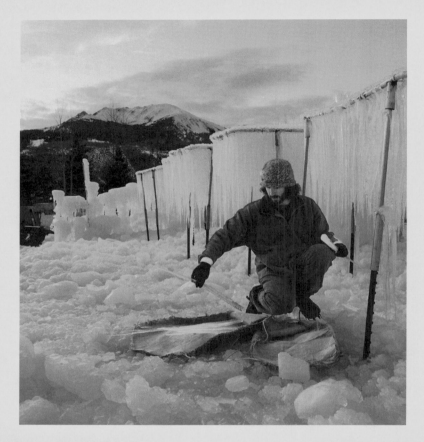

Brent Christensen working on an *Ice Castle*.

Brent Christensen

— IMAGES P. 24 —

Formed from thousands of icicles, Brent Christensen's immense ice wonderlands have attracted huge audiences, captivated by their organic and otherworldly beauty. Aided by twenty or so crew members, the

Based in Alpine, Utah, Christensen has spent the last few years perfecting the craft of making solid structures from icicles, although he developed the process some years earlier. The practice was partly born out of the artist's devotion to his children. Even before experimenting with ice, he would often create artworks and objects to amuse his kids – taking bicycles apart and reconstructing them as child-size tandems, for example. The turning point came when he moved to Utah from California and began to search for outdoor winter activities for his children. After building ice-skating rinks, ice caves and other frozen creations, he decided to construct a fort made entirely of ice. This led him to focus on icicle formations as a construction method, which resulted in a small prototype in his front yard. His children called it an 'ice castle' – a name that has stuck and now lends itself to his ongoing

project. As the home-built structure grew, word got out and he had a steady stream of visitors stopping by to view it. In 2009–10, he got his first commission to create a giant version of this prototype for the Zermatt Resort in Midway, Utah. Since then, every year has presented new opportunities to create even greater castle constructions, including works in Midway's town square (2010–11), Silverthorne (Colorado, 2011–12), Steamboat Springs (Colorado, 2012–13) and the Mall of America in Bloomington (Minnesota, 2012–13). The 2013–14 season included works in Breckenridge (Colorado), Loon Mountain (New Hampshire) and Midway.

A sense of play is at the heart of these works, presenting children and adults with a giant glacial arena in which to have fun and marvel at the amazing formations teased out of nature. Having gathered momentum with each season, the project has become a labour of love, with thousands of man-hours spent creating a fleeting partnership between man and natural science.

Janet Echelman

— IMAGES P. 28 —

Janet Echelman is known for her monumental art installations: intricately woven net sculptures that light up the sky with their billowing, colourful forms. Responding to wind, water and light, these mesmerizing works transform public spaces into contemplative oases. Exploring the potential of unusual materials – from fishing net to atomized water particles – the American artist combines craft with high-tech media to create works that are precisely engineered, yet charmingly ethereal. Notable examples include *Her Secret Is Patience* (2009), spanning two city blocks in Phoenix, Arizona; *She Changes* (2005) on the waterfront in Oporto, Portugal; and *Every Beating Second* (2011) in Terminal 2 at San Francisco International Airport. In recognition of her pioneering work, Echelman has been the recipient of the Guggenheim Fellowship and an inspirational speaker at the 2011 TED conference; an estimated one million people have viewed her *Taking Imagination Seriously* TED presentation online.

While Echelman's talent has won her commissions in cities around the world, her journey towards public sculpture was partly shaped by chance and circumstance. A Fulbright grant was the turning point, enabling her to travel to the fishing village of Mahabalipuram in India, renowned for its sculpture. As a self-taught artist, she had travelled to India intending to paint, but her art materials never turned up. She began working with bronze casters in the village, although this medium

soon proved too much of a stretch for her Fulbright budget. The sight of fishermen on the beach bundling their nets into mounds inspired her to create volumetric forms using lightweight materials. In collaboration with the fishermen, she created her first sculpture using nets, which – when hoisted onto poles to be photographed – was brought to life by the ever-changing patterns of the wind. Enchanted by the results, she continued to study craft traditions. Travelling to Lithuania, she worked with lace makers who introduced her to fine detail, but she wanted to make her work larger, shifting it 'from being an object you look at, to something you can get lost in'.

Returning to India, she worked again with fishermen to make a net sculpture made from one and a half million hand-tied knots (*Target Swooping Down…Bullseye!*, 2001), which was temporarily installed at the ARCO exhibition in Madrid. Collaborations have continued to be an important part of Echelman's work, particularly in her permanent work, which presented a new set of challenges. To create work that would survive the elements long-term, she had to change to more durable materials, such as polyester fibre, and employ the skills of a range of professionals, including aeronautical engineers, architects, lighting designers and fabricators. Despite the hurdles, her team has been able to conjure vast billowing forms more than 100 m (328 ft) in diameter – feats of highly technical engineering – while remaining true to the original craft inspiration. Echelman's evocative and organic forms channel the ebb and flow of the wind, reminding us that nature penetrates even the densest urban spaces. The sheer scale of the work instils a sense of wonder, drawing us to the sculptures as focal points in the city and, as a consequence, reconnecting us with each other through public art.

Leandro Erlich

— IMAGES P. 32 —

Argentinian artist Leandro Erlich is internationally renowned for his extraordinary visual illusions that disrupt our notion of reality. Through installations, sculptures, photographs and videos, he presents a world that is familiar yet different: up is down, inside is out. Scenes of everyday life are meticulously recreated but altered to throw us off guard: for example, windows, doors and lifts do not appear or function as we might expect, and mirrors do not seem to give us a true reflection. By changing one aspect of normality, the artist challenges the viewer to reassess the factors that make up reality. He cites famed magical realist author and fellow Argentinian Jorge Luis Borges as an inspiration, as well as the

cinematic works of iconic directors such as Alfred Hitchcock, Roman Polanski, Luis Buñuel and David Lynch, who 'have used the everyday as a stage for creating a fictional world obtained through the psychological subversion of everyday spaces'.

Erlich's works are intended to be interactive and explored. Although what they present is a deception, we as participants are invited to be in on the illusion. *Dalston House* (2013), an installation commissioned by the Barbican in London, is a perfect example of this exciting approach. For this work, the artist created the façade of a life-sized house and laid it horizontally on the ground. This structure was juxtaposed with a huge reflective mirror hinged at a 45-degree angle, which captured the visitors as they intuitively acted within the creative potential of the scene. Built in an otherwise empty plot in Dalston, London, the house paid homage to the Georgian and Victorian architecture that existed at that location before it was bombed in the Second World War. The artist included historically accurate details such as ornate cornerstones and weathered brick to complete the conjuring trick, so that it worked in both time and space.

International Art Festival, played with mirrors to make the viewer's reflection seemingly disappear. In another work, *Elevator Pitch* (2011), the artist played with our notion of up and down by recreating a 15-m (50-ft) lift shaft and turning it on its horizontal axis; visitors were disorientated as they walked along the inside wall of the shaft towards the lift. Similarly, in one of Erlich's most celebrated works, *Swimming Pool* (first presented in 1999 but on permanent display at the 21st Century Museum of Contemporary Art at Kanazawa, Japan), viewers look down into what seems like a pool to see other fully clothed visitors walking beneath the surface of the water. The trick is created using a thin sheet of glass with water running over it.

Erlich is a master at revealing the extraordinary in the seemingly mundane. By recreating recognizable settings in minute detail and then disrupting them, he presents the viewer with a visual problem that is not designed to deceive; on the contrary, visitors are given the tools to understand and resolve it. As the artist explains, 'Such an engagement with the work involves the viewer's participation and leads to the thought that reality is as fake and constructed as the art; it's a fiction.'

'I wouldn't say my work's about visual illusions; I would say my works have often involved a visual illusion. There's a big difference. The interactive aspect and the scale are crucial as my work proposes an experience based on the recognition of the spaces we use in our daily lives.'

Leandro Erlich

Jean-François Fourtou

— IMAGES P. 36 —

Dalston House was the latest in a series of similar projects involving façades and mirrors installed by the artist in Paris (*Bâtiment/Building*, 2004), Japan (*Tsumari House*, 2006) and Ukraine (*Bank*, 2012). Each installation was created with meticulous attention to local architectural history, so that the buildings seemed to blend seamlessly into their respective environments. Wherever these works have been created, the audience has responded instinctively, with visitors taking their cue to be tactile with the piece, stand on window ledges and otherwise live out impossible, gravity-defying moments.

These spectacular works of contemporary *trompe l'œil* are staged at a large scale to be accessible. However, for Erlich scale is often simply another parameter to be played with, to make the impossible appear possible, with the artist using space to create a false perception. For example, his *Double Tea* (2010), an installation at the Setouchi

Since the 1990s, French artist Jean-François Fourtou has been preoccupied with the evocative theme of childhood memories. Playing on our perceptions of scale, he places his subjects in environments that, though familiar, are disproportionately small or large so that they take on an almost dreamlike quality – an oversized man curled up in a tiny room, for example, or a tiny man at a huge table. From giant giraffes to miniature houses, the artist's sculptures and installations are rendered with delightfully rich detail that is reminiscent of art-house movies such as Jean-Pierre Jeunet's *Amélie* (2001).

Fourtou's work has developed dynamically over time. Since graduating from the École Nationale Supérieure des Beaux-Arts in his home city of Paris in 1992, he has lived in Madrid and New York, and now resides in Marrakesh, Morocco. In the 1990s, he became known for his animal sculptures: geese, giraffes, orangutans and other creatures in mixed media, such as metal and papier-mâché, and a range of sizes, from tiny to life-size to oversize. The animals were installed in unusual places

and juxtapositions so as to create strange surrealistic scenes: for example, a flock of small sheep viewing a giant painting of a sheep in a gallery space or a puzzlingly monumental-sized sculpture of a donkey. These sculptural scenarios seem to comment on man's relationship with and domestication of animals, as well as the incongruity of the natural world in contrast to the urban and art-world environment.

'If I work with different scales, it's to destabilize the viewer and particularly the adult, by making him remember his perspective as a child. By making objects bigger or smaller, I am able to surprise the viewer and add an extra layer to the perception of my work. My work in general – whether I'm creating animals or furniture – is realistic, with the right proportions, even if I sometimes reduce or reverse the dimensions; and it is always placed in incongruous contexts. This leads to a change of perception, with the viewer being destabilized and losing his points of reference. He leaves his routine for a moment. The reaction of the viewer is always fresh, full of curiosity, and with a desire to experience the installation.'

Jean-François Fourtou

The animal world remains a motif in his work today, alongside the theme of architecture, which he approaches in a similarly disorientating fashion. For instance, he recreates houses and interiors but adds an absurd twist, enlarging or reducing the size of people or objects to encourage us to see familiar things in a new way. Many of these architectural experiments are part of a decade-long series of works undertaken at his parents' home near Marrakesh. These include *La maison de géant* (*The Giant's House*, 2007), which was inspired by the artist's childhood room at his great-grandmother's house near

Bordeaux. 'For me, architecture is really a return to primary sensations, and with *La maison de géant* I wanted to rediscover the sensations of wellbeing and protection I had [in that room],' he says. 'I tried to create the spirit of that room, using objects double their original size, as if I were once again a child of five. I was not only recalling a privileged childhood with my grandparents, but also thinking about my daughter – thanks to her, I still live in a childhood universe.' Following on from this idea, the artist designed rooms in which he had to squeeze into the space alongside detailed miniature furniture to create the illusion of shrinking and bewilderment.

Tombée du ciel (*Fallen from the Sky*, 2010), installed on his land in Morocco, pays homage to his grandfather and their house in the small town of Fouras, on the Atlantic coast of France, where Fourtou spent his summers as a child. Built at full scale, it was an ambitious undertaking, realistically reconstructed in every way – except everything is upside down. Accessed via a window, the interior recreates the original atmosphere – from the colour of the plaster to particular plates and cutlery – but the disorientation produces a feeling of unease, 'as if you're on a boat, destabilized by the water', the artist observes. The building is a metaphor for memory, for an important time and place for the artist, which for the viewer can also evoke similar nostalgic feelings and childhood fantasies. In 2012, Fourtou was invited to exhibit a new version of his topsy-turvy house concept for the 'Fantastic 2012' festival in Lille, but this time he was inspired by the traditional Flemish houses he saw there. Over the three-month duration of the installation, it became a central attraction and was visited by 80,000 people.

Katharina Grosse

— IMAGES P. 40 —

The work of German artist Katharina Grosse is rooted in painting, although it is her radicalization of painting as a medium in the creation of stunning large-scale installations that has brought her international acclaim. She first began working in this way in 1998, painting on canvas and directly on gallery walls with an airbrush. The use of a spray gun, which she found immensely liberating, allowed her to speed up her processes and produce work at a scale beyond the immediate reach of her body. Gradually she expanded into the entire gallery space, covering every surface from floor to ceiling, and later introducing unusual materials, objects and sculptures, such as soil, balloons and Styrofoam, as further textural structures on which to paint. While these works can be viewed as paintings, they are also effectively environments that

envelop the artist and viewer within the picture. This revolutionary approach transgresses the traditional formalities of the gallery space to submit to a riot of colour, curious forms and all-encompassing scale.

Grosse breaks all the unwritten rules of formal presentation, but museums and institutions worldwide clamour to work with her, allowing her full access to spaces both inside and out. Big and bold, the results unabashedly collide with existing structures to create new colour-filled landscapes that are lavish and explosive. Remarking on her sweeping use of scale, the artist observes: 'Using paint in such a generous way is also, in a sense, absurd. It's overdone. And I think that's a fantastic artistic strategy, to overdo… It's not just about being a big, beautiful, sensual experience. It does talk a lot about other things. Like anarchy and doing things you're not supposed to do in a funny and amusing way. What you would love to do as a kid: take the felt pen and paint the most beautiful furniture your parents have.'

Recently Grosse's work has extended beyond internal architecture to interact with the exterior of buildings in pieces such as *The Blue Orange* (2012) at Station House, Vara, Sweden. Transforming this otherwise typical municipal building into something unexpected, the artist painted the entire exterior blue and installed a multicoloured tube-like structure that weaves its way around the walls and rooftop. The playful title of the work invites us to question how we would view an orange if it, too, were painted blue. Would we still perceive it as an orange? Similarly, if you transmute a civic building into a vibrant container of art, does it necessarily contradict the building's chief function? Grosse's maverick approach melds painting with architecture and consequently seems to question how we see, use and navigate spaces.

Another exciting work in the public sphere is *Just Two of Us* (2013), an immersive sculptural installation set in MetroTech Commons Plaza, an urban park in downtown Brooklyn. Displayed in clusters among the trees, the work takes the form of eighteen fibreglass-coated shard-like structures resembling boulders, painted in the artist's signature raw and luminous colours. Reminiscent of the glacial boulders in New York's Central Park, these rather more updated versions reflect the vibrant nature of the multicultural neighbourhood. In the words of the director and chief curator of New York's Public Art Fund, Nicholas Baume: 'Katharina Grosse's hybrid approach to painting and sculpture feels very natural in the context of a public space at the centre of a thriving urban area where culture, technology and innovation intersect.'

From canvas to architecture to parkland, Grosse's paintings and installations expand the limits of the way we approach space, encouraging us to see objects, surfaces and volumes as a whole rather than as individual elements. This notion of an expanded view of art's scale and location recalls the theories of American land artist Robert Smithson, whose own works can be experienced by viewers at both a macro and micro level, reflecting his interest in multiple viewpoints. Smithson illustrated his view that 'size determines an object, but scale determines art', as cited in the introduction of this book, with the example of looking at an object through both ends of a telescope to show how a shift in perception can change our understanding of an object's size. In Grosse's expansive and enigmatic work, viewers' perceptions shift as they are immersed within the piece, becoming part of the bigger picture that surrounds them.

Jason Hackenwerth

— IMAGES P. 46 —

New York-based artist Jason Hackenwerth is known for his large-scale balloon sculptures, performances and environments, which have wowed audiences around the world, from the Venice Biennale to the Victoria & Albert Museum in London. Inspired by organic and biological forms, these vibrant creatures are constructed from thousands of biodegradable latex balloons, which, although rooted in the language of sculpture, are akin to painting in their spontaneity. The artist begins by sketching his designs on paper, which helps him to visualize both the forms and the colours. As many of his sculptures are at an epic scale, he has a team of assistants to blow up the balloons while he weaves and twists them into organic forms.

Ethereal, futuristic and full of life, these creatures have a visceral presence that draws you in. The choice of such an unusual medium comes from the artist's desire to connect with a wider audience and create experiential art: balloons are not only accessible but also appealing and uplifting, perhaps because they remind us of childhood. 'One of the things about balloons is that they are very compelling,' the artist states. 'Everyone's attracted to balloons. Your hair is attracted – when I work on balloons in the studio, everything wants to attract to them, they have so much static attraction. On some level they have that effect on people, the way that they are compelled.'

One sculpture that is typical of the artist's approach is *Pisces* (2013), created for the Edinburgh International Science Festival at the National Museum of Scotland. Made from 10,000 balloons, it took three assistants nearly six days to inflate its individual constituents. This work – a complex spiral that opens into a huge seashell-like form – takes its title from an episode in Greek mythology, in which Aphrodite and her son Eros transformed themselves into fish to escape from Typhon, the most feared monster. The artist sees this story as a metaphor for the evolution of life and our ability to transcend our greatest threats in unexpected ways. Symbolically, the spiral reflects the dynamic motion of the universe, the geometry of the sea and plant life, and the double helix that is the blueprint for life.

Scale and space are important considerations for the artist: responding to the surroundings and anticipating the effect on the viewer, he must find a way to activate the space with forms that we – as organic beings ourselves – find compelling. The results – supersized, molecular, almost otherworldly forms in an enchanting, ephemeral medium – take on a theatrical dimension, dislocating them from literal interpretation to trigger and engage with people's imaginations.

Theo Jansen

— IMAGES P. 50 —

Somewhere on the Dutch coast, across windswept sand dunes, is the testing ground for new forms of life: huge beach animals – fashioned using a skeletal base of plastic tubes – that take their energy from the power of the wind. Known as 'Strandbeests', which means 'beach animals' in Dutch, the wild and wonderful creatures are the brainchild of Theo Jansen, an artist and engineer who has been responsible for their evolutionary path for more than twenty years. Performing amazing feats of balance, strength and movement, these mechanical kinetic sculptures mimic the incredible forms and propulsive abilities found in the natural world. But rather than simply imitating animals that exist, Jansen creates new innovative structures that have a basis in engineering and research.

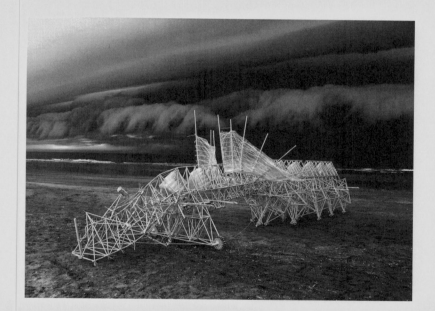

Theo Jansen, *Animaris Percipiere Rectus*, 2005.
IJmuiden, Netherlands. PVC. *c.* 10 × 2 × 3 m (33 × 6 ½ × 10 ft).

The Strandbeests have their beginnings in a computer program developed by Jansen many years ago, in which virtual four-legged creatures raced each other to identify the most efficient designs. It was at this point that he became compelled to put the same idea into practice using plastic tubing – a material that was lightweight, cheap and in plentiful supply – as his basic building block. He continued to run computer models to calculate movement and the perfect walking curve, which he tested using rods held together with cable-ties and nylon strings. The final result was *Animaris Currens Vulgaris*, the first creature to successfully walk on the beach. Later incarnations were constructed in a free-form manner, guided by trial and error. Jansen likens each new

generation of creatures to evolutionary eras; at the end of each era, the deceased creatures are consigned to his studio's 'bone yard', where they can be seen as fossils of extinct species.

With each new generation, the Strandbeests have become more multifunctional – developing wings to flap in the wind, using sensors to identify obstacles and, on detecting an approaching storm, having the ability to hammer themselves into the sand for safety. Each evolutionary step solves different problems. For example, *Animaris Percipiere* has a stomach of recycled plastic bottles, which – with the aid of bicycle pumps – can be used to store wind energy for later. While many of these developments have functional goals, Jansen's creations have a majestic quality – the resulting combination of science and aesthetics – that has awed viewers all over the world. There is an innate attraction to the technical intricacies of the machines, with their futuristic shapes in white and neutral shades laid bare like bones, as they are set in motion. While the wind carries away these vast, complex machines, we as spectators will them on in their life-like endeavours, playing an empathetic role as co-curators of life.

Jansen's work has been exhibited across the world, from London to Munich, from Taipei to Tokyo, in both art and science museums. He has also built up a huge following for his visionary work through the media – particularly online, where videos of his beasts and his inspirational TED talk have attracted huge numbers of views. His mammoth sculptures, set against the expansive dunes, transport us to another world, perhaps another planet where new mega-fauna have evolved. Indeed, the artist's ultimate wish is to release herds of these animals on the shore to live out their lives.

Choi Jeong-Hwa

— IMAGES P. 54 —

The work of South Korean artist Choi Jeong-Hwa spans many disciplines, including fine art, industrial design and architecture. Although nationally and internationally fêted by the establishment, he is seen as something of a maverick who likes to challenge convention. This is shown to great effect in his large-scale installations, which are inspired by everyday items. In his opinion, the strongest expression of Korean art can be found in these ordinary domestic objects. As he explains, 'Things that are colourful, shocking, rough, tacky and fragile – my work can be described by those words.' Jeong-Hwa takes familiar objects that are culturally or symbolically significant and recontextualizes them. For example, in the outdoor sculpture *Dream Tower* (Daegu, 2009), the

artist scaled up ornate porcelain tea cups into a teetering oversize pile. In other works such as *1,000 Doors* (Seoul, 2009) – a colossal public art installation in which the artist encased a ten-storey building with a colourful patchwork of 1,000 used doors – he uses found or recycled materials to make playful structures or displays, turning junk into alternative architecture.

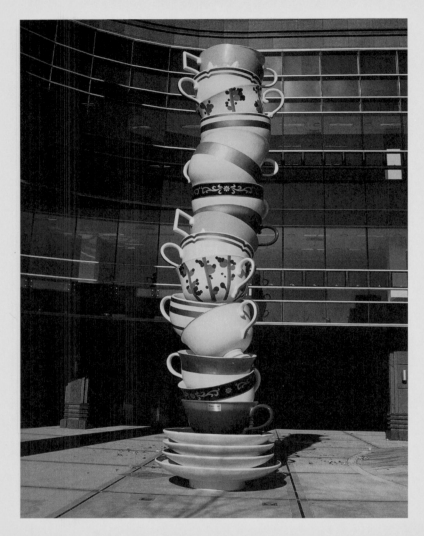

Choi Jeong-Hwa, *Dream Tower*, 2009. Daegu, South Korea.
Reinforced plastic. Dimensions variable.

The artist's use of recycled materials serves many purposes. On the one hand, it highlights consumption and waste in society; on the other, these are items we can all identify with as part of our daily lives. Central to the artist's philosophy is the idea that art should be accessible and enjoyed by everyone, and using common materials such as rubbish is a way of breaking down the barriers. In the project *Gather, Together*, created for the Seoul Design Olympiad in 2008, he used donations from the city's ten million citizens to cover the Olympic Stadium with a beaded-curtain-like structure made from over two million pieces of plastic rubbish, such as water and milk bottles. The artist explored the fine line between art and waste in this work, and in doing so demonstrated that there is a certain beauty in discarded things, and undervalued objects can become grand when they are brought together as a collection.

According to Jeong-Hwa, plastic is his 'master' – a material that does not decompose and looks like new, even when it is old. Many of his works use it in quantity or are inspired by its aesthetic, particularly the kitsch and vibrant products that are mass-produced in South Korea. The attractiveness of the material is a somewhat guilty pleasure, its bold, appealing colours belying its artificiality. The artist's work seems to celebrate the unnatural vibrancy of the artificial, particularly when it is used to imitate nature, such as plastic fruit and flowers, while at the same time commenting on the contradictions between what is real and what is synthetic. This is illustrated by his numerous lotus blossom sculptures, which have become signature works and are displayed in public spaces around the world. The blossoms have been produced at an incredible scale in improbably bright or metallic colours in a pastiche of this ancient Buddhist symbol. At the same time, they seem to rejoice in this form: whether floating on water or swaying in the wind, these inflatable works have motorized fabric leaves that simulate the movement of a real lotus flower, causing onlookers to pause in reflection. In engaging the audience through larger-than-life objects that represent the past and the present, and capture the beauty of nature in the modern urban sprawl, he points to the disappearance of the spiritual as it is replaced by consumerism.

José Lerma

— IMAGES P. 58 —

Based in the USA, Spanish-born artist José Lerma uses an unusual range of materials and supports, including carpet, plastic, parachute fabric and puppets, to create large-scale works and environments that stretch the medium of painting. It was in his final semester of law school that he chose to pursue art: having enrolled in art classes to take his mind off studies, he found the course so inspiring that he dropped out of law school to follow his dream. In contrast to the conventions of law, art was a liberating experience. History has long held a fascination for Lerma, and perhaps for this reason he was initially drawn to 18th- and 19th-century social satire, particularly the work of James Gillray, Honoré Daumier and William Hogarth.

Lerma's interest in history is an ongoing theme in his work – especially the stories of minor figures that might be considered the B-sides of history. This historical outlook was prevalent in the artist's solo exhibition, 'The Credentialist' (2012), at CAM Raleigh, North Carolina. The centrepiece of the show was a room-sized portrait of Charles II of Spain (1661–1700) – known as the 'Bewitched King' – which was made out of carpet remnants and displayed on the gallery floor. The reign of Charles II was disastrous, with the disabled king effectively relegated to the role of figurehead during an ignominious

period of Spanish history. As a result, he is largely a forgotten character in history, more commonly brushed under the carpet than commemorated with a portrait. In this work, Lerma points to the nature of power and corruption – an issue that remains as pertinent today: Charles II, one of the most powerful monarchs in the world, was also one of the weakest. To view the works in the show, visitors had to walk on the face of the king, a feature that the artist makes reference to in the gallery guide: 'I like the thought of people walking over my ideas… examining and stepping over an intimate space while simultaneously feeling small.'

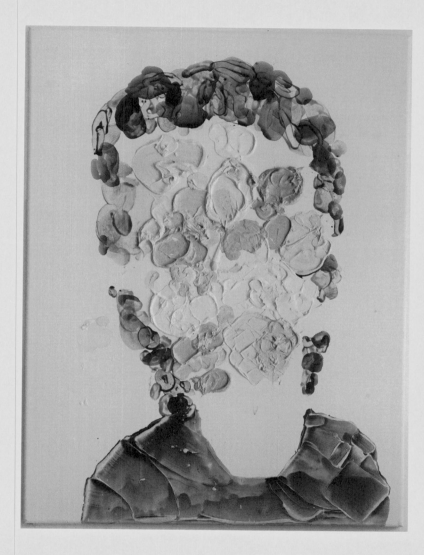

José Lerma, *Untitled*, 2007. Oil and acrylic on canvas.
244 × 183 cm (96 × 72 in.).

Heads recur throughout Lerma's work and include enormous caricatures of bewigged 18th-century bankers and state leaders rendered with blue biro on mixed media. Produced in the style of an intensely detailed doodle, the artist's portraits are experimental but also convey the pomposity of privilege. Some show figureheads in profile in coin-like designs, reminding us of the power and corruption of the bureaucratic state. Others, such as *John Law* (2010), depicting the 18th-century Scottish financier who caused one of the first economic bubble collapses in France, remind us of history repeating itself. Tied to these historical

themes, Lerma brings to the work his own idiosyncratic painting style. If a painting becomes too much about ideas, he tends to sabotage it, making it cartoonish and giving it a personal footprint.

In recent years, Lerma has expanded his preoccupation with the head to include large-scale busts made from sheets of paper. These are done in collaboration with Héctor Madera, a fellow Spanish artist and a former student of Lerma's. In *Bust of Emanuel Augustus*, which was shown at London's Saatchi Gallery in 2012, Lerma and Madera celebrated yet another forgotten figure in history: born in 1975, Emanuel Augustus is a retired American journeyman boxer, known for his clowning in the ring. The artists decided that such a colourful and overlooked character deserved a bust to honour his artistry in the sport. The work is comically outsized, making use of the tactile qualities of the paper, with the swollen shapes abstractly suggesting a man who has spent time in the ring.

Lerma's use of non-traditional materials, from giant balls of coloured paper to canvases held up by electronic keyboards, is an icebreaker. It is both refreshing and accessible, without being too earnest. While the artist does reference art history, his affable approach brings down our guard and enables us to simply enjoy the originality and excitement of the work.

Fujiko Nakaya

— IMAGES P. 62 —

Born in Sapporo in 1933, Fujiko Nakaya is the daughter of physicist Ukichiro Nakaya, who is credited with producing the first artificial snowflakes. Her life-time fascination with the dynamism and metamorphosis of atmospheric phenomena led her to create the world's first fog sculpture using artificially produced water fog at the Pepsi Pavilion at Expo '70 in Osaka. To realize this work, Nakaya collaborated with cloud physicist Thomas Mee, with the support of Experiments in Art and Technology (EAT). She has since produced fog installations at prestigious venues around the world, including the National Gallery of Australia in Canberra, the Guggenheim Museum Bilbao and Place de la République in Paris.

We usually associate sculpture with tangible media. However, a number of high-profile installations may point to a movement in contemporary art towards making work that simulates natural phenomena: Random International's *Rain Room* (2012) at the Barbican, for example, and Olafur Eliasson's *Weather Project* (2003) at Tate Modern, both in London. Pioneering this development towards

elemental and ephemeral media, Nakaya harnesses the atmospheric properties of water fog for artistic means. Her banks of fog have cascaded over, billowed against or enveloped a host of natural and man-made environments, from deserts, hills and rivers to parks and rooftops. The artist adapts the angles and intensity of the nozzles to create convection currents according to the specific location, with sites of vast proportions employing up to 2,000 nozzles.

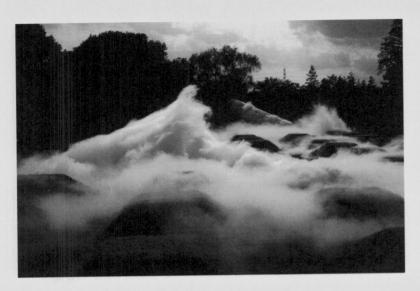

Fujiko Nakaya, *Foggy Forest*, *Fog Environment #47660*, 1992. Showa Kinen Park, Tachikawa, Tokyo, Japan. Water fog, 814 nozzles, 6 high-pressure pumps, 1 timer.

As fog is not a material that can be easily shaped to one's will, Nakaya takes a collaborative approach, factoring in the local atmosphere, air currents and time itself. For instance, in *Fog Bridge, Fog Sculpture #72494* (2013) – a work that marked the reopening of the Exploratorium in San Francisco, a city famed for its fog – the artist created an installation that spanned the 50-m (164-ft) pedestrian bridge between Piers 15 and 17 at the venue. Wind was important to her in programming the fog, but – as she explains – her expressed interest is 'less in how to control the wind than in how to negotiate with it'.

Nakaya's sculptures are reminiscent of conceptual and land art, and the artist sees fog as a medium to experience nature's primal life process. The appeal of fog arose from an interest in what she calls 'decomposition' or the 'process of decaying'. As an art student, she expressed a fascination in natural phenomena that 'repeated form and dissolve themselves' through her depiction of perpetually dying flowers and a series of cloud paintings.

Fog was seen as the life breath of the atmosphere by the ancient Japanese, a source of life, and has long been considered an important visual and metaphorical component of traditional Japanese poetry and landscape painting. In the West, too, it has long been used in literature and cinema to create atmosphere and a sense of mystery. There is something otherworldly about the formation of mist and clouds that makes Nakaya's installations such an enthralling and interactive experience as visitors are enveloped by it. The changing patterns of the

visitors as they move through these sculptures bring a magical quality and accentuate the dynamism latent in the boundaries of the visible and the invisible – the fluctuation that lies at the heart of the artist's work.

Penique Productions

— IMAGES P. 66 —

Based in Barcelona, Penique Productions are a collective of four artists from different disciplines who come together to create ephemeral installations. Their work explores and transforms architectural locations using vibrant inflatable sculptures, which expand to envelop the space, thereby altering the appearance and function of the original interior. While the existing architecture is outlined by the action of air pressing upon plastic, new curves, textures and forms are also created. The use of light is an important consideration as the new space becomes immersed in a single colour. For the viewer, it creates an all-encompassing experience that is simple and direct, yet transports a mundane reality into something strangely unfamiliar. 'The balloon acts as a border and frames a new space,' the artists say. 'The container is also the content, blurring the idea of the art object.'

The project therefore is a symbiosis of an existing space and the new identity that the collective gives it through the coloured inflatable that encases its environment; each location becomes part of the work, with its own distinct atmosphere. This is technically achieved using balloons constructed from regular patterns, with bespoke adjustments made to fit the characteristics of each location. It is an idea that has evolved over time but began with the installation *Espai 1* (*Space 1*, 2007), exhibited at Barcelona University. As the artists explain, the aim of this work was to 'investigate the possibilities for creating an inflatable and invasive sculpture that would block the public's access to the exhibition space, thus generating a reaction that would itself complete the piece'. The results, however, drew attention to the potential of the inflated interior space, an unexpected outcome that set the team on its current path.

Further explorations led the group to try their hand at more domestic settings. For *Bathroom* (2009), installed at Nottingham Trent University, they stripped this familiar environment of its usual function by essentially vacuum-packing the toilet, sink and other elements and turning it into a work of art. As opportunities have arisen to work across the globe, including Mexico, Brazil and Italy, the collective's installations have increased in scale. *18 Clocktower Place* (London, 2010), for example, consumed an entire six-room apartment, enveloping

the space and all the furniture in coloured plastic. For *La capella* (*The Chapel*, Piera, Spain, 2009), the group covered the interior of the 16th-century Gothic chapel of Sant Sebastià in pink plastic. The centrepiece of this intervention was a blue neon crucifix, 4 m (13 ft) tall, set against natural light that streamed in from the outside. As a result, the installation gradually changed colour depending on the time of day, creating a contemporary interpretation of the original architecture.

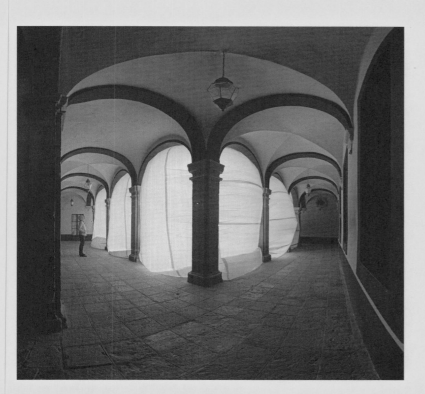

Penique Productions, *El claustro* (*The Cloister*), 2011.
Querétaro, Mexico. Inflatable plastic. 10 × 10 × 11 m (33 × 33 × 36 ft).

Making reference to the work of artists such as Christo and Jeanne-Claude, Rachel Whiteread and Ernesto Neto, among others, these temporary building takeovers explore the art of revelation through concealment, negative space and the relationship between full and empty. While many of their projects tackle huge architectural volumes, creating spaces that can accommodate many participants, others draw attention to intangible spaces. *Forat de l'escala* (*Stairwell*, Barcelona, 2010) is one such work: a 16-m-high (52-ft) stairwell – a functional but uninhabitable piece of architecture – blanketed in coloured plastic, which draws attention to a space that we might otherwise have overlooked. By creating new sensations with colour and light, Penique Productions compel us to consider spaces in new ways.

Kurt Perschke

— IMAGES P. 70 —

Kurt Perschke works across various media, including sculpture, video and collage, but it is through a series of temporary public artworks in particular that he has come to international attention. His celebrated *RedBall Project* has been seen by an audience of millions and taken the New York-based artist all over the world, including the USA, Canada, the UK, Spain, the United Arab Emirates and Australia, among other places.

The *RedBall Project* has a simple premise: by integrating a 4.5-m (15-ft) inflatable red ball into selected architectural spaces, the artist encourages us to engage with the object and, through the experience, reimagine the cities we live in. The ball squeezes into passageways, rolls under and over bridges, and finds its way into all sorts of unusual places, to the bemusement of unsuspecting passers-by. Perschke has actively promoted inclusivity since he started the project in 2001, welcoming suggestions as to where the ball should travel next and inviting everyone to take part.

The playful simplicity of the red ball is a great part of its success: there are no language or cultural barriers in the way we view the object and its location, its soft form and intense colour contrasting with the hard lines of the buildings. The ball's larger-than-life appearance marks it out as something unexplainable or out of the ordinary: a giant red dot, reminiscent of a marker on a map but at a theatrical scale, like an escaped circus prop. This is particularly true if we view it through the medium of photography: a photograph of the ball in situ heightens the sense of disjointedness, as though a global mapping system has marked a location in real life with a huge three-dimensional red spot. 'On the surface,' Perschke explains, 'the experience seems to be about the ball itself as an object, but the true power of the project is what it can create for those who experience it. It opens a doorway to imagine what if? As *RedBall* travels around the world, people approach me on the street with excited suggestions about where to put it in their city. In that moment the person is not a spectator but a participant in the act of imagination.'

As the ball has travelled further afield, the project has grown apace and its fame has spread. Residents begin to imagine what it might look like in their city, and where it will end up amid the local landmarks and buildings, providing a visual link with other cities on the ball's trail. Perschke sees his role as a catalyst for new encounters within the everyday. How each city responds to the invitation to engage with the ball reveals the greater purpose of the project: to cast a light on our individual and cultural imagination as the ball's story gradually unfolds.

'To me, scale is one of the great muscles of sculpture. Size is simple but scale is complex, and **RedBall** plays with the relativity of scale constantly. The three points in the relationship – the body, the site and **RedBall** – shift perceptually with each placement. The sites allow it to move from grand awe to a kind of marker for how we ourselves are often packed into a city. I believe working publicly is not just about being on the street: the work has to live in the public imagination.'

Kurt Perschke

Jaume Plensa

— IMAGES P. 74 —

Jaume Plensa is a Catalan artist who is internationally renowned for his monumental figurative sculptures. He has been creating public sculpture since 1992 and received commissions from around the globe. However, the pivotal work was *Crown Fountain* (2004), installed in Millennium Park, Chicago. For a long time, Plensa had dreamed of an 'art totale',

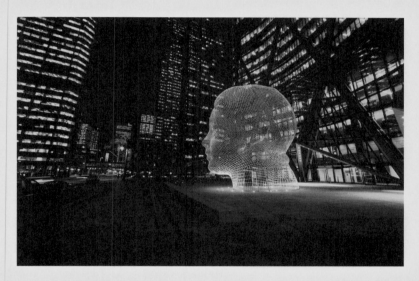

Jaume Plensa, *Wonderland*, 2012. Calgary, Canada.
Painted stainless steel. 12 m (39 ft) high.

a piece that would combine the contrary disciplines of photography and sculpture. 'While photography captures the moment,' he explains, 'sculpture thinks about eternity.' *Crown Fountain* was the realization of this dream. Consisting of two opposing, 16-m-high (52 ½-ft) glass towers, linked by a pool of water, the work features two large video screens that play moving close-up images of a thousand Chicagoans on a random loop, as if in conversation. The giant faces intermittently spit a jet of water into the pool like modern-day gargoyles through an outlet in the screen. The videos are a homage to the residents of Chicago, while the artist also cites the local children who naturally gravitate to the work as an important link between the art and the people.

The architectural scale of *Crown Fountain* undoubtedly added to the grassroots success of the work. In particular, Plensa considers the social dimension of public space by creating a Mediterranean-style plaza – an area where people can gather – between the towers. While his work pushes technical and visual boundaries, it remains accessible. Similarly, his subject matter reflects ordinary people by immortalizing

them at monumental size, a theme exemplified in his ongoing series of head sculptures. Ranging from 1.7 to 20 m (5.5–66 ft) in height, some of these head sculptures are made from translucent resin, lit from within; others are built with metal mesh, suggesting 3D computer graphics. Since 2009, Plensa has been producing gigantic heads of girls. *Echo* (2011), a 14-m-high (46-ft) sculpture of a girl's head in Madison Square Park, New York, is a particularly striking example. Made from polyester resin, fibreglass and marble dust, this extraordinary apparition rises from the grass like an apartment block. The model was the 9-year-old daughter of a man who runs a Chinese restaurant near the artist's studio. The process of making these head sculptures starts with the artist taking digital photographs of the subject. Computer modelling is used to elongate and simplify the face, transforming the image into an iconic portrait rather than a wholly realistic one. A prototyping machine then creates a scale model of the result, which the artist recarves until, finally, after repeating the process over and over again, the full-size mould is cast.

Recently Plensa has become known for his *Souls*, a series of works – often depicting large, crouching figures – made from alphabet latticework. The use of letters is symbolic, as he explains: 'Letters are graphically very nice. They were revised and cleaned up over the generations, until reduced to essential signs. Can you imagine a better way to represent a culture than with the alphabet? I do not know, I am trapped by it.' *Body of Knowledge* (2010), an 8-m-high (26-ft) stainless steel sculpture commissioned by the Goethe University in Frankfurt, Germany, is a fine example: a human figure made from a volume of letters, the fundamental tools of communication. The artist views the body as the home of the spirit but also a meeting place, where our ideas and various experiences can live, converge and flourish. University, he explains, is an extension of the body, 'a gathering space in which people and ideas, tradition and future, meet to converse, weaving the mesh of human knowledge.'

Nikolay Polissky

— IMAGES P. 80 —

The work of Russian artist Nikolay Polissky could be described as utopian, integrating principles of land art and art for social regeneration. With a singular vision, he creates vast architectural structures and site-specific installations using local and natural materials. Since 2000, most of his works have been created within the village of Nikola-Lenivets, in the Kaluga Region, a four-hour drive from Moscow, and in

co-authorship with the local villagers. This semi-abandoned village has been rejuvenated through art, turning it into a cultural centre with its own annual festival of landscape architecture, 'Archstoyanie', which has attracted further visitors.

Polissky takes inspiration from symbolic forms in world architecture and interprets them in the Russian landscape using readily available materials. Examples of his work include a Roman aqueduct made from snow (*Aqueduct*, 2002), a Mesopotamian-style ziggurat made of wheat sheaves (*Hay Tower*, 2000) and a homage to the pioneering Russian architect Vladimir Shukhov's radio tower (*Media Tower*, 2002), fashioned from branches. Making use of traditional village craft skills, Polissky's creations reduce architecture to basic forms, revealing a universalism in archetypal constructions common to different societies, but also in the animal kingdom — for instance, in a bird's nest or a beaver's dam.

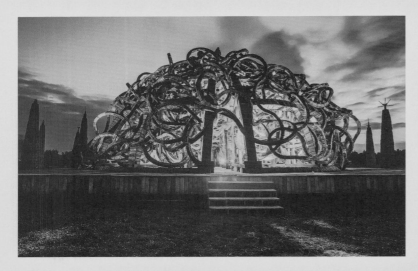

Nikolay Polissky, *Universal Mind*, 2012. Village of Nikola-Lenivets, Kaluga Region, Russia. Timber. Dimensions variable.

During the 1980s, Polissky studied ceramics and later became a member of the Mitki group of artists, a social and aesthetic movement originally based in St Petersburg. Without specific artistic principles, the Mitki represented an artistic spirit that expressed the transitions taking place in Russia during the 1980s and '90s. In 2000, he began his career as a land artist with *Snowmen*, his first work at Nikola-Lenivets. Together with Konstantin Batynkov and Sergey Lobanov, he conjured up a surreal scene: an army of snowmen — 220 in total — marching across the wintry fields. Neighbours from the village also joined in. The work recalls a local historical event in which a Mongol army stood opposed by Russian troops; to boost the numbers of visible troops, the Russian army built extra guards out of snow.

Other monumental projects soon followed, including the aforementioned *Hay Tower*. For this project, Polissky teamed up with groups of volunteers to build the ziggurat-like structure, constructed by laying hay along spiral ramps on wooden bases. The artist had originally intended the finished tower to be used to feed cattle, but the hay began to rot, so it was turned into a ceremonial pile and burned — an idea that

was carried through to the next project, *Firewood Tower* (2001), in which an enormous woodpile castle was summarily burnt to the ground. With every passing year, Polissky has tried his hand at evermore ambitious projects, from *Aqueduct* and *Media Tower* to *Nizhny Novgorod Ice-run* (2004), a structure reminiscent of the Tower of Babel with a 280-m-long (919-ft) slide, and *Firebird* (2008), a metal firebird as big as a house.

Perhaps one of the most stunning works by Polissky and his collective is *Large Hadron Collider* (2009), which was exhibited at the Musée d'Art Moderne Grand-Duc Jean (Mudam) in Luxembourg. This huge installation made from wood, which emulates the workings of the iconic particle collider, is a symbolic celebration of man's scientific progress. The artist views scientists almost as oracles, privy to secrets of the universe that are hidden from ordinary people. In this sense, the scientific worldview, like the magical or religious one, can only be taken on faith. *Large Hadron Collider* therefore takes on the properties of a mystical machine 'from which God may emerge', to quote art historian Irina Kulik. Enormous projects such as this are a communal expression to be enjoyed and experienced by everyone. Polissky believes that 'all life can be art and that anyone can be an artist if they live an artful life'.

Jorge Rodríguez-Gerada

— IMAGES P. 86 —

Celebrated artist Jorge Rodríguez-Gerada is known for his large-scale urban interventions, above all the captivating portraits that he skilfully executes in a variety of different media, from charcoal to earth. His approach to urban art has evolved over time, influenced by his upbringing and willingness to experiment and develop as an artist.

Born in Cuba but brought up in the USA from the age of three, he moved to Manhattan when he was nineteen. In the 1990s, he became one of the founders of the New York City culture jamming movement with the group Artfux. Using guerrilla art actions, the group targeted the disproportionate number of billboards promoting unhealthy products such as alcohol and cigarettes in deprived areas. By essentially hijacking billboards and altering the messages of high-profile brands in clever, original ways — manipulating letters to change the meaning of words, for example, or tweaking brand logos to make satirical social commentaries — they hoped to give the community an alternative voice

and open up a dialogue. Rodríguez-Gerada's approach focused on the faces of the cultural icons chosen by the advertisers: by replacing them with portraits of anonymous people, he questioned the controls imposed on public space. By 1997, having become disillusioned with culture jamming, which he felt was increasingly motivated by self-promotion, he switched to working independently to explore new areas – altering street signage, for example.

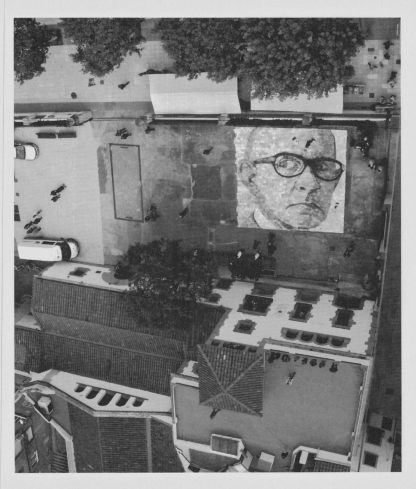

Jorge Rodríguez-Gerada, *Tribute to Salvador Espriu*, 2012.
Arenys de Mar, Spain. Open books, spray paint.

In 2002, he moved to Barcelona and started his *Identity Series*, which marked a new creative chapter. Inspired by the rich textures of the city, he explored the role of public space in more depth, rendering gigantic charcoal portraits of local people on the weathered walls of carefully selected buildings. 'I decided to apply the same approaches used by advertising, such as strategic positioning and size, but with the intention of creating a poetic counter commentary that fades away with beauty,' he explains. 'These portraits transformed local, anonymous residents into social icons, giving relevance to an individual's contribution to the community and touching upon the legacy that each life has to offer.' The charcoal gradually fades over time and becomes a metaphor for the passing of life, fame and everything that once seemed important.

With the *Terrestrial Series* (2008–ongoing), he began to work at a geographic scale with interventions ideally viewed from above, using aerial photography. The series intends to highlight important social issues, work in harmony with the local environment and, like his *Identity Series*, leave no lasting impact. One stunning example is *Mama Cash* (2012), a huge portrait made from earth and straw, spanning almost two football fields. The work, which depicts an anonymous female human rights activist, was created to mark International Human Rights Day and promote awareness of the *Vogelvrije Vrouwen: Defend Women Who Defend Human Rights* campaign in the Netherlands. The massive piece was assembled over a period of a week and involved eighty volunteers. The process of creating the work, using communal labour to impact directly on the earth, is as much part of the concept as the final piece.

Every aspect of Rodríguez-Gerada's work is deliberately chosen to emphasize what he is trying to say. In making us question the way advertising in particular encroaches on public space with its targeted messages, the artist adopts the industry's own tactics – massive scale, strategic location, eye-catching images – and uses them against it.

Adrián Villar Rojas

— IMAGES P. 90 —

The curious and colossal installations of Argentinian artist Adrián Villar Rojas are reminiscent of the post-apocalyptic ruins of a collapsed future civilization. Made principally from clay, his larger-than-life pieces often take the form of robotic or hybrid beings from another world: roughly hewn, dusty and even crumbling in appearance, these alien structures rise up like ancient monuments in a forgotten city. Clay is an elemental and traditional material, but in Rojas's hands it becomes both contemporary and prophetic: 'It makes an instant ruin – this is the gift the material gives us,' says Rojas.

Rojas is known for his use of clay, often mixed with cement, burlap and wood, but this choice of material was at first accidental. In 2008, he moved from his home city of Rosario to his first studio in Buenos Aires. While preparing for a show, he discovered a 5-kg (11-lb) bag of clay sitting in the space. Without any traditional training in sculpture or particular impulse to work in this way, he created a sculpture of a small whale. His previous work had primarily consisted of mixed-media installations that combined different disciplines, such as drawing, video and painting. The medium for him is not so much the main interest as the occupation of space, but he found himself at home with clay: it was approachable, and the opposite of the highly conceptual projects he had been used to. From then on, he began to create larger pieces using tons of clay, eventually revisiting the whale subject with a much bigger

rendition, *Mi familia muerta* (*My Dead Family*, 2009) – a sculptural installation of a whale corpse, laid with care in a leaf-covered forest as part of the End of the World Biennale in Ushuaia, Patagonia.

Over the next few years, Rojas's work gained a significant following. In 2011, he was invited to represent his country at the Venice Biennale where he installed what has become a pivotal work, translated as *Now I Will Be With My Son, The Murderer of Your Heritage*. Filling the 250 m² (2,690-sq.-ft) pavilion from floor to ceiling, the artist's groups of oversized sculptures towered above the viewer like a dystopian science-fiction film set. With this work, Rojas was asking what the final art made by humans might look like, if we were to disappear from the face of the earth. The sculptures suggest a future of hybrid organic and mechanic forms, while the viewer remains dwarfed and in awe of this gargantuan artistic vision. The message is not intended to be overt; Rojas prefers to view his own work like 'a form of "film", in the sense that when you were viewing one layer, you could not see the next'. As he has continued to produce pieces at a huge scale, to make these monumental, hand-built creations Rojas works with a team of builders, engineers, sculptors and assistants. The finished piece is often the product of creative discussions and teamwork. 'I take the position of a director,' he says. 'I assemble a team and direct as if it were a film crew.' When asked to comment on the use of spectacle and scale in his work, Rojas replies: 'In order to immerse people, I need time, and to have time, I need space. Time is created by space, which often affects the scale of my work.'

Tomás Saraceno

— IMAGES P. 94 —

Visionary artist and architect Tomás Saraceno creates inflatable and floating biospheres that draw their inspiration from cloud formations. He has also started to work on the construction of three-dimensional spider webs, which he uses as objects of study and models for highly complex thread-and-knot-structures. His modular constructions could therefore be perceived as either the result of a process of experimentation or utopian designs, ranging from cloud cities to flying gardens to more practical engineering approaches to collecting water or improving solar-power efficiency, for example. Through his work, which combines artistic vision with engineering and scientific expertise, Saraceno creates forward-thinking projects that suggest futuristic dreams may become a reality.

Saraceno was born in Argentina, where he studied art and architecture. In 2001 he enrolled at the Städelschule in Frankfurt, and in 2009 he presented his first large-scale installation at the Venice Biennale. Soon he was being invited to create increasingly ambitious large-scale installations by world-renowned museums and galleries, such as the Barbican in London (*Cumulus*, 2006), the Hayward Gallery in London (*Observatory: Airport City*, 2008), the Hamburger Bahnhof in Berlin

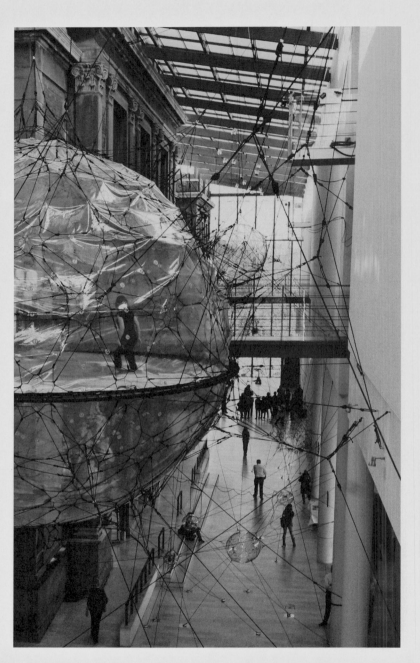

Tomás Saraceno, *Biosphere*, 2009. Statens Museum for Kunst, Copenhagen. Acrylics, rope, nylon filament, net, plants, air pressure regulator, hydrating system, distilled water. Dimensions variable.

(*Cloud Cities*, 2011) and the Metropolitan Museum of Art in New York (*On the Roof: Cloud City*, 2012). Many of his projects invite audience interaction, for example *On Space Time Foam* (2012), exhibited at the HangarBicocca in Milan. This multilayered installation of translucent PVC membranes, inflated with air, acted like a giant trampoline, allowing participants to bounce and slide across its surface and achieve the dreamlike sensation of floating. Measuring 24 m (79 ft) in height and 400 m² (4,300 sq. ft), this improbable construction was made possible

by extensive testing, while health and safety demanded the careful distribution of people within the interconnected ecosystem.

Connectivity is a central theme in Saraceno's work, reflected in the geometric mode of construction and the artist's aim to create habitable networks. These networks emphasize not only the ecological structure of natural environments, but also of social spaces and communal connections. Beyond the spectacular visual and sensorial effect, Saraceno appeals to the creative ability of his viewers by involving them in actions that demand their participation, ingenuity and responsibility. Each work is an invitation to consider the way we live, our feelings and interaction with others. At the same time, these pieces demonstrate the possibility to transform the world through collaboration with others.

Saraceno's utopian ideology has been likened to the work of American architect and futurist Buckminster Fuller, famous for his development of the geodesic dome and for promoting the idea of 'Spaceship Earth' – a term describing our planet that calls on us to manage its limited resources more effectively. Fuller's radical conceptions of the universe linked architecture not only to engineering, but also to the macroscales of the cosmos and the microscales of Planet Earth, ideas that Saraceno has further developed in his own work. Saraceno's spellbinding installations open our eyes to astronomical and molecular scales that are normally beyond the limits of our everyday experience.

Nike Savvas

— IMAGES P. 100 —

Through her large-scale sculptural installations – ranging from labyrinths of coloured plastic strips to rainbow webs of geometrically woven threads to galaxies of shimmering spheres – Australian artist Nike Savvas explores colour and space. Having begun her artistic career with painting, she found herself naturally gravitating towards three-dimensional work: 'All of my studies majored in painting,' she says, 'but even at that time, I always sought to work outside the canvas. I have an aversion to categorizations and prefer to see art as more fluid, open and malleable – where everything is up for grabs. I like the possibility of creating a brand new animal.' The resulting colour-infused environments share similar attributes to paintings but with added depth, light and movement – qualities that change as visitors immerse themselves within the piece.

One of Savvas's most influential works is *Atomic: Full of Love, Full of Wonder* (2005), first exhibited at the Australian Centre for Contemporary Art in Melbourne. This extraordinary installation featured 100,000 ping-pong-sized coloured balls suspended on horizontal wires throughout the gallery space to create a moiré effect. Originally

manufactured as fishing floats, the polystyrene balls were transformed by the artist's application of colour and energized using fans to create a shimmering multidimensional spectrum. Visitors viewed the installation as they would a painting but had ever-changing perspectives as the balls oscillated gently on the wire in an almost galactic display.

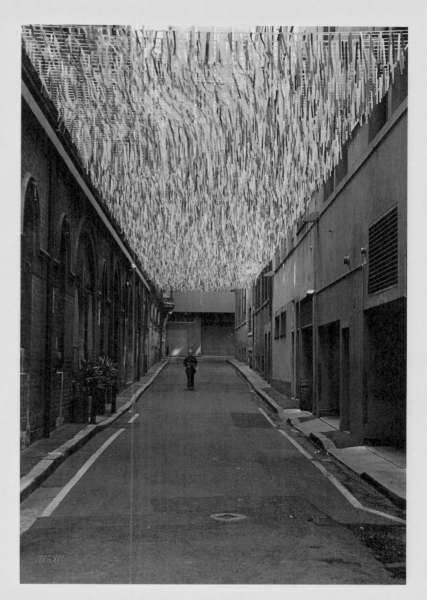

Nike Savvas, *Rush*, 2010. Bridge Lane, Sydney, Australia. Biodegradable plastic. 10 × 46 m (33 × 151 ft).

Many of Savvas's works are transient in nature, created to last the duration of an exhibition, such as *Rush* (2010). This Laneways Commission – an initiative to reinvigorate Sydney's lanes with art – was installed for one month in the open air of the city's Bridge Lane. In trademark fashion, the artist chose unusual materials: thousands of multicoloured strips of plastic ticker tape, hung above the entire length of the lane to create a floating ceiling of bunting. Whenever the breeze blew through the passageway, it animated the coloured strips in a celebration of light and movement.

Savvas's work has been described as straddling 'Zen and disco', which sums up her broad appeal. She does not want to make art solely

'I have been drawn to working on a large scale with a number of works. The intended function and the approach taken tend to differ relative to the specific needs of each work. Large-scale works embody a number of different considerations. These works focus less on the production of objects and place more emphasis on the creation of immersive environments and sensorial experiences to transport the viewer to other realms. The scale of these works functions to immerse the viewer optically and physically, while colour activates and triggers the senses. While this may transport us to a temporary state of elation, it also invites the unwelcome prospect of bewilderment and crisis that may ensue from optical overload and spatial disorientation.'

Nike Savvas

for the elite, she says. In the first instance, she finds that people seem to respond to her work on an experiential level. For example, her lauded solo exhibition 'Liberty and Anarchy' (2012–13) at Leeds City Museum in the UK gave her the freedom to work on a much larger scale than usual and to maximize the ways in which visitors could experience and interact with the works. The central piece was a deep labyrinth of eighteen tall screens, each made up of bright plastic strips running from top to bottom and tightly spaced to create a wall of colour. The screens were stacked one behind the other but allowed visitors to move between them and immerse themselves in the work. The overall effect of the overlapping colours as the visitor moved deeper into the piece created an unsettling experience.

This experience of colour is key to Savvas's work. She believes there are two responses to colour – a cultural one and a psychological one. 'The cultural response includes the idea of colour,' she says. 'It's clear this piece acknowledges a history of artists who worked with colour and its psychology. And though sensation itself might be dwelt on, you see the piece properly if you also see it as an idea of sensation (and I think it still allows you to ask the question: is not nature, after all, always better?). It's an idea expressed in a mixture of actual sensation, physical objects, and references to other things, ideas and artworks.'

Doug and Mike Starn

— IMAGES P. 104 —

A fishing boat made from bamboo poles sits above a canopy of leaves to create an expansive, organically constructed platform in the heart of the forest. Situated on the island of Teshima in Japan, with views of the Seto Inland Sea in the distance, this breathtaking sight – part sculpture, part architecture – is a piece (*Big Bambú #8*, 2013) by maverick American artists Doug and Mike Starn, who over the past few decades have become known for their groundbreaking and category-defying work. The Starns, who are identical twins, first gained international attention at the 1987 Whitney Biennial and are widely known for their conceptual work with photography, probing into ideas of chaos, interconnection and interdependence. Within their diverse practice, they combine traditionally separate disciplines, such as photography, sculpture, site-specific art and architecture – a talent that is perhaps most evident in their *Big Bambú* series.

Big Bambú started in 2008, when the Starns moved to their new studio in Beacon, New York. At 98 m (320 ft) long and 15 m (50 ft) high, the space allowed them the opportunity to work at a vast scale.

The first artwork in the series, made by lashing together bamboo poles, was a massive structure that evolved daily, with each new form captured on camera. In a continual performance, the initial structure grew larger and eventually reached out in an arch and touched the ground, at which point the back of the structure was dismantled pole by pole. These poles were carried through the structure and over the arch, and attached to the front, creating a forward momentum so that the structure gradually moved through the space like a caterpillar. Without scaffolding or support, the structure was in constant evolution and involved a team of eight to fifteen rock climbers at a time. The evolving artwork explored the concepts of self-organization, adaptation and the interconnectedness of all things.

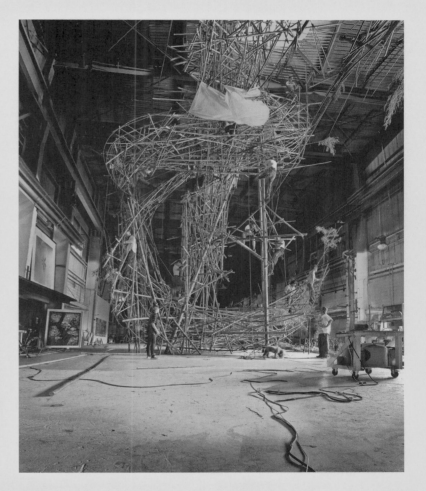

Doug and Mike Starn, *Big Bambú*, 2009. Beacon, New York, USA.
Cover image for *T Magazine* (*The New York Times*).

The first public outing of *Big Bambú* – subtitled *You Can't, You Don't, and You Won't Stop* – came in 2010 with the invitation to create a site-specific installation in the roof garden of the Metropolitan Museum of Art in New York. Constructed over a period of six months, the monumental structure – made up of 7,000 bamboo poles – stood 30 m (100 ft) long, 15 m (50 ft) wide and 21 m (70 ft) high to form a cresting wave above Central Park. It was open to the public during its construction, suggesting an ever-changing living organism. 'The reason we had to make it so big is to make all of us feel small – or at least to awaken us to the fact that individually we are not so big,' Doug

Starn explains. 'Once we're aware of our true stature, we can feel a part of something much more vast than we could ever have dreamed of before.'

After attracting record-breaking attendance at the Met, other iterations of *Big Bambú* have followed, including a vast spiral at the former United States Consulate for the 54th Venice Biennale in 2011. Despite the beauty and importance of the organic materials and the use of hand-made methods, in their artist statement the Starns say that the concept of the series has nothing to do with bamboo: *'Big Bambú* is the invisible architecture of life and living things. Every person, every culture has been built with this architecture. That architecture is chaos, random interdependence of moments, actions becoming interactions, trajectories intersecting – creating growth and change.' The Starns' magical architecture reflects what it means to be alive – to be forever evolving and changing, not only as individuals but also as a culture, a society, a city – and plays with scale to challenge our perceptions of our place in this world.

Jason deCaires Taylor

— IMAGES P. 108 —

British artist Jason deCaires Taylor has become internationally acclaimed for his underwater sculptures. Installed on the seabed, these predominantly figurative works are transformed into artificial reefs, which in turn increase marine biomass and provide a habitat for fish species. As well as providing an attraction that diverts tourists away from more fragile natural reefs, they often have an environmental message.

The roots of Taylor's extraordinary mission lie in his background: born to an English father and a Guyanese mother, he grew up in Europe and Asia, where he spent much of his early childhood exploring the coral reefs of Malaysia. Later he was able to follow this passion to become a fully qualified diving instructor and underwater naturalist, as well as studying sculpture in London and achieving a degree. The idea to create sculpture in an aquatic setting seemed like the perfect synthesis, combining his practical and creative skills as an experienced diver and award-winning underwater photographer with an environmental calling.

In 2006, Taylor created the world's first underwater sculpture park, situated off the coast of Grenada in the Caribbean, which paved the way for works on an even grander scale. In 2009, he co-founded the Museo Subacuático de Arte (MUSA) – an underwater sculptural museum that features more than 500 permanent life-size sculptures by deCaires and other artists – off the coast of Cancún, Mexico. Both sites are intended to facilitate 'positive interactions between people and fragile underwater habitats, while at the same time relieving pressure on natural resources'.

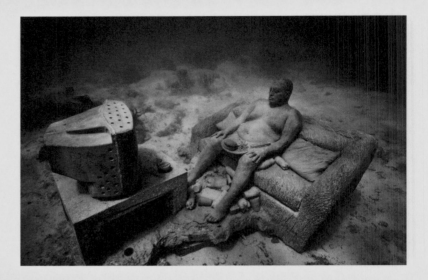

Jason deCaires Taylor, *Inertia*, 2011.
MUSA Collection, Punta Nizuc, Mexico.
Depth 5 m (16 ft).

Designed to attract marine life, Taylor's sculptures are made from Ph neutral, environmentally friendly materials and often feature live transplanted coral. They tend to be life-size and are produced in large clusters to create impact. One stunning example is *The Silent Evolution* (2010), which has created a monumental artificial reef in Mexico in an otherwise barren area. Comprising more than 400 casts of individuals, this work symbolically represents humanity's responsibility towards the oceans. In a scene that calls to mind the ash-covered victims of Pompeii, the figures stand with their eyes shut. Still and contemplative, they meditate their fate, conveying both loss and hope.

Such interventions promote organic growth and transformation, as the artist explains: 'It's environmental evolution, art intervention as growth, or a balancing of relationships.' Part of the beauty of these submerged environments is that they are intended to change as they are subsumed by nature. Taylor's subjects become ghostly as algae, seaweed and coral take hold, obscuring their likeness as they gradually turn into a symbiosis of man and nature. While the artist's photographs capture the atmospheric scenes, he encourages visitors to view the works in person to feel a sense of discovery and participation. Seeing the works first-hand is an intimate, personal experience, with each viewing shaped by factors such as the changing light and currents. It is also the best way for visitors to understand the importance of conserving our precious reef ecosystems.

Pascale Marthine Tayou

— IMAGES P. 112 —

Born and raised in Nkongsamba in Cameroon in 1966, Pascale Marthine Tayou has become something of a nomad over the years, basing himself in Stockholm, Paris, Brussels and, more recently, Ghent. This nomadism, as noted by *New York Times* art critic Roberta Smith, is also evident 'in the materials he uses, in his artistic sources, and in the way he thinks'. He employs a rich variety of media in his work, which includes installation,

'The world is big and wide and we shouldn't only look at that space in terms of square metres. What I'm primarily interested in is sharing what's inside of me, and I don't think there can ever be enough space to express that artistic vision.'

Pascale Marthine Tayou

sculpture, drawing, photography and video, approaching it with an all-embracing spirit and inventiveness. His themes are often personal, such as family and life in Cameroon, but he also explores more existential issues — for example, Aids, the effects of globalization and urban contemporary life. Tayou's temporary exile affords him an interesting viewpoint, allowing him to explore Africa and its identity from afar while drawing attention to how people from different countries are perceived around the world. In this way, he does not see himself solely as an African artist but as part of a new post-colonial culture, fusing homeland and Western experiences.

Since his invitation to the Gwangju Biennale in South Korea in 1995, Tayou has had the opportunity to travel widely and has exhibited in many cities around the world, including Sydney, São Paulo, Venice, Liverpool

and Istanbul. His work is often site-specific, influenced by his experiences of visiting new places. Tayou prefers to work with found everyday materials, and a by-product of travelling is that he collects ephemera from his journeys — symbols of people's travels, such as ticket stubs and postcards, which he then reuses and recycles in his work, almost in a diaristic way. He also repurposes materials to highlight our throw-away consumer culture. This is exemplified in his iconic work *Plastic Bags* (2001–11), which has been installed in various locations around the world, including France, Italy and Australia. At almost 10 m (33 ft) tall, this sculpture is made up of thousands of coloured plastic bags that form a monolithic drop-like shape. It is a spectacle of the excess we see around the world, making its impact felt in sheer volume. The artist compares plastic bags to humans, calling them both 'useful and dangerous'.

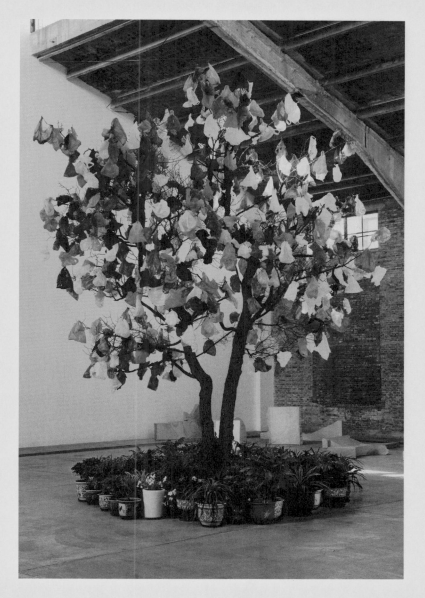

Pascale Marthine Tayou, *Plastic Bag Tree*, 2010. Wild pear-tree (*pyrus pyraster*), plastic bags, Chinese pot plants, flowers, soil. Dimensions variable.

Despite the global reach of Tayou's work, Cameroon remains at the heart of it, as he says: 'I was born and raised there, by my parents, my friends and the street. I want to include all that in my work.' Indeed, the

extraordinary eclecticism of his work often calls to mind the vibrancy of African city streets, particularly in the ingenious conglomerations of materials, which evoke the recycling that is done out of necessity in Africa and the developing world. This can be seen in *Home Sweet Home*, exhibited at Mudam in Luxembourg in 2011. The installation took the form of an aerial city – constructed from birdcages, African statuettes and a network of wires, headphones and speakers, which broadcast the sound of birds – perched on a structure of wooden posts. This dreamlike edifice presents an imaginary world that seems to evoke the chaotic growth of urbanization and the fetishization of Western consumerism. Tayou's use of found and natural materials in this vast construction suggests the workings of a cargo cult attempting to emulate a Western model, while its entire precariousness hints at its inevitable downfall.

Motoi Yamamoto

— IMAGES P. 116 —

Japanese artist Motoi Yamamoto is internationally acclaimed for his intricate, large-scale installations using the medium of salt. With meticulous attention to detail, the artist casts salt by hand into vast labyrinths or simple, elegant forms such as cherry blossoms and paper boats, in arrangements reminiscent of a Zen garden. His choice of material is as much emblematic as it is visually appealing. In Shinto, the indigenous religion of Japan, salt symbolizes purification and is used, for instance, in funeral rituals as well as by sumo wrestlers, who scatter it to purify the ring. Small piles of *morijio* or *mori shio* (piled-up salt) are left outside houses and restaurants so that people who pass through are purified. Yamamoto made a personal link to this substance while mourning the death of his sister, who tragically died from cancer at the age of twenty-four. He began to make art from salt as an act of remembrance, and to convey something transcendental and tranquil.

The artist's creative methods – the practice of patiently shaping these beautiful formations using only fine grains of salt – can be seen as ritualistic. This slow and considered process is a meditative and healing exercise, as much part of the work as the finished article. In a similar way to the detailed sand mandalas made by Tibetan Buddhist monks, the act of creating the work is a respectful humbling before nature. Reflecting the fleeting nature of life, the finished work itself is transitory and is ultimately swept away. To emphasize this, when an exhibition has come to an end, the installation is often dismantled with the aid of the public, who help to gather up the salt for returning to the sea.

Although it holds a special place in Japanese culture, salt has universal significance. As a vital mineral, it is essential to many living creatures, recycled from organism to organism in the cycle of life. A grain of salt therefore becomes a metaphor for this mortal coil, while the countless grains of salt that make up Yamamoto's work suggest

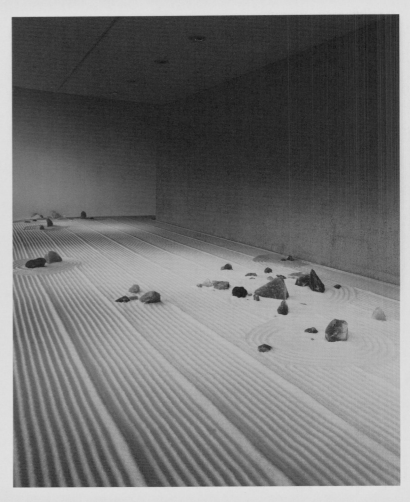

Motoi Yamamoto, *Forest of this World*, 2011.
Hakone Open-Air Museum, Kanagawa, Japan. Salt. 17 × 9 m (56 × 29 ½ ft).

the interconnectedness of all things and the greater cosmos. In a process of continual innovation, the artist adapts his installations to the idiosyncrasies of each exhibition space – reacting to their size and shape, and responding to peculiarities of light and architecture. His salt formations often evoke landscapes – mountains, clouds, forests, gardens and other places in which we can ponder and dream. While they can be seen as physical spaces, they are also mental maps whose crystalline forms guide the viewer into contemplation.

'For me, installation work is like a long journey to rediscover all the memories of my sister who passed away. I am compelled to work on large-scale installations, which take a very long time to complete, by a strong belief that my dream may come true only by accumulating small steps. For the audience, the large-scale patterns drawn on the floor may look like the earth's surface seen from an aeroplane or a microcosm viewed through a microscope. Those people who join the <u>Return to the Sea</u> project, which happens on the last day of exhibitions, participate in a process to complete the installation. With this project, salt returns to the ocean and starts a new cycle of life. In this sense, the project may be understood as a celebration of new beginnings.'

Motoi Yamamoto

Websites

Boa Mistura
boamistura.com

Diem Chau
diemchau.com

Brent Christensen
icecastles.com

Nguyễn Hùng Cường
flickr.com/photos/blackscorpion

Brock Davis
itistheworldthatmadeyousmall.com

David DiMichele
daviddimichele.com

Thomas Doyle
thomasdoyle.net

Lorenzo Manuel Durán
lorenzomanuelduran.es

Janet Echelman
echelman.com

Leandro Erlich
leandroerlich.com.ar

Evol
flickr.com/photos/evoldaily

Joe Fig
joefig.com

Jean-François Fourtou
jffourtou.com/en/work

Nancy Fouts
nancyfouts.com

Katharina Grosse
katharinagrosse.com

Jason Hackenwerth
jasonhackenwerth.com

Theo Jansen
strandbeest.com

Choi Jeong-Hwa
choijeonghwa.com

Luke Jerram
lukejerram.com

Guy Laramée
guylaramee.com

José Lerma
joselerma.com

Nadín Ospina
nadinospina.com

Penique Productions
peniqueproductions.com

Kurt Perschke
redballproject.com

Jaume Plensa
jaumeplensa.com

Nikolay Polissky
polissky.ru

Liliana Porter
lilianaporter.com

Klari Reis
klariart.com

Jorge Rodríguez-Gerada
jorgerodriguezgerada.com

Tomás Saraceno
tomassaraceno.com

Egied Simons
egiedsimons.com

Doug and Mike Starn
dmstarn.com

Jason deCaires Taylor
underwatersculpture.com

Pascale Marthine Tayou
pascalemarthinetayou.com

Iori Tomita
shinsekai-th.com/en/profile.php

Motoi Yamamoto
motoi.biz

Yang Yongliang
yangyongliang.com

Bibliography

'Interview with Artist Brock Davis', mymodernmet.com, 18 December 2010

Otherworldly: Optical Delusions and Small Realities, foreword by David Revere McFadden, catalogue for the exhibition at the Museum of Arts and Design, New York, 7 June–18 September 2011

Catherine Craft, *Katharina Grosse: WUNDERBLOCK*, catalogue for the exhibition at Nasher Sculpture Center, Dallas, Texas, 1 June–1 September 2013

Leandro Erlich, *ArtKrush* interview, 29 October 2008

Joe Fig, *Inside the Painter's Studio*, Princeton Architectural Press, 2009

Paul Flynn, 'Nike Savvas: The Sliding Ladder Equation', date unknown

Blue Greenberg, 'In Exhibit, Chaos Comes Together', *The Herald Sun*, 25 May 2012

Lynn M. Herbert, interview with Katharina Grosse, in *Perspectives 143: Katharina Grosse*, Contemporary Arts Museum, Houston, 2004

Kevin Holmes, 'Theo Jansen Discusses Why He Hates the Wind and Is Inspired by Evolution', *The Creators Project*, 21 November 2012

Theo Jansen, *The Great Pretender*, 010 Publishers, Rotterdam, 2009

Randy Kennedy, 'A Colossus in Clay Speaks a Generation's Message', *The New York Times*, 14 February 2012

Meghan Killeen, 'Guy Laramée: Our interview with the artist about sand-blasted books, ethereal paintings and a transcendental point of view', coolhunting.com, 12 June 2012

Brian Merchant, 'The Insane Alien Balloon Animals of Jason Hackenwerth', *Vice*, 2013

Fujiko Nakaya, *Over the Water: Fujiko Nakaya*, Exploratorium, San Francisco, 2013

Milena Orlova, 'Moving Heavens and Earth', BRIC Editorial by Phillips de Pury, 2000

Christina Ruiz, 'Sky's the Limit for Sculpture', *The Art Newspaper*, June 2013

Anna Sansom, 'Fall for It', *Frame*, Issue 82, September/October 2011

Barbara Sansone, 'The Poetics of the Intangible: A Conversation with Jaume Plensa', *DigiMag*, September 2010

Gregory J. Scott, 'Art: Brock Davis, The Punch-Clock Creative', vita.mn, 2012

Roberta Smith, 'Art in Review: Pascale Marthine Tayou', *The New York Times*, 7 May 1999

Robert Smithson, *Robert Smithson: The Collected Writings*, edited by Jack Flam, University of California Press, Berkeley and London, 1996

Pascale Marthine Tayou, *Always All Ways*, catalogue for the exhibition at the Musée d'Art Contemporain de Lyon, in collaboration with Malmö Konsthall, Sweden, 24 February–15 May 2011

Lien Truong, 'The Miniature Work of Diem Chau', diacritics.org, 22 February 2011

Marc Valli & Margherita Dessanay, *Microworlds*, Laurence King, London, 2011

Motoi Yamamoto, *Return to the Sea: Saltworks by Motoi Yamamoto*, University of South Carolina Press, 2012

Picture Credits

a = above, b = below, l = left, r = right, c = centre

All images courtesy of the artist, unless otherwise indicated:
p. 9 (b) Photograph by Gar Powell-Evans; p. 13 (b) Photograph by David Feldman; p. 25 Photograph by Kendra Garvin; pp. 26 & 27 Photographs by Ryan Davis; p. 28 Photograph by Ben Visbeek; p. 29 Photograph by Peter Vanderwarker; p. 30 Photograph by Marinco Kojdanovski; p. 31 (a) Photograph by Christina O'Haver; p. 31 (b) Photograph by Karie Porter; p. 32 Photograph by Martin Argyroglo; p. 36 Courtesy of Aeroplastics Contemporary, Brussels. © Jean-François Fourtou and maxime dufour photographies; p. 37 (a) Courtesy of Aeroplastics Contemporary, Brussels. © Jean-François Fourtou; p. 37 (bl) Courtesy of the artist and Aeroplastics Contemporary, Brussels. © Salvador Bolarin Photography and Jean-François Fourtou; p. 37 (br) Courtesy of the artist and Aeroplastics Contemporary, Brussels. © Salvador Bolarin Photography and Jean-François Fourtou; p. 38 (a) Courtesy of the artist and Aeroplastics Contemporary, Brussels. © Salvador Bolarin Photography; p. 38 (b) Courtesy of the artist and Aeroplastics Contemporary, Brussels. © Salvador Bolarin Photography and Jean-François Fourtou; p. 39 Courtesy of Aeroplastics Contemporary, Brussels. © Salvador Bolarin Photography and Jean-François Fourtou; p. 40 Photograph by Art Evans. © 2010 Katharina Grosse and VG Bild-Kunst, Bonn; p. 41 (a & b) Photographs by James Ewing. © 2013 Katharina Grosse and VG Bild-Kunst, Bonn; pp. 42–43 Photograph by Peter Cox. © 2013 Katharina Grosse and VG Bild-Kunst, Bonn; p. 44 Photograph by Kevin Todora. © 2013 Katharina Grosse and VG Bild-Kunst, Bonn; p. 45 Photograph by Gert Voor in't Holt. © 2013 Katharina Grosse and VG Bild-Kunst, Bonn; p. 46 Photograph by Sean Gilligan; p. 47 (a) Photograph by Sean Gilligan; pp. 50–52 Photographs by Loek van der Klis; p. 58 Courtesy of Andrea Rosen Gallery,

New York. © José Lerma; p. 59 (a) Courtesy of Andrea Rosen Gallery, New York. © José Lerma; p. 59 (b) Courtesy of Andrea Rosen Gallery, New York. © José Lerma; p. 60 (a) Courtesy of the Saatchi Gallery, London. Photograph by Sam Drake; pp. 60 (b) & 61 Courtesy of José Lerma and Héctor Madera; p. 62 Courtesy of the Yokohama Triennale, 2008. © Nacása & Partners Inc, Tokyo; p. 63 (a) Courtesy of the National Gallery of Australia, 1993; p. 63 (b) Courtesy of Domaine de Chaumont-sur-Loire. © Eric Dufour; p. 64 (a) Courtesy of OK Centrum, Linz. © Otto Saxinger; p. 64 (b) © Martin Argyroglo; p. 65 Photograph by Gayle Laird. © Exploratorium, San Francisco; p. 73 (b) Photograph by Tom Martin; p. 74 Photograph by Ari Karttunen. © EMMA, Helsinki; p. 75 Photograph by Laura Medina. © Plensa Studio, Barcelona; p. 76 (a) Photograph by Hedrich Blessing. © Plensa Studio, Barcelona; p. 76 (c) Photograph by Laura Medina. © Plensa Studio, Barcelona; p. 76 (b) Photograph by Cesar Russ. © Plensa Studio, Barcelona; p. 77 Photograph by Kenneth Tanaka. © Plensa Studio, Barcelona; p. 78 Photograph by James Ewing. © Madison Square Park Art, New York; p. 79 (a) Photograph by Laura Medina. © Plensa Studio, Barcelona; p. 79 (b) Photograph by Jonty Wilde. © Plensa Studio, Barcelona; pp. 82–83 Photograph by Ilya Ivano; p. 90 Courtesy of the artist and Ruth Benzacar Gallery, Buenos Aires. Photograph by Carla Barbero; p. 91 Courtesy of the artist, kurimanzutto, Mexico City, and Marian Goodman Gallery, New York. Photograph by Hiroki Kobayashi; p. 92 Courtesy of the artist and Ruth Benzacar Gallery, Buenos Aires. Photograph by Oliver C. Haas; p. 93 (a) Courtesy of the artist and kurimanzutto, Mexico City. Photograph by Diego Pérez and Patricia Alpizar; p. 93 (b) Courtesy of the artist, kurimanzutto, Mexico City, and SAM Art Projects, Paris. Photograph by Marc Domage; pp. 94 & 95 Courtesy of the artist and Tanya Bonakdar Gallery, New York. © 2012 Studio Tomás Saraceno; pp. 96

(a & b) & 97 © 2010 Studio Tomás Saraceno; p. 98 (a & b) Photographs by Alessandro Coco. © 2012 Studio Tomás Saraceno; p. 99 Courtesy of the artist and Tanya Bonakdar Gallery, New York, Andersen's Contemporary, Copenhagen, and Pinksummer Contemporary Art, Genoa. Photograph by Jens Ziehe. © bpk / Nationalgalerie im Hamburger Bahnhof – Museum für Gegenwart – Berlin, Staatliche Museen zu Berlin; p. 100 Courtesy of the Australian Centre for Contemporary Art, Melbourne. Photograph by John Brash; p. 101 (b) Courtesy of the Art Gallery of NSW, Sydney. Photograph by Jenni Carter; p. 112 Courtesy of Galleria Continua, San Gimignano / Beijing / Le Moulin. Photograph by Alicia Luxem; p. 113 Courtesy of Galleria Continua, San Gimignano / Beijing / Le Moulin. Photograph by Giorgio Benni; p. 114 (a) Courtesy of Galleria Continua, San Gimignano / Beijing / Le Moulin. Photograph by Takenori Miyamoto + Hiromi Seno; pp. 114 (c & b) & 115 Courtesy of Galleria Continua, San Gimignano / Beijing / Le Moulin. Photographs by Andrés Lejona; p. 116 Photograph by Stefan Worring; p. 118 Photograph by Makoto Morisawa; p. 119 (a) Photograph by Sen Naganawa; p. 120 (a) Courtesy of Mikiko Sato Gallery, Hamburg; p. 129 Photograph by Loek van der Klis; p. 131 Courtesy of Andrea Rosen Gallery, New York. © José Lerma; p. 132 Photograph by Shigeo Ogawa; p. 138 © 2009 Studio Tomás Saraceno; p. 139 Photograph by Jamie North; p. 218 Courtesy of the Organizing Committee for Yokohama Triennale. Collection of Yokohama Museum of Art. Photograph by Keizo Kioku; p. 219 (ar) Courtesy of the artist and Arataniurano, Tokyo; p. 220 (a & b) Courtesy of the artist and Arataniurano, Tokyo; p. 221 Courtesy of the artist and Arataniurano, Tokyo; p. 252 Courtesy of the Pace Gallery, Beijing. © Yin Xiuzhen; p. 253 Courtesy of the Pace Gallery, Beijing. © Yin Xiuzhen.

Acknowledgments

I would like to thank all the artists featured in this book.

Thank you also to the following: Aeroplastics Contemporary, Brussels; Andersen's Contemporary, Copenhagen; Andrea Rosen Gallery, New York; Arataniurano, Tokyo; Martin Argyroglo; Art Gallery of NSW, Sydney; Australian Centre for Contemporary Art, Melbourne; Carla Barbero; Barbican Centre; Giorgio Benni; Hedrich Blessing; Rebekah Bowling; John Brash; Lance Brewer; Sarah Brown; Jenni Carter; Alessandro Coco; Peter Cox; Ryan Davis; Laetitia Delorme; Marc Domage; Domaine de Chaumont-sur-Loire, France; Sam Drake; Eric Dufour; Dutrie S.A.S.; EMMA, Helsinki; Eva Albarran & Co.; Art Evans; James Ewing; Exploratorium, San Francisco; David Feldman; Galerie Lange + Pult; Galleria Continua, San Gimignano / Beijing / Le Moulin; Kendra Garvin; Sean Gilligan; Beatriz Gómez;

Oliver C. Haas; Melissa Henry; Ilya Ivano; Janet Echelman Inc.; Keizo Kioku; Hiroki Kobayashi; Marinco Kojdanovski; kurimanzutto, Mexico City; Gayle Laird; Céline Lange-Pult; Laura Langer; Leandro Erlich Studio; Hoeun Lee; Leeds Art Gallery; Andrés Lejona; Liliana Porter Studio; Alicia Luxem; Héctor Madera; Madison Square Park Art, New York; Jean Manco; Olivia Manco; Marian Goodman Gallery, New York; Tom Martin; Natalija Martinovic; maxime dufour photographies; Laura Medina; Kate Menconeri; Mikiko Sato Gallery, Hamburg; Takenori Miyamoto + Hiromi Seno; Delphine Morel; Makoto Morisawa; Urano Mutsumi; Nacása & Partners Inc., Tokyo; Sen Naganawa; National Gallery of Australia, Canberra; Sandrine Niesten; Jamie North; Shigeo Ogawa; Christina O'Haver; Ariane Oiticica; OK Centrum, Linz; Organizing Committee for Yokohama Triennale; Pace Gallery; Diego Pérez and Patricia Alpizar; Pinksummer

Contemporary Art, Genoa; Plensa Studio, Barcelona; Karie Porter; Gar Powell-Evans; Stefano W. Pult; Judith Ribbentrop; Gaudéricq Robiliard; Andrea Rosen; Cesar Russ; Ruth Benzacar Gallery, Buenos Aires; Saatchi Gallery, London; Salvador Bolarin Photography; SAM Art Projects, Paris; Otto Saxinger; Spacex; Studio Tomás Saraceno; Kenneth Tanaka; Tanya Bonakdar Gallery, New York; Wendy Taylor; Anouk Tessereau; Sylvie Tiao; Aurélie Tiffreau; Kevin Todora; Loek van der Klis; Peter Vanderwarker; Ben Visbeek; Gert Voor in't Holt; Anna Wiese; Jonty Wilde; Stefan Worring; Jens Ziehe.

Small

Art

Profiles

Alberto Baraya

— IMAGES P. 177 —

Alberto Baraya explores the blurred lines between fact and fiction, science and myth, by examining the historic representation of nature and calling into question the notion of culture and science as an impartial truth. This is exemplified by the Colombian artist's fascination with the scientific expeditions made by European explorers to the Americas in the 18th and 19th centuries, the purpose of which was to collect, describe and classify undocumented flora and fauna. Although these surveys were painted as objective observations in the name of science, in reality they were governed by clear political and economic agendas. Empirical evidence was used to give weight to ideas of geographic determinism, to suggest that indigenous peoples were unable to develop 'sophisticated' civilizations and the cultural values of Europeans were somehow superior. For the artist, this chapter in the history of science remains relevant to Central and South America, haunted by the ghosts of European colonialism and the legacy of an imposed system of classification whereby indigenous organisms including plants were documented and renamed.

In his ongoing project *Herbario de plantas artificiales* (*Herbarium of Artificial Plants*) (2001–ongoing), Baraya lampoons the methodology and empirical objectivity of the European botanists. Instead of real plants he collects artificial ones, meticulously annotating and displaying them in a similar manner to the scientists and botanical illustrators of the past. Applying his own peculiar taxonomy to each specimen, he classifies every artificial plant he can find — whether made from plastic, paper or cloth — documenting where it was sourced, its colour and its various components. The specimens in the collection are all stolen, perhaps from a restaurant or a doctor's waiting room, thereby echoing the ethical ambiguity of those historical scientific expeditions.

Initially the project was limited to urban areas, but in 2004 Baraya was invited as a documentarian on an institutional trip along the Putumayo River, one of the tributaries of the Amazon. The expedition echoed those of the 18th- and 19th-century scientists: equipped with scientific tools and notebooks to make drawings and observations, he set out to find plastic flowers as evidence of globalization in the most remote places — the final frontiers of resistance to 'progress'. His fears were finally confirmed in what he described as 'the laws of decoration': the impulse to ornament exists even in the most natural places on earth, highlighting not only the power of globalization, but also the breakdown of cultural boundaries.

While the *Herbarium* is a deliberately absurd fiction, it is also aesthetically beautiful and intriguing in its detail. Over the years, it has grown to take on the attributes of a natural history library, filled with samples, photographs, documents, references and instruments. For the viewer, the artificial plants — carefully dissected, annotated and displayed — hold a similar exotic appeal to the real thing: we marvel at each specimen in minute detail, just as we would with a genuine botanical illustration, and are simultaneously fascinated by its meticulous fakery.

Diem Chau

— IMAGES P. 180 —

Born in Vietnam and now resident in Seattle, USA, Diem Chau is drawn to the intimacy of working at a small scale. Using modest everyday or found objects such as pencils, crayons and vintage porcelain as her media, she applies exquisite carving or fine-line embroidery techniques to create delicate, minimalist and charming works. The familiarity of these ordinary objects is part of their disarming attraction, combined with the miniaturized scale, which — in the artist's words — tends 'to bring smiles to people's faces'. With Chau's wit, extraordinary patience and eye for a narrative, even the smallest of surfaces — the width of a pencil lead, for example

– has the potential to metamorphose into something truly magical.

In recent years, Chau has become particularly well known for her miniature sculptures using pencils and colourful crayons, which have been exhibited in

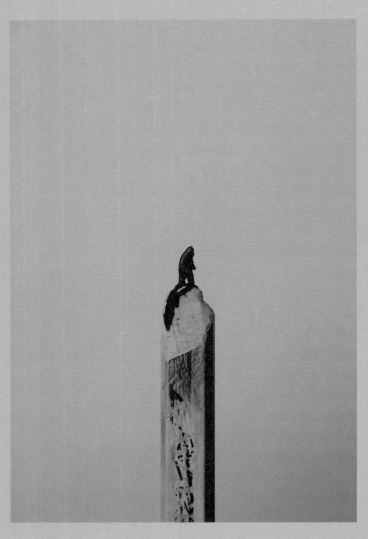

Diem Chau, *The Last Bear*, 2013. Carved carpenter's pencil. 121 × 16 × 6 mm (4 ¾ × ⅝ × ¼ in.).

numerous shows across the USA and further afield. Hand-carved, each material has its own particular quality; the graphite pencil leads are hewn as if from blocks of basalt or obsidian, extenuating the shape and shadow of each sculpted form, while the crayons' waxy sheen is reminiscent of carved lacquer. Chau began carving in 2005, inspired by folk and hobo art. As she explains in her artist statement, 'Hoboes were travelling labourers with a variety of skills; they often made whimsical carvings with whatever they had at hand. The artwork was simple and heartfelt. I fell in love with its genuine nature; the work is unassuming and approachable. Much like the hoboes of the past, I come from a humble background; our resources were few but our stories are great. I really embrace the idea that art is for all and, to reflect this philosophy, the mediums I've chosen to use are objects from everyday life.'

Reflecting the straightforward style of folk and traveller art, Chau's subject matter is unpretentious, simple and elegant. *The Last Bear* (2013) – the bear standing with arched back on the tip of a wooden pencil, as if on the brow of a hill – and *Four Seasons* (2011) – four carved crayons that are like beautiful floral totems – exemplify this approach. While the imagery is restrained, there is poetry and thoughtfulness to it, and it sometimes tackles serious issues: *The Vanishing* series, for example, depicts iconic animals that are now endangered. The artist's works with porcelain and embroidery similarly evoke more expressive narratives using figures and gestures, often inspired by personal memories and family stories.

Naturally there are physical limitations to working at such a small scale, but for Chau one of the greatest challenges has been the psychological inadequacy. As she explains, 'It was hard fighting to legitimize my work, even to myself. Coming from art school, it was all about the giant installations and life-size stuff. It's all about the BIG in the art world. It has to be 30 ft [9 m] long to be great art.' However, with a huge grassroots following and commercial success, Chau has proved with her perfectly formed miniatures that smallness can equal greatness.

Nguyễn Hùng Cường

— IMAGES P. 186 —

Nguyễn Hùng Cường has been wowing the paper arts and craft community worldwide with his sophisticated and naturalistic take on the ancient art of origami. Since he first began folding paper at the age of around

five or six, this young Vietnamese artist has nurtured his passion for origami, creating beautiful and intricate models for pleasure and to hone his design skills. In 1997 his parents, noting his talent and enthusiasm, encouraged him with a book called *Prehistoric Origami: Dinosaurs and Other Creatures* by John Montroll, which Cường devoured, recreating every design in it. It was at this point that he saw the potential in the craft as an art form; until then, it had simply been a game he played with his older sister. His parents continued to find him more books and specialist origami paper, but in 1999 he decided to make his work more refined

'It is a huge challenge to achieve such detail with a small piece of paper and breathe life into it. As I can fold virtually anything from one square piece of paper, it feels like I hold the universe in my hand – a bit like God, I think.'

Nguyễn Hùng Cường

and created his first original design, aged just ten. By referring to instructions and techniques from origami artists such as Robert J. Lang, Satoshi Kamiya, Hideo Komatsu and others, he was able to develop his own unique style.

Origami is essentially about transformation, taking a square sheet of beautifully made paper and conjuring it into a finished sculpture through folding and shaping – a miraculous feat of imagination and engineering. While traditional origami tends to be angular with crisp edges, contemporary origami such as Cường's raises the game to embrace curves and become increasingly life-like. In a similar way to a chess player, the artist needs to plan many steps ahead, visualizing every stage of the execution of the piece to tease a complex and characterful model out of the paper. Cường finds great joy in this thoughtful process, which eventually – sometimes after hundreds of experiments, developed over months – leads to the

final creation. He not only considers the anatomical proportions of his subjects, which tend to come from natural history, but also their dramatic stance and intricate details. Occasionally, he revisits and reworks his favourite designs. For example, he loves his gorilla not only because it has beautiful features, but because of his own achievement in capturing its posture and ferocity. Moreover, the artist found the process of creating the gorilla enjoyable – an experience he would be happy to relive again and again.

To create his work, Cường prefers to use single sheets of a special type of Vietnamese tree bark paper that is similar to Japanese *washi,* sometimes adding glue for stability. This paper was not considered suitable for origami, but the artist now promotes its qualities through his work. For each model, he carefully selects the paper according to its colour or weight. Many of the finished pieces remain in Cường's collection or are exhibited at origami conventions around the world, from Tokyo to Lyon. Some pieces have been sold, but for the artist it is less the money and more the process of creating exquisite and extraordinary origami that spurs him on. His work has inspired a vast online audience and brought him to the attention of the global press. Although more than a hobby, he has yet to consider it a career. Offering insight into his motivations, he states: 'Since I'm not good with words, I use origami to share my ideas, how I feel and how beautiful this world is.'

Brock Davis

— IMAGES P. 190 —

American artist Brock Davis has a knack for seeing a creative idea in the smallest, most commonplace items, from building a tree house in a floret of broccoli to creating a scale model of Stonehenge with Rice Krispies. As an award-winning creative director for almost two decades, he has also put this talent to good use in his professional career, but it is in his personal artwork and photography that he allows his imagination to run riot. To some extent, his personal

'I like working with everyday objects because I can immediately effect them and instil my vision. With small scale, it's easier to maintain control. When I have an idea, I get excited and curious to see if I can create what I see in my head. I love the creative challenge of trying to make something that is familiar and seemingly bland feel interesting and new. I hope that my work can inspire others to look closely at the things we seldom think about, to be observant and see that uninteresting things can be interesting.'

Brock Davis

work ethic has almost become a force of habit since he famously took part in an online project called *Make Something Cool Every Day* (2009). Launched by Olly Moss, a friend and fellow designer, the assignment called upon a group of designers and artists to commit to making an artwork every day for a whole year and share their results via a Flickr group. At first thousands of people signed up, but gradually they dropped out as it became impossible to stick to the pledge – all except Davis, who was the only one to complete the challenge.

Finding the time to make 365 artworks was no mean feat, and some were executed at the last moment. 'One time, I had about 20 minutes to go,' says Davis. 'I was pacing around the kitchen, and I saw a pen, so I picked it up and illustrated a Converse-esque shoe on my wife's foot, snapped a shot of it, and uploaded it to the group at about 12.15 am. Things like that happened all the time.' Although Davis considered the project to be a second job, he began to find it quite meditative. It made him notice the smaller things in life, and moments that he might have missed were it not for his creative task. He cites as an example a self-portrait created using his own stubble by drawing with a toothpick in the bathroom sink. 'My favourite pieces are the ones that pull something interesting out of something seemingly bland,' Davis explains. Often the works are visual puns, but rather than being merely jokes, there is a poetry in the simple and elegant way he tells each visual story.

Although he feels his strengths are in drawing and photography, the *Make Something Cool* project pushed him towards miniature sculptures, making original and unusual use of the media that were available to him, from cut vegetables to dead flies. Today, he continues to make work for fun and to amuse his children. While other parents tell their kids not to play with food, Davis meticulously recreates the cover of the classic Joy Division album *Unknown Pleasures* with noodles on a plate or the bombing of Nagasaki using a cunningly photographed cauliflower. In 2012, he used Instagram to make Polaroid-style photographs of carefully observed or cleverly staged moments in his signature witty style. 'I strive to make work that makes people feel something,' he says. 'I want them to get excited and want to talk about what they've seen and share it with their friends.'

David DiMichele

— IMAGES P. 194 —

In a hangar-like gallery space, a precarious installation made up of enormous panels of shattered glass catches the light from above as figures carefully make their way between the broken shards (*Pseudodocumentation: Broken Glass*, 2006). In another, the white walls of a vast pristine gallery are pierced by gigantic lightrods, which penetrate the space floor to ceiling (*Pseudodocumentation: Lightrods*, 2009). Los Angeles-based artist David DiMichele creates imaginary installations that appear to be on an epic scale but are in fact meticulously staged dioramas small enough to sit on a table in the artist's studio. He then turns to his camera to create the finished piece, producing a large-scale photograph of a grandiose installation in a make-believe exhibition space.

David DiMichele, *Pseudodocumentation: Metal Pour*, 2009. LightJet print. 114 × 165 cm (45 × 65 in.).

Forming part of DiMichele's ongoing *Pseudodocumentation* series, these imposing works combine his background in installation, painting and sculpture with a passion for monumental museum and gallery architecture and a love of abstract form.

He begins by designing and building scale models of gallery spaces, which he then fills with his own original artworks in media such as drawing, painting and sculpture. Within these spaces he also positions miniature gallery visitors to complete the illusion of a real exhibition environment. The end result – the

'The Pseudodocumentation photographs are a kind of fantasy installation art visualized through the creation of architectural models and photography. I enjoy the shift in scale that happens when the image goes from a tabletop diorama to a large-scale photograph, and the way that the ostensible scale of the fictive installation can be manipulated. The sense of ambiguity of the final photographs (they are sometimes mistaken for documentations of actual installations) is also important to me conceptually. I use this process to try to imagine what sort of projects I would make if there were no logistical or financial constraints; unlike actual installation artists, I am limited only by my imagination.'

David DiMichele

large-scale photograph – blurs the lines between fact and fiction, playing on our ideas of scale and perception, and encouraging us to re-examine how we view and experience art.

DiMichele came up with the idea for the series when he was going through the process of documenting his own projects and began to consider the role of photography in the documentation of art. The majority of people experience contemporary art through photographs rather than first-hand. For instance, artists such as American sculptor Richard Serra rely on photography to interpret the spectacle of their large-scale works in real life. Unlike most installation photographs, however, DiMichele's documentations are themselves artworks. He has denied that his photographs are a parody, arguing that they pay homage to both large-scale art and the supersized contemporary art spaces that are becoming prevalent today, such as Tate Modern in London, by imagining abstract installations without limits. Working in this way, and by controlling the lighting and viewpoint of the photograph, he can create an installation scene that would be impossible in real life.

The small scale of the dioramas allows the artist to imagine at a gigantic scale, use extravagant materials and place his subjects in dramatic situations – encircled by towers of melting ice, for example. These powerful scenes share the shock and awe of supersized works, but without the huge teams of workers, large budgets and expensive fabrication. The result: small art dreams with a big art impact.

Thomas Doyle

— IMAGES P. 198 —

American artist Thomas Doyle creates intricate worlds encased under glass domes or bell jars, as if captured by a collector. Crafted at a scale of 1:43 – sometimes smaller – these scenes are somehow familiar, depicting the suburban landscapes we are accustomed to seeing in Hollywood movies, with white picket fences and immaculate lawns, but in those moments after catastrophe has struck. There is an air of science fiction or post-apocalyptic dystopia

to these otherwise everyday worlds that have been transformed by extraordinary events and brought to life by the cast of small characters who act within them. Buildings are inverted or vast chasms appear between them to create surreal scenes that are designed to evoke transformational moments in a person's life or sensations triggered by a muddle of memories. As Doyle describes, 'In much the way the mind recalls events through the fog of time, the works distort reality through a warped and dreamlike lens.'

'I've always been interested in smaller scales due to their potential for wonder. Smaller works, especially those that attempt to create worlds and environments, not only allow us a place to escape to momentarily; they transform the mundane into something extraordinary. The materials themselves, be they from kits or taken straight from the trashcan, come together in unexpected ways to effect detailed miniature worlds. There's an element of magic there.'

Thomas Doyle

Doyle created his first diorama at the tender age of three, using wood, Play-Doh and a plastic penguin to depict a snow and sea scene. He was soon hooked and spent much of his childhood creating models and shoebox dioramas. After studying fine art at Humboldt State University in California, he began a period of painting and printmaking but found himself returning to what had made him happiest as a child. His approach to creating models as a trained artist was more sophisticated, but no less absorbing. Describing the process as meditative, Doyle can spend months working on each piece, from the initial sketch to the gradual sculpting with plaster, foam, wood and plastic, to the finishing process of weathering and modifying the work until it mimics reality as closely as possible.

The miniature narratives in their glass bubbles remind us of the fragile world we live in — and the delicate balance with nature and each other. As viewers looking down on the scenes below, we are placed in a position of great power: we see every aspect of the dark landscapes that threaten the figures trapped within. The radically reduced scale gives these snapshots of life a private intensity that draws us in, in a similar way to a doll's house. The characters also play out the scenes of chaos and destruction with little emotion, inviting us to lose ourselves in these worlds and all the feelings and memories that they stir up.

Having long been fascinated with the dioramas at the American Museum of Natural History in New York, Doyle uses the same visual language to surprise the viewer with exhibits that are not of this world. 'By sealing the works in this fashion,' he says, 'I hope to distil the debris of human experience down to single, fragile moments. Like blackboxes bobbing in the flotsam, these works wait for discovery, each an indelible record of human memory.'

Lorenzo Manuel Durán

— IMAGES P. 202 —

After observing a caterpillar munching its way through a leaf, Spanish artist Lorenzo Manuel Durán had a flash of inspiration: he wondered whether he might be able to use the same material to create works of art, in a similar technique to paper cutting. Unable to find any information on 'leaf-cutting art', he set about a process

of trial and error to discover what might be achieved with the material. During this period of development, he remained captivated by the idea that combined his two lifetime passions – art and nature – and was determined to make a success of it. It was important for him to find a way to realize his designs without spoiling the beauty of the leaf.

Over time, he has established a working method that involves washing, drying and pressing the leaves and then sketching an outline of his design on paper, which is fixed to the leaf as a guide. The cutting process is a painstaking operation, using a surgical blade and dental equipment to carefully remove the plant tissue and reveal the image. Each piece can take

'Depending on your point of view, small things may look huge and vice versa. Working at a small scale opens up endless possibilities that I could never have imagined. When I develop an idea and apply it to a leaf, the leaf's own shape starts playing with the design and always asks me for more. On top of all that, I'm working with a natural element, with all the beauty and challenges that come with it.'

Lorenzo Manuel Durán

between a week and two months to complete, with the slightest mistake causing irreparable damage. When the work is completed, he peels it off – an incredibly difficult and skilled task because the leaf is so fragile and can easily be ruined. The brilliance of the finished work lies in the cutting, which has to be extremely delicate so that the design does not feel overly imposed on the pattern of veins in the leaf but instead works within its natural structure. Recently, he has been exploring these processes and applying them in reverse, 'skeletonizing' the leaf – removing the plant material

through a scraping process – instead of cutting it, to create a positive rather than reversed-out image.

Durán's subject matter is often drawn from nature or his own personal experiences. Many of his pieces are beautifully crafted portraits of anonymous faces or pop culture icons. Some designs depict birds or animals such as snakes, frogs and big cats. Others reveal intricate geometric patterns characteristic of Celtic decoration. Flora and fauna also feature prominently in works cleverly framed by the leaves' natural form. Through these works, the artist highlights the indispensable role of animals and plants in life and the complexity of nature. 'A simple leaf hides mysteries that only time will reveal,' he explains. Durán also takes inspiration from his love of mountains, which made him realize how insignificant we are as individuals. At the same time, we have a huge impact on the environment. By using leaves as his medium, the artist points to the importance of trees to our very existence and our responsibility to take care of our fragile environment. Quoting the scientist and writer Jorge Wagensberg, he says: 'The environment is one of the essential parts of a living being.'

Evol

— IMAGES P. 206 —

Berlin-based Tore Rinkveld, aka Evol, is perhaps best known for transforming everyday features of our cityscape into mini concrete tower blocks through the medium of paint. Inspired by architecture, which he sees as a mirror for society, he paints directly onto the surface of electrical enclosures, concrete planters and other familiar elements of the modern city, as well as working on found materials such as cardboard. Drawing on his background in graffiti, he uses his artistic skills to explore the inner workings of the city and make us look at our surroundings in a new light.

Evol often takes photographs of buildings as he wanders around Berlin, with a particular interest in the postwar socialist architecture of the former East Germany. Although originally constructed with the

ideology of a socialist utopia, areas of this city – and others like it that have been subject to governmental programmes – are, architecturally, a far cry from the original vision. Many of the buildings Evol depicts are grey, functional and in a style that has fallen out of favour, yet they have a brutalist, monumental appeal. The artist draws our attention to the striking geometry of the architecture and everyday details we sometimes take for granted: a billowing tarpaulin hung from scaffolding, shadows cast from a balcony or light falling on a curtain. Unpopulated by figures, these works contain signs of life – the exteriors of compartments in which people live and work – but are eerily quiet.

Evol, Smithfield Market, London, UK, 2011. Stencil on concrete.

We are drawn into these intricacies partly because of the astonishing small scale of the works, which the artist achieves by carefully applying many layers of light and shade to build up a realistic image. With a wonderful eye for detail, he picks up all the nuances of the grey concrete buildings and reduces them down to miniature apartment blocks. Camouflage is a key element in the artist's work. When he paints on an electrical enclosure, the metal box is often drab, weathered and covered in graffiti. These features are integrated into the work, but they are also used to play on the passer-by's natural associations – to make us do a double take. In the blinking lights of the city centre, they invite us to take another look and remind us of the dystopian ghettos on the outskirts of the city.

In contrast, Evol's studio works, created on found cardboard boxes, celebrate the architecture of

an earlier time – the simple Berlin townhouses built around 1910, which have survived two world wars and totalitarian regimes. These ordinary buildings are typical of the neighbourhood the artist has lived in for years – relics of a bygone era that have not yet succumbed to the gentrification sweeping the area. The cardboard provides a rich patina on which to stencil, with existing marks and structures reflecting the passage of time on the walls. The printed graphics, tape and other minute details found on the cardboard also echo the distressed nature and visual pollution of real urban landscapes. In both his studio-based works and his temporary street installations, Evol reduces the environment that surrounds us to bite-sized pieces. Through this reversal of scale, he somehow renders the works harmless: while evoking a stark urban environment, they remain charming and approachable. At the same time, the artist claims small spaces for his art by re-using the existing infrastructure, transforming it subtly and simply with shades of black and white.

Joe Fig

— IMAGES P. 210 —

American artist Joe Fig is renowned for his extraordinary miniature reproductions of well-known artists in their studios. These fascinating and beautifully observed sculptures capture the artist at work and act as portraits in the form of a diorama. The idea began in 2000, when he embarked on a study of the artistic process and the 'myth of the sacred studio space' by creating small-scale representations of the studios of historically significant artists, such as Jackson Pollock and Willem de Kooning. These first works relied on historical references but by 2002, after graduating from the School of Visual Arts in New York, he had decided to look at contemporary subjects to get first-hand experience of studio life and learn about the day-to-day practicalities of being an artist. On the strength of his already completed works, he began to ask well-known painters whether they

'Working at a small scale allows me to create entire studio spaces that can be taken in as a whole, viewed with a "God's eye" perspective. There is a sense of voyeurism, sneaking a peek into what is often a lone and intimate space. The intimacy of the work comes from that small scale, but also from the intimacy of my own creative process. I visit contemporary artists in their studios, interview them, then photograph and document their spaces. They open up to me about their daily routines and how they inhabit their studio space. Through this process, I gain an insight into key elements in the studio that I find of interest, which allows the work to attain a lived-in, homey and personal feel.'

Joe Fig

would allow him to visit their studios. His first visit, to the late painter Michael Goldberg in his cavernous loft space, was a revelation. He found that the focus of discussion quickly turned from art to everything else, the daily routine, how the studio was practically set up, in particular his painting table. 'It was an amazing experience for a young artist starting out,' Fig says, 'except I had one great, nagging regret: if only I had recorded our conversation!'

built up a psychological picture of the artist at work, which helped him encapsulate the atmosphere of the spaces. By scaling these figures down to around 15 cm (6 in.) in height, he somehow magnifies our process of observation, making us take notice of the smallest fold of a painter's overalls or the way he or she holds the brush. As observers, we become a fly on the wall to something we might not otherwise experience. Somehow the sculptures exude the energy and creativity of the many years that the artists have spent in their studios. In another series of sculptures, Fig confined himself to the artist's painting table only, focusing the spectator to a greater degree on each artist's unique signs and means of production.

Fig's conceptual and aesthetic interest in the creative practices of fellow artists goes beyond the production of sculptural dioramas: it is also something that filters into his own painting practice. The details of artists' studio floors, their brushes and palettes have all been subjects of his paintings, but in 2010 he returned to his love of art history and began to paint scenes in the life of artists such as Édouard Manet and Jean-Louis-Ernest Meissonier, at the moment when pioneers of modernism met with the old guard of classicism. An unexpected legacy of nearly ten years' study of other artists' creative processes was his book, *Inside the Painter's Studio* (2009). This hugely popular publication, which brought together all the photographs, interviews and artwork from his many visits, now stands as an important document of modern painters at work.

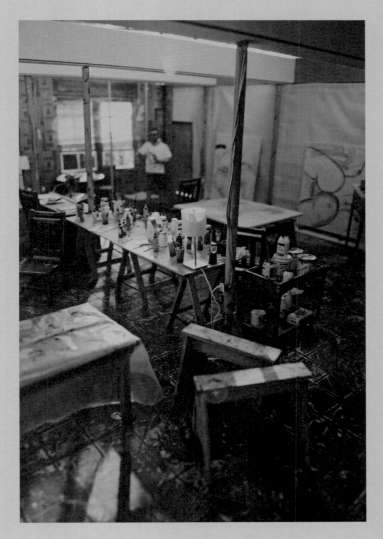

Joe Fig, *Leonardo Drew: September 24, 2013*, 2013.
Mixed media. 67.3 × 51.1 × 43.8 cm (26 ½ × 20 ⅛ × 17 ¼ in.).

Nancy Fouts

— IMAGES P. 214 —

Learning from this experience, he decided in future to devise a questionnaire, to ask each artist the very same questions, to record the moment fully. Over time, he clocked up more than fifty studio visits. While his thorough photographic records allowed him to pick up on the tiniest paint splatters, which he delicately recreates in his sculptures, the conversations

American artist Nancy Fouts reimagines objects in the tradition of surrealist sculpture, creating beautiful juxtapositions such as a cactus-like balloon with spines (*Cactus Balloon*) or a purse with a set of human teeth (*Purse with Teeth*). These works, which are either presented as photographs or gallery installations, can be seen as visual puns that often marry opposing

concepts or properties. For instance, the inflatable *Cactus Balloon*'s dangerous spines suggest its inevitable demise, in sharp contrast to the object's otherwise buoyant innocence. In some cases, the artist draws on quirky associations to bring together seemingly disparate elements within a work. In *Butterfly Dart* (2010), for example, the flight of the dart is made from butterfly wings – a magical pairing of the natural and the man-made. Both a butterfly and a dart suggest flight, but fused together the result is more like an enchanted object – a flight of fancy.

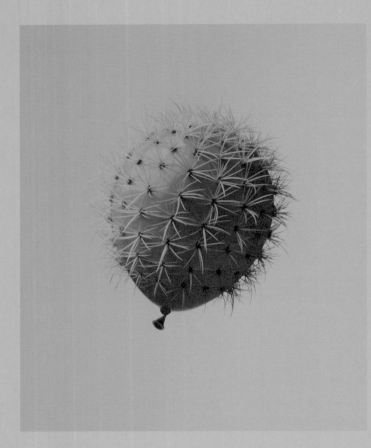

Nancy Fouts, *Cactus Balloon*.
Balloon, cactus spines. Dimensions variable.

Originally from Kentucky, Fouts has spent most of her working life in the UK, having moved to London in the early 1960s to study art at Chelsea College of Art and Design. Soon after, she co-founded the pioneering design and model-making company Shirt Sleeve Studio, creating seminal ad campaigns for Tate Gallery (now Tate Britain) and album covers for influential bands including Jethro Tull and Steeleye Span, among others. In the pre-digital era, the studio was seen as the ultimate destination for realistic models, sculpted using a wide variety of materials and photographed with enormous plate cameras. With three decades of experience of conjuring up imaginary tableaux for camera, in the 1990s Fouts began applying her skills and imagination as a full-time artist from her London studio. She now spends her time collecting interesting objects to repurpose and as inspiration for her original ideas.

A central theme in Fouts's work is freedom of thought – a means to trigger those leaps of imagination. In this aspect of her work, the artist is inspired by the innocence of childhood. This is something she touched on in an interview with *The Independent* in 2012: '[Children] have a fresh way of looking at things. So I try to be naïve all the time. While being sophisticated at the same time, of course.' She tries to imagine her subjects without preconceptions. To use her own words: 'My work is not a comment on religion, nature or indeed anything. It is all about manipulating the object to realize my idea. Everything starts with the idea.' Whether she approaches her work through the eyes of a child or is inspired by the objects she finds along the way, many of her pieces are created on a small or domestic scale. The 2012 work *Ladybird Pill Packet*, for example, presents the curious image of these insects in vacuum-packed pharmaceutical packaging. Its diminutive size and peculiarity draw the viewer in, as well as prompting certain questions: How did the ladybirds get there? What would happen if we took one of those pills?

Themes such as religion, mortality, and the natural world versus the man-made world recur throughout her work. Equally striking, perhaps, is the atmospheric quality of her pieces. Her work has been likened to a wizard's medicine cupboard, or maybe a cabinet of curiosities, as the objects she uses tend to have layers of history. These intriguing items are often design classics or archetypes – whistles, knives, miniature pistols, medals, buttons – objects that, like something from a story book, suggest another time and place. Although often reluctant to acknowledge the symbolic nature or deep meanings of her work, Fouts uses the evocative qualities of objects to create new narratives that surprise and beguile us.

Takahiro Iwasaki

— IMAGES P. 218 —

Japanese artist Takahiro Iwasaki transports us into a miniature world that reflects our own. His intricate creations are painstakingly crafted from recognizable but unusual materials, such as hair, towel threads, toothbrush bristles and rubbish bags. Similarly, the subjects he chooses are everyday features of our cityscapes that often go unnoticed, such as utility poles, pylons and construction cranes. In Iwasaki's hands, these towering but mundane symbols of modern life are transformed into tiny fibre structures.

Takahiro Iwasaki, *Geo Eye (Victoria Peak)*, 2012.
Tape. 11.5 cm (4 ½ in.) diam.

The skeletal works are presented either as freestanding objects or as part of a larger landscape. *Out of Disorder (Blue Mountain)* (2012), for example, features pylons made from threads from soft toys, against a backdrop of towels and soft toys that suggest an undulating mountain range. The pylons seem to have grown like plants from unlikely materials, creating the impression of a vast landscape in what appears to be a domestic situation. By displacing our ideas of scale and combining incongruous materials with highly engineered micro models, Iwasaki creates a world that is both familiar and surprising.

These fragile constructions look like they might be destroyed by a gust of wind, which only makes them seem more precious and, in turn, forces us to pause and marvel at them in quiet contemplation. It could be argued that the scaling down of the work in this way apparently slows down time, thus prolonging the viewer's gaze. This notion of fragility is particularly evocative in Iwasaki's cityscapes – works such as *Differential / Integral Calculus* (2011), in which

'I produce work on a small scale in order to impact the viewer's perspective and subjective view. A small work on the floor forces us to crouch down and see it from a rat's perspective. Being at that level makes us think of the microscopic, day-to-day things around us – a stain on the wall, dust on the floor or the shell of a bug – as well as the work. In this way, we realize that the scale of an object is always affected by the position of the viewer and his or her distance from the object.'

Takahiro Iwasaki

the artist uses utility poles and cables made from mechanical pencil refills and ultra-fine threads as a metaphor for the urban environment.

This concept of an infinitely precarious city is linked with his thoughts on Hiroshima, the city that was consumed in an instant by an atomic bomb in 1945. In a series of works called *Phenotypic Remodeling* (2011–12) (phenotype refers to the observable characteristics of an organism), Iwasaki returns to this idea by creating miniature cities from small pieces of discarded rubbish and printed ephemera found in

those places. Each piece has a unique visual landscape as a result. Examples include *Phenotypic Remodeling (Wiesbaden)* (2011), *Phenotypic Remodeling (Moscow)* (2012) and *Phenotypic Remodeling (Hiroshima)* (2012).

In his reinterpretation of historical architecture, Iwasaki takes a different approach. *Reflection Model (Perfect Bliss)* (2010) is a stunning scale model of Byōdō-in, a 10th-century Buddhist temple in the city of Uji, near Kyoto. The real temple is surrounded by a pond that acts as a mirror, reflecting the structure in all its glory. The artist incorporated this reflection into his work by seamlessly doubling the temple to create a single suspended object, crafted from Japanese cypress.

In presenting his contemporary and traditional forms together, as he did in the solo show 'Nichtlokalität' (2011) at the Nassauischer Kunstverein Wiesbaden in Wiesbaden, Germany, Iwasaki underlines the similarities between these illusory works. 'The false image reflected in the water is sculpted in a moment,' he says. 'With delicate towel cloth, solid mountains are presented as an unstable existence. The images, reflected in the water, the pylons on the top of the mountains, and the construction cranes complement and resonate with each other in fleeting moments.'

Luke Jerram

— IMAGES P. 222 —

This versatile and original British artist is not restricted by scale. He is equally capable of thinking big or small — on the one hand, enlivening our cities with his large-scale interventions and, on the other, focusing our minds on the deadly power of a microbe.

Jerram's joyous *Play Me, I'm Yours* piano project has toured around the world since 2008. Painted pianos — bearing the simple instruction of the work's title — have been installed in parks and squares, shopping precincts, train stations and other public places for members of the public to play. As an experiment in social bonding, it has proved a huge success. Strangers are drawn together by the street music, and there

have even been a couple of marriages as a result. *Sky Orchestra* (2003–13) is another large-scale touring project that centres around music. Seven hot air balloons fly over a city at dusk or dawn, each playing a different element of a musical score, with the aim that the combined audio will drift into the dreams of the sleepers below.

'Because I'm colourblind, I'm interested in how we see the world and in exploring the edges of perception. Early on in my research, I discovered that viruses have no colour as they are smaller than the wavelength of light. They are so small they can only be seen under an electron microscope as grainy images. Creating viruses in glass shows them as they actually are – colourless. The sculptures are approximately one million times larger than the actual viruses. By extracting the colour from the imagery and creating jewel-like, beautiful sculptures in glass, a complex tension arises between the artworks' beauty and what they represent.'

Luke Jerram

Sky Orchestra is one example of Jerram's exploration of the edges of perception. Similarly, at the other end of the scale is his unique blend of microbiology and glass. Since 2004, he has worked with glassworkers and virologists to create sculptures of viruses, taking these tiny, virtually imperceptible infective agents and revealing them in all their beauty. By blowing them up to a million times their actual size, he can unveil the complex and varied shapes of

these enemies of humankind – HIV, smallpox, swine flu, salmonella and E. coli, among them. Jerram's engagement here is as much with science as art. His own colourblindness gives him an intellectual interest in colour perception. He was aware that viruses have no colour, as they are smaller than the wavelength of light, yet they are often portrayed in colour. By using clear glass, he creates a truer image of a structure a shade away from invisibility.

Jerram's *Glass Microbiology* sculptures are represented in museum collections around the world, including the Metropolitan Museum of Art in New York, the Shanghai Museum of Glass and the Corning Museum of Glass (USA). Of equal interest to scientists, they have featured in *The Lancet*, *The British Medical Journal* and *Nature Structural & Molecular Biology*. They found a congenial home in the Wellcome Collection in London, which exhibits both medical artefacts and original artworks exploring ideas about the connections between medicine, life and art. In 2007 Jerram won the 'Institute for Medical Imaging Award', and in 2010 the coveted 'Rakow Glass Award' for this work, as well as being awarded a fellowship at the Museum of Glass, Washington (2011). He continues to explore the relationship between science and art with works such as the *Tōhoku Japanese Earthquake Sculpture* (2011), created by converting a seismogram of the earthquake into a sculpture.

project, the *Insectarium Bestiary* has become the artist's signature work. As a collection of alternative natural history, these fantastic creatures are treated with the same respect as authentic finds: the form of display has evolved from museum-style vertical glass cabinets to insectariums, stressing their collectability as specimens and alluding to their necessary preservation. Conceptually the works ask us to consider the scientific classification of all living organisms and the values that we, as individuals, place on them – subjective values that ultimately turn our capacity to classify into an endless task.

> 'My creatures are formed through a process of alchemy by which matter is transformed. Working at this small scale is a way for me to preserve ideas through objects. The objects encapsulate these ideas and, in some ways, are instruments of contemplation and stimulation for the imagination.'
>
> Nicolás Labadia

Nicolás Labadia

— IMAGES P. 224 —

Since 2007, Chilean artist Nicolás Labadia has been working meticulously on an evolutionary art project known as the *Insectarium Bestiary* (*Insectario Bestiario*). Using discarded objects collected during long walks around Santiago – a mix of manufactured and organic items – he creates a parallel micro world of small-scale hybrid creatures. Originally started as a research

The artist's imaginatively constructed miniature sculptures are rooted in two childhood passions: a fascination with the natural world and an avid interest in collecting diverse objects. He starts with an assembly process whereby he puts different objects together through a visual association of parts to create small works that are collectable pieces of a greater body of art. In his research, he refers to scientific books to study biological, cellular and entomological forms, in part, he explains, 'because these areas of study are full of beautiful human mediations such as maps, photographs, drawings, scientific notes, field journals, etc.,' which support and advance his own work. While science provides inspiration and a logical point of reference, Labadia's sculptures are creatures of invention, intuitively made, often in response to the textural and symbolic aspects of the collated parts.

Juxtaposing natural and man-made found materials, Labadia suggests an ecological or philosophical message. On the one hand, he underlines the resistance of nature and the regenerative/degenerative cycles of life. On the other, he emphasizes human intervention in the environment: we create objects that are – to use the artist's own words – 'resistant to time' but 'fragile in terms of memory and their link with people'. For the artist, the process of gathering objects such as mementoes and manually changing them to create these imaginary beasts is both personal and enjoyable. Aesthetically these used objects, with their faded colours and sometimes obsolete technology, can evoke in the viewer a sense of history or time. But the gift of these sculptures also lies in their beauty and humour – qualities that the artist does not set out to achieve in a conscious, premeditated way but realizes through the semantic richness that a collection of such diverse objects acquires.

Guy Laramée

— IMAGES P. 228 —

Canadian artist Guy Laramée works in many different fields, including scriptwriting, set design, music composition, sculpture and painting. In recent years, he has been exploring the relationship between text and sculpture through extraordinary carved books – which have become his signature works – dioramas and installations. The book concept came to him by chance back in 2000, while he was studying anthropology. Inspired by the impressive collection of Quebec's Grande Bibliothèque, he became intrigued by the mythic idea of an encyclopedic collection of humanity's knowledge and the role of the printed book in the digital age. After receiving a commission for a theatre set, he had the idea of putting a book in a sandblasting cabinet. It was the start of a whole new chapter for him. Laramée has developed a remarkable approach to books as an artistic material, both technically innovative and conceptually insightful.

In his artist statement, Laramée contemplates the eventual obsolescence of the printed book. Knowledge, he notes, changes over time, as does the way we view it; similarly, cultures emerge and are replaced by new ones. In this way, Laramée suggests that, ultimately, the idea of knowledge can be seen as an erosion rather than an accumulation – the perfect analogy for the landscapes he sculpts into antiquated books, whose relevance has been surpassed by new forms of content. 'Mountains of disused knowledge return to what they

Guy Laramée, *Prajna Paramita*, 2011. Carved book. Dimensions variable.

really are: mountains,' he explains. 'They erode a bit more and they become hills. Then they flatten and become fields where apparently nothing is happening. Piles of obsolete encyclopedias return to that which does not need to say anything, that which simply IS.' The erosion of knowledge is represented metaphorically by geological erosion in miniature.

As Laramée sandblasts and drills through old encyclopedias, the landscape he reveals is often

Asian in character, with terraced valleys, mountains and temples that are reminiscent of Chinese and Japanese art. While there is a Zen-like tranquillity to them, the artist says: 'My work is existential. It may depict landscapes that inspire serenity, but this is the serenity that you arrive at after traversing life crisis.' Indeed, some of Laramée's works have been created in response to trauma, such as his *Guan Yin* series of sculptures and paintings, produced after the death of his mother in 2011, just a few days after Japan's tsunami. Devastated by both events, the artist dedicated this project to the mysterious forces that enable us to 'traverse ordeals'.

'I don't feel that I work on a small scale at all! I make rather big mountains, huge caverns! To me "scale" is like "age". When I feel things from the inside, I feel the same way I did when I was younger. So when I become totally absorbed in the work – feeling things from the inside – I'm actually out there, within the mountains, and the question of "scale" simply disappears. I guess it is all a question of involvement.'

Guy Laramée

In another series of works titled *A Caverna/ The Cave* (2012), Laramée carved beautifully formed grottos into old leather and cloth-bound books. Through a soft light, our gaze is drawn into the stratification of the paper and ghosts of typeset pages. The caves are symbols of our eternal quest to dig relentlessly in the pursuit of knowledge, only to discover that what we find on the inside is much the same as the outside. The small worlds that the artist carves out in miniature 'are no smaller than the big ones', he says. '[Claude] Lévi-Strauss thought that artworks were always miniatures; that even the paintings of the Sistine Chapel are small compared to what they depict. He was partly mistaken, because you cannot put feelings on a physical scale, or try to measure them.'

Nadín Ospina

— IMAGES P. 232 —

Colombian artist Nadín Ospina is best known for combining iconic cartoon characters and toys of modern popular culture with the traditions of ancient pre-Columbian art. In his sculptures, he meticulously emulates the materials and stylistic hallmarks of indigenous art objects, using media – for example, stone, ceramics, jewelry – that at first glance resemble those of precious and significant works from the great civilizations of the Americas, such as the Olmecs, Maya, Aztecs and Incas. However, on further inspection, we realize that the iconography of the works has been subtly changed: instead of mythological portraits of gods, demons and animals, Ospina depicts icons from the low-brow pop culture of cartoons such as Mickey Mouse, Goofy and Bart Simpson. These modern-day comic characters can be seen as emblematic of cultural colonialism, in contrast to the preoccupations and artistry of pre-Columbian cultures. In a sincere yet witty way, the artist points to the globalization of culture through entertainment and information, while indigenous identity becomes subsumed and marginalized.

Born in 1960 and raised in his home city of Bogotá, over the following decades Ospina began to notice the gradual increase in European and American influence on day-to-day life. From food to fashion, the new goods and appliances being adopted from abroad fascinated him, but it was the imported toys in particular that left a long-lasting impression. He began to realize the universal attraction of otherness: wherever we come from, we are drawn to the exotic and those objects that conjure up thoughts of far-away places. Colombia has been experiencing growing

'I am very drawn to small-scale objects in general terms, because of their interactive, tactile, transportable qualities. This interest springs from several sources. First, from the scale of toys, which are the ultimate interactive objects. Toys are playful, tools for the imagination, companions in times of solitude, and symbolic representations of the world at a scale that is tactile, personal and intimate. Second, from small-scale pre-Columbian objects that serve a utilitarian or ritual function, which become objects of magical interaction and symbolism with a huge cultural significance. And finally, from consumer goods, with their interactive accessibility as items for consumption, appropriation, collection and social empowerment. These sources of inspiration come out in my work as simulations of these primordial objects, viewed through a critical, questioning and even political lens.'

Nadín Ospina

interest in traditional crafts and pre-Hispanic art, but the revival is primarily driven by tourists who want to take back a memento of their adventure in a foreign land. At the same time, digital communications and economics are making us all more globalized. As a result, some of the most beloved characters have been transformed into celebrated cultural icons on a worldwide scale – even if they are sometimes a little dysfunctional, as in the case of Matt Groening's *Simpsons* family.

In 1992, Ospina began to explore how different cultures influence each other. In an important part of this exercise, he took it upon himself to reverse the dynamic by exerting his own national cultural identity on the prevailing global tide. This mission took him to San Agustín, a small town known for creating replicas of indigenous art (the area is famed for its pre-Columbian archaeological sites), where he started to work with skilled craftsmen to create works with a cross-cultural fusion. While he has worked on other concurrent projects, he has continued to create reimagined pre-Columbian sculptures as a central body of work. These statues have subsequently been exhibited in numerous exhibitions, but rather than present them in a classic white-walled gallery, Ospina positions them as if they were natural history. Displayed in cases or on pedestals, and using dramatic lighting, they take on a hushed historical importance and paradoxically present Western culture as foreign, as if the characters of Walt Disney were created by unknown primitive cultures. In this way, he reverses ingrained perceptions that non-Western art is somehow backward, to create a cultural fusion in which everyone has become the 'other'.

between reality and representation, particularly through her use of 'theatrical vignettes', which she creates as subjects for her photographs, videos and installations. These staged scenarios, which she describes as 'situations', are created using humble items sourced from flea markets and antique shops, including crockery, figurines and used toys, alongside

Liliana Porter, *Limit*, 2010. Figurine on wooden geometric shape, wall installation. 10.2 × 7 × 7 cm (4 × 2 ¾ × 2 ¾ in.).

Liliana Porter

— IMAGES P. 236 —

Argentinian artist Liliana Porter works across many disciplines, including painting, printmaking, video, photography and installation art. Throughout her practice, she explores the disconnection and distance

miniature models and simple materials, such as wood and thread. By skilfully juxtaposing these objects, she forms narratives that are engaging and humorous, but on further inspection reveal layers of pathos and careful observations of life's everyday struggles.

These situations are often surreal or absurd in character. In *To Go Back* (2011), for example, a miniature figure is seen carrying a suitcase down a hand-drawn path on a white shelf that leads to the painted landscape of a blue and white delft jug.

The disparate parts that make up the vignette rely on illusion and the imagination of the audience to bring this curious scene to life and make their own interpretation. As Porter explains, 'The objects have a double existence. On the one hand, they are mere appearance, insubstantial ornaments, but, at the same time, have a gaze that can be animated by the viewer, who, through it, can project the inclination to endow things with an interiority and identity. These "theatrical vignettes" are constructed as visual comments that speak of the human condition. I am interested in the simultaneity of humour and distress, banality and the possibility of meaning.'

Porter presents her vignettes using standard supports for exhibition in a gallery, such as plinths and shelves. However, these props are often subverted by the small-scale protagonists who cover them in paint, vandalize them or otherwise break them apart. This subversion works in a number of ways: first, the scale of the work and its supports is unusually small, which is unexpected in a gallery context; and second, by interfering with the plinths, Porter draws attention to the deception of the art, highlighting the difference between what is real and the artistic fiction.

Similarly, by using small-scale objects, Porter is able to create seemingly impossible situations that would be difficult to recreate at life size or, at least, would not have the same allegorical weight. The artist's fictional world allows her to play with scale to dramatic effect. One example is the *Forced Labor* series, in which she presents her model-sized figures performing Herculean tasks: a woman sweeping a proportionately vast mound of dirt (2004), although to the viewer it is only a sprinkling of dust; or a man attempting to knock down a gallery wall with a pickaxe and barely scratching the surface (2008).

While there is a divide between the scale of the artwork and the viewer, we are able to empathize with the plight of these figures, just as we would have done as children. When we are young, we explore our ideas and emotions through imaginative play with toys and characters. Porter instinctively recognizes that we never really lose this ability, and through her work is able to remain playful with an adult sense of humour and perspective.

Klari Reis

— IMAGES P. 240 —

'Jelly Beans Melting on the Surface of the Sun', 'Brain Eaters from Jupiter', 'Radioactive Kiwis': such are the evocative titles that Klari Reis has given her circular works, characterized by their intense colour,

'Working on a small scale was a new constraint when I chose to paint within the confines of a Petri dish. I used to dislike working small but found over time, with experimentation, that the Petri dish was the perfect vessel for my biologically based cellular works. I now enjoy creating intricate effects that I couldn't produce as part of a larger painting, as well as working on many dishes at one time. I love their portability and their availability to art enthusiasts with limited budgets. My medium, epoxy polymer, lends itself to working on a few paintings at a time. It's endothermic: it heats up and then cools down with a very short working time – if unused, there is no going back.'

Klari Reis

cellular-like formations and swirling lines. Each of the San Francisco-based artist's paintings is the result of an experimental process that brings together art and science. She creates the paintings in Plexiglas

Petri dishes by mixing pigments into a base of epoxy polymer, a rubbery resin more often associated with flooring. The chemicals in each mixture react differently to produce unique results, and by using heat or cold the artist can provoke further unpredictable effects. Taking the role of artist and technician, Reis is able to orchestrate the combination of colour and composition as she harnesses the chemical forces at play.

Having originally graduated in architecture, Reis chose to study fine art at the City & Guilds of London Art School, where she began to paint abstract works in bold colours on canvas. Around 2005, she was diagnosed with Crohn's disease and began to undergo treatment. This experience furthered her fascination with biology and led her to think about the different ways our bodies respond to medication. Her doctor, knowing that she liked to paint biological subject matter, let her watch her cells react to different anti-inflammatory drugs through an electron microscope. While engrossed by the science, she was struck by the beautiful reactions made by the fluorescent dyes as they were used to isolate parts of the cells. The initial idea for her Petri dish paintings began to take shape.

Reis started out painting with epoxy polymer on wood and canvas but she found it increasingly difficult to source her materials in London, so she returned to San Francisco to be closer to her supplier. She had put her Petri dish idea on ice temporarily, but the move enabled her to experiment more freely. After pouring her first dish, she was hooked: 'I didn't sleep for two days.' As the Petri dishes multiplied, she began to collate them, exhibiting them as installations in groups of 30, 60 or 150, using a range of sizes, from 7.5–15.25 cm (3–6 in.) in diameter. Supported by steel rods, the paintings are positioned at different distances from the wall to add further depth.

Each small dish is surprisingly different from the next, with seemingly endless permutations of form. These colourful constellations draw attention to the scientific wonders we see in the microscopic natural world and, at the same time, evoke the unfathomable vastness of the universe. Titles such as 'Beautiful Trash Orbits a Full Moon' enhance these associations, conveying the miniature worlds of wonder within these unique artworks, as well as revealing the artist's sense of fun.

Egied Simons

— IMAGES P. 244 —

The experience of space is the inspiration for Egied Simons's sculptures, installations and public art interventions. Creating an intriguing blend of art and science, the Dutch artist and photographer uses natural phenomena and dynamic processes in our immediate environment, such as the wind and small organisms, as a basis for his work. He ingeniously applies scientific principles and tools, such as lenses, mirrors, cameras and projectors, to harness natural forces and present them in interactive ways. Quirky and charming, the results are designed to be accessible and engage with communities, often in unusual locations. One example is *Cita Morgana Rotterdam* (2012): having converted a bus into a mobile camera obscura, the artist offered visitors a unique view of Rotterdam and the opportunity to experience the city in an entirely new way.

'Small has different motions. Small has different accelerations. Small is more transparent. Small reveals patterns. Small is magic. Small reflects really big.'

Egied Simons

The *Liquid Files* series (2010–13), exhibited at various locations including the Verbeke Foundation in Kemzeke, Belgium, also exemplifies the artist's approach. In this installation, Simons projected biological materials onto walls, from spider webs, butterfly wings, fish scales, blood and insect eggs to living organisms suspended in water. By literally zooming in on the matter that surrounds us, framing both the living and dead, he revealed beautiful compositions. 'Watching reality becomes an almost

cinematic experience,' he explains. In another branch of the project, *Bus Stop North* (2011), living organisms from a nearby pond were projected onto the matte glass sides of a bus stop in Rotterdam, complementing the movement of the passing buses.

Similarly, *Aqua Morgana* (2013), an installation at Gemeentemuseum in The Hague, was also designed to evolve during the course of the exhibition. Using the Dutch polder landscape as a reference, the work featured three shallow basins filled with water containing algae, water plants, insects and snails taken from the Gemeentemuseum ponds. These basins were lit from below, while mirrors above — angled at 45 degrees — reflected the lively water fields. Free from the effects of gravity and with sufficient surface oxygen, the organic matter created beautiful, complex, shifting patterns. Light played a key role in this work, as it does in almost all of Simons's projects, focusing the attention of the viewer in an otherwise darkened room.

In another work, *Fruits Exploded View* (2011), which formed part of the group show 'The Botanist's Reverie' at the Retort Art Space in Amsterdam, the artist exhibited soft fruits crushed between two sheets of glass, transforming three dimensions into two. Critically, the framing and presentation of this compressed organic matter change it from an everyday material into something fascinating and glorified. Simons's interest in plant life has also extended to a study of root systems with the work *Root Lab Field Research, Weaving Patterns & Root Extracts* (2013) at Radboud University in Nijmegen. This project was inspired by the artist's fascination with the connections between the world above and the world below — which plants attract or repel each other, for example, and the role of roots in this regard. From plant roots to pond life, Simons brings the wonder of small things to our captive attention through his unique take on art and science.

Iori Tomita

— IMAGES P. 248 —

Art meets science in Iori Tomita's quirky, mesmerizing creatures. The Japanese artist's inventive take on a process originally used to study the skeletal systems of animals goes back to his university days, when he studied ichthyology (the zoology of fish). The method of turning specimens transparent, and highlighting their bones and cartilage with magenta and blue dyes, fascinated Tomita and it wasn't long before he began creating his own versions. Although he briefly worked

'I create art to make people look at the beauty of life. One of the reasons I work at a small scale is because my process of making specimens transparent and adding colour works better on small creatures; the effects are more striking. The creatures have already died when they become the artwork, but my hope is that they make the viewer see living creatures in a new light.'

Iori Tomita

for a company in Tokyo after leaving university, in 2007 he became an apprentice fisherman. This new direction allowed him to continue experimenting with the transparent specimen technique using discarded or found fish carcasses. Over time, as he became increasingly proficient in the method, his work was driven as much by artistic impulses as scientific fascination. With the launch of the ongoing *New World Transparent Specimens* project in 2008, Tomita turned his passion into a full-time career.

In the creation of his specimens, Tomita first removes the scales and skin of fish that have been preserved in formaldehyde. He then soaks the creatures in a stain that dyes the cartilage blue, followed by an enzyme called trypsin and other chemicals that break down the proteins and muscles. The creatures must hold their form, so Tomita has to intervene at just the right time. The bones are then stained red and, depending on the physical make-up of the animal, different hues are created. Refining this process to accentuate forms and define the colouration for each specimen requires great skill. The results are extraordinary, translucent, jewel-like creatures, which are placed in a jar of glycerin to preserve them and keep their colours vibrant. Despite the time-consuming nature of the process, which can take anything from five months to a year to complete, depending on the size of the specimen, Tomita has produced more than 5,000 specimens since 2005.

Tomita's subjects tend to be sea creatures that have passed away naturally, including sea horses, crabs and squid, or deceased animals from pet shops, such as lizards. With their vibrant colours that are reminiscent of the CMYK model used in four-colour printing, these transparent specimens give us a unique view of the inner workings of the natural world. Their placement in small vials and jars draws us in further, inviting a closer look. In an interview with Sky News, Tomita concludes: 'Although these are just transparent specimens, they're filled with the drama of organisms which I have so much love for. I want people to enjoy the beauty of life, treat life with respect and understand that there is drama happening that is not centred on themselves when they look at the specimens.'

Yin Xiuzhen

— IMAGES P. 252 —

Yin Xiuzhen is a hugely inventive Beijing-based artist, known for her intimate sculptural objects and large-scale installations. Since creating her first installations in the early 1990s, she has incorporated recycled material into much of her work – particularly old clothes, which she uses in colourful and textural arrangements to explore issues of urbanization and globalization.

Born in 1963, Xiuzhen grew up during the Cultural Revolution, at a time when the Chinese government kept the people in a firm ideological grasp. With the onset of reform in 1978, Chinese artists such as Xiuzhen fully embraced the freedom of personal expression that came with the transition from the old China to the new. Xiuzhen's generation was the first to experience this freedom, yet vividly remembered how it was before – a theme that continues to run through her work.

Representative of her approach is *Collective Subconscious* (2007). In this project, the artist bisected an abandoned minibus and reconnected the two parts using a stainless steel structure and patchwork of discarded clothes, creating a 14-m-long (46-ft) vehicle that resembled a caterpillar. Extra wheels were added to the underside of the cloth tunnel that connected the two parts of the minibus, and stools were installed inside to encourage viewers to sit and listen to a pop song played on a loop. The minibus was a common form of transportation in Beijing in the 1990s, but has now almost vanished with the increase in car ownership. In this way, the work suggests a bygone era before China's economic liberalization and the illusive security of belonging to a collective. By using found materials, Xiuzhen's sculptures encapsulate and document memory. As the artist explains, 'In a rapidly changing China, "memory" seems to vanish more quickly than everything else. That's why preserving memory has become an alternative way of life.'

As her work became internationally recognized, allowing her to travel abroad, Xiuzhen was inspired by the theme of dislocation. Spending time at airports, waiting at baggage carousels, she started to think about suitcases as shrunken homes or symbols of our increasingly globalized lives. This idea motivated her to create two of her best-known series. In *Suitcases* (2000–2), she used suitcases as a base to make small sculptures of homes from old clothes. *Portable Cities* (2001–ongoing) is a continuation of this project, in which the artist creates miniature cities within suitcases using second-hand clothes from citizens of a specific city, from Beijing to Berlin. Displayed open on the floor, the suitcases reveal pop-up cityscapes

with recognizable landmarks and can be lit from the inside, giving them an ethereal quality. The works are accompanied by sounds recorded in the selected city's public space. In a similar way to souvenirs, Xiuzhen views these portable cities as collections of memory, or portraits of the city imbued with her reflections of the city. Xiuzhen has made more than twenty portable cities in total – all places she has visited. They are not always accurate, but through them she tries to encapsulate a feeling. In the artist's view, these works represent a shrinking of the globe, as urban architectural forms become increasingly similar from continent to continent. Equally, with the modern world characterized by an evermore transient way of life, she sees the suitcase as a symbol of a self-contained home and likens it also to a computer, which has become our virtual home. In these globalized times, with many of us living out of a suitcase or in our virtual worlds, she feels that 'the suitcase has taken control of our lives'.

Yang Yongliang

— IMAGES P. 254 —

Born and raised in his home city of Shanghai, Yang Yongliang combines his background in traditional painting and calligraphy with a knowledge of photography and digital art to present a view of China that lies somewhere between the modern and the traditional. In his painstakingly constructed images, the artist invents urban scenes ubiquitous in China today, with construction towers, skyscrapers, electricity pylons and motorways, and imagines them rising up from the stylized landscapes depicted in historical art.

These two visions of the Chinese landscape are visually suggestive of each other. Yongliang sees similarities between the craggy, tree-covered mountains familiar in Chinese watercolours and the contours of these new growing cities; the city lights echo the use of light and shade in traditional painting. While there is some visual harmony between the industrial and natural forms, the impact of recent rapid progress is made starkly clear: as cities and populations grow, the environment and historical culture inevitably suffer. Yongliang originally chose Shanghai as his subject, but a lot of his pieces draw elements from many different cities, including some beyond Chinese borders, as he wants his work to reflect a common idea.

Although not overtly political, his landscapes present a viewpoint that is critical and at the same time filled with wonder at the spectacle of development, as they conjure up dark emerging cities that are simultaneously filled with energy and light. This work to some extent has been made possible by Yongliang's coming of age at a pivotal time in China's history, as he enjoys an artistic freedom unobtainable by previous generations during the Cultural Revolution. In this period of increasing acceptance and openness, contemporary art in China has been flourishing. Yongliang's up-and-coming voice within this scene has led to many exhibitions both at home and internationally.

The use of scale in Yongliang's work is more conceptual than physical: although his photographs are printed in a variety of formats according to the number of editions and exhibition requirements, it is in the image itself that the artist plays with scale, creating impossible but believable scenes that blend two- and three-dimensional forms. This is exemplified by his elegant *A Bowl of Taipei* series (2012), created for an exhibition in Taiwan, which reimagines the city of Taipei nestled within porcelain bowls from different periods of Chinese history. These ancient bowls are inscribed with auspicious symbols, while also making reference to Taiwan's food culture. The mountains, urban landscape and even the clouds are based on photographs taken in Taipei by Yongliang himself. The artist manages to distil many levels of meaning into these small monochromatic scenes: the glow of a warming bowl of soup, an urban jungle rising into ink-brushed clouds, and a feeling of fragility and nostalgia in a world of harsh progress.

'The concept of "seeing a big world from a small angle" has always been rooted in Chinese people's ideologies. Chinese philosophy believes all things share the same rules. In my works, I incorporate core values of traditional Chinese philosophy in my investigations into contemporary graphic techniques. The way I present my works resembles how traditional Chinese landscape paintings were created, building up sophisticated structure with simple elements. However, I replace the original brushstrokes ("cun") with images of city landscapes.'

Yang Yongliang

Small
Art

In this era of ambitiously grandiose art, it is perhaps more important than ever to have a counterbalance. Some artists are indeed taking their work to the other extreme by embracing the 'small is beautiful' principle, highlighting the fact that we form a tiny part of the wider world and drawing attention to the wonderful minutiae all around us. Small art, although not formally recognized as a genre or movement, is becoming an increasingly popular term that aptly describes these artworks created at a domestic or miniaturized scale. Why work big when big ideas can also be conveyed in a modest or intimate way? Small art may lack the sheer presence of its large-scale counterparts, but it is no less memorable, engaging and important.

The works featured in this book show to great effect how art can be beautifully striking and persuasive at a small scale. They have not been bound by strict criteria; while each work is undeniably small, the dimensions can vary quite considerably, depending on whether the piece is a photograph, a sculptural object or an installation, for example. Producing pieces that range from intricate origami to glass sculptures, from carved leaves to apocalyptic dioramas, the artists presented in the following pages employ diverse original techniques, materials and approaches in their work. They include sculptors, painters and photographers who work exclusively at a diminutive scale or have produced significant work of this nature. To represent the rich currents within small art, the works encompass a variety of practices and skills, as well as different artistic aims and aesthetics. However, perception is key to all the works: there is always a distance between the viewer and what is being represented, the filter between the artist and audience — a concept that is accentuated through scale.

Many of the artists create small alternative worlds, but with very different results. These small worlds are approachable by nature of their size, and are often captivating in their extraordinary detail. The viewer is placed in a voyeuristic or god-like position, looking down over a miniaturized scene frozen in time. Joe Fig takes detail to new levels in his miniature reproductions of artists in their studios. As viewers looking into these small-scale replicas, we are granted privileged access to what is generally a closed-off, intimate space. Thomas Doyle emphasizes the viewer's god-like perspective by encasing his realistic, intricate scenes under glass domes or bell jars. The suburban landscapes that he depicts seem familiar, with their white picket fences and immaculate lawns, yet are shown in the midst of disaster.

Doyle's small-scale worlds become a stage, forming a backdrop for the miniature figurines as they play out the scenes of chaos. Tiny figurines also take centre stage in the work of Liliana Porter, whose often surreal or absurd theatrical vignettes explore the disconnection between reality and representation. Using second-hand objects from flea markets and antique shops, she creates what she calls 'situations': staged scenarios in which her miniature models, skilfully juxtaposed with everyday items that tower above them, are seen endlessly toiling on seemingly impossible tasks. These miniaturized worlds have a way of connecting with us emotionally, evoking childhood memories and times spent playing with smaller, pretend versions of real-life objects.

Rather than creating snapshots of life, other artists are choosing to craft vast landscapes on a small scale. Free of human figures, these landscapes instead focus on the structures that form an integral part of the modern urban sprawl. In *Portable Cities* (2001– ongoing), Yin Xiuzhen uses second-hand clothes from residents of a particular city to create a miniature representation of that city within a suitcase, which becomes a symbol of our increasingly transient way of life. Takahiro Iwasaki makes tiny, fragile models of towering elements of the urban landscape, including utility poles and pylons, out of familiar but unusual materials, such as toothbrush bristles and pencil

lead – the delicate nature of the media suggesting the fragility of our own place in the world. Evol also focuses on everyday urban features but uses them as his support in a series in which he paints mini concrete tower blocks in the street. By miniaturizing large-scale, mundane symbols of the modern city in such detail, these artists open our eyes to common features of our surroundings that we often take for granted.

Many of the sculptural works in this book also stop us in our tracks, with artists repurposing everyday materials or subverting familiar icons to create unexpected, sometimes disorientating associations that spark our imagination. Nadín Ospina makes sculptures in the style of indigenous art objects that instead depict icons of pop culture, such as Mickey Mouse. Diem Chau also carves sculptures but surprises through her choice of media: pencil leads and colourful crayons. As viewers, we can only marvel at the skill involved in transforming such a small, everyday item into a highly detailed object of beauty. In a similar way, Guy Laramée and Nancy Fouts catch us off guard. Laramée's element of surprise also comes in part from his choice of material – antiquated books – which he carves to reveal beautiful, complex landscapes. Fouts creates subversively surrealist sculptures that play on our natural associations – replacing the flights of a dart with the fragile wings of a butterfly, for example. With meticulous skill and a brilliant eye for creative possibilities, these artists transform everyday objects into things of fantasy and wonder.

In some cases, the small scale of the work accentuates the properties of the raw material, such as the veins of a leaf (Lorenzo Manuel Durán) or the patina of origami paper (Nguyễn Hùng Cường), making the detail and textural qualities of an object integral to the work. For other artists, it is an interest in microscopic or scientific beauty that has led them to investigate the art of small things. For example, Egied Simons uses organic materials to create projected light installations, Luke Jerram makes flameworked glass sculptures of viruses and Klari Reis creates paintings in Petri dishes. Nature is a strong inspiration in other works that might not look out of place in a museum display cabinet: Nicolás Labadia uses found objects to create tiny hybrid creatures, Alberto Baraya dissects and marks up artificial flowers as if they were real, and Iori Tomita highlights the skeletal systems of creatures in his series of transparent specimens. In combining science with art, alongside an appreciation of natural materials, these artists reveal their fascination with the beauty of detail.

In the digital age, art is often experienced in pixels rather than in person. When we see big art in situ, it has a distinct advantage over small art due to its size. Although we still perceive and react to scale online, the virtual experience levels the playing field and perhaps even gives small art the upper hand. Small art can appear particularly intriguing onscreen: the viewer is drawn into the detail, unconventional media and inventive world of the artist. While the highly skilled and handcrafted aesthetic of many of the works in this book is part of their appeal, a number of artists are also embracing modern technology, including David DiMichele, Yang Yongliang and Brock Davis, who all use photography in their work.

As we have seen, scale – and, in particular, the creative use of small scale – can be an evocative and effective tool in art: it can be used to create narrative, to satirize, to theorize, to explore microscopic and scientific worlds, or to surprise and amaze. While greatly varied in their artistic endeavours and goals, the selected artists bring a strong human touch to their work. They invite us to look at the world differently, to question our perceptions, to notice everyday materials that are so often overlooked, and to see the very particles that make up our planet. Even in its most simple form, small art can be profound, witty and spectacularly beautiful, demonstrating that less is definitely more.

Alberto Baraya

— PROFILE P. 149 —

Herbario de plantas artificiales, Urapan 2
(*Herbarium of Artificial Plants*), 2011. Mixed media.
450 × 600 × 7 mm (17 ¾ × 23 ⅝ × ¼ in.).

BELOW
Herbario de plantas artificiales, Cymbidium Athos
2013
Artificial flower, drawing and
colour photograph on cardboard
×
450 × 600 × 7 mm (17 ¾ × 23 ⅝ × ¼ in.)

ABOVE
Herbario de plantas artificiales, Sietecueros
2003
Photograph
×
370 × 500 mm (14 ⅝ × 19 ⅝ in.)

LEFT
Herbario de plantas artificiales, Geranium
2004
Plastic leaf, paper label
×
c. 7 × 4 × 2 cm (2 ¾ × 1 ⅝ × ¾ in.)

Herbario de plantas artificiales, Pop Tulip

2012

Artificial flower, drawing and black-and-white photograph on cardboard

×

112 × 82 × 7 cm (44 ⅛ × 32 ¼ × 2 ¾ in.)

Diem Chau

— PROFILE P. 149 —

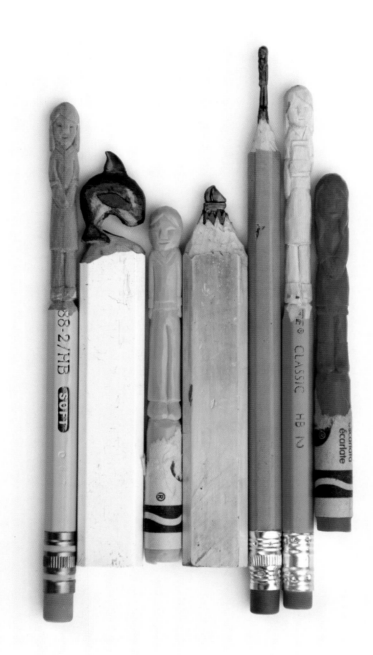

ABOVE Selection of works. Carved Crayola crayons.

Dimensions variable.

OPPOSITE *C is for Cortez*, 2013. Carved Crayola crayons.

Individual crayon measurement: 89 mm (3 ½ in.), 10 mm (⅜ in.) diam.

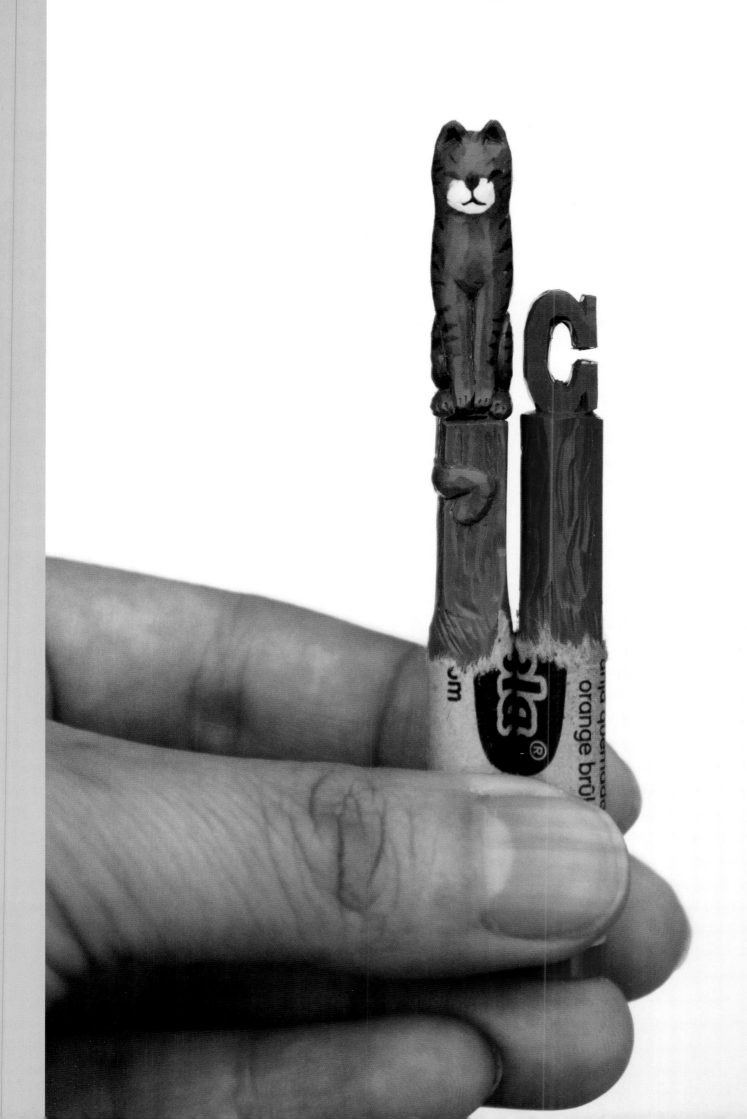

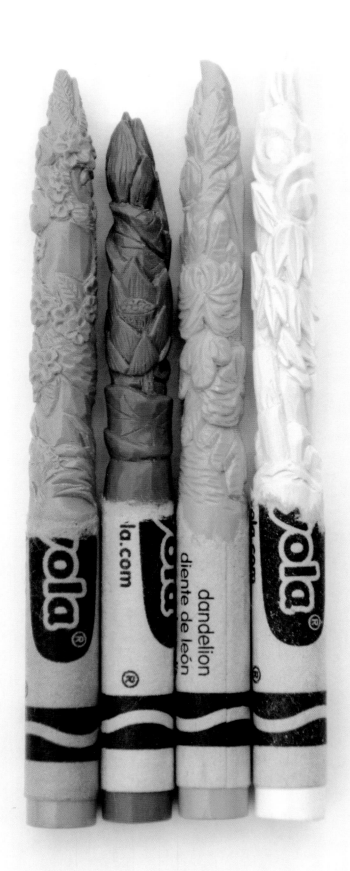

RIGHT

The Last Bear

2013

Carved carpenter's pencil

×

121 × 16 × 6 mm (4 ¾ × ⅝ × ¼ in.)

BELOW

Alphabet

2012

Detail of carved crayons from
Alphabet series (T–Z)

×

Individual crayon measurement:
89 mm (3 ½ in.), 10 mm (⅜ in.) diam.

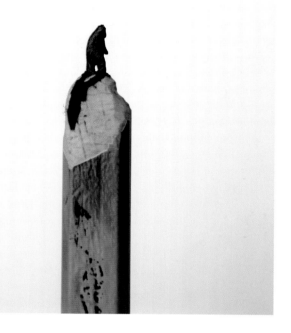

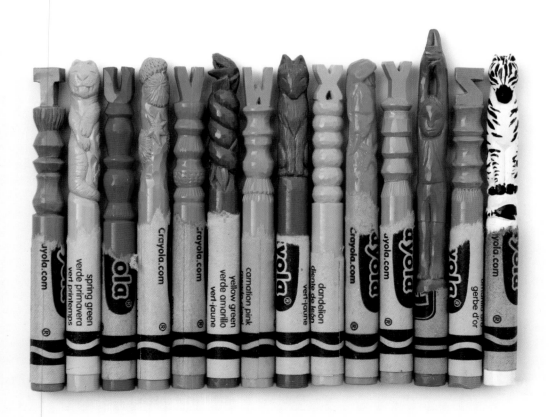

OPPOSITE

Four Seasons

2011

Carved Crayola crayons

×

Individual crayon measurement:
89 mm (3 ½ in.), 10 mm (⅜ in.) diam.

BELOW
The Last Elephant
2012
Carved carpenter's pencil
×
133 × 16 × 6 mm (5 ¼ × ⅝ × ¼ in.)

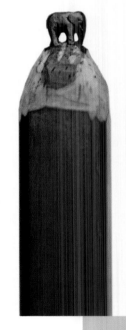

ABOVE
Union
2011
Hand-painted porcelain cup, organza, thread
×
89 × 89 × 44 mm (3 ½ × 3 ½ × 1 ¾ in.)

LEFT
Gather
2012
Porcelain plate, organza, thread
×
572 × 140 × 19 mm (22 ½ × 5 ½ × ¾ in.)

OPPOSITE
Jack
2013
Carved carpenter's pencil
×
127 × 16 × 8 mm (5 × ⅝ × ⅜ in.)

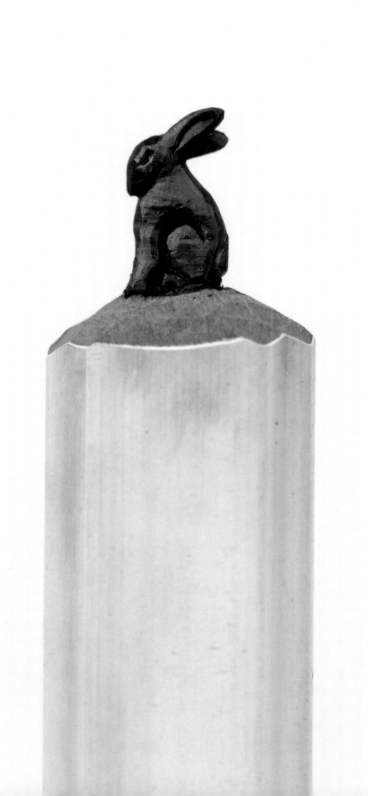

Nguyễn Hùng Cường

— PROFILE P. 150 —

ABOVE *Twin Rabbits*, 2013. Paper.
Dimensions variable.

OPPOSITE *Great White Shark*, 2013. Paper.
Dimensions variable.

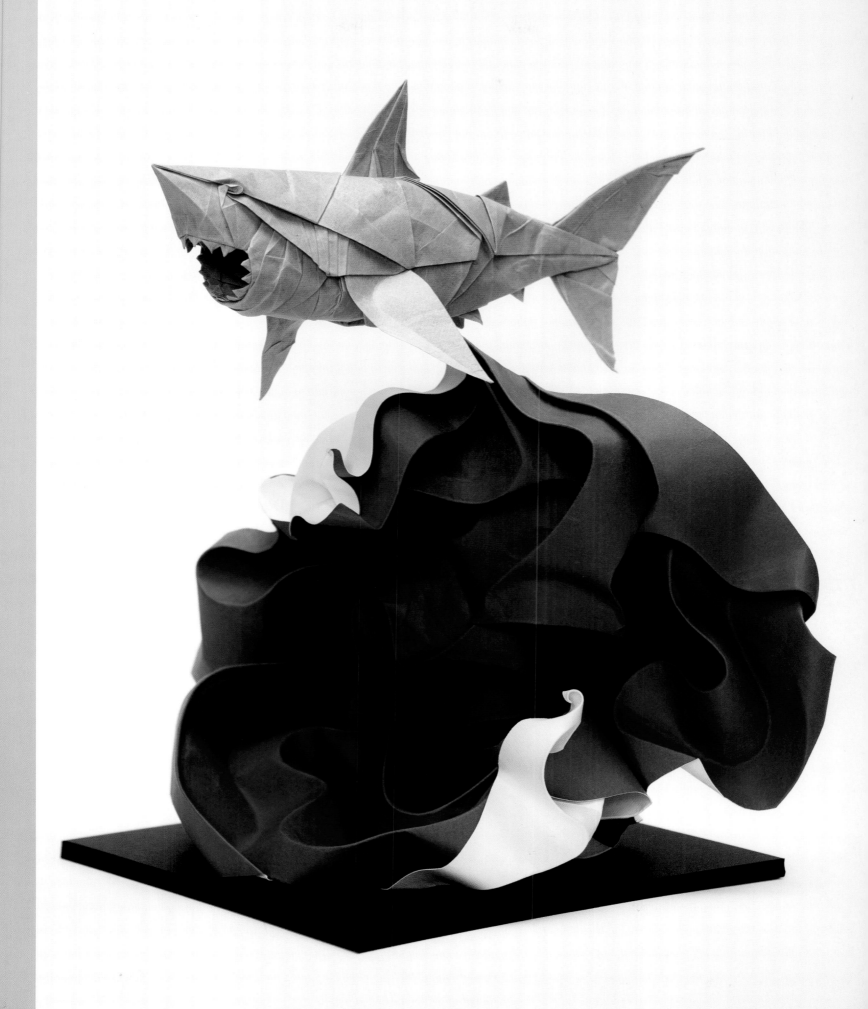

LEFT
Psychopsis Krameriana
2012
Paper
×
Dimensions variable

BELOW
Horse
2013
Vietnamese banknote
×
Dimensions variable

OPPOSITE
Gorilla
2013
Paper
×
Dimensions variable

Brock Davis

— PROFILE P. 151 —

Cucumber Killer Whale
2012
iPhone photograph, posted on Instagram
×
30 × 30 cm (12 × 12 in.)

RIGHT
Cake Ramp
2012
iPhone photograph,
posted on Instagram
×
30 × 30 cm (12 × 12 in.)

LEFT
Rudy
2012
Personal photograph
×
46 × 61 cm (18 × 24 in.)

Cottonball Cloud
2012
iPhone photograph
×
30 × 30 cm (12 × 12 in.)

David DiMichele

— PROFILE P. 153 —

ABOVE *Pseudodocumentation: Apollonian and Dionysian*, 2010. Digital C-print.
107 × 140 cm (42 × 55 in.).

OPPOSITE, ABOVE *Pseudodocumentation: Bark Gestures*, 2011. Digital C-print.
104 × 142 cm (41 × 56 in.).

BELOW
Pseudodocumentation: Broken Glass
2006
Digital C-print
×
102 × 152 cm (40 × 60 in.)

OVERLEAF
Pseudodocumentation: Lightrods
2009
Digital C-print
×
102 × 165 cm (40 × 65 in.)

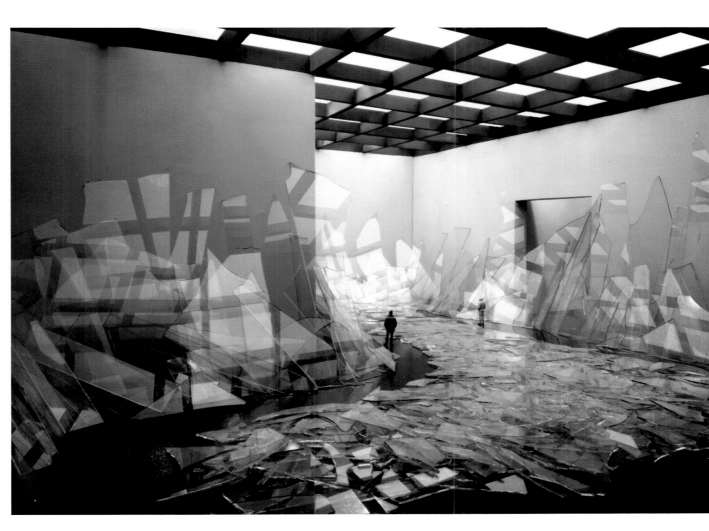

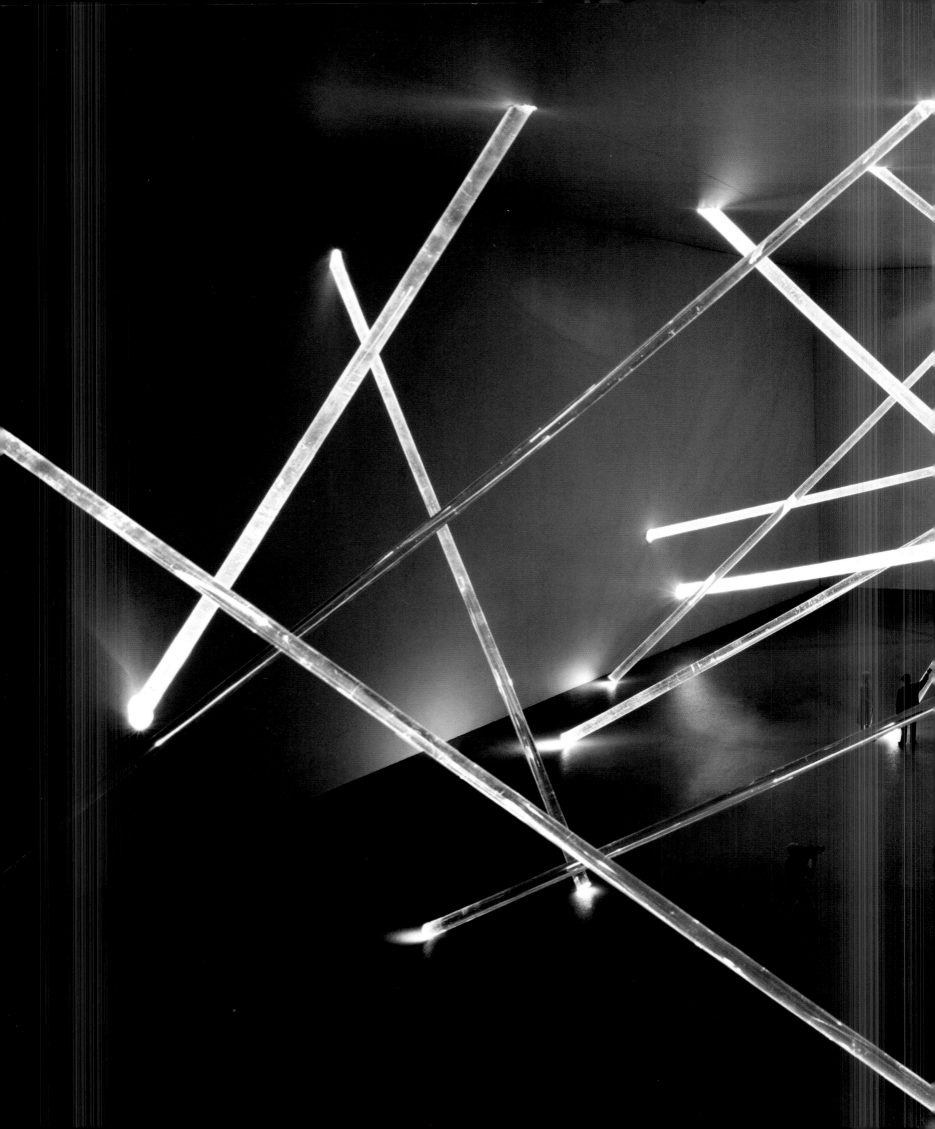

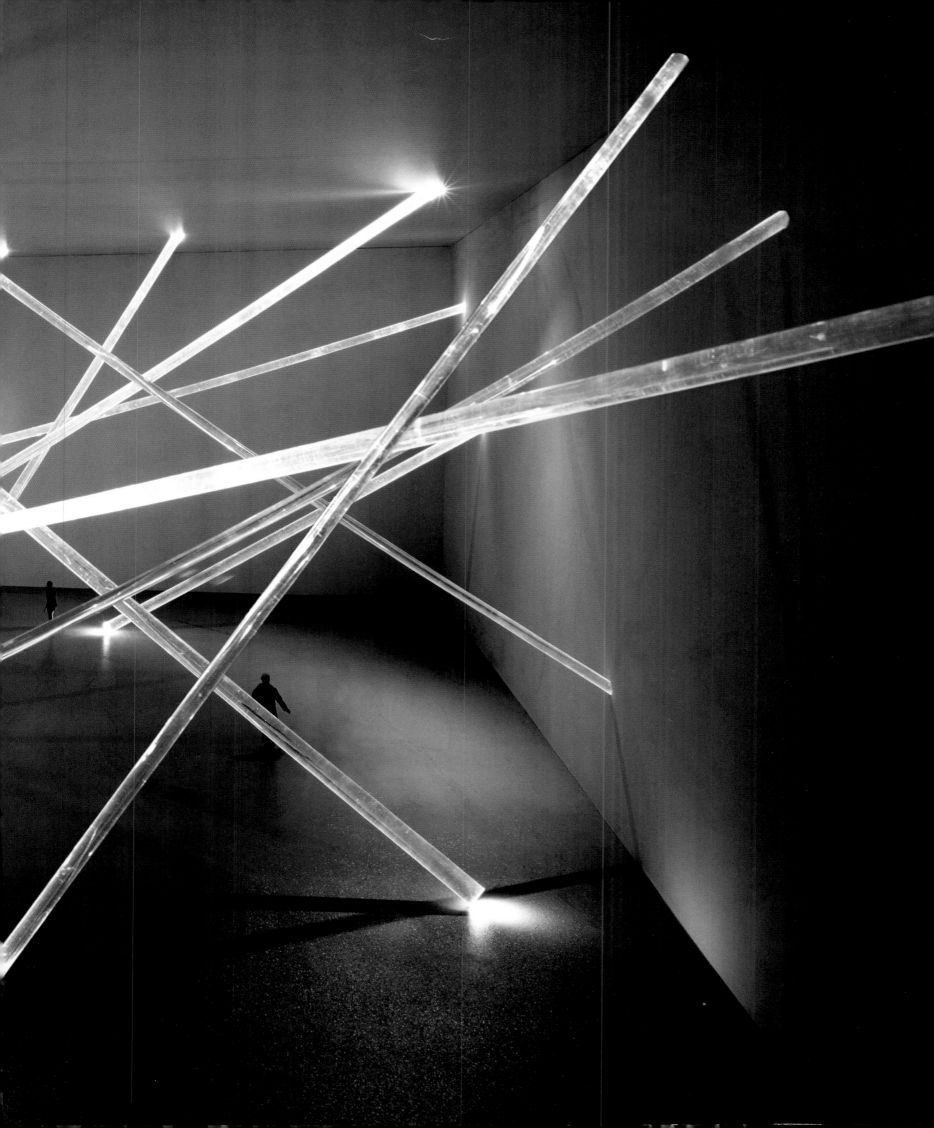

Thomas Doyle

— PROFILE P. 154 —

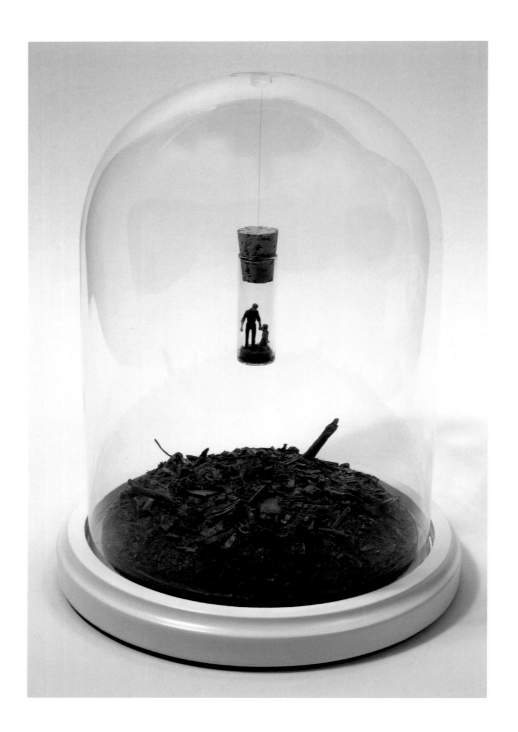

Brace
2012
Mixed-media sculpture
×
21.5 cm (8 ½ in.), 16.5 cm (6 ½ in.) diam.

RIGHT AND BELOW
Coming from Where We're Going
(details)
2010
Mixed-media sculpture
×
61 cm (24 in.), 35.5 cm (14 in.) diam.

Lorenzo Manuel Durán

— PROFILE P. 155 —

Halcón (Falcon)
2011
Leaf (*Catalpa bignonioides*),
cut with a scalpel

×

40 × 50 cm (15 ¾ × 19 ⅝ in.)

LEFT

Ciervos (Deer)

2012

Leaf (*Mespilus germanica*),
cut with a scalpel

×

30 × 12 cm (11 ¾ × 4 ¾ in.)

RIGHT

Mantis Religiosa
(Praying Mantis)

2011

Leaf (*Populus alba*),
cut with a scalpel

×

26 × 24 cm (10 ¼ × 9 ½ in.)

ABOVE *María*, 2013. Skeletonized leaves (*Platanus x hispanica*).
36 × 57 cm (14 ⅛ × 22 ½ in.).

OPPOSITE *Serpiente* (*Snake*), 2012. Leaf (*Juglans regia*), cut with a scalpel.
30 × 25 cm (11 ¾ × 9 ⅞ in.).

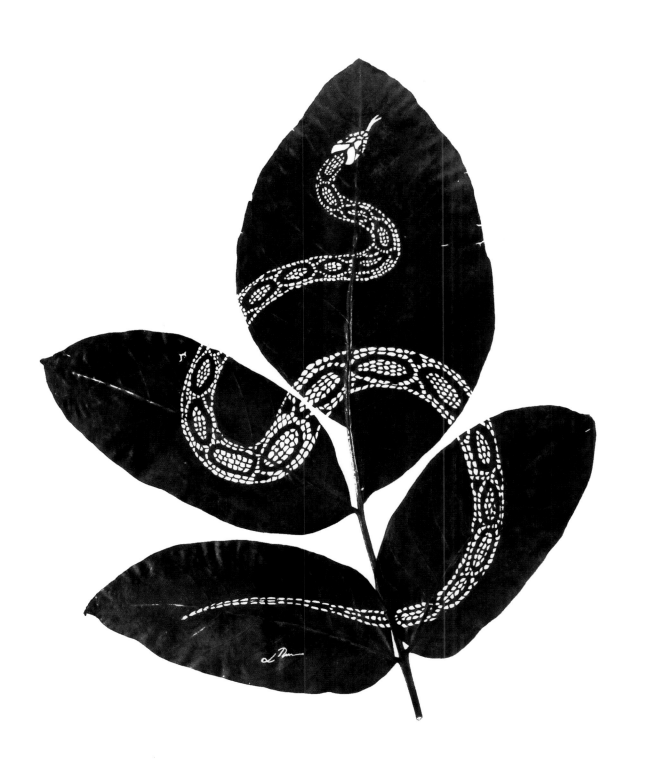

Evol

— PROFILE P. 156 —

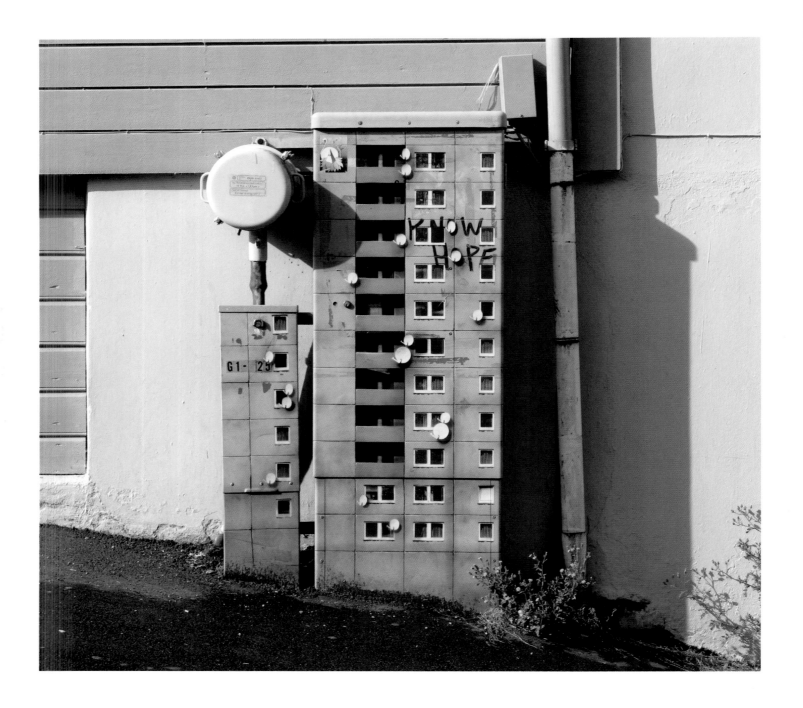

Block G1-25 (w/ Know Hope)
2010
Stavanger, Norway
Spray paint on electrical box

×

Dimensions variable

LEFT
Caspar-David-Friedrich-Stadt
2009
Dresden, Germany
Mixed media
×
Dimensions variable

BELOW
The Jame Finer House
Collaboration with Monstfur
2012
Warsaw, Poland
Spray paint on electrical boxes
×
Dimensions variable

RIGHT
Nordkreuz
2011
Hamburg, Germany
Mixed media
×
9 × 9 × 1.5 m (29 ½ × 29 ½ × 5 ft)

BELOW
Detail of *Nordkreuz* after rain

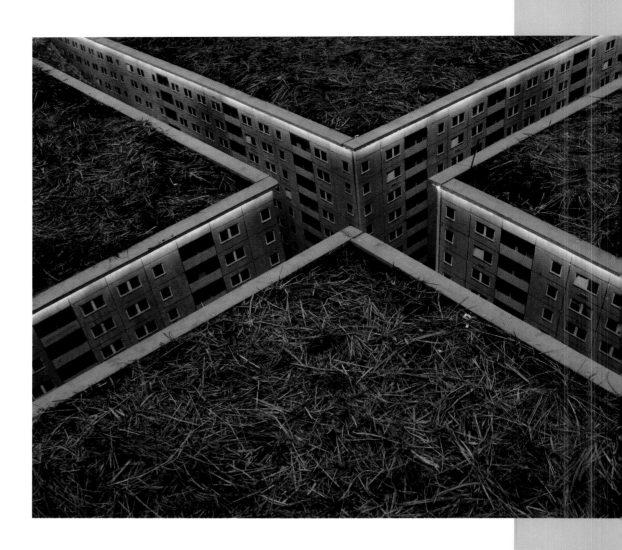

Exportware
2012
Spray paint on cardboard
×
75 × 80 cm (29 ½ × 31 ½ in.)

Joe Fig

— PROFILE P. 157 —

Gregory Amenoff: March 28, 2006
2006
Mixed media
×
28 × 28 × 24 cm (11 × 11 × 9 ½ in.)

LEFT
Line, Color, Form
(Henri Matisse 1950)
2002
Mixed media
×
32 × 46 × 30.5 cm
(12 ½ × 18 × 12 in.)

BELOW
Jackson Pollock
2008
Mixed media
×
20 × 53 × 44.5 cm
(8 × 21 × 17 ½ in.)

OPPOSITE
Leonardo Drew:
September 24, 2013 (detail)
2013
Mixed media
×
67 × 51 × 44 cm
(26 ½ × 20 ⅛ × 17 ¼ in.)

ABOVE
Malcolm Morley: July 19, 2007
2008
Mixed media
×
76 × 51 × 89 cm (30 × 20 × 35 in.)

RIGHT
Chuck Close: Summer 2004
2005
Mixed media
×
61 × 79 × 107 cm (24 × 31 × 42 in.)

Nancy Fouts

— PROFILE P. 159 —

ABOVE *Shuttlecock Egg*, 2009. Life-size shuttlecock with egg.
Dimensions variable.

OPPOSITE *Balloon Pear*, 2006. Life-size pear with balloon tip.
Dimensions variable.

RIGHT

Butterfly Dart

2010

Life-size vintage dart
with butterfly wings

×

19 × 12 × 12 cm (7 ½ × 4 ¾ × 4 ¾ in.)

BELOW

Crow Head with Eye

2010

Life-size taxidermy crow
head with glass eye

×

30 × 16 × 16 cm (11 ¾ × 6 ¼ × 6 ¼ in.)

OPPOSITE

Cherry Dice

2010

Life-size dice with cherry stems

×

Dimensions variable

Takahiro Iwasaki

— PROFILE P. 161 —

Out of Disorder (Cosmo World)

2011

Hair, dust

×

Dimensions variable

ABOVE
Out of Disorder (Coney Island)
2012
Beach towels
×
40 × 160 × 130 cm (15 ¾ × 63 × 51 ⅛ in.)

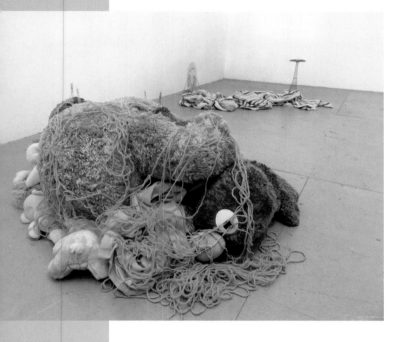

ABOVE AND RIGHT
Out of Disorder (Blue Mountain)
2012
Threads, soft toys, towels
×
Dimensions variable

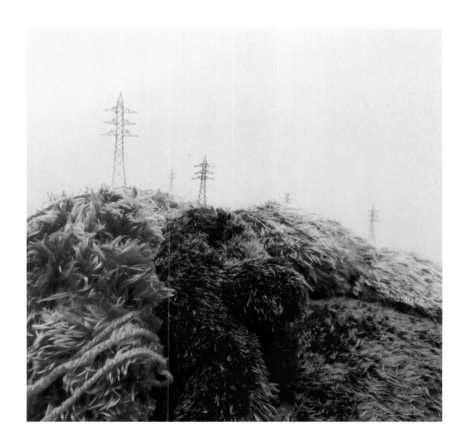

OPPOSITE
Out of Disorder (Neonscape)
2013
Clothes, Lily yarn
×
Dimensions variable

ABOVE
Phenotypic Remodeling (Moscow)
2012
Moscow Museum of Modern Art, Moscow, Russia
Flyers, packaging
×
Dimensions variable

RIGHT
Phenotypic Remodeling (Cleaning)
2011
Nassauischer Kunstverein Wiesbaden,
Wiesbaden, Germany
Packaging
×
Dimensions variable

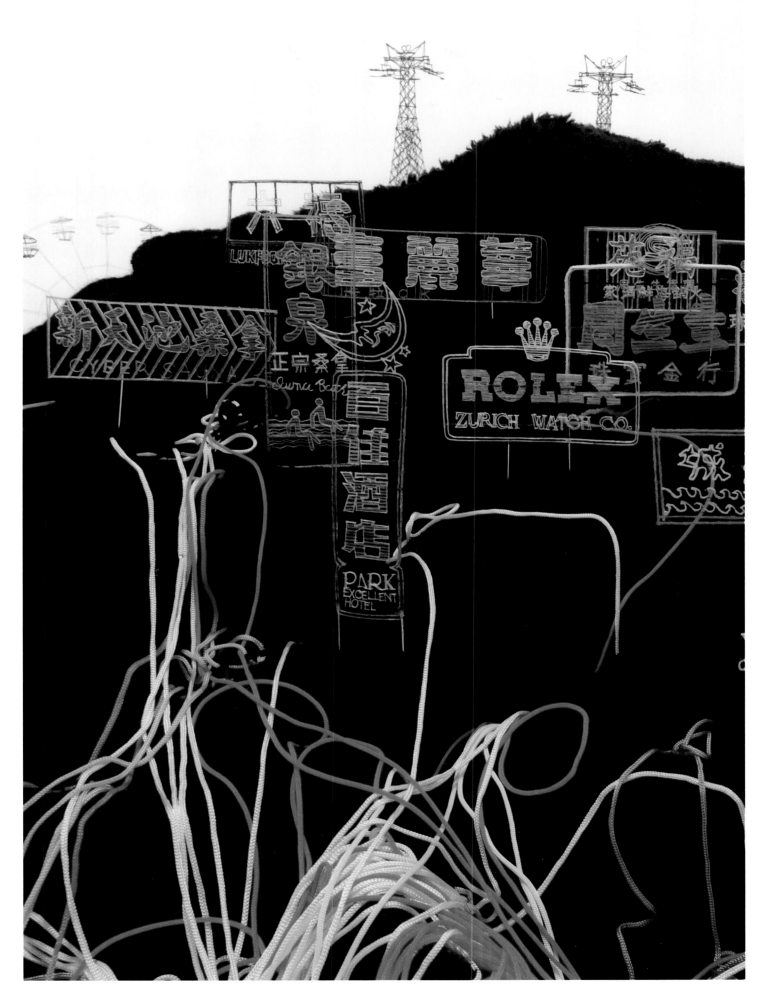

Luke Jerram

— PROFILE P. 162 —

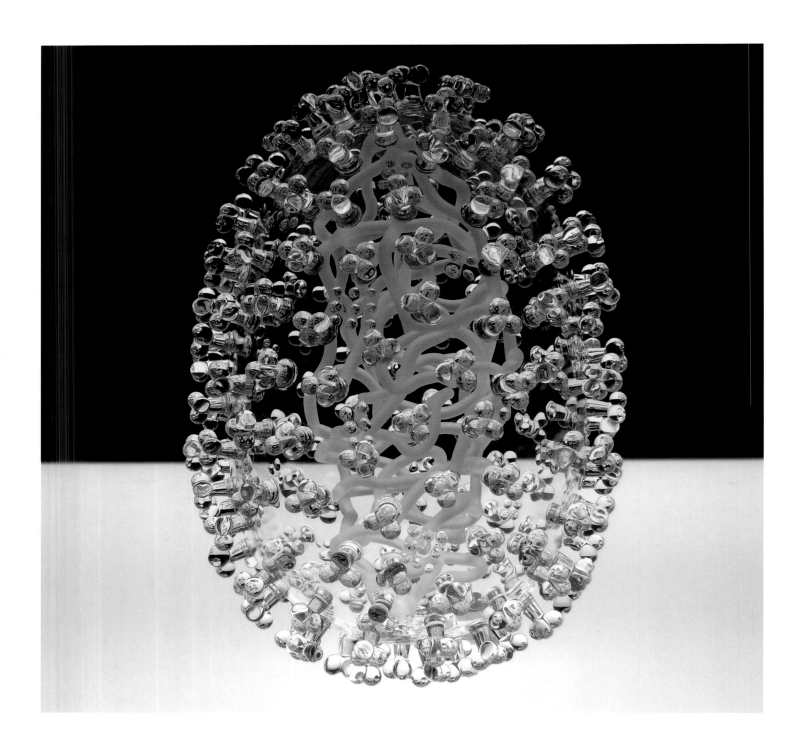

Swine Flu
2009
Flameworked glass
×
26 × 18 cm (10 ¼ × 7 ⅛ in.)

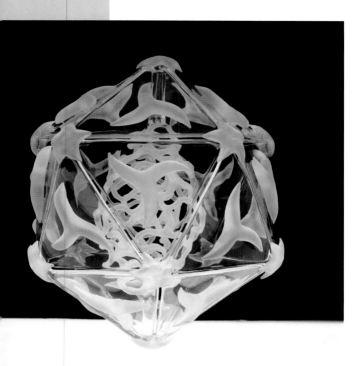

BELOW
Papillomavirus
2011
Flameworked glass
×
20 × 20 cm (7 ⅞ × 7 ⅞ in.)

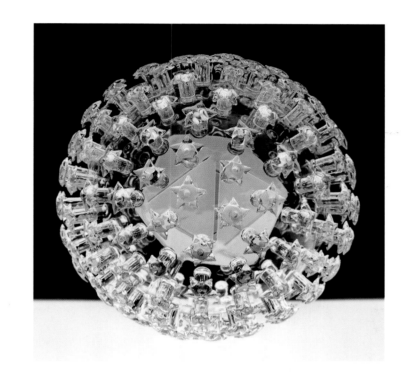

ABOVE
EV71 – Hand, Foot and Mouth
2012
Flameworked glass
×
23 × 23 cm (9 × 9 in.)

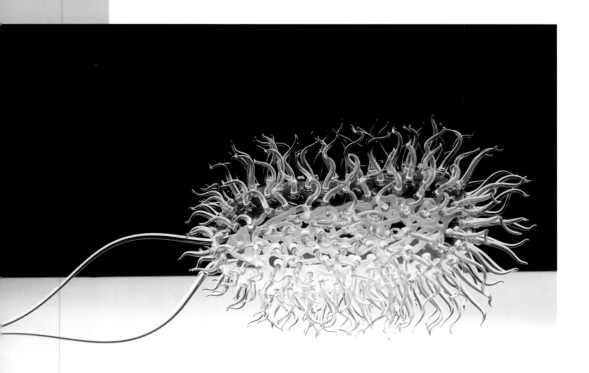

LEFT
E. coli
2010
Flameworked glass
×
70 × 25 cm (27 ⅝ × 9 ⅞ in.)

Nicolás Labadia

— PROFILE P. 163 —

Neodiabolepis
2008
Found objects
×
7 × 5 × 5 cm (2 ¾ × 2 × 2 in.)

LEFT
Neohumbolti
2008
Found objects
×
6 × 4 × 4 cm (2 ⅜ × 1 ⅝ × 1 ⅝ in.)

RIGHT
Granatum Alae
2009
Found objects
×
6 × 7 × 5 cm (2 ⅜ × 2 ¾ × 2 in.)

LEFT

Magnolium Ossium

2010

Found objects

×

10 × 7 × 5 cm

(3 ⅞ × 2 ¾ × 2 in.)

OPPOSITE

Homogranum

2011

Found objects

×

11 × 8 × 6 cm

(4 ⅜ × 3 ⅛ × 2 ⅜ in.)

RIGHT

Manubrium Alae

2009

Found objects

×

11 × 8 × 6 cm

(4 ⅜ × 3 ⅛ × 2 ⅜ in.)

Guy Laramée

— PROFILE P. 164 —

Great Wave
2012
Altered book, inks
×
19 × 15 × 23 cm (7 ½ × 5 ⅞ × 9 in.)

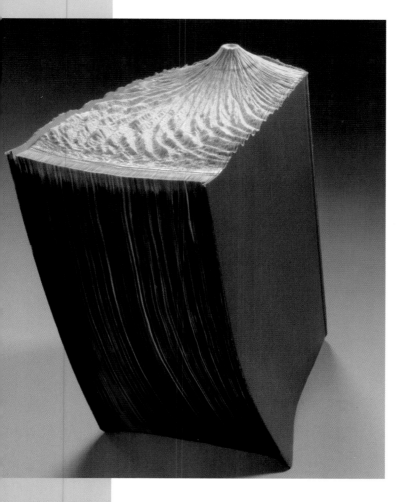

In Advance of a Broken Land (Tsunami), 2011
2012
Altered book, inks
×
15 × 16 × 22 cm (5 ⅞ × 6 ¼ × 8 ⅝ in.)

El amor por las montañas nos curará
(*Love for the Mountains Will Cure Us*)
2012
Carved Littré dictionary, inks
×
43 × 14 × 27 cm (16 ⅞ × 5 ½ × 10 ⅝ in.)

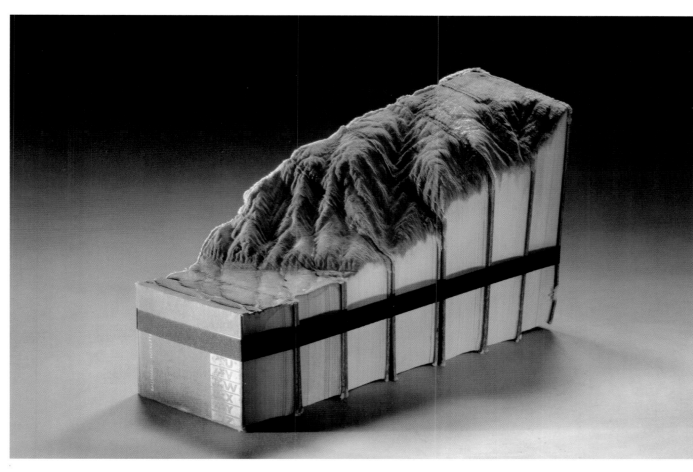

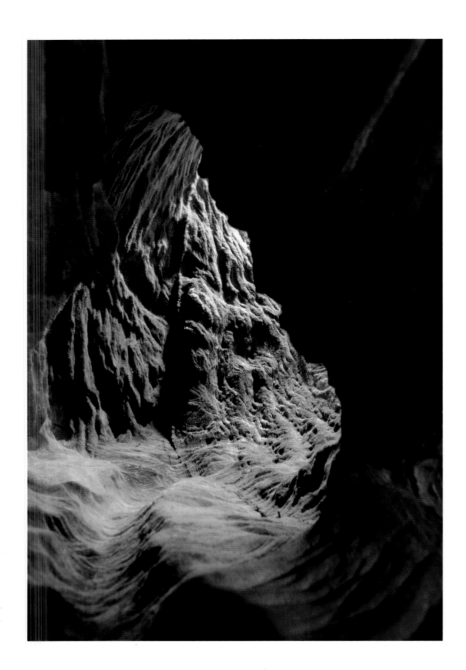

OPPOSITE
Brown's Bible
2012
Carved Bible, ribbon, lamp
×
32 × 27 × 9 cm (12 ½ × 10 ½ × 3 ½ in.)

ABOVE AND RIGHT
Grotta
2012
Altered books, pigments, lamp
×
28 × 18 × 18 (11 × 7 × 7 in.)

Nadín Ospina

— PROFILE P. 165 —

ABOVE *Chacmool*, 1999. Stone.
47 × 59 × 27 cm (18 ½ × 23 ¼ × 10 ⅝ in.).

OPPOSITE *Dignatario* (*Dignitary*), 2000. Ceramic.
27 × 13 × 12 cm (10 ⅝ × 5 ⅛ × 4 ¾ in.).

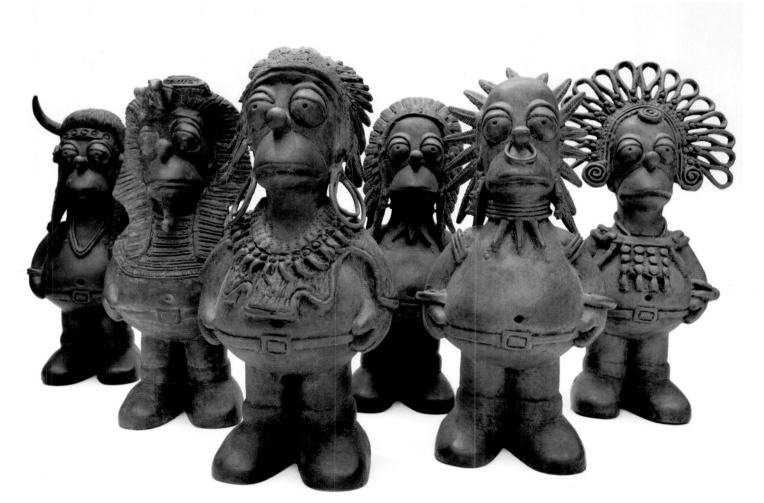

ABOVE *Jefes* (*Chiefs*), 2006. Bronze.
c. 29 × 14 × 12 cm (11 ⅜ × 5 ½ × 4 ¾ in.).

OPPOSITE *Guerrero* (*Warrior*), 1998. Ceramic.
40 × 30 × 33 cm (15 ¾ × 11 ¾ × 13 in.).

Liliana Porter

— PROFILE P. 167 —

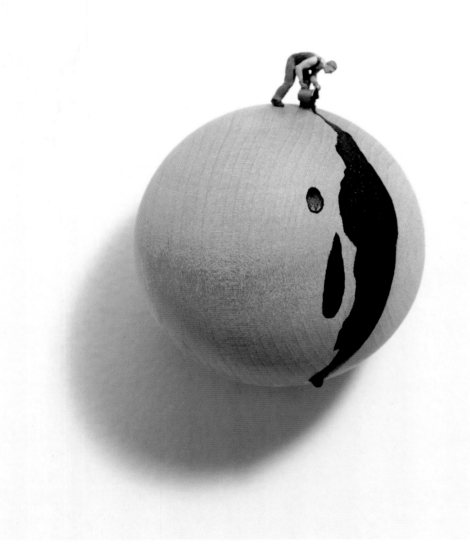

Black Drip
2009
Wooden sphere, metal figurine, acrylic
×
8 × 6 cm (3 × 2 ½ in.)

LEFT
Forced Labor — Man with Axe II
(detail)
2011
Objects and figurines
on wooden platform
×
114 × 366 × 386 cm (45 × 144 × 152 in.)

ABOVE
Dialogue with Alarm Clock
2000
Ilfochrome print
×
80 × 58.5 cm (31 ½ × 23 in.)

LEFT
Them with Nazi
2011
Duraflex print
×
52 × 68.5 cm (20 ½ × 27 in.)

LEFT
Untitled with Wall Work
2009
Painted wooden base, metal figurine,
spackle on wall
×
Dimensions variable

OPPOSITE
The Anarchist
2012
Shelf with figurine and yarn
×
142 × 110 × 26 cm (56 × 43 ¼ × 10 ¼ in.)

RIGHT
Forced Labor (Orange Vest)
2009
Figurine on painted wooden
base with holes
×
6.5 × 15 × 5 cm (2 ½ × 6 × 2 in.)

Klari Reis

— PROFILE P. 168 —

Twilight Zones
2013
Epoxy polymer, Petri dish
×
10 cm (4 in.) diam.

RIGHT
150 Piece Petri Dish Installation
2013
Epoxy polymer, Petri dishes,
T-nuts, steel rods
×
152 cm (60 in.) diam.

LEFT
Midas in Winter
2013
Epoxy polymer, Petri dish
×
15 cm (6 in.) diam.

150 Piece Petri Dish Installation
2013
Epoxy polymer, Petri dishes,
T-nuts, steel rods

×

152 cm (60 in.) diam.

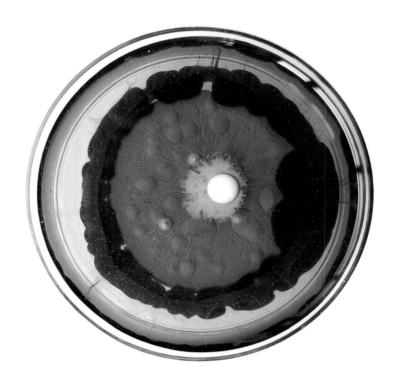

LEFT
Pickled Blueberry
2013
Epoxy polymer, Petri dish
×
10 cm (4 in.) diam.

RIGHT
Frantic Air Plant
2013
Epoxy polymer, Petri dish
×
7.5 cm (3 in.) diam.

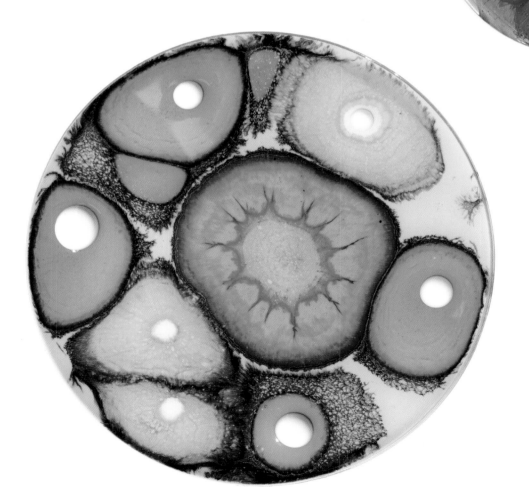

LEFT
Twilight Zones
2013
Epoxy polymer, Petri dish
×
15 cm (6 in.) diam.

Egied Simons

— PROFILE P. 169 —

ABOVE AND RIGHT
Liquid Files: Aqua Morgana
2011
Kunstliefde, Utrecht, Netherlands
Mixed media
×
127 × 20 × 40 cm
(50 × 7 ⅞ × 15 ¾ in.) each

OPPOSITE
*Root Lab Field Research, Weaving
Patterns & Root Extracts*
2013
Mixed Media
×
300 × 200 × 50 cm
(118 ⅛ × 78 ¾ × 19 ⅝ in.)

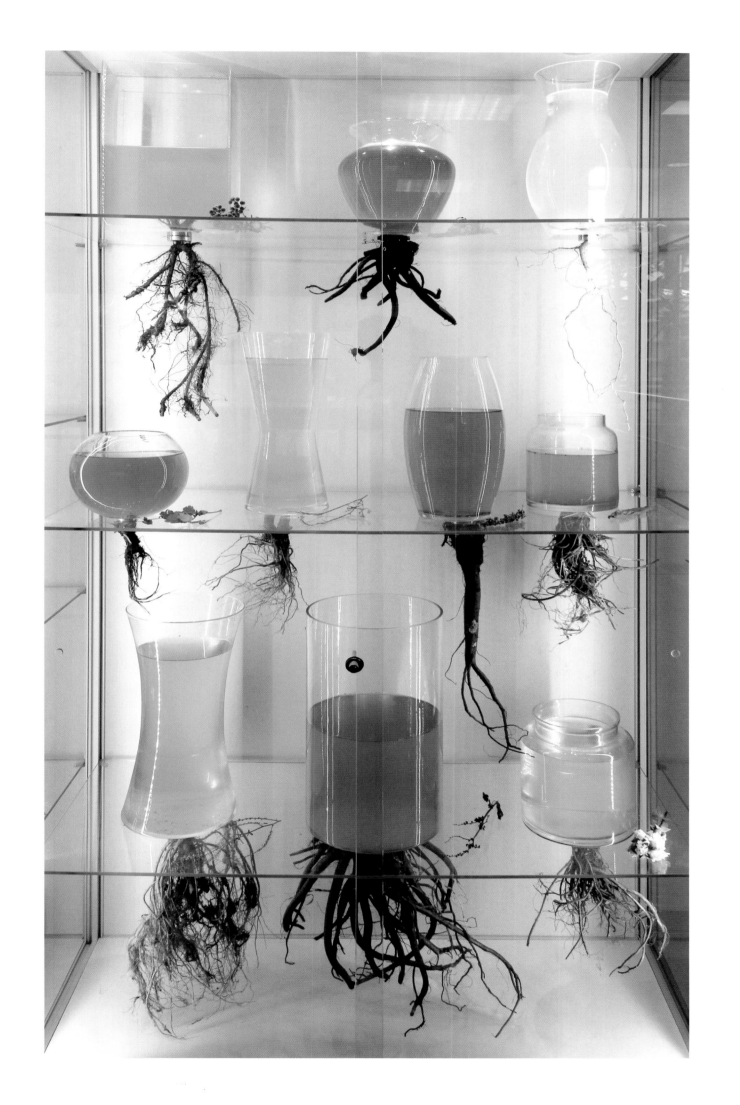

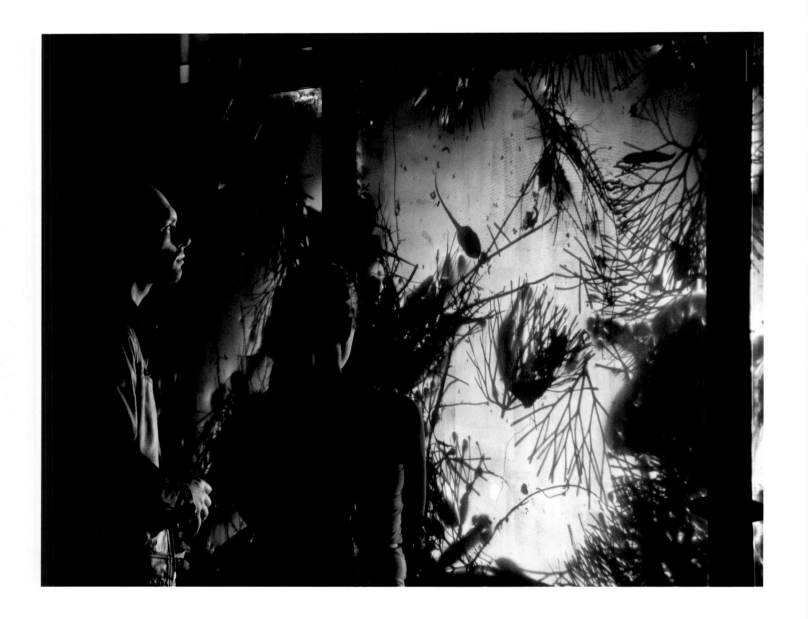

Liquid Files: Bus Stop North
2011
Station Noord, Rotterdam, Netherlands
Mixed media
×
8 × 4 × 2.2 m (26 × 13 × 7 ft)

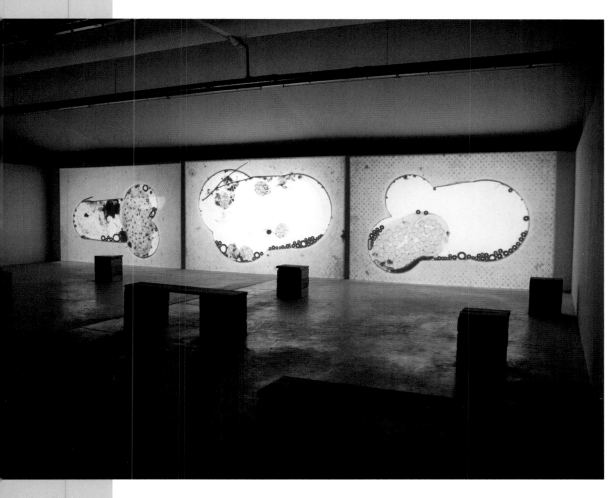

LEFT AND BELOW
Liquid Files: Installation
LF_VBF IV
2010
Verbeke Foundation,
Kemzeke, Belgium
Mixed media
×
10 × 10 m
(33 × 33 ft)

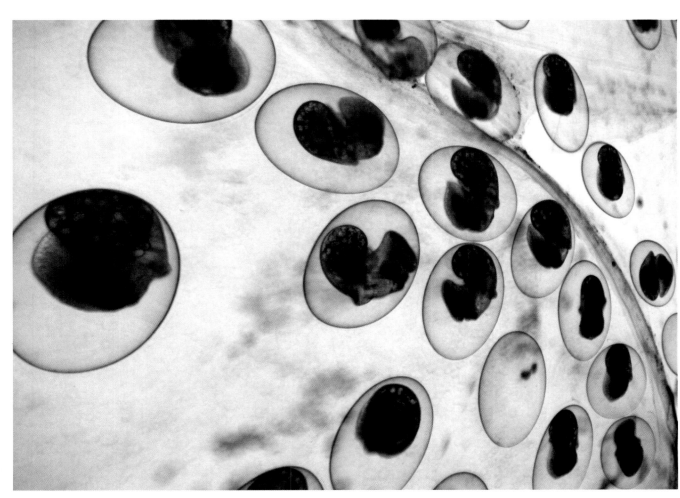

Iori Tomita

— PROFILE P. 170 —

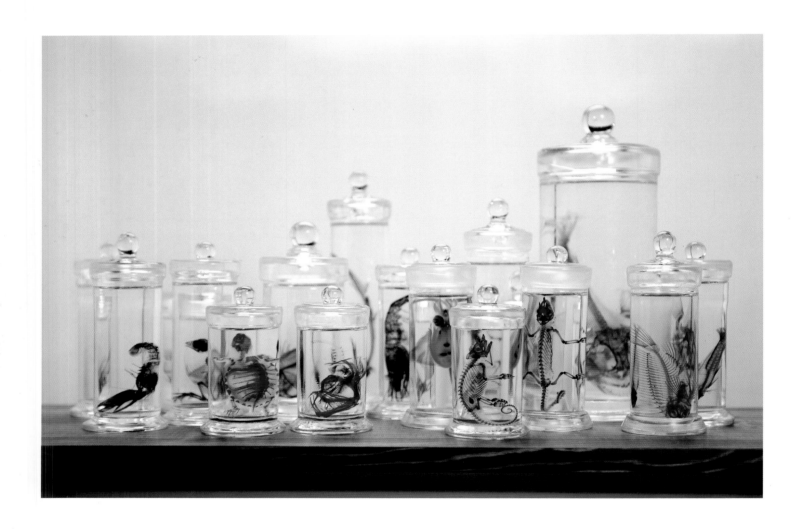

ABOVE *Transparent Specimens*, 2009. Mixed media.
Dimensions variable.

OPPOSITE *Lethotremus awae*, 2009. Transparent specimen.
25 mm (1 in.).

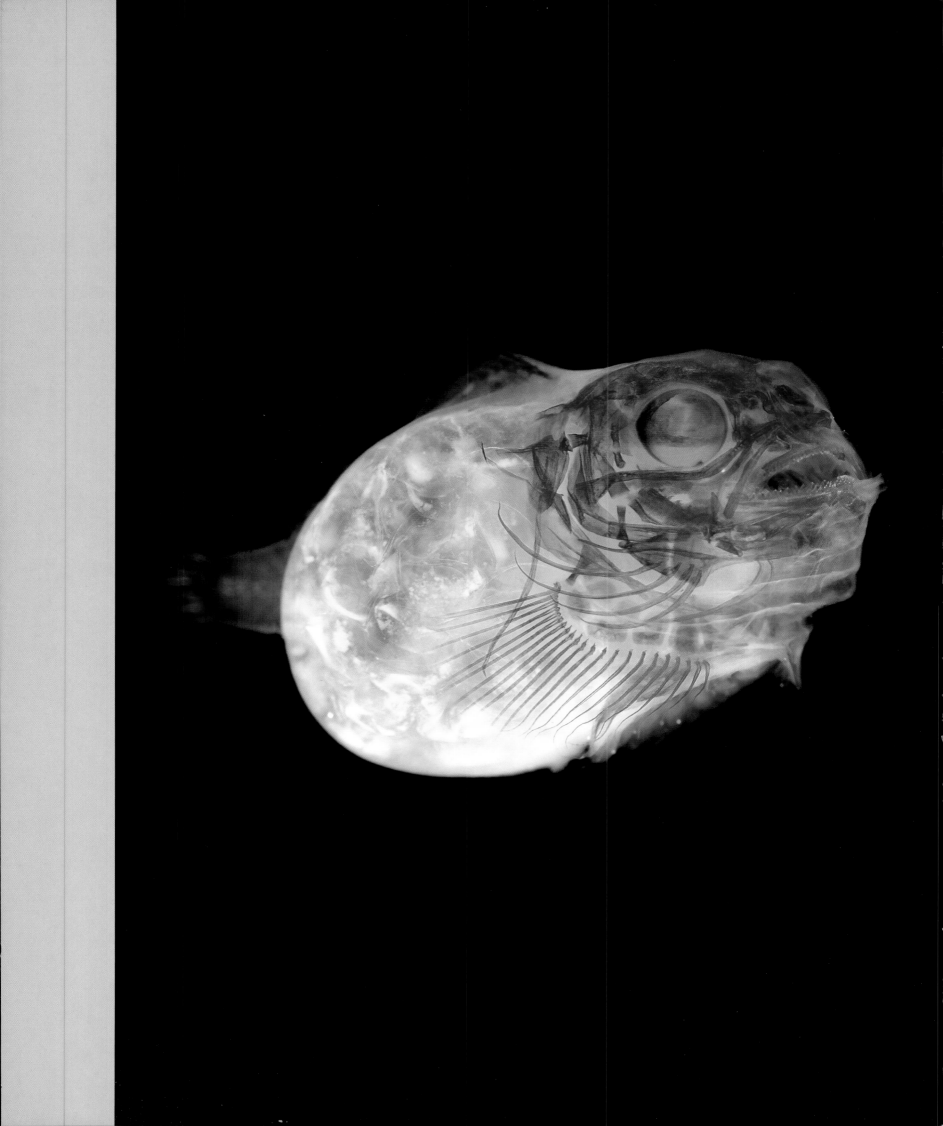

LEFT
Hyla japonica
2009
Transparent specimen
×
67 mm (2 ⅝ in.)

RIGHT
Brachyura sp.
2009
Transparent specimen
×
40 mm (1 ⅝ in.)

RIGHT
Testudinidae sp.
2009
Transparent specimen
×
71 mm (2 ¾ in.)

LEFT
Lactoria cornuta
2009
Transparent specimen
×
53 mm (2 ⅛ in.)

Yin Xiuzhen

— PROFILE P. 171 —

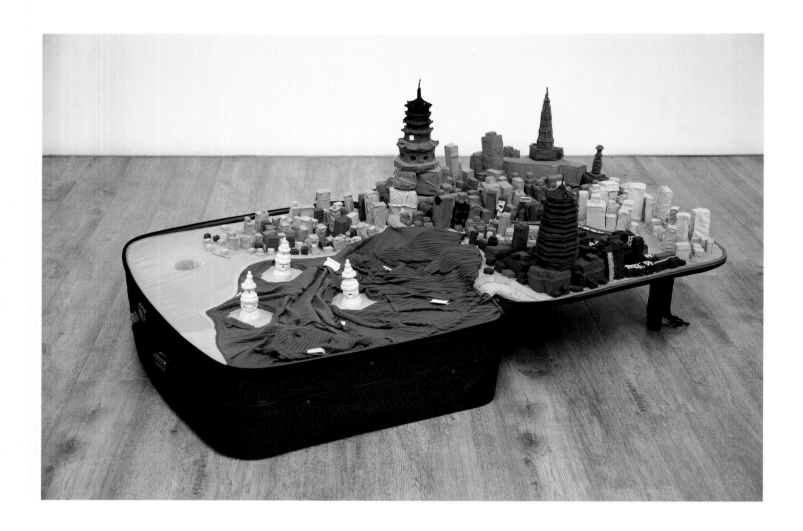

ABOVE *Portable City: Hangzhou*, 2011. Suitcase, clothes.
Dimensions variable.

OPPOSITE *Portable City: Shenzhen*, 2008. Suitcase, found objects.
Dimensions variable.

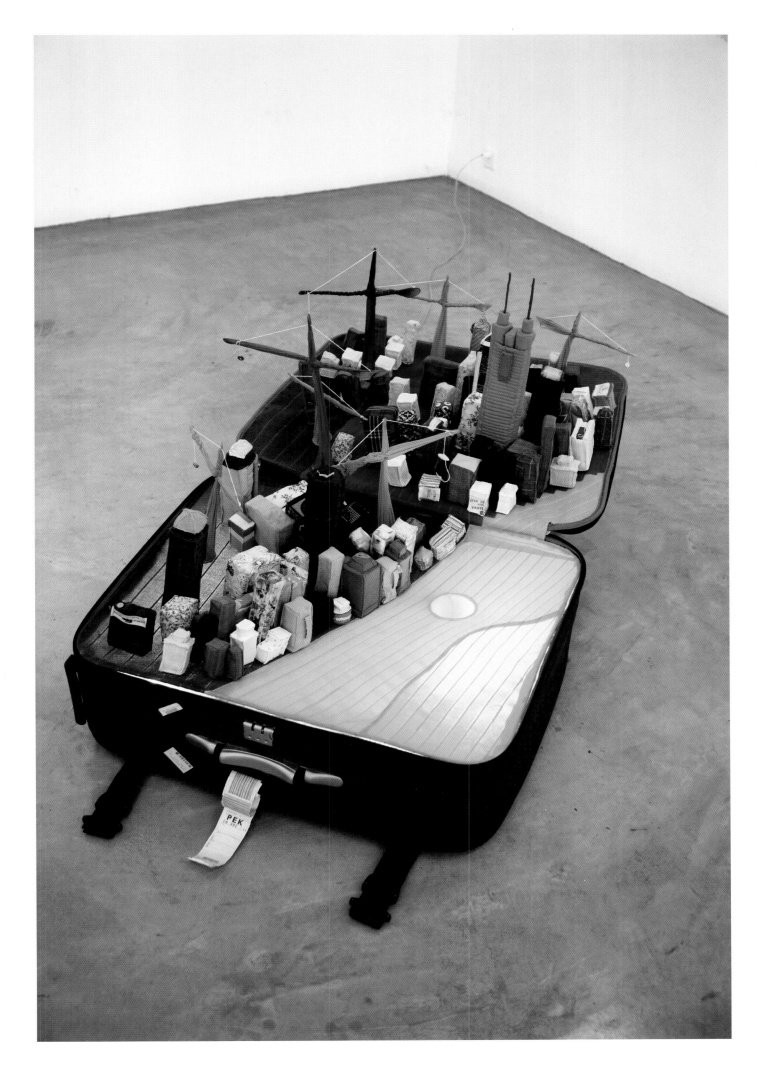

Yang Yongliang

— PROFILE P. 172 —

ABOVE *A Bowl of Taipei No. 3,* 2012. Photograph.
150 × 150 cm (59 × 59 in.).

OPPOSITE *A Bowl of Taipei No. 4,* 2012. Photograph.
100 × 100 cm (39 ⅜ × 39 ⅜ in.).

For Edward Charles Manco

Big Art / Small Art © 2014 Tristan Manco

Designed by Therese Vandling

First published in 2014 in hardcover in the United States of America by Thames & Hudson Inc., 500 Fifth Avenue, New York, New York 10110

thamesandhudsonusa.com

Library of Congress Catalog Card Number 2014932760

ISBN 978-0-500-23922-3

Printed and bound in China by Everbest Printing Co. Ltd